MONET TO MOORE

MONET

RICHARD R. BRETTELL

with NATALIE H. LEE

TO MOORE

The Millennium Gift of Sara Lee Corporation

Yale University Press
New Haven and London

EXHIBITION ITINERARY

Singapore Museum of Art
1 April–30 May 1999

National Gallery of Australia, Canberra
11 June–22 August 1999

North Carolina Museum of Art, Raleigh
10 September–7 November 1999

Portland Art Museum, Oregon
19 November 1999–23 January 2000

The Art Institute of Chicago
13 March–28 May 2000

Design consultant: Derek Birdsall
Printed in Singapore

Library of Congress Cataloging-in-Publication Data

Brettell. Richard R.
 Monet to Moore : the millennium gift of Sara Lee Corporation /
Richard R. Brettell.
 p. cm.
 Includes bibliographical references and index.
 ISBN 0–300–08134–0 (cloth : alk. paper)
 1. Art, Modern–20th century Catalogs.
 2. Private collections–Illinois–Chicago Catalogs.
 3. Cummings, Nathan, d. 1985–Art collections Catalogs.
 4. Sara Lee Corporation–Art collections Catalogs.
 I. Title.
 N4020.S27B74 1999
 709′.04′0074–dc21 99–24949
 CIP

A catalogue record for this book is available from The British Library

NOTE ON ILLUSTRATIONS
Most details of the works in the Catalogue are reproduced actual size.
The photographs for cats. 1, 22, 24, 32, 33, and 34 are by David Finn
and are reproduced with his permission.

Contents

The Sara Lee Collection: A Critical and Historical Introduction

RICHARD R. BRETTELL
CONSULTING CURATOR
SARA LEE COLLECTION

Unlike most corporate collections, that of Sara Lee Corporation has only one source – its founder, Nathan Cummings. From the large and scattered collection formed by Mr. Cummings over many years, Sara Lee Corporation identified a select group of fifty-two paintings and sculptures that had been produced over a century – from 1870 to 1970 – by major European modernist artists. These works, all of which at one time had been owned by Mr. Cummings, were acquired by Sara Lee during the course of twenty years in tribute to him as both businessman and art collector. Now, precisely twenty years after the Sara Lee Collection was begun, it is to be given away to museums throughout the United States and the world. This act, unprecedented for an American corporation, is the culmination of a fascinating history – the history of a private collection, of a public corporation's decision to "take that collection corporate" through the act of purchase, and of its ultimate decision to "take the collection public" through the medium of major urban art museums. The last decision will ensure that these important works by artists from Monet to Moore will be seen in perpetuity by diverse urban publics. Chicago, where Nathan Cummings moved his business in 1945 to create what was to become Sara Lee Corporation and where the corporation's worldwide headquarters remain today, has been awarded the largest share of this gift – twelve works – in recognition of the importance the corporation attaches to its home city. But thirty-nine other museums have been designated to receive single works for their permanent collections as part of the Millennium Gift of Sara Lee Corporation. This book documents that gift.

The Nathan Cummings Collection

Throughout the latter part of his long and productive life (1896–1985), Nathan Cummings was known equally as a business genius and an art collector. His "collection of companies" was considered a textbook model for the many conglomerate corporations that were being created in America during the postwar years. His art collection, formed mostly in the 1950s and 1960s, was one of the few "new" collections of modern European painting and sculpture formed after the Second World War to be recognized by major exhibitions at the National Gallery of Art in Washington, the Metropolitan Museum of Art in New York City, and the Art Institute of Chicago. Many other institutions in America and Europe also benefited from the generous lending policies of Nathan Cummings. In 1971, when the Cummings Collection was shown as a summer exhibition at the Metropolitan Museum of Art, Thomas Hoving called it "a spirited, vigorous, constantly evolving thing . . . a source of satisfaction to Nathan

Fig. 1 Nathan Cummings waits on a customer at one of his retail stores, *c.*1949. Photo Sara Lee Corporation.

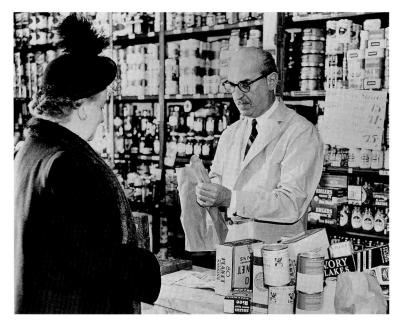

Cummings." He went on to say that Cummings's "willingness to share it with the public, making it accessible through exhibitions and loans, underlines his commitment to the importance of art for all people." There were not many founders of large American industrial corporations about whom such a claim could have been made in 1971.

This notion of a collection that was at once "constantly evolving" and "shared with the public" places Nathan Cummings in a long tradition of enlightened American donor-collectors. As proof that his collection was constantly evolving, no two publications that describe it are the same, reflecting the fact that he continued to purchase – and to sell – works of art as both he and the art market developed. Like many self-made men, he sought the advice of many and then did what he wanted, using the advice that accorded with his own instincts and discarding the rest. Not only did he develop personal relationships with Pablo Picasso (fig. 2), Georges Braque, Fernand Léger, Jean Arp, Giacomo Manzù, and others, he also befriended many of the greatest dealers and collectors of modern art in Europe and the United States. Yet Cummings was never swayed simply by reputation and, unlike

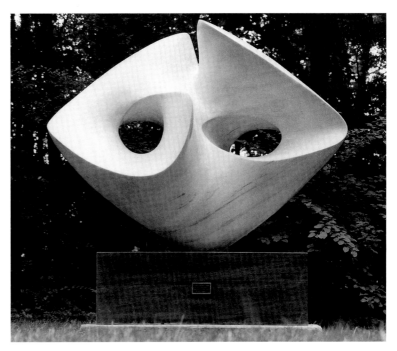

Fig. 3 Antoine Poncet, *Fleuriforme*, c.1968–9.
Collection of the Dixon Gallery and Gardens,
Memphis; Gift of Sara Lee Corporation.

Fig. 2 Nathan Cummings with Pablo Picasso in
the 1960s. Photo Sara Lee Corporation.

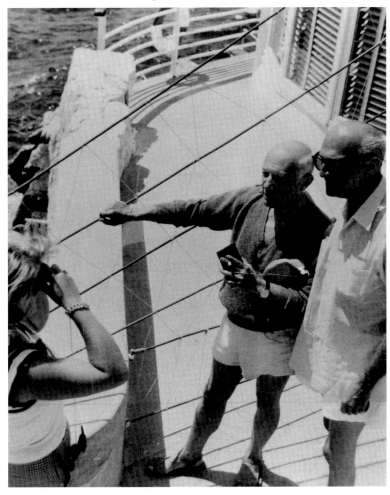

many other collectors of his generation, was capable of being moved by the work of artists with no critical standing and no "official" backing from a major dealer or collector. His lifelong devotion to the sculpture of Antoine Poncet (fig. 3), for example, is an indication of the breadth of his taste and his willingness to go beyond the advice of art experts, many of whom consider Poncet to be a minor follower of Arp.

Cummings himself was fond of admitting his complete lack of formal education in fine-art history and appreciation. He never attended university – or even high school – and was so involved in business from such an early age that he had no leisure time for a conventional education in the arts. In contrast to other major collectors of his generation – David Rockefeller, Joseph Pulitzer, Philip Johnson, and many others – Cummings had never been taught a system of esthetic values and concomitant social connections that could form the basis of an "important" collection of modern art. Perhaps for that reason, his collection was never shown at that institutional arbiter of modernist collecting, the Museum of Modern Art, although he did lend important objects to exhibitions at "The Modern."

When Nathan Cummings began to buy art, he did so by trusting his instincts, by listening to the remarks of others after he had made his purchases and, subsequently, by revising his "instincts." Indeed, he repeated many times the story of one of his first major acquisitions – the Camille Pissarro *Bountiful Harvest* in Paris in 1945 (cat. 38) – always stressing that when he purchased the painting he had never heard of Pissarro. Rather, because he was

attracted to the painting and acquired it, he learned more and more about Pissarro and added increasingly important works by that artist to his collection, which at one time included as many as nine Pissarros. There is one person, however, who must be mentioned as a major figure in the formation of the Nathan Cummings Collection: his son-in-law, Robert B. Mayer. Mayer was well educated and had a real knowledge of modern and contemporary art. In fact, he had enough knowledge and a close enough familial relationship with Cummings to convince his father-in-law to buy at a more ambitious level, to concentrate on the work of certain key artists, to "upgrade" his collection whenever possible, and to buy major works by such artists as Roger de La Fresnaye, Berthe Morisot, and Jean Metzinger, who were "out of fashion." These lessons were well learned by Cummings, and he and Mayer each carved out a territory for their respective collections so that there would be no competition — Nathan Cummings plowed the higher-priced field of modern European painting and Robert Mayer, before his death in 1974, ventured into contemporary American and European art, forming one of the largest American private collections outside New York of art from the 1960s and 1970s.

After the death of his wife, Ruth, in 1952, Cummings moved in with the Mayers in Winnetka, just north of Chicago overlooking Lake Michigan, and took his collection with him. This phase in the history of the collection is well documented, both through family photographs and because constant tours by visitors resulted in the publication of a pamphlet-like guide to the various rooms in the house. From this guide, we learn of the wonderful mixtures of nineteenth- and twentieth-century art, with pre-Columbian artifacts, Tang tomb sculptures, Ming porcelain, and Chinese ivories in the Mayer home.

Perhaps the best way to get a sense of the "evolving" nature of the Cummings Collection is to study the three exhibition catalogues of the collection produced during Cummings's lifetime. Each opens a window onto his ambitions and the shifting nature of his taste and collecting. The earliest of these exhibitions was held in 1968 at the Lyman Allen Museum in New London, Connecticut.

For this first exhibition, a small pamphlet-catalogue entitled *Paintings and Sculpture from the Collection of Mr. and Mrs. Nathan Cummings* was published, and the exhibition was held in New London from 19 January until 18 February 1968, during the period when the Cummingses were away from their New York apartment in Palm Beach. This form of "seasonal" lending — virtually painless to the lender and highly important to the regional public — was practiced widely in New York, Chicago, and other major cities, but these loans of works from urban apartments to the galleries and storage rooms of museums were almost never

important enough to result in exhibitions with publications like those that documented the evolving collection of Nathan Cummings from 1968 until 1973.

What was the Nathan Cummings Collection in 1968? First of all, it included only works that were in Cummings's New York apartment, omitting completely the large-scale sculpture from the grounds of his summer property at Charlevoix, Michigan. Therefore, the five bronzes exhibited — by Honoré Daumier, Henri Matisse, Manzù, and Henry Moore — were intimate objects appropriate to their domestic situation. Of these, four remain in the Sara Lee Collection. In addition to the sculpture, the exhibition featured thirty-four paintings, varying in date from an 1870s floral still-life by Pissarro (cat. 37), to works from the 1950s by Léger and Franz Kline. These later works had not been part of the Cummings Collection in the Winnetka house, and they represent the influence of his second wife, Joanne, who had studied painting with Léger and was knowledgeable about European postwar art.

Twelve of the paintings in the exhibition at the Lyman Allen Museum are now in the Sara Lee Collection, the others were either sold by Cummings during his lifetime, sold by the corporation after his death, or remain in the collection of his heirs. At the core of the collection were works from the period 1890–1940, by Edouard Manet, Claude Monet, Auguste Renoir, Pissarro, Mary Cassatt, and Edgar Degas. These provided a "base" for an edifice that included multiple works by Paul Gauguin (3), Braque (2), Amedeo Modigliani (2), Rouault (2), and Léger (2). The cover (fig. 5) of the exhibition catalogue featured a delightful, but minor, late Renoir, *Young Woman combing Her Hair*, and there were color plates of works by Braque, Cassatt, Manet, Monet, Pissarro, Rouault, and Paul Signac, only four of which remain in the Sara Lee Collection.

It is fair to say that there had never been such an important group of modernist paintings on public display in New London, and that the hopes of the town and of Connecticut College must have been quite high when the exhibition was mounted. Yet Cummings was also being wooed by Carter Brown of the National Gallery of Art and his rival Thomas Hoving, Director of the Metropolitan Museum of Art. With their interest in the collection and their willingness both to display it in important galleries and to publish an illustrated catalogue, the competition for the Cummings Collection heated up. In the summer of 1970 the National Gallery of Art mounted an exhibition of the Cummings Collection with a major catalogue, *Selections from The Nathan Cummings Collection.* A year later this exhibition opened at the Metropolitan Museum as part of a larger exhibition with the generic title, *Summer Loan 1971: Paintings from New York Private Collections.* Most of the collectors in this latter exhibition

Fig. 4 The installation at the National Gallery of Art's 1970 exhibition. Photo Sara Lee Corporation.

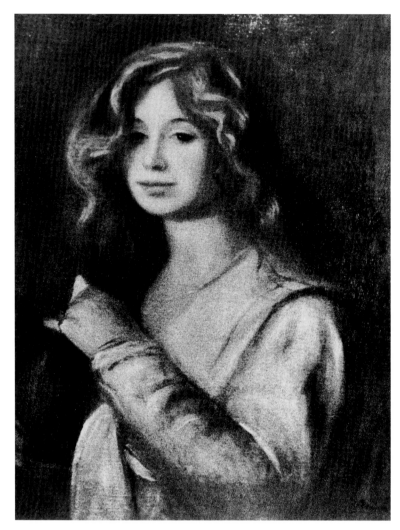

Fig. 5 Cover illustration of Renoir's *Young Woman combing Her Hair* for the 1968 exhibition catalogue for the Lyman Allen Museum.

did, Cummings threw down his prepared remarks with the élan of a practiced showman and told stories "off the cuff" of a life with art which were designed to convey an important message – that Nathan Cummings started from nothing, that he educated himself, that he bought what he liked, and that he enjoyed both living with art and sharing it with others.

The selection of works for the Washington/New York exhibition was made by Carter Brown and Ted Rousseau, Curator of European Painting at the Metropolitan, and both men sought the advice of the great connoisseur and historian Douglas Cooper, who was persuaded to write a lengthy article about the Cummings Collection in the catalogue. The article is reprinted in this book as an appendix (pp. 205–6, below).

What was the shape of the Cummings Collection in 1970 when it was presented to the large urban public of the United States? First of all, the selection for the Washington/New York exhibition was more discerning and generous than was possible with the rapidly organized exhibition held in New London in 1968. Sixty-two paintings and twelve sculptures appear in the 1970 catalogue, varying in date from a 1860s Degas to a Jean Dubuffet painted nearly a century later. These were arranged in chronological order and stressed the works of certain artists that Cummings had acquired in some quantity. Two paintings by Daumier, two Pissarros, five Degas (one loaned by the Art Institute of Chicago, to which it had already been donated by Cummings; fig. 6); five

Fig. 6 Edgar Degas, *The Bathers*, 1895–1905. The Art Institute of Chicago, Gift of Nathan Cummings.

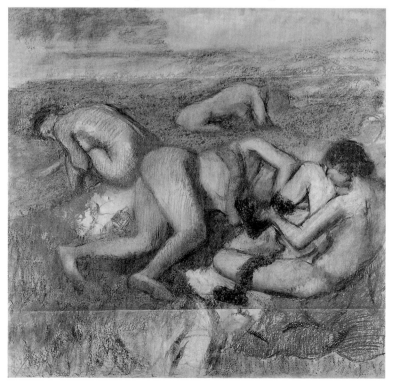

represented the cream of New York society, and many of them loaned their paintings anonymously, but the loan from Cummings was considered so important that it was segregated within the exhibition and given its own section entitled *The Nathan Cummings Collection*.

Carter Brown and Thomas Hoving wrote the preface to the catalogue, used for both exhibitions, and the press staff of the National Gallery of Art ensured that the Washington exhibition received ample national and international publicity. Lengthy and laudatory reviews and articles appeared in the English art magazine *Apollo*, as well as in New York's venerable *Art News*. Even *Life*, the largest circulation weekly magazine in America, devoted a lavishly illustrated article to Cummings and his collection entitled "In the Art Market, Nobody Doesn't Like Mr. Sara Lee (figs. 7a and b)." Indeed, almost everyone gushed about the Cummings Collection, and the collector himself was given the opportunity to speak to America's most important collectors and patrons at the Washington and New York openings. As he often

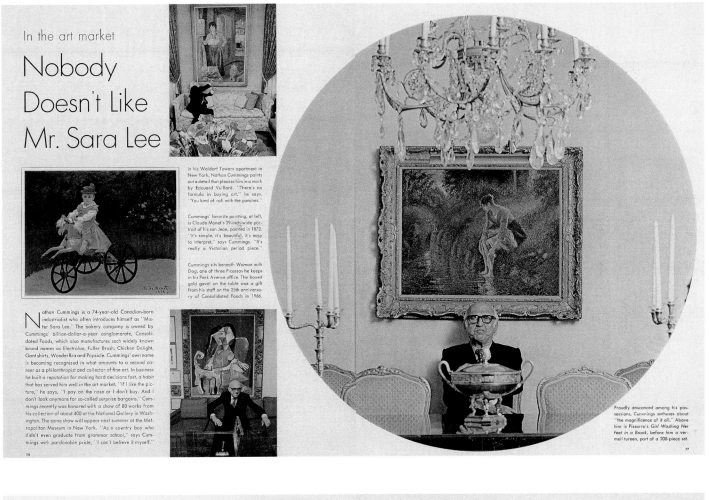

In the art market

Nobody Doesn't Like Mr. Sara Lee

In his Waldorf Towers apartment in New York, Nathan Cummings points out a detail that pleases him in a work by Edouard Vuillard. "There's no formula in buying art," he says. "You kind of roll with the punches."

Cummings' favorite painting, at left, is Claude Monet's 29-inch-wide portrait of his son Jean, painted in 1872. "It's simple, it's beautiful, it's easy to interpret," says Cummings. "It's really a Victorian period piece."

Cummings sits beneath Woman with Dog, one of three Picassos he keeps in his Park Avenue office. The boxed gold gavel on the table was a gift from his staff on the 25th anniversary of Consolidated Foods in 1966.

Nathan Cummings is a 74-year-old Canadian-born industrialist who often introduces himself as "Mister Sara Lee." The bakery company is owned by Cummings' billion-dollar-a-year conglomerate, Consolidated Foods, which also manufactures such widely known brand names as Electrolux, Fuller Brush, Chicken Delight, Gant shirts, WonderBra and Popsicle. Cummings' own name is becoming recognized in what amounts to a second career as a philanthropist and collector of fine art. In business he built a reputation for making hard decisions fast, a habit that has served him well in the art market. "If I like the picture," he says, "I pay on the nose or I don't buy. And I don't look anymore for so-called surprise bargains." Cummings recently was honored with a show of 80 works from his collection of about 400 at the National Gallery in Washington. The same show will appear next summer at the Metropolitan Museum in New York. "As a country boy who didn't even graduate from grammar school," says Cummings with pardonable pride, "I can't believe it myself."

Proudly ensconced among his possessions, Cummings enthuses about "the magnificence of it all." Above him is Pissarro's Girl Washing Her Feet in a Brook, before him a vermeil tureen, part of a 200-piece set.

76

77

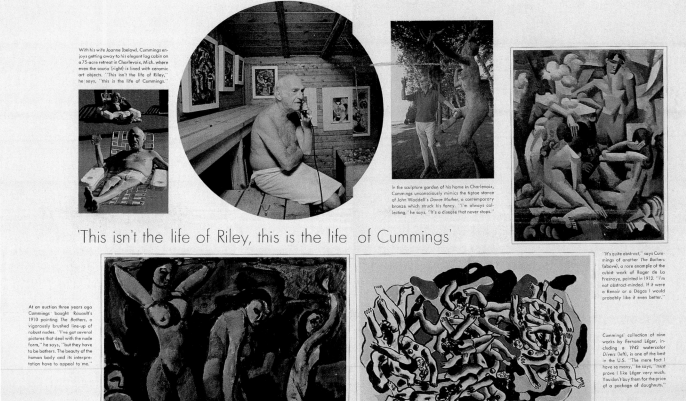

With his wife Joanne (below), Cummings enjoys getting away to his elegant log cabin on a 75-acre retreat in Charlevoix, Mich. where even the sauna (right) is lined with ceramic art objects. "This isn't the life of Riley," he says, "this is the life of Cummings."

In the sculpture garden of his home in Charlevoix, Cummings unconsciously mimics the tiptoe stance of John Waddell's Dance Mother, a contemporary bronze which struck his fancy. "I'm always collecting," he says. "It's a disease that never stops."

'This isn't the life of Riley, this is the life of Cummings'

"It's quite abstract," says Cummings of another The Bathers (above), a rare example of the cubist work of Roger de La Fresnaye, painted in 1912. "I'm not abstract-minded. If it were a Renoir or a Degas I would probably like it even better."

At an auction three years ago Cummings bought Rouault's 1910 painting The Bathers, a vigorously brushed line-up of robust nudes. "I've got several pictures that deal with the nude form," he says, "but they have to be bathers. The beauty of the human body and its interpretation have to appeal to me."

Cummings' collection of nine works by Fernand Léger, including a 1942 watercolor Divers (left), is one of the best in the U.S. "The mere fact I have so many," he says, "must prove I like Léger very much. You don't buy them for the price of a package of doughnuts."

78

79

Fig. 7 A 1970 issue of *Life* magazine featuring "Mr. Sara Lee." Photo Sara Lee Corporation.

Selections from the Nathan Cummings Collection

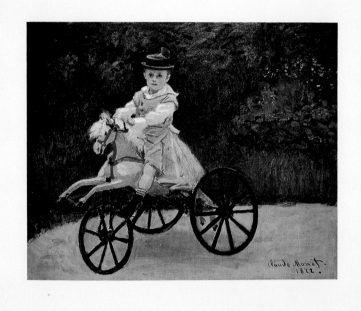

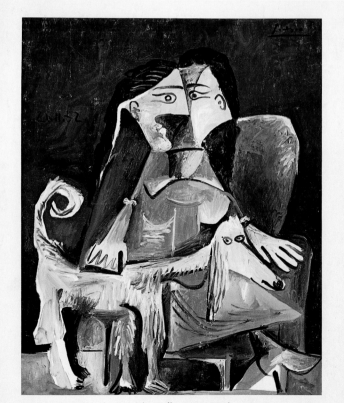

Major Works from the Collection of Nathan Cummings

works by Wassily Kandinsky, four Rouaults, three Picassos, six Légers, three Braques, three Soutines, and two Dubuffets. Of sculptors, Matisse, Manzù, and Alberto Giacometti were represented by more than one work.

Installation photographs of the Washington exhibition indicate clearly that Carter Brown and his staff were making every effort to seduce the collector by hanging his paintings in ways that replicated the installations of major works in the gallery's growing permanent collection (figs. 4a and b). In 1970 the National Gallery of Art was very strong in French painting from 1860 to 1910, but weak thereafter. Together with the collection of fellow Chicagoan Chester Dale, then already in the National Gallery, the Cummings Collection would have created a substantial public collection with major works well into the twentieth century. The work on the cover of the Washington/New York catalogue, Monet's *Jean Monet on His Mechanical Horse*, was chosen perhaps to emphasize the earlier, or Impressionist, side of Cummings's taste, thereby linking it to those of Chester Dale in Washington, and the Havemeyers in New York (fig. 8).

The last major exhibition of the Cummings Collection held during Nathan Cummings's lifetime was in 1973, at the Art Institute of Chicago, in the city in which his corporation has its headquarters and where his family continues to live. The new Director of the museum, John Maxon chose the works, ninety of which were selected to be the largest and most comprehensive exhibition of the collection during Cummings's lifetime. Another catalogue was produced, with a laudatory preface by Leigh Block, President of the Art Institute, a chronological survey of the collection by Maxon, and a fully illustrated checklist. The San Francisco Museum of Modern Art loaned the great Matisse *Portrait of Michael Stein* (fig. 10) given by Cummings to be part of San Francisco's Sara and Michael Stein Collection, and the Metropolitan loaned an important portrait by La Fresnaye, also given by Cummings (fig. 11). There were few substantive differences between the Washington/New York and the Chicago exhibitions, other than the presence in the latter of a major work by Francis Bacon, a Giorgio Morandi, and a large sampling of sculptures by Poncet. But the "image of the collection" was different by the sheer fact that the Art Institute chose to place Picasso's *Woman with a Dog*, just acquired by Cummings, on the cover of its catalogue (fig. 9). This suggested that an urban art museum with a strong collection of works by Picasso, Matisse, and other vanguard artists was more "ready" for Cummings's twentieth-century paintings than were the more traditional museums in New York and Washington.

Very few American collectors of the 1960s and 1970s were as assiduously courted by three such great museums. Cummings went on to loan his painting and sculpture collection to the

Louvre in Paris, where it was integrated with his important collection of pre-Columbian Peruvian art acquired in 1954, loaned for many years to the Art Institute of Chicago and given to the Metropolitan Museum of Art beginning in 1962. He also made important loans to Stanford University and gifts to the University of Wisconsin, to the City of Jerusalem, to the communities of Charlevoix, Michigan, and Deerfield, Illinois, to the University of Chicago and to other institutions wanting and needing works of art. This generosity was supplemented by major financial gifts to selected institutions, and many of these included gifts of works of sculpture specifically commissioned for the site.

Cummings also "used" his collection in personal ways – lending a Renoir to the British Prime Minister Edward Heath to hang in 10 Downing Street, or decorating the hotel suite of the Duke and Duchess of Windsor with his art for their annual visit to New York during the 1960s and 1970s. He gave art to executives when they retired, to friends at weddings and bar mitzvahs, to grandchildren, nephews, and nieces at birthdays, and to others whenever the spirit so moved him.

In general, Cummings collected in ways little different from those of other wealthy members of his generation. In Chicago, the collections of Leigh and Mary Block, although more privately maintained than the Cummings Collection, were directly comparable in both size and esthetic character. In terms of sheer esthetic courage, Cummings did not range as far as his son-in-law Robert Mayer, or other Chicago collectors, such as Joe Shapiro, Muriel Newman, Claire Zeisler, or Morton Newman, who were able to buy "cutting edge" contemporary art as well as modernist classics. Cummings preferred artists whose works were already being collected by important museums and was never comfortable with abstraction. The only exception to this rule was a group of paintings by Kandinsky, purchased by Cummings from a Guggenheim Museum sale, largely under the impetus of his wife Joanne.

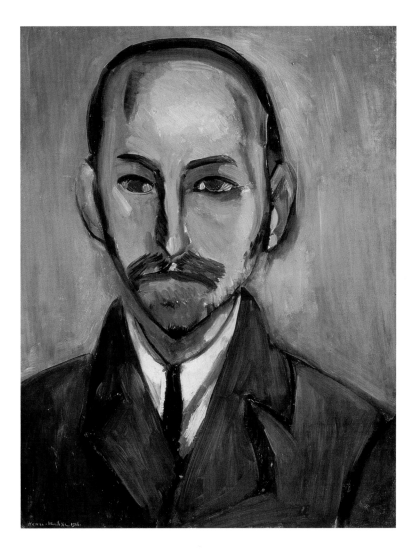

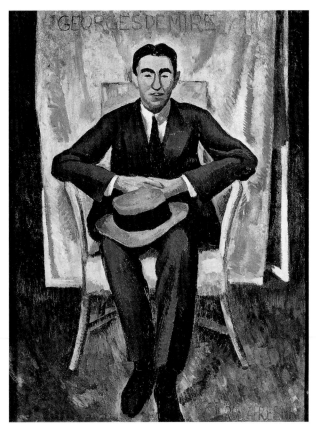

Fig. 8 (*facing page top*) Cover of the catalogue for the 1970 exhibition at the National Gallery of Art, Washington. Photo Sara Lee Corporation.

Fig. 9 (*facing page bottom*) Cover of the catalogue for the 1973 exhibition at the Art Institute of Chicago. Photo Sara Lee Corporation.

Fig. 10 Henri Matisse, *Portrait of Michael Stein*, 1916. San Francisco Museum of Modern Art; Sarah and Michael Stein Memorial Collection, Gift of Nathan Cummings. © Succession H. Matisse/DACS 1999.

Fig. 11 (*right*) Roger de la Fresnaye, *Georges Miré*, 1910. The Metropolitan Museum of Art, Gift of Mr. and Mrs. Nathan Cummings, 1962.

The Sara Lee Collection

Late in the 1970s John H. Bryan, Chairman and Chief Executive Officer of Sara Lee Corporation, learned that Nathan Cummings was beginning to sell some of the most important works in his collection. This news, together with the approaching relocation of Sara Lee's headquarters offices in downtown Chicago, prompted Bryan to formulate a plan. He had been thinking about the idea that the art to be displayed in the new Sara Lee corporate offices should come from the private collection of its founder and be a tribute to him. He decided to talk with Cummings about selling key works to the corporation for that purpose. Cummings liked the idea, and in 1980 Bryan selected twenty-three works from the Cummings Collection and arranged for them to be installed in the executive offices and conference rooms on the forty-seventh floor of the new headquarters building. Bryan then approached me to select an additional thirteen major works from the Cummings Collection with the agreement that Sara Lee would not take possession of them during the founder's lifetime. When Cummings died in 1985, these works entered the Sara Lee Collection.

During the next twelve years, an additional fourteen works that at one time had been part of the Cummings Collection were acquired for the Corporation: some at auction; others from private owners and dealers, and a few from members of the Cummings family. Several of Cummings's most important works — three paintings by Picasso — *Woman, Sculpture and Vase of Flowers* (fig. 12); *Woman with a Dog*; and *Woman with a Flower*; the great Mary Cassatt *Young Lady in a Park* (fig. 14); the Matisse *Portrait of Michael Stein*; the Gauguin *Boys Wrestling* (fig. 13); the Monet *Jean Monet on His Mechanical Horse* (cat. 31); Sisley's *A Path at Les Sablons* (cat. 46); Marie Laurencin's *Young Woman with a Guitar* (cat. 19), and other works — had been donated or sold by Cummings during his lifetime and needed to be tracked down. In several cases, the corporation succeeded in finding and acquiring these works. *A Path at Les Sablons*, for instance, was purchased from Cummings's sister Minnie Abbey and her husband Monroe. After several unsuccessful attempts, the corporation was able to purchase *Jean Monet on His Mechanical Horse* from a major private collector, and a Léger and a Henry Moore from London dealers. Still other works had been left by the Cummings estate to his widow, Joanne, from whom the corporation was later able to purchase works by Matisse, Giacometti, and Marino Marini, both before and after her death in 1995.

Some highly desired works that at one time had been owned by Cummings proved to be beyond reach. For instance, the corporation would very much have liked to have acquired the great Picasso of 1929, *Woman, Sculpture, and Vase of Flowers* or one of

Fig. 13 (*facing page*) Paul Gauguin, *Boys Wrestling*, 1888. Josefowitz Collection.

Fig. 12 Pablo Picasso, *Woman, Sculpture, and Vase of Flowers*, 1929. Private Collection. © Succession Picasso/DACS 1999.

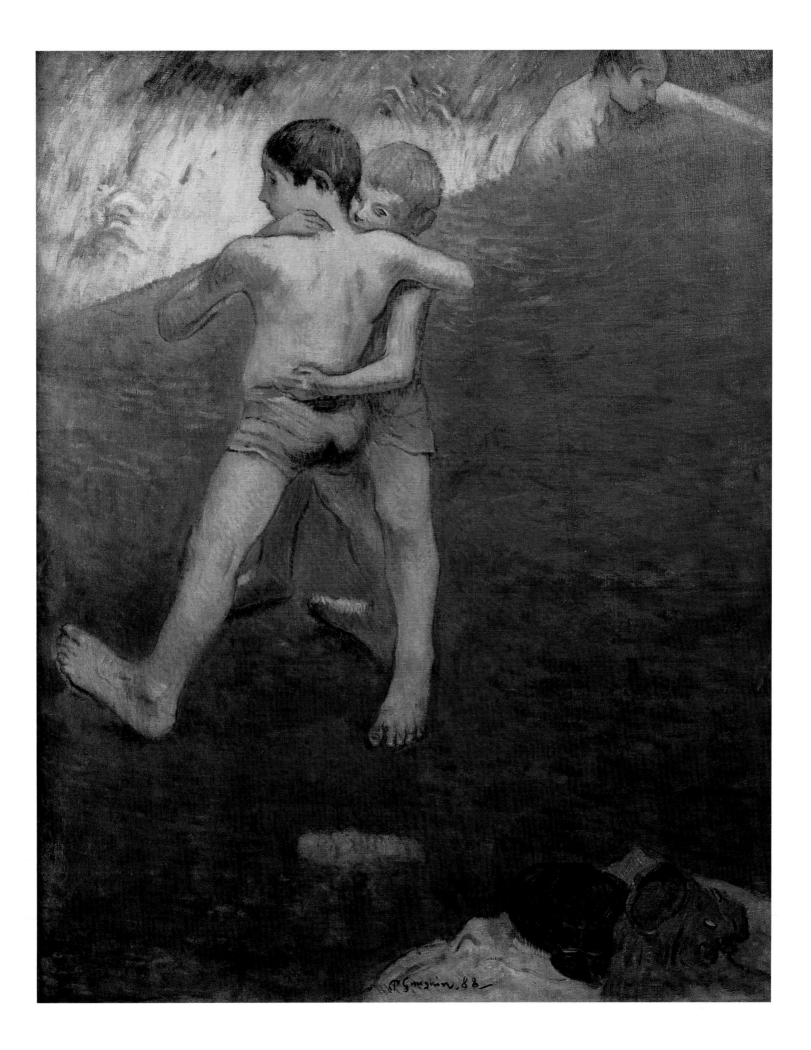

the great Cummings Gauguins, *Still-Life with Sunflowers and Puvis de Chavannes's "Hope"* (fig. 15), or *Boys Wrestling*. However, these proved to be unavailable, and even if they had been, the price would have been too high for a public corporation.

The basic principle of the Sara Lee Collection was that the works chosen from the Cummings Collection should be of high quality, should collectively represent the range, strengths, and variety of his taste, and should include groups of works by the same artists favored by Cummings himself. This principle was followed with a fair degree of success, and the corporate collection has "mini groupings" of works by Degas, Pissarro, Matisse, Dufy, Edouard Vuillard, Braque, Chaim Soutine, Léger, Rouault, Giacometti, Manzù, and Moore. Three artists favored by Cummings who are not now represented in the Sara Lee Collection are Modigliani, Kandinsky, and Dubuffet. Modigliani was omitted because the Modigliani marketprice was very high in the early 1980s, when the corporation began purchasing works from Cummings, and the decision was made not to spend limited corporate resources on an artist of which Cummings had only one masterpiece. Although one work by Kandinsky was included in the corporate collection at an early stage, it was felt not to be of the same level of quality as other works, nor did it "fit" into the predominantly figural esthetic of the collection. This work was given to the Sara Lee Foundation for further gifting or sale. Dubuffet was also felt to be somewhat outside the core of the collection, and only one work in the Cummings Collection was of the quality of the others and that had already been sold by Cummings.

Fig. 14 (*below left*) Mary Cassatt, *Young Lady in a Park*, c.1880. San Francisco Museums of Art.

Fig. 15 Paul Gauguin, *Still-Life with Sunflowers and Puvis de Chavannes's "Hope,"* 1901. The Metropolitan Museum of Art, New York, Partial Gift of Joanne Toor Cummings, 1948.

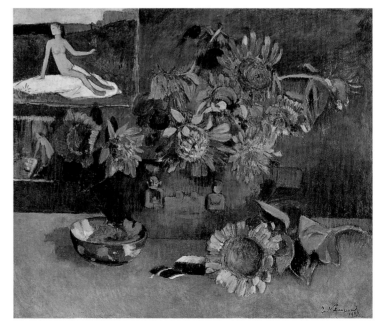

During the time that the Sara Lee Collection was being formed as a tribute to the corporation's founder, it became clear that sharing it with its "natural constituency," the employees and shareowners of the corporation, as well as with important customers and members of the community, was of vital interest to the corporation. This principle embodied one of Cummings's own philosophies concerning the role of art in the workplace. The founder felt passionately that art as part of a total work environment encouraged quality job performance. This legacy is reflected in the way in which the corporation included works in its collection as an integral element in the interior design of Sara Lee's new executive offices and work spaces. In some instances, the art displayed in a particular room gave that room its "unofficial" name. Employees attending a meeting in the Braque Room, for example, frequently commented on the inspiration that came from working at the conference table under the watchful gaze of Braque's *Woman at an Easel* (fig. 16).

As part of its philosophy for sharing its collection with others, Sara Lee adopted a policy of providing guided tours of the collection at its Chicago headquarters for interested individuals and small groups from the surrounding area and from throughout the United States and abroad. To this end, the corporation organized after-hours tours, and many art groups, museum visitors, scholars, clubs, and others were able to see the collection as it was displayed in a work environment.

As part of the same philosophy, exhibitions of the collection were arranged with certain museums in parts of the United States where large concentrations of Sara Lee employees, shareholders, and customers lived and where no major public collections of similar works existed. The three American museums chosen were all in the south: the Dixon Gallery and Gardens in Memphis, Tennessee, and Reynolda House in Winston-Salem, North Carolina (both areas where major Sara Lee divisions have headquarters), and the Polk Museum in Lakeland, Florida, headquarters for a major retail customer.

Sara Lee's international operations are coordinated from its Sara Lee/DE division located in Utrecht, The Netherlands. Here too, not only does Sara Lee/DE have its own corporate collection of nineteenth- and twentieth-century Dutch paintings, but it also has commissioned works for its executive office spaces. It was therefore appropriate that the corporation's first international exhibition of its collection be held in The Netherlands and the corporation chose the Singer Museum in Laren, a short distance from Amsterdam, to mount the exhibition. This first international museum experience was enormously successful, with attendance of more than 105,000 in a small town with a population of about 12,000.

Fig. 16 The Braque Conference Room, Sara Lee Corporation, Chicago, with Braque's *Woman at an Easel* and Renoir's *Laundress*. Photo Sara Lee Corporation.

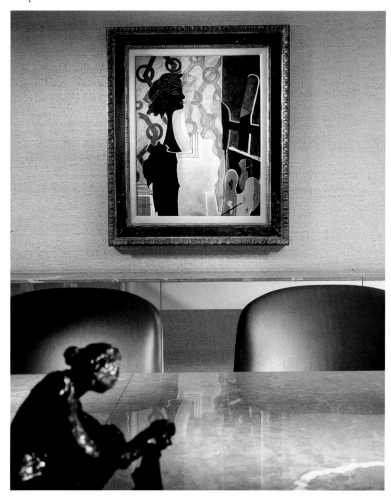

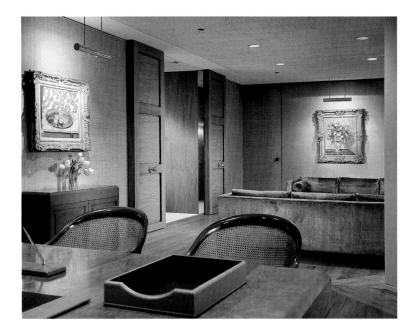

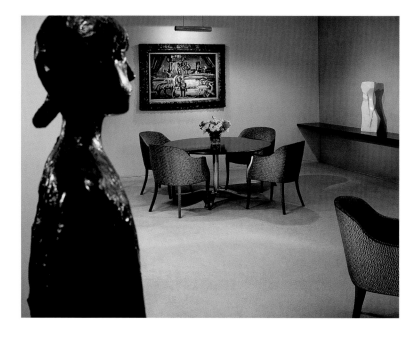

Fig. 17 (*above left*) The Chairman's Office, Sara Lee Corporation, Chicago, with Pissarro's *Vase of Flowers* and Matisse's *Lemons on a Pewter Plate*. Photo Sara Lee Corporation.

Fig. 18 The Executive Office, Sara Lee Corporation, Chicago, with Manzù's *Skating Girl* and Rouault's *Circus*. Photo Sara Lee Corporation.

Another important aspect of the corporation's policy toward its collection was aimed at those with serious appreciation for art, particularly the scholarly community. Publication of a catalogue of the collection, complete with background information on Cummings and with high-quality color illustrations, and details as to provenance, exhibition and loan history, and bibliography, had been a priority for Sara Lee since the inception of the collection. Entitled *An Impressionist Legacy: The Collection of Sara Lee Corporation*, the first edition of the catalogue was published in 1986. Four other editions followed the first, and a careful reader of the five printings will be able to chart both the growth and the judicious pruning that took place over eighteen years to form the final collection, as it is presented in this, its final publication.

Like its founder, Sara Lee Corporation has been generous over the years in making gifts of works from its collection to museums and other institutions in areas where its core businesses are located. Among them are Edouard Vuillard's portrait of Madame Guérin given to the Art Institute of Chicago (fig. 20), and Edgar Degas's *Ballet Dancer on the Stage*, given to the Dixon Gallery and Gardens in Memphis, Tennessee. The Corporation has also donated works from outside its collection, such as paintings by Jim Dine given to the National Gallery of Australia, an Eduardo Chillida sculpture to the Museum of Contemporary Art in Barcelona, and a work to be commissioned for the Museum of Contemporary Art in Chicago.

Fig. 19 The reception, Sara Lee Corporation, Chicago, with Vuillard's *Foliage–Oak Tree and Fruit Seller*. Photo Sara Lee Corporation.

The Millennium Gift

The unanimous decision by Sara Lee Corporation's board of directors to give the Sara Lee Collection to selected museums in key Sara Lee locations around the world is in keeping with the corporation's traditions of philanthropy and support of the arts. Nathan Cummings was strongly committed to sharing his wealth with others and his philanthropic contributions were outstanding and extend even to this day through the Nathan Cummings Foundation, which was established after his death.

Under the leadership of John H. Bryan, the Cummings legacy for philanthropy and support of the arts has flourished. For more than twenty years, the corporation has supported cultural programs and projects, including the performing and visual arts, and activities and causes benefiting people who are disadvantaged.

The idea for the Millennium Gift of Sara Lee Corporation emerged as the result of an ongoing evaluation of the Sara Lee Collection and its effectiveness within the corporation. Bryan asked me, as consulting curator of the collection, and members of Sara Lee's senior management to develop several strategies for the collection's role in the new millennium. With a team that included corporate financial analysts, tax advisors, lawyers, and corporate affairs specialists, we began to explore the possibility of "gifting" all or part of the collection to public art museums. Various gifting and sale possibilities were presented to the Sara Lee Board of Directors, and the Board voted unanimously to effect a logical, orderly and gradual process of giving either all or most of the finest works in the collection to appropriate American museums. Later it was agreed that certain institutions in other countries where Sara Lee has a major presence should be included.

The initial gift program was closely coordinated with the White House's Millennium Gift to America. In recognition of the fact that the National Gallery of Art in Washington, the Metropolitan Museum in New York, and the Art Institute of Chicago each had mounted exhibitions of, and devoted publications to, the Nathan Cummings Collection in the past, these institutions were given their first choice from the entire Sara Lee Collection. Other institutions that would be invited to participate in the program would be given an opportunity to choose one work for their permanent collections from among a selected group of objects.

Recognizing that strong sentiment existed among the Board of Directors and senior Sara Lee management to keep the core of the collection intact, we elected to give the Art Institute the choice of an additional eleven works, for a total number of twelve, for its permanent collection. After several weeks of deliberation, the museum's director and curators made their twelve choices and, as

Fig. 20 Edouard Vuillard, *Madame Guérin*, 1916–17. The Art Institute of Chicago. Gift of Sara Lee Corporation, in memory of its founder, Nathan Cummings. © ADAGP, Paris and DACS, London 1999.

a result, the Art Institute of Chicago will receive the most important single gift of art it has ever received from a corporation, and one of the most important of any kind in its long and distinguished history.

A list was then made of an additional seventeen American museums in areas of strategic importance to Sara Lee. Directors of these museums were informed of the Millennium Gift program and about the manner in which they could select a work from the collection as a gift to their institution to be made either in 1999 or 2000. In each case, a selection of between three and six works from the Sara Lee Collection was made that reflected each museum's specific needs, and offered each museum staff the choice of one work.

At a press conference in Chicago attended by First Lady Hillary Rodham Clinton, Bryan announced our intention to make the specific gifts to the Art Institute of Chicago, the National Gallery of Art, and the Metropolitan Museum, as well as the names of the additional seventeen museums across the country (fig. 21). The national publicity from this press conference produced a flood of requests to Sara Lee from museums wanting to be included in the program. A detailed evaluation followed, and it was decided to add five museums in the United States and to expand the program to selected museums outside the United States.

The latter project involved a thorough analysis of the corporation's global presence and the suitability of the remaining works in the collection for important international institutions. The largest areas of Sara Lee's business in Europe – The Netherlands, Great Britain, France, Scandinavia, Italy, Spain, and Belgium – and the Americas – Canada and Puerto Rico – were considered, and negotiations with museum directors in those areas were initiated in a carefully considered sequence. In certain cases, consideration was given to foreign museums with well-developed American foundations, and the Hermitage in St. Petersburg, the Israel Museum, the Vatican Museums, and the National Gallery of Australia were included in the process in recognition of specific ties to Sara Lee Corporation. Again, every effort was made to give the directors and curatorial staffs of the international museums a choice from among several works of art selected specifically with their collections in mind. As a result, the Sara Lee Millennium Gift program was extended to fifteen museums in twelve countries outside the United States.

During the process of negotiation and announcement, the corporation was approached by many institutions to be included in a final exhibition tour of the collection. We readily accepted a proposal from the Art Institute of Chicago to host a final exhibition in the spring of 2000, and then concluded that the collection should be shown in at least two other American venues and two

Fig. 21 Hillary Rodham Clinton, First Lady of the United States, and John H. Bryan, Chairman and Chief Executive Officer of Sara Lee Corporation, at the press conference to announce the Millennium Gift.

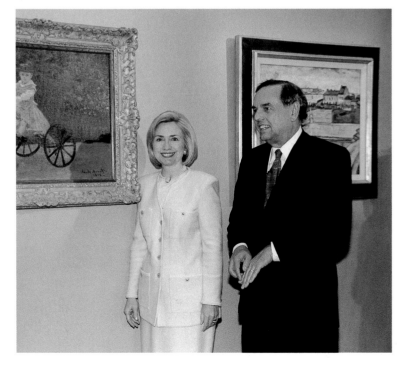

international venues. The museums chosen in the United States were the North Carolina Museum of Art in Raleigh, and the Portland Art Museum in Oregon. The North Carolina Museum's proposal was particularly welcome because the corporation is one of the largest employers in that state and, while the permanent collection of European painting and sculpture at the museum is the greatest such collection in the south, it is comparatively weak in the area of the Sara Lee Collection's strength – Parisian painting and sculpture, 1870–1960. We also very much liked the Portland Art Museum's proposal that it be the only west coast venue and that the exhibition of the Sara Lee Collection inaugurate the museum's newly constructed Schnitzer Exhibition Galleries.

Because the collection had already been exhibited in Europe – at the Singer Museum in The Netherlands – it was decided to accept the offers of institutions in Asia and Australia as the two international venues for the final exhibition. Sara Lee's presence in Asia is growing rapidly and its operations in that vast area of the world have their headquarters in Singapore. For that reason, we were pleased to be able to work with the staff of the Singapore Art Museum to open the final exhibition tour in the spring of 1999. And since Sara Lee Corporation has had a long and very successful business relationship with Australia, and Bryan has been involved with the American Friends of the Australian National Gallery for many years, it was decided that Canberra would be the site of the second international exhibition, where it will be the first American corporate collection ever exhibited. The exhibition will be held from June to August 1999.

The components of the Millennium Gift of Sara Lee Corporation are now complete. Fifty-two works of art – all formerly from the Nathan Cummings Collection – will be given to a "collection" of forty museums throughout the world. Twenty-five of these museums are in the United States of America and the other fifteen are in Europe, Asia, Australia, Latin America and Canada. Each work of art will be permanently displayed as a "Millennium Gift of Sara Lee Corporation." To document this historic gift of art – the largest corporate gift to the arts in American history – it was decided to prepare a permanent scholarly catalogue of the collection.

With the departure of the Sara Lee Collection, what will adorn the corporation's executive offices in downtown Chicago? For many years before John Bryan's 1980 decision to build a corporate collection, Nathan Cummings had given or sold to the corporation literally hundreds of works of art. Although none of these was made by artists of the stature of Picasso or Monet, there are many works by their compatriots and followers in Europe and America. Many of these works are currently in offices and conference rooms in various parts of the Sara Lee organization, and a representative sample of the best of them will be installed in the headquarters offices and work spaces. Thus, the spirit of the corporation's founder will live on in two senses – first, the greatest of his works will be seen in perpetuity in public art museums throughout the world, and second, many other works he purchased and loved will adorn the walls of the corporation he founded.

Catalogue

*Works appear in alphabetical order by artist; multiple works by
the same artist are grouped in chronological order.*

Detail of cat. 5.

Jean (Hans) Arp (1886–1966)
Knight Torso (*Torse-chevalier*), 1959

Bronze, 88.6 × 28.8 × 20.6 cm. (34⅝ × 11⅛ × 7⅞ in.)
Edition of five: 4/5
Arp 191

Provenance: Jeffrey H. Loria and Company Inc., New York; Nathan Cummings, Chicago; Herbert K. Cummings, Scottsdale, Arizona; The Sara Lee Collection; Arken Museum for Moderne Kunst, Copenhagen

Exhibitions: Chicago 1973: no. 72; Laren 1997–8.

Bibliography: François Arp (catalogue), with Eduard Trier (introduction), and Marguerite Arp-Hagenbach (bibliography), *Jean Arp Sculpture: His Last Ten Years*, New York: Harry N. Abrams, 1968, pl. 23, no. 191 [Also published as *Hans Arp: Sculpturen, 1957–1966*, Teufen: Verlag Arthur Niggli, 1968, and *Jean Arp: Sculpture 1957–1966*, London: Thames and Hudson, 1968].
Stefanie Poley, *Hans Arp, Die Formensprache im plastischen Werk*, Stuttgart: Verlag Gerd Hatje, 1978, p. 182.
Brettell 1993, 1997, pp. 130–31, 144, and back cover.

Arp started his career as an anti-sculptor – indeed as an anti-artist. He ended it as one of the great sculptors of the twentieth century. The change from a career of what might be called anti-objects to one of editioned bronzes and stone sculptures carved in part by assistants tells us a good deal about the triumph of modernism and about Arp's own developing sense of "art" in the modern world. As a defiant and witty "Dadaist" of the teens and twenties, Arp brought the "laws" of chance and a devotion to anti-art materials into his work. But, by 1930, when he created his first permanent "torso," he came to believe in the traditional mediums of sculpture. From that date until the end of his life, he worked in plaster, bronze, stone, and cast stone to create permanent images of mutability, objects that seem to shift and change as you look at them. Permanence for Arp became a challenge as he filled sculpture with a shifting modernity.

The *Knight Torso* dates from 1959 and this vertical "torso" is more like a bud or a biomorphic image of growth than it is like any traditional image of a knight. Where is the horse? the lance? the armor? the shield? It is precisely because it is not like a knight that Arp conceived it and gave it that title – it was, for him, the poetic and visual contrast between the verbal and visual messages that allowed room for interpretations not determined exclusively by the artist. Hence,

this torso-knight-bud-plant-poem is at once permanent (it is bronze) and transient (its identity slips forever away). In fact, the origin of this deliberately – and delightfully – mysterious form lies in a plaster by Arp created six years earlier in 1952. Although this object sits on four legs, omitted by Arp in the "final" version, it has all the qualities of form – the protrusions and concavities – that characterize the Sara Lee bronze. It is called a "Human Concretion,"[1] and is known only from an old photograph. This plaster "original" seems to have been cannibalized by Arp to make two later sculptures – the *Dancing Flower* of 1957 (private collection, New York; Arp 153) and then the *Knight Torso* of 1959.

The *Knight Torso* was made at a crucial time in the production of Arp's mature sculpture. In 1954 he won the International Sculpture Prize at the Venice Biennale, and in 1958 his great retrospective curated by James Thrall Soby was held at the Museum of Modern Art in New York. As the direct result of this exposure, orders poured into Arp's studio, and the artist hired three assistants and began to let others to work with him on the creation of increasing numbers of works of art. This collaborative method allowed Arp, like his friend Miró, to produce more and more sculpture and to do so without tiring himself.

In 1959 the 73-year-old Arp had reached an artistic plateau. He was heaped with honors and had overcome the depression that haunted him following the death of his first wife, Sophie Tauber Arp, in 1943. In May 1959 Arp married his second wife, Marguerite Hagenbach, who had been his companion for many years. In addition to his active life as a sculptor, Arp continued to write poetry, which had been a lifetime career for him, equal in every way to his career as an artist. His friend, the critic and art historian Herbert Read, expressed the opinion "that the poetry of Arp is inseparable from his plastic work and that a full understanding of his genius . . . must take into account both arts."[2] We are told that Arp often thought of the titles of his sculpture as abbreviated poems.[3] "Knight Torso," then, is perhaps a poem as much as an enigmatic title. Interestingly, in Arp's poetry of the late 1950s the knightly image appears in unlikely contexts, as it seems to do as part of the title of this sculpture.[4]

Fig. 1 Hans Arp, *Helmet-Head I*, 1959. Private Collection. © DACS 1999.

Fig. 2 Hans Arp, *Helmet-Head II*, 1959. Private Collection. © DACS 1999.

Having acknowledged that *Knight Torso* is a poetically subjective and ambiguous work it can, nonetheless, be connected, in a way, to certain sculptural works – also of 1959 – in which Arp's imagery is decidedly more objective and decidedly "knightly." These are the works that he called *Helmet-Head I* and *Helmet-Head II* (figs. 1 and 2).[5] The "helmets" that Arp describes both visually and verbally are in no way vague. They are certainly helmets and cannot be confused with football helmets or pith helmets or any except those worn by medieval knights. Looking at the protean forms of *Knight Torso*, it is perhaps possible to see the outline of a "Helmet-Head" suggested in the uppermost protuberance, and it comes as no surprise to learn that for sixteen years of his life (1914–30) Arp read medieval chronicles.[6] Why did this imagery come to the fore in this last decade of Arp's life? After the death of Sophie Tauber, Arp had studied intensely Christianity and the lives of the saints (possibly the knightly saints – George and Michael),[7] so it may be that as he faced his own mortality, he again began to think of saints, especially knightly ones.

It is foolish to search for precise meanings in the *Knight Torso*, but the essence of this vaguely anthropomorphic work can be felt in a piece of Dadaist prose that Arp wrote more than twenty-five years before creating it: "But man is also an animate bud/But man is also a poet/But man is also a saint."[8] Perhaps the wise thing is to heed the artist's own gentle warning: "The content of sculpture has to come forward on tiptoe, unpretentious and as light as the spoor of an animal in snow."[9]

1. Margherita Andreotti explains that Arp gave the collective title Human Concretions to many sculptures between 1933 and 1936, using it occasionally in later decades, and that the term implies a merging of the human figure with nature. See Margherita Andreotti, *The Early Sculpture of Jean Arp*, Ann Arbor and London: U.M.I. Research Press, 1989, p. 213.
2. Herbert Read, *The Art of Jean Arp*, New York: Harry N. Abrams, Inc., 1968, p. 139.
3. See Andreotti (1989), p. 3.
4. See Marcel Jean, ed., *Arp on Art: Poems, Essays, Memories*, trans. Joachim Neugroschel, New York: The Viking Press, 1972, pp. 365, 372, 406, 434, 444.
5. See Trier, Arp-Hagenbach, and Arp (1968), pls. 34 and 35, fig. 202a. (nos. 202, 202a, 203, and 203a).
6. See Read (1968), 144.
7. Quoted by Stefanie Poley, "The Human Figure in the Later Work," in Jane Hancock, Stefanie Poley, et al., *Arp, 1886–1966*, Cambridge: Cambridge University Press, 1987, p. 228.
8. Ibid.
9. Jean (1972), p. 341.

Pierre Bonnard (1867–1947)
Apple Gathering (*La Cueillette des pommes*)
[formerly *The Apple Pickers*], 1899

Oil on canvas, 169 × 104 cm. (66½ × 40¾ in.)
Dauberville, vol. I, 209

Provenance: Thadée and Misia Natanson (?);
Galerie Pierre Colle, Paris; Private Collection,
Paris (sold at Christie's, London, 14 April
1970, lot 23); R. B. Davies; M. Knoedler and
Co. Inc., New York; Nathan Cummings,
Chicago; The Sara Lee Collection; The
Virginia Museum of Fine Art, Richmond,
Virginia

Exhibitions: Paris, Galerie Charpentier,
Jardins de France, 1943, no. 311 (as *Jardin de
Provence*); London, Royal Academy, *Pierre
Bonnard*, 6 January–6 March 1966: no. 22;
Munich, Haus der Kunst, *Pierre Bonnard:
centenaire de sa naissance*, 8 October 1966–
1 January 1967; and Paris, l'Orangerie,
13 January–15 April 1967: no. 20; New York
1971: not in catalogue; Roslyn Harbor, New
York, Nassau County Museum of Art, *Poets
and Painters*, 7 June–7 September 1997; Laren
1997–8.

Bibliography: Jean and Henry Dauberville,
Bonnard: catalogue raisonné de l'oeuvre peint,
vol. I, Paris: Editions J. and H. Bernheim-
Jeune, 1965, p. 221, no. 209 (dated *c*.1899),
repr.
Christie's, *Impressionist and Modern
Drawings, Paintings and Sculpture*, 14 April
1970, lot 23, p. 23, repr. (dated 1895–6 on the
authority of Charles Terrasse).
Helen Emery Giambruni, "Early Bonnard,
1885–1900," Ph.D. dissertation, Berkeley:
University of California, 1983, pp. 209–11,
283–4, 364, repr. (dated 1898–9).
Consolidated Foods Corporation, *Consolidated
Foods Corporation's Nathan Cummings
Collection*, Chicago: Consolidated Foods
Corporation, 1983, p. 22, fig. 17.
Brettell 1986, 1987, 1990, 1993, 1997, pp.
68–9, 144, repr. (dated 1899).

Pierre Bonnard and Edouard Vuillard, both
core members of a group of vanguard artists
called the Nabis, were responsible for the
revival of decorative painting in France.[1]
Long decried as a genre of minor importance,
the "decoration" of rooms in private homes
and apartments became one of the chief
expressive arenas of Nabi artists, who tended
to work either on a very small ("intimist") or
a very large (decorative) scale. Although the
decorative paintings of Vuillard have been
well studied, there is comparatively little in
the Bonnard literature that deals seriously
with his decorative painting. *Apple Gathering*
was conceived as a "decoration," most
probably as one of a number of other
paintings for an ensemble that seems never to
have been completed or even exhibited. It has
been published rarely, but the existing
literature indicates that it came from the
collection of Thadée and Misia Natanson, the
high priest and priestess of the Nabis
movement. Thadée, a Polish writer and
collector, was part of the international Jewish
expatriate community in Paris and was the
founder and, with his family, chief backer of
La Revue blanche, the most influential literary
and artistic journal of *fin-de-siècle* Paris. The
Natansons were closely associated with the
Nabi painters and with decorative painting in
particular. They had commissioned a loosely
connected series of "panels" for their famous
Paris apartment from Bonnard's friend,
Edouard Vuillard in 1894–5 and acted as
informal agents for both Vuillard and
Bonnard in the commissioning of other
private decorative schemes.[2] For that reason,
their acquisition of this panel by Bonnard
gives it an importance in the history of French
decorative painting.

Apple Gathering is essentially a painted
"drawing" on a monochrome gray-green
background. It represents a woman, three
children, and a dog in a garden setting
dominated by a large, resplendently fruited
apple tree. Most of the "drawing" is executed
in wavy lines of varying thickness made with
black oil paint thinned so as to reveal the
weave of the fine linen support. This black on
green "drawing" is enlivened with selectively
colored painted areas in red, yellow, blue,
white, pink, and gray that give form to the
basket, the apples, the dog, the path, and the
clothing of the woman and children. The
variable and seemingly tentative nature of
Bonnard's drawn style gives the painting an
informality that, due also to the absence of a
signature, leads many viewers to assume that
it is unfinished. Yet, if the Natanson
provenance is accurate, this is certainly not

the case, because, despite the absence of
documentary proof of this part of the
provenance, there are five drawings by
Toulouse-Lautrec on the back of the canvas,
which suggests that the painting was either in
the Natansons' Paris apartment or in one of
their country houses at Valvin or Villeneuve-
sur-Yonne, where Toulouse-Lautrec and
Bonnard most often met.[3]

There are several other works by Bonnard
that share undeniable stylistic, compositional,
and iconographic affinities with *Apple
Gathering*. The largest and most important of
these is *The Large Garden* (fig. 1), which
recently entered the collection of the Musée
d'Orsay.[4] The Orsay and Sara Lee paintings
have almost identical vertical dimensions and
are painted in precisely the same manner on
monochrome green backgrounds. Two other
paintings in a Japanese private collection, *The
Apple Harvest* (fig. 2) and *Child playing with a
Goat* (fig. 3), are the same height as the Orsay
and Sara Lee pictures and share stylistic
affinities.[5] Another panel, *The Plum Harvest*,
formerly in the collection of Katia Granoff in
Paris, although slightly smaller than the
others (160 × 70 cm.), is very closely related in
style and imagery to the Sara Lee and Orsay
paintings.[6] This group of five paintings seems
clearly to have been conceived in series,
possibly for a single room. They are also
closely related to a trio of panels, *Screen with
Rabbits* (Museum of Modern Art, New York),
which, together with a fourth panel, *Child
with a Pail* (Musée d'Orsay, Paris), formed
part of a folding screen visible in a 1905
photograph of Bonnard in his Paris studio on
the rue de Douai.[7] The subject of all these
paintings is a domestic garden dominated by
fruit trees and populated by women, children,
and domestic animals, a subject that Bonnard
had already essayed in a very large decorative
painting on paper, *The Terrasse Family in the
Garden* (Staatliche Museen Preussischer
Kulturbesitz, Berlin), and was to investigate
almost obsessively in a series of decorative and
easel paintings made in the first decade of the
twentieth century.

This garden has been frequently and
conclusively identified as that surrounding the
Bonnard family country house, Le Clos, in the
village of Grand-Lemps in the Dauphine
region of eastern France.[8] Bonnard's family
had owned the house since the mid-
nineteenth century, and it was associated with
the matriarch of the family, the painter's
maternal grandmother, Mme Frédéric
Metzdorff (1812–1900). This house was, in
many senses, the emotional center of the
painter's life, even after the death of his

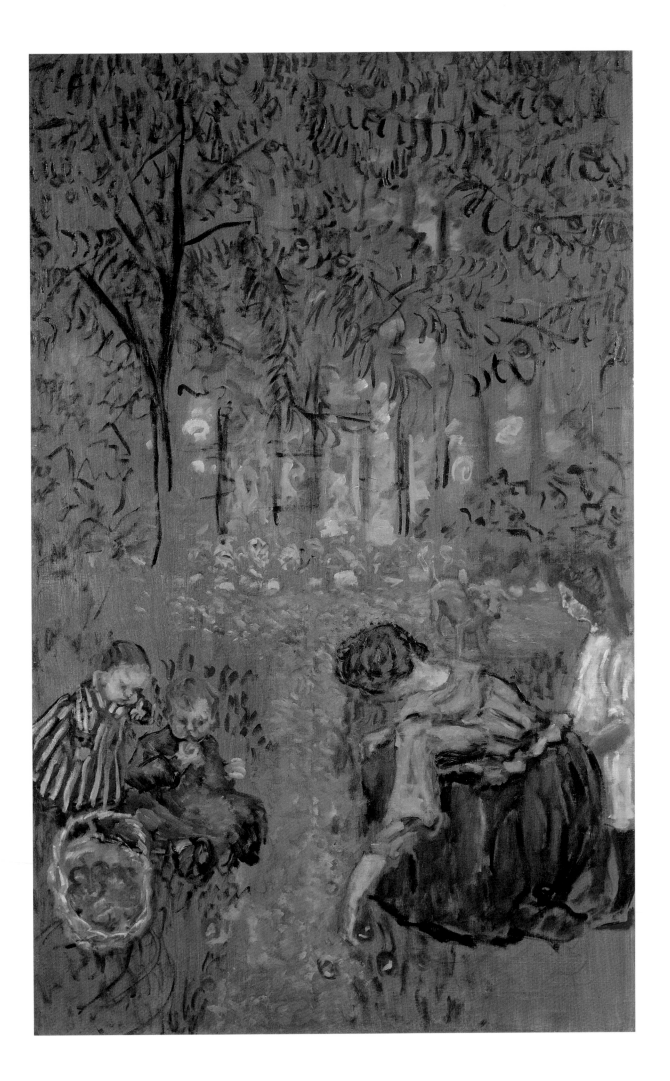

grandmother. Having played there every summer as a child, he painted its rooms, façades, and garden countless times in the 1890s, paying his last visit there in 1925, after which the property was sold. Yet, even in his old age, Le Clos held sway over the painter's imagination, and his last book, *Correspondances*, a series of letters and informal drawings published in Paris in 1944 just three years before his death, begins with an undated letter written to the painter by his grandmother:

> I'm here installed at Le Clos before everyone else. I'm well in the country. At the moment I'm shelling peas in the dining room, the dog at my feet and two cats on the table. I hear breathing; it's the cow who puts her big head in the window. The little maid shouts outside, "Joseph, the calf is loose!" Tell your mother everything is going well and I'm watching the kitchen garden.[9]

It is the garden that is the subject of all the decorative paintings related to *Apple Gathering*. In all of them, fruit trees, animals, and family members engage in a pastoral dance that Bonnard evokes in another letter, this time the one (to his brother, Charles) chosen by the painter as part of the ending of *Correspondances*:

> Finally I arrived (at Le Clos) and hope you can get leave so we can all be together . . . There are masses of fruit. Maman does her rounds every afternoon with her basket. It's pleasant to see our cousin up in the big peach tree, in the midst of the branches and the blue sky.[10]

Clearly, Bonnard's idea of a terrestrial paradise was centered on Le Clos. As an old man, his memories took him back there, and several of his last drawings that became the prints illustrating *Correspondances* are closely related to the group of decorative paintings made nearly fifty years earlier.[11] In some ways, the sensations of Le Clos and its gardens were Bonnard's pictorial equivalent to Proust's Combray, and for both artists the actual experience of these places becomes mythical when it is filtered through the mind as memory. It is highly likely that all of the representations of Le Clos, both the intimist interiors and the larger paintings of the garden, were painted by Bonnard in Paris, where he kept various studios in the late 1890s, rather than at Le Clos itself. In fact, if the Natanson provenance of *Apple Gathering* can be accepted, it is probable that the "green" garden decorations by Bonnard were made as a chromatic and iconographic counter-balance to the series of rose, red, and

purple (the color complements of Bonnard's greens) decorative paintings of women in domestic interiors made by Vuillard for the Natansons. As Gloria Groom has conclusively demonstrated, these works by Vuillard were never installed in a fixed way, but seem rather to have played various roles in the domestic theater created by Misia Natanson.[12]

The Natanson provenance, at once tenacious in the literature and tenuous in terms of documentation, is perhaps most helpful in clearing up the conundrum of the date of *Apple Gathering*. Interestingly, none of the works related to it is dated, and the Sara Lee painting has been dated to either the mid- or the late 1890s with no real evidence for either date. Bonnard's authoritarian father died at Le Clos late in 1895 and his beloved grandmother died there in September of 1900, and these were dates that linked paradise with its opposite, mortality. It is, therefore, likely that all of Bonnard's paintings of Le Clos were made before the death of his grandmother, and, if Françoise Heilbrun and Philippe Neagu's dating to 1899 of the many photographs of the garden and family made by Bonnard is correct, it seems at least plausible that the paintings postdate the photographs.[13] Yet, there are no precise relationships between any photograph and any painting, and the fact that Bonnard was less involved with the Natanson circle in 1899 than he was in 1895–6 suggests that the paintings might well predate the photographs and that Bonnard painted the group of screens and panel decorations in the mid-1890s. While it is tempting to date the paintings by identifying each of Bonnard's nephews and nieces represented in them, this too has its hazards. Bonnard is known to have painted chiefly from memory and from *croquis* from life drawn in his sketchbooks so there is no reason to link a painted representation with a particular child at a particular age. For all those reasons, it is more likely that the entire series was made in 1899, after Bonnard's return from Le Clos in the early autumn.[14]

The selection of the Bonnard decoration by the Virginia Museum of Fine Arts was made for two reasons. First, the museum has a collection of late nineteenth-century French easel paintings, but no major decorative paintings from the 1890s. Second, and as important, the museum has collections of late nineteenth-century French furniture and decorative arts, all of which were made at the same moment and under the same domestic impulses as those that led the childless and then-unmarried Bonnard to create images of domestic and familial bliss at Le Clos.

1. The word *nabis* is derived from the Hebrew for prophet. It was chosen as a group name in the late 1880s when all the members were in their late teens or early twenties and had fashionably messianic ideas. The quasi-religious origins of the movement were abandoned by Vuillard, Bonnard, and Roussel by the mid-1890s.

2. See Gloria Groom, *Edouard Vuillard: Painter-Decorator, Patrons and Projects, 1892–1912*, New Haven and London: Yale University Press, 1993, pp. 5–18, 43–98.

3. Ibid., p. 99.

4. The most recent and thorough discussion of this painting, together with its only color reproduction in print, can be found in Nicolas Watkins's important monograph, *Bonnard*, London, Phaidon: 1994, pp. 51–2.

5. A full discussion of this group of paintings will appear in Gloria Groom's forthcoming exhibition catalogue devoted to the decorative paintings of Bonnard, Vuillard, and Roussel for the Art Institute of Chicago and the Metropolitan Museum in 2001–2002.

6. This wonderful panel was reproduced in color in the issue of *Verve* devoted to Bonnard after his death in 1947 (see *Verve*, v, no. 17–18, 1947) and in black and white in Dauberville (1965), vol. I, no. 204, p. 216.

7. All of these are published together in the exhibition catalogue for *Bonnard*, Centre Georges Pompidou, 23 February–21 May 1984, pp. 52–3. The photograph of Bonnard is dated *c.*1905 and the panels are all dated 1894–5 on the basis of the similarity to figures from an undated notebook that, by analogy to other dated work, can be conclusively dated to the mid-1890s.

8. The most intelligent and complete discussion of Le Clos in the Bonnard literature can be found in Giambruni (1983), pp. 9–10, 209–11, 283–4. The house is located in the hilly countryside between Lyons and Grenoble.

9. Pierre Bonnard, *Correspondances*, Paris: Editions de la Revue Verve, 1944, p. 7.

10. Ibid., p. 77. The translation of both these passages is presumably that of Helen Emery Giambruni, who quotes both passages in her dissertation of 1983, p. 10.

11. Ibid., pp. 84, 85.

12. See Groom (1993), pp. 81–90.

13. See Françoise Heilbrun and Philippe Neagu, *Bonnard photographe*, Paris: Les Dossiers du Musée d'Orsay (16), 1987, pp. 4–6, 9–14.

14. This argument for an 1899 date is not, however, conclusive. When Gloria Groom turns her attention to the decorative ensembles of Bonnard in preparation for her exhibition of 2001, it is highly likely that she will reveal documentary evidence that conclusively links the five panels reproduced here with a specific project. Interestingly, none of the numerous decorative projects from the 1890s by Vuillard shares the dimensions of Bonnard's decorative scheme, and the large panel in the Musée d'Orsay is very similar in imagery, scale, and palette to Vuillard's 1899 decorations for Thadée's father, Adam Natanson.

3

Eugène Boudin (1824–1898)
Entrance to the Port at Dunkirk (*Dunkerque – l'entrée du port*), 1889

Oil on canvas, 50 × 74 cm. (19⅝ × 29⅛ in.)
Signed and dated lower right: E. Boudin 89
Schmit, vol. III, 2572

Provenance: M. Level, Paris (?); Beugniet et Bonjean (Paris); Galerie de Berri, Paris; Alan H. Cummings, Palm Beach; Mr. and Mrs. Nathan Cummings, New York; The Sara Lee Collection; The Laren Rogers Museum of Art, Laurel, Mississippi

Exhibitions: Paris, Salon de la Société Nationale des Beaux-Arts, 1890: no. 112; St. John, Canada, New Brunswick Museum, 24 April–31 May 1958; New Orleans, Louisiana, Maison Blanche and Company, 25 September–8 October 1960; Minneapolis 1965; Winston-Salem 1990: and Memphis 1991; Laren 1997–8.

Bibliography: Robert Schmit, *Eugène Boudin, 1824–1898*, Paris: Schmit; 1973 vol. III, p. 11, no. 2572, repr.
Consolidated Foods Corporation, *Consolidated Foods Corporation's Nathan Cummings Collection*, Chicago: Consolidated Foods Corporation, 1983, p. 19, fig. 13.
Brettell 1986, 1987, 1990, 1993, 1997, pp. 34–5, 145, repr.

Eugène Boudin is known today chiefly as the teacher of Claude Monet and as a stalwart exponent of *plein-air* (or out-of-door) landscape painting. His career began in the late 1850s, and he worked almost without interruption until his death in 1898. Because his oeuvre is so consistent and seemingly unvarying, it has not received much critical scrutiny. Yet, because of the widespread appeal of his paintings in France, Britain, the United States, and Japan, his body of works is very well published, and Robert Schmit produced a voluminous and reasonably well-documented catalogue raisonné in 1973.[1]

Entrance to the Port at Dunkirk is one of the minority of late works by Boudin that was chosen by the painter for public exhibition. It was painted in 1889, and was one of ten works from 1889 and 1890 included in the first Salon of the Société Nationale des Beaux-Arts. Often mistaken in the literature for the official government-sponsored Salon, this exhibition was actually a kind of "anti-Salon" organized by a newly formed organization of French artists under the leadership of Ernest Meissonier and Pierre Puvis de Chavannes. Both of these artists were entrenched "academics," but both were opposed to the enormous and unwieldy size of the official Salon and to the fact that it had come increasingly to be an exhibition of international (rather than French) art. For this reason, they organized a private society of artists, all of whom were invited by them and their friends to exhibit together. The aim was to produce an annual exhibition of manageable size with real representation of the best French artists (excluding those in the avant-garde). Puvis de Chavannes visited Boudin in the summer of 1889 in order personally to invite his participation, and Boudin seems heartily to have accepted.

Although he had exhibited with the Impressionists in their first exhibition of 1874, Boudin had never deserted the official Salon (in fact his work was also in the Salon of 1874). Yet, he was often included in "Impressionist" circles, and his unpretentious paintings were championed by the same dealers and critics who promoted the oeuvres of Monet, Renoir, Pissarro, and Sisley. Throughout the 1870s and 1880s he regularly sent work to the government Salons, and his submissions were always accepted. In 1889 he was included in both the Salon and the Exposition Universelle (or World's Fair). He was awarded the Gold Medal for the two works included in the fair, and it was perhaps for that reason that Puvis visited the Norman painter in August of that year. Eighteen-ninety-nine was a wrenching – yet fruitful – year for Boudin. He lost his wife in February, sent eighty-nine paintings and nine pastels to the famous dealer Durand-Ruel in July, took an intensely productive trip to Dunkirk in the same month, and completed a new studio outside of Deauville in September.[2]

Boudin's 1889 trip to Dunkirk was his second. He had made an emotionally charged trip there in December of 1870, fleeing the Prussian troops who were moving into Normandy during the Franco-Prussian War. Although he was then in Dunkirk for only four days (he arrived by boat from Le Havre on 7 December and had fled again to the safety of Brussels by 12 December), he painted four views of the French border port during a snow storm (these are the only four landscapes with snow in the entire oeuvre of Boudin). Yet, when he returned to the same city nearly twenty years later, he stayed long enough to begin work on twenty-three canvases, all of which he completed, signed, and dated in 1889. Of these, the largest and most ambitious is *Entrance to the Port at Dunkirk*, which was one of four views of Dunkirk and its surroundings selected by Boudin for the 1890 Salon of the Société Nationale des Beaux-Arts. The painting has a virtually identical composition to that of a smaller painting, *Seascape – Dunkirk*, now in a private collection in France (fig. 1). While it is tempting to interpret the smaller painting as a preparatory study for the larger "studio" painting now in the Sara Lee Collection, such an assumption would most likely be incorrect. Indeed, differences in point of view and lighting suggest that Boudin rented a boat for the day, took at least two canvases with him, and began work on both that day. It is likely that they were completed in Deauville in Boudin's newly constructed studio.[3]

Fig. 1 Eugène Boudin, *Seascape – Dunkirk*, 1889. Private Collection.

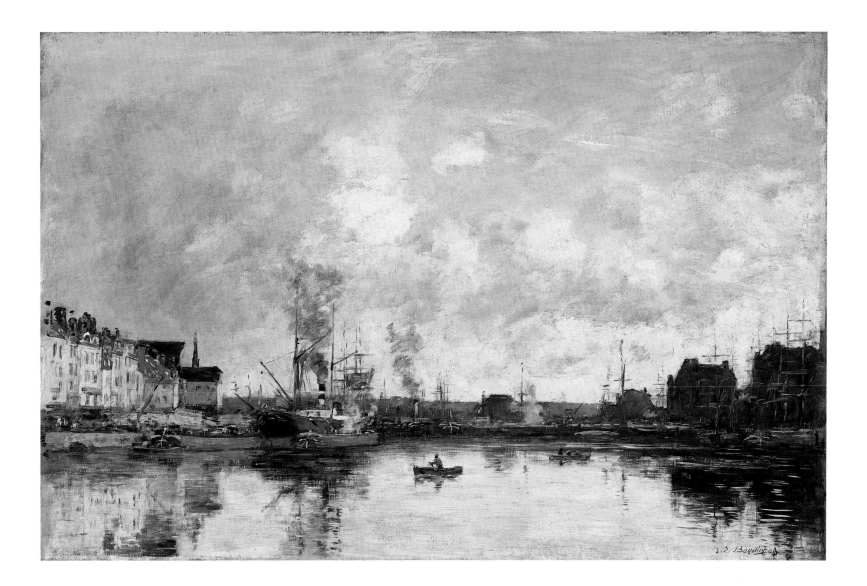

Fig. 2 Eugène Boudin, *Berck: Boats leaving*, 1889. © Musée des Beaux-Arts de la Ville de Reims

Fig. 3 Eugène Boudin, *Berck: Boats returning*, 1889. © Musée des Beaux-Arts de la Ville de Reims.

The 1890 Salon de la Société Nationale des Beaux-Arts was a major esthetic event for "official" art in France, and Boudin's decision to position himself with the conservatives must have been made because he suspected that this might increase his sales. The exhibition gave him the chance to exhibit up to ten works (rather than the two allowed in the government-sponsored Salon) with conventionally regarded artists, creating a highly favorable context for sales. If this was Boudin's reasoning, it proved correct, and his submissions fared very well from the point of view of sales. The largest paintings of the ten he submitted, a pair of related landscapes representing the port of Berk (figs. 2 and 3), were snapped up (with one of the Dunkirk paintings) by M. Henri Vasnier, a wealthy collector from Reims, who paid the large sum of 2,400 francs for the three paintings (most works by Boudin sold for amounts varying from 250 to 600 francs).[4] Other works from the ten sold almost immediately. Vasnier willed his three works by Boudin (with the rest of his collection) to the Musée des Beaux-Arts in Rheims, making them among the earliest paintings by the artist in a French museum. Evidence suggests that the Sara Lee painting was also acquired either from the exhibition or shortly thereafter.

Like all the finest paintings from Boudin's maturity, *Entrance to the Port at Dunkirk* is at once complex and subtle. Its surface is covered with hundreds of deftly interlocking touches of paint – some daubs, some lines, and some patches – all applied with an ease and confidence of execution achieved after years of practice. For this reason, the painting bears careful analysis. Its balanced composition, with a low horizon line and shimmering water, derives from the tradition of seaport paintings inaugurated in seventeenth-century Holland, where Boudin's early friend and colleague, Johann Bartholod Jongkind, still lived and worked. Both these artists had done more than any others to father Impressionism, and both died in the 1890s, just as the careers of their once promising students were taking off.

1. Schmit's *Eugène Boudin, 1824–1898*, was published under the auspices of his own gallery in Paris in 1973. Its three volumes have been amended by a supplement published in 1984, and it remains a model dealer-catalogue. The only weakness of the catalogue involves the nineteenth-century exhibitions and their criticism. Most of the works included in the Durand-Ruel exhibitions of work by Boudin are unidentified and certain works included in the Salons have not been tracked down. Boudin's nineteenth-century sales and exhibitions await further research.
2. The two best annotated chronologies devoted to Boudin are in Laurent Manoeuvre, *Eugène Boudin Dessins*, Anthese: Arcueil, 1991, particularly pp. 191–204, and the multi-authored exhibition catalogue, *Eugène Boudin, 1824–1898*, Honfleur: Musée Eugène Boudin, 1992, pp. 203–9.
3. Although the voluminous and rather boring Boudin literature is rich in "regional" studies devoted to the painter's representations of Brittany, Normandy, Trouville, and even Venice, there has been no separate study of his "northern" work in Belgium, Holland, and the border towns of France.
4. Vasnier's purchases are documented in the Musée Eugène Boudin's 1992 exhibition catalogue, p. 231, no. 128. The two large Berk seascapes are among Boudin's greatest late works and have not been seen with the Sara Lee picture since 1890.

4

Georges Braque (1882–1963)
Antwerp (Anvers), Summer 1906

Oil on canvas, 59.7 × 73 cm. (23¼ × 28½ in.)
Signed on verso: G Braque

Provenance: Mr. and Mrs. William Bedford, Copenhagen; Mrs. N. Bedford, New York; Kahnweiler Fine Arts Associates, New York; Nathan Cummings, Chicago; The Sara Lee Collection; The Art Institute of Chicago

Exhibitions: Edinburgh, Royal Scottish Academy, *Georges Braque*, 18 August–16 September 1956; and London, Tate Gallery, 28 September–11 November 1956: no. 5; Chicago 1963; Minneapolis 1965; Davenport 1965; New London, 1968; Washington, D.C. 1970: no. 47: New York 1971, no. 47; Chicago 1973: no. 42; Los Angeles County Museum of Art, *The Fauve Landscape*, 7 October–30 December 1990; New York, Metropolitan Museum, 14 February–5 May 1991; and London, Royal Academy of Arts, 13 June–18 August 1991: p. 93, pl. 103; Sydney, Australia, Art Gallery of New South Wales, *The Fauves*, 8 December 1995–18 February 1996; and Melbourne, National Gallery of Victoria, 29 February–13 May 1996: no. 2; Tel Aviv, Israel, Tel Aviv Museum of Art, *Fauvism: "Wild Beasts,"* 22 May–15 September 1996: no. 2; Laren 1997–8.

Bibliography: Cahiers d'art, VIII, no. 1–2, 1933, p. 11 (repr. in black and white with no title or information).
John Elderfield, *The "Wild Beasts:" Fauvism and its Affinities* (exh. cat.), New York: Museum of Modern Art, 1976. pp. 74, 79, repr. Youngna Kim, *The Early Works of Georges Braque, Raoul Dufy, and Othon Friesz: The Le Havre Group of Fauvist Painters*, Ph.D. dissertation, Ohio State University, 1980, Ann Arbor, Michigan: University Microfilms, 1980 pp. 132–45, no. 151, fig. 151 (entitled *The Escaut at Antwerp* from a photograph provided by Galerie Leiris in Paris. The author did not know of the whereabouts of the painting).
Alvin Martin, "Georges Braque: Stylistic Formation and Transition, 1900–1909," Ph.D. dissertation, Harvard University, 1980, repr. Brettell 1986, 1987, 1990, 1993, 1997, pp. 62–3, 145–6, repr.

Although Braque himself told friends, critics, and historians of art that the creative portion of his career began in the summer of 1906 in Antwerp, there has been a profound ambivalence toward the "northern" Fauve pictures of Braque in the vast literature devoted to his career. Even the recent multi-volume catalogue raisonné produced by the Maeght Foundation begins late in 1907, and there is no reliable catalogue of Braque's Fauve paintings.[1] Most of the Braque literature treats the Fauve period of 1906-7 as a form of apprenticeship to Matisse made before Braque's 1907 "discovery" of Cézanne and Picasso and the subsequent "classicizing" tendency of his oeuvre. Only Judi Freeman, in her exhibition devoted to the Fauve landscape, restored to the history of art this period of Braque's career with real fervor, and Braque's work made before the autumn of 1907 is routinely included and discussed in the literature devoted to Fauvism.[2] Indeed, the "Fauve Braque" is considered more "Fauve" than "Braque."

The year 1906 was crucial for the young Georges Braque.[3] The painter had grown up in the Norman port of Le Havre, where he met both Othon Friesz and Raoul Dufy as an adolescent. His training in Paris was fortified by long periods in Le Havre, and it was most likely through his friend Friesz that Braque was encouraged to visit the now infamous Salon d'Automne exhibition of 1905, with its room of works by Matisse, Derain, Vlaminck, and Friesz himself – all of whom were dubbed "Les Fauves" by Louis Vauxcelles. Braque seems to have responded somewhat timidly to the challenge of these brilliantly – indeed savagely – colored canvases, because he later destroyed all seven paintings that he submitted to the Salon des Indépendants in the spring of 1906 as well as the majority of his earlier work. For that reason, when he decided to join Friesz on a painting trip to Antwerp in the summer of 1906, he seems to have started afresh as a painter.

The biographical literature devoted to Braque tells us that Friesz and Braque rented rooms in a cheap pension in Antwerp between 12 June and 12 July and in another one between 11 August and 11 September.[4] We also know that they rented a studio with a large window and access to a rooftop terrace overlooking the River Scheldt (L'Escaut in French). From this studio, they painted the majority of their views of Antwerp. In his 1956 exhibition catalogue, Douglas Cooper refers to "about a dozen" paintings from that summer by the artist,[5] and thirteen – a baker's dozen – is precisely the number of works that

have been published in a scattered manner in the Braque literature. Of these, the finest – and, with one exception, the largest – is the Sara Lee *Antwerp*. Christian Zervos, with Braque's collaboration, included photographs of it, another Antwerp painting now lost, and a small vertical painting now in Japan on the single page devoted to Braque's Fauve work in his catalogue of all Braque's work before 1933, published in a special issue of *Cahiers d'art*. Douglas Cooper called it "calm and . . . organized," and said that Braque himself thought that "these views of Antwerp were his first creative work" in his entry for the painting in the 1956 retrospective of Braque's oeuvre at the Tate Gallery.[6]

Of the thirteen published paintings made in Antwerp by Georges Braque, nine were recently published by Judi Freeman with eleven companion works by Othon Friesz (most of which had been gathered in 1979 in Friesz's only retrospective exhibition).[7] Braque's other four Antwerp paintings have been published at various points: one by Zervos in 1933,[8] another by John Russell in his elegant monograph on Braque published in 1959,[9] and two in the 1994 Maeght Foundation retrospective devoted to Braque.[10] These thirteen paintings have never been exhibited or published together, but, if they were, Braque's brilliance as a Fauve painter would be immediately recognized. It has long been known that Braque came grudgingly to Fauve practice and that the slightly older and more experienced Othon Friesz was his mentor in the movement. But, comparing the achievements of Braque and Friesz in the summer of 1906, it is clear that Braque quickly outstripped his mentor. Braque's compositions are bolder and more experimental, his color at once more saturated and more varied, and his *facture* more experimental than those of his friend. Bearing in mind that Braque had not yet seen the 1905-6 paintings of Matisse or the Gauguin retrospective at the Salon d'Automne of 1906 and that he was not to meet Matisse until the spring of 1907, the real achievement of these paintings is even more astonishing.

Antwerp is in many ways a direct challenge by Braque to Friesz. In fact, four of the eleven canvases by Friesz published by Freeman represent the same view from the roof terrace of their studio looking downriver to the port. Of these, three are small canvases that serve as compositional and chromatic "studies" for a final large painting, *The Port of Antwerp* (fig. 1), which was clearly intended by Friesz to be the "masterpiece" or exhibition picture of the summer season. So, too, Braque decided to

Fig. 1 Othon Friesz, *The Port of Antwerp*, 1906. Private Collection.

make his version of the rooftop view one of his two largest and by far his most ambitious picture of the summer. In this way, each artist challenged the other to a sort of duel that was not fought in a public arena until 1990 in Los Angeles.[11] Although Braque occasionally worked in a manner similar to that of Friesz by making two or three smaller compositional/chromatic studies before tackling the subject on a larger scale,[12] no smaller works related to the Sara Lee painting survive. For that reason, comparison can only be made between both "final" compositions. It is likely that Friesz included his largest picture from the summer of 1906 among his four submissions to the Salon d'Automne exhibition held in October–November of that year. Braque seems not to have been ready to exhibit with the Fauves at that point, but it is known that he visited the exhibition before leaving with Friesz on another painting expedition to Cézanne's coastal village of L'Estaque. He must have felt quietly proud in the knowledge that his own work rivaled that of Matisse and Derain and far surpassed that of his weaker friend Friesz.

Friesz's *Port of Antwerp* is a highly conventional composition in contrast to Braque's bolder and more elliptical

organization of the same scene. Both artists placed their easels on the rooftop terrace with its large balustrade. Friesz elected to position both the painter and the viewer in the clearly legible space of the terrace, which he defined with shadows and repetitive painted lines to suggest intelligible pictorial space. In the next "plane" of the composition devoted to the cityscape with the river, Friesz was equally obsessed with the representation of measurable pictorial space. The overlapping rooftops recede logically, and the space of the great Scheldt River is defined by a series of ships and boats that are placed so as to allow clear spatial recession. Even Friesz's sky is generously populated with curvilinear clouds that seem almost to have stepped from a Dutch or Flemish seventeenth-century seascape. For Friesz, Fauve color is constrained by an utterly "correct" and "conventional" composition that "reveals" space in a manner little different than that employed by an academic artist.

Braque's composition is everywhere stranger, bolder, and less clearly comprehensible. The terrace from which the work was painted is "represented" by the single bold curve of the balustrade that swoops into the composition from the lower-right

corner. The rooftops in the middle distance are compressed into awkward overlapping rectangles that seem to push against each other and the pictorial surface with an urgency that refuses spatial recession. The viewer rushes quickly over the great river, with no space-suggesting ships or boats, to the regular band of rectangles that comprises the distant town. Even Braque's sky challenges us with its almost intestinal reticulation of icy blues and yellow-oranges. To emphasize the artificiality of his enterprise, Braque places a neo-Baroque roof ornament at the precise center of the composition so that it becomes almost a fetish surrounded by pulsating color. No painter other than Matisse was capable of such pictorial intelligence and urgency in the summer of 1906.

It is tempting to discuss the Antwerp paintings by Braque and Friesz as isolated experiments in which French pictorial theory was simply applied to the Flemish town of Antwerp and its surrounding countryside. This was surely not the situation. Although there is no indication of just where the two painters stayed in the month of July, we know that they spent two full months – June and August – in Antwerp. They must surely have done more than paint the port and dune landscapes outside the city, and "Matisses" in Antwerp. Friesz himself had visited the museums of Brussels and Antwerp in 1900

(and again in the summer of 1905) and most probably also visited the towns of Bruges and Ghent.[13] Clearly Braque, too, was as fascinated by the museums of Antwerp as he was by the city's architecture. It is no accident that, in a summer in which both Friesz and Braque devoted themselves to the liberation of color, they did so in the city of the greatest colorist of northern Baroque art, Peter Paul Rubens. Although Rubens's own house was not yet open to the public as a museum, the extraordinary collections of the Royal Museum of Fine Art in Antwerp had been housed in a splendid and monumental museum since 1890, and a surviving postcard from Friesz to Henri Manquin records that they visited the museum on their first days in Antwerp.[14] Gathered in this monumental building were more than twenty paintings by Rubens, and the museum acted as a sort of introduction to the monumental canvases by the artist that had been commissioned for the churches and public buildings of Antwerp. Rubens's achievements in modeling with color had been recognized by the "dean" of modern French colorists, Delacroix, whose position as the fountainhead of modern painting was widely recognized by 1906.[15] Unfortunately, very little documentary evidence (two hotel receipts in addition to the postcard) survives from the summer of 1906, and one can only speculate on Braque's

interaction with the work of Rubens in Antwerp.

Who saw Braque's masterpiece from the summer of 1906? The answer is most probably Othon Friesz and no one else. Their trip together to Cézanne's country took Braque on a pictorial odyssey away from his native northern France, and by the autumn of 1907 he was so deeply involved with the art of both Cézanne and Picasso that he never again turned back. It is likely that Braque or his dealer Daniel-Henry Kahnweiler still owned *Antwerp* in 1933 when Zervos first published it, and its absence from the early literature devoted to Fauvism surely proves that Braque never exhibited the picture in the teens or twenties. Yet, it is among the greatest works from 1906 produced by any member of the Fauve group. It is unique among Braque's Antwerp paintings in betraying no direct influence from Matisse, Dufy, or Derain, as all the other twelve paintings do; in fact, some of them are virtually "translations" from specific works by other painters. *Antwerp* is also unique in its hard-fought balance between the competing claims of color and pictorial structure. The overlapping roofs and geometric compactness of *Antwerp* have been compared by Judi Freeman to the urban paintings of the ever-underrated Albert Marquet. Yet, the rooftop painting by Caillebotte, *View of Rooftops (Snow Effect)*,

Fig. 2 Gustave Caillebotte, *View of Rooftops (Snow Effect)*. Musée d'Orsay, Paris. Photo © RMN.

Fig. 3 Georges Braque, *Little Harbor in Normandy*, 1909. The Art Institute of Chicago; Samuel A. Marx Purchase Fund. © ADAGP, Paris and DACS, London 1999.

then in the Musée du Luxembourg (fig. 2), however different chromatically, has many affinities with Braque's masterpiece – affinities of both composition and paint handling. And the slab-like *facture* of the middle ground suggests that Braque had studied 1880s paintings by Cézanne even before he saw the great retrospective in the fall of 1907. If Douglas Cooper included a carefully chosen sequence of works by Braque in what he called "The Essential Cubism," surely he – or anyone else – would include *Antwerp* in either of two collections: "The Essential Fauvism" or "The Essential Braque." How wonderful it will look at the beginning of the Braque sequence in the Art Institute of Chicago, where it will prepare the visitor for Braque's greatest port scene of 1909, *Little Harbor in Normandy* (fig. 3).

1. See Nicole Mangin Worms de Romilly and Jean Laude, *Braque: le cubisme fin 1907–1914*, Paris: Maeght Editeur, 1982. This is the most recently published of the seven-volume catalogue of Braque's work published by Maeght. The other six cover his production between 1916 and 1957.

2. Judi Freeman's exhibition catalogue is among the indispensable recent works of museum scholarship. Crammed with information and images, it digests this material in a variety of ways and is constantly useful. It does not, however, include a reliable catalogue of Braque's Fauve oeuvre. See Los Angeles (1990). Sadly, Youngna Kim's 1980 dissertation is also woefully incomplete as a catalogue. Not only are many works missing, but certain of those that are included were not actually seen by Dr. Kim and, thus, her comments about them derive from black and white archival photographs. Such is the case with her discussion of *Antwerp*, which she analyzes using a file photograph provided to her by the Leiris gallery.

3. The most reliable chronology among the many in the Braque literature is Russell T. Clement's in his compilation, *Georges Braque: A Bio-Bibliography*, Westport, Conn., and London: Greenwood Press, 1994, pp. 1–10.

4. The most accurate information from the receipts is found in Judith Cousins's "Documentary Chronology," *Picasso and Braque: Pioneering Cubism* (exh. cat.), Museum of Modern Art, New York, 1989, pp. 341, 434.

5. See London (1956), p. 26.

6. Ibid.

7. Los Angeles (1990), pp. 93 (pl. 103), 203–5 (pls. 212–16), 228 (pl. 241), 271 (pls. 281–2) (for Braque), and pp. 93 (pl. 104), 206 (pls. 217–19), 211 (pl. 222), 229 (pl. 242), 300 (pls. 313–15), 301 (pls. 316–17) (for Friesz). For Braque, these are: 1. *Antwerp*, 1906, 59.5 × 7 cm., Sara Lee Corporation; 2. *The Bay at Antwerp*, 1906, 50 × 61 cm., R. and H. Batliner Collection, Vaduz (listed as private collection, Liechtenstein); 3. *The Mast, the Port of Antwerp*, 1906, 46 × 38.4 cm., Marion and Nathan Smooke; 4. *Landscape near Antwerp*, 1906, 60 × 81 cm., The Solomon Guggenheim Museum, New York; 5. *The Port of Antwerp*, 1906, 45 × 35.6 cm., Nippon Autopolis Co. Ltd., Japan; 6. *The Port of Antwerp*, 1906, 49.8 × 61.2 cm., The National Gallery of Canada, Ottawa (these six were included in the exhibition itself); 7. *The Window*, 1906, 46 × 38 cm., location unknown; 8. *The White Boat*, 1906, 38.4 × 46.5 cm., Fondation Fridart (listed as collection of Mr. Christopher Wright); and 9. *The Port of Antwerp*, 1906, 38 × 46 cm., Von der Heydt Museum, Wuppertal, Germany.

8. *Cahiers d'art* (1933), p. 11 (upper left corner of the page. Zervos includes no information beyond the photograph and a date of 1906).

9. John Russell, *G. Braque*, London: Phaidon, 1959, pl. 3, pp. 119, identified as *Landscape near Antwerp*, 1906, private collection, 42 × 50 cm.

10. Jean-Louis Prat, *Georges Braque Retrospective*, exh. cat., Fondation Maeght, Paris, 1994, no. 4, pp. 26–7 (*The Scheldt at Antwerp*, 1906, 33 × 41 cm., private collection Germany (from Kahnweiler)), and no. 6, pp. 30–31 (*The Port of Antwerp*, 1906, 36 × 45 cm., private collection, France). This latter painting is probably mis-titled, however, because there are clearly mountains visible behind the boats, suggesting that it was painted not in Antwerp, but in L'Estaque or La Ciotat in 1906 or 1907.

11. Unfortunately, none of the critics of the exhibition noticed this pictorial duel, nor was it noted in the excellent catalogue.

12. The clearest examples of this from the summer of 1906 are the three dune landscapes with virtually identical compositions; two are smaller (those in Vaduz published in the Los Angeles catalogue and in a private collection published by Russell) and one larger (that in the Guggenheim, which is, in fact, the largest painting of the summer).

13. See Los Angeles (1990), pp. 202, 298.

14. The postcard was the "Spring" panel from a seasonal four-panel series by Abel Grimmer in the Royal Museum of Fine Arts. For a reproduction of this painting and a full discussion of the museum, its history, and its collections, see Els Marechal and Leen de Jong, *The Royal Museum of Fine Arts, Antwerp*, Antwerp, 1990, repr. p. 34. Interestingly, the three panels produced in Antwerp in 1607 had just been acquired by the museum in 1904. For the postcard reference, see Los Angeles (1990), p. 213, n. 32.

15. The most widely read text among vanguard Fauve painters was Paul Signac's *D'Eugène Delacroix à Neo-Impressionisme*, published by the Revue Blanche in 1899. Oddly, it was not republished until 1911, when its usefulness had largely waned.

5

Georges Braque (1882–1963)
Woman at an Easel (*Green Screen*) (*Femme au chevalet [Paravent vert]*), [also *Woman painting* (*Femme se peignant*)], 1936

Oil on canvas, 92 × 73 cm. (36¼ × 28¾ in.)
Signed and dated lower left: G Braque/36
Mangin vol. 2

Provenance: Paul Rosenberg and Company, New York; Keith Warner, New York; E. and A. Silberman Gallery; Nathan Cummings, Chicago; Herbert Cummings, Phoenix; The Sara Lee Collection; The Art Institute of Chicago

Exhibitions: Oslo, Stockholm, and Copenhagen, *Exposition Braque, Laurens, Matisse, Picasso* 1937 (organized by M. Walther Halvorsen); Paris, Galerie Paul Rosenberg, *Braque*, April 1937; Paris, Petit Palais, *Les Maîtres d'art indépendant*, June–October 1937: no. 2; Pittsburgh, Carnegie Institute, *International Exhibition of Paintings*, 14 October–5 December 1937; Melbourne, Australia, *Melbourne Herald Exhibition 1939*; San Francisco 1953; Eugene, Oregon, University of Oregon; and Portland, Oregon, Portland Museum of Art, 1953; Zurich, Kunsthaus, *Braque*, 1953; Chicago, Arts Club of Chicago, September 1954; Paris 1956; New York, E. and A. Silberman Galleries, *Art – United Nations*, December 1957: no. 26; St. John, Canada, New Brunswick Museum, 24 April–31 May 1958; Pittsburgh, Carnegie Institute, *International Retrospective Exhibition*, 4 December 1958–8 February 1959; Cincinnati, Contemporary Arts Center, *Homage to Georges Braque*, 22 September–22 October 1962; Minneapolis, Walker Art Center, 6 November 1962–20 January 1963; New York, Paul Rosenberg Gallery, 7 April–2 May 1964; Minneapolis 1965; Washington, D.C. 1970; New York 1971: no. 49; Chicago 1973: no. 44; Winston-Salem, 1990; Memphis 1991; Lakeland 1995; Laren 1997–8.

Bibliography: M. Walther Halvorsen, "Exposition Braque, Laurens, Matisse, Picasso, à Oslo, Stockholm, Copenhague," *Cahiers d'art*, XII, no. 6–7 (1937), repr. opposite p. 220.
Christian Zervos, *Histoire de l'art contemporaine*, Paris: Editions "Cahiers d'art", 1938, p. 286, repr.
Rosamund Frost, *Contemporary Art: The March of Art from Cézanne until Now*, New York: Crown Publishers, 1942, p. 54, repr.
Maurice Gieure, *G. Braque*, Paris: Editions Pierre Tisné, and New York: Universe Books, Inc., 1956, pp. 53 (pl. 90), 101.
John Russell, *Georges Braque*, London: Phaidon, 1959, pl. 52, repr.
Nicole S. Mangin, ed., *Catalogue de l'oeuvre de Braque: peintures 1936–1941*, Paris: Galerie Maeght, 1961, no. 2, repr.
John Richardson, *George Braque*, Paris: La Bibliothèque des arts, 1961, 1962, no. 29, repr.
Edwin Mullins, *The Art of George Braque*, New York: Harry N. Abrams, 1968, p. 138, pl. 104.
Raymond Cogniat, *Georges Braque*, trans. I. Mark, New York: Harry N. Abrams, 1980, p. 64, fig. 61.
Consolidated Foods Corporation, *Consolidated Foods Corporation's Nathan Cummings Collection*, Chicago: Consolidated Foods Corporation, 1983, p.14, fig. 8.
Brettell 1986, 1987, 1990, 1993, 1997, pp. 110–11, 142, 146, repr.

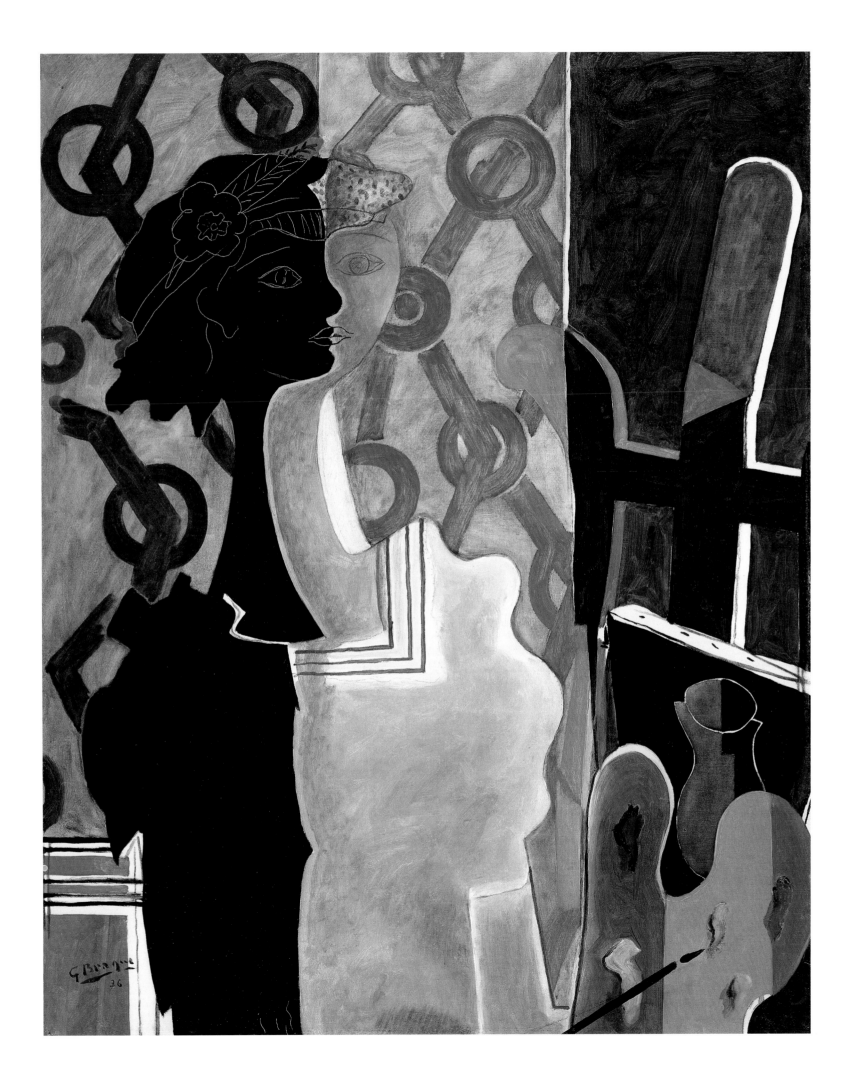

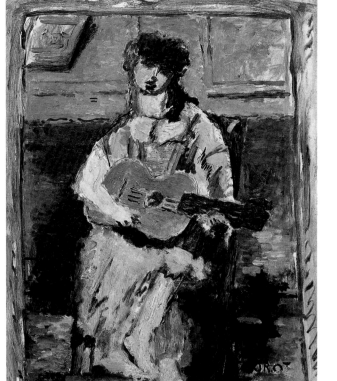

Fig. 1 Georges Braque, *Woman with a Mandolin (After Corot)*, 1923. Collections Mnam-Cci, Centre Georges Pompidou, Paris.

Fig. 2 Camille Corot, *Interior of the Artist's Studio*. Musée des Beaux-Arts de Lyon. Photo Studio Basset.

In February of 1936 a great retrospective exhibition of the work of Camille Corot opened at the Orangerie in Paris. Its evocative catalogue includes a poetic essay by Paul Jamot as well as a small group of quotations in verse and prose from Théophile Gautier, Delacroix, and Baudelaire, and its catalogue list contains 119 paintings from collections throughout the world.[1] It was, in short, the first "modern" retrospective of Corot – the first, that is, to recognize the global reach of this utterly Parisian and utterly modest artist. There is no doubt that Georges Braque rushed to see it. He had already demonstrated his admiration for the nineteenth-century artist closest to his heart and his temperament by painting in the early 1920s a subtle "translation" of a painting by Corot (fig. 1) and by keeping a photograph of Corot's portrait of Christine Neilsen in his studio.[2] Surely he was ready to see more than one hundred major works by Corot in February of 1936.

It goes without saying that Braque was not by nature a painter of the human form, although Picasso and Matisse (through their own figurative works) sometimes goaded him into grappling with the representation of flesh. In fact, two earlier French artists, Chardin and Corot – one a painter of figures as still-life and the other a painter of figures as landscape – served as his most important models. The 1936 Corot exhibition in Paris

had a wonderful selection of late figure paintings. The greatest of them, *Interrupted Reading*, was loaned by The Art Institute of Chicago, and another, a small studio interior then as now in the Musée des Beaux-Arts de Lyon (fig. 2), was surely the impetus for Braque to begin the series of paintings representing a women or two women in the studio, which consumed his attention from 1936 until 1939. How fitting it is that one of these paintings, *Woman at an Easel (Green Screen)*, is now entering the collection of the Art Institute of Chicago and another, also of 1936, *Woman with a Palette*, from the collection of Jacqueline Delubac, is now entering that of the Musée des Beaux-Arts in Lyon. In fact, Braque's experience of the Corot exhibition must have sent him back to his beloved Louvre, which had owned one enigmatic studio interior by Corot since 1911 and had acquired another in 1933. Indeed, Corot's "series" of studio interiors inhabited by silent model-muses spawned another made by Braque more than two generations later.[3] The one is as essential to an understanding of French twentieth-century painting as the other is to that of the nineteenth.[4]

Nothing in the Braque literature reveals the identity of the model. None of the endless speculation about the character and sexuality of models that infects the Matisse and Picasso literatures has yet prompted scholars to wonder whether this young woman, prim and

well-dressed as she is, had any real identity or interacted in any more than a genial professional way with Braque. In this also Braque is like Corot, whose models are always chaste and usually decorously anonymous. Braque's model here is certainly not his wife, Marcelle Lapre Braque, who was considerably older (they had married in 1912), and the Braques never had children, so it is not a daughter. Yet, the evident youth, asexuality, and freshness of the model do suggest a daughter, a niece, or a family friend more than paid model or lover. She is, in the end, an utterly unthreatening muse, and muses were much on Braque's mind in the mid-1930s, when he was forced to "take stock" of his career for his first, very large, retrospective at the Kunsthalle in Basel in 1933. He had also seen virtually his entire oeuvre (minus many human figures) reproduced in a special issue of *Cahiers d'art* published in connection with that exhibition.[5]

Additionally, Braque had become all but obsessed with classical art and literature, even illustrating Hesiod's *Theogony* for Vollard in 1931, and the wonderfully crisp white on black drawing of the muse's head in *Woman with an Easel* has clear association with Greek black-figure vase painting, which Braque saw at the Louvre and which he could also have studied from the superb photographs in the special issue of *Cahiers d'art* devoted to *l'Art ancien Grec* at the end of 1933.[6] Indeed,

Georges Limbour has noticed that it was the muses that attracted the middle-aged Braque to the Greeks:

> The painter's thoughts had already turned to Greece, where he had never been. What did he take from Hesiod? Nothing, it seems except his inspiration. What did he learn from him? Only that there were muses and goddesses that Courbet did not know because Hesiod had not been able to show him them. But what could Braque get from Artemis, this slender and excessively beautiful young girl?[7]

Like most major modern artists, Braque did everything in series, and the muse-occupied studio-interiors engaged him in a concentrated fashion for four years and then sporadically for another five. It was also during the late thirties that he returned again to sculpture, and we feel this impulse in the head of the Greek muse in *Woman at an Easel*. She seems to rest on her excessively rectilinear bodice as if it were a base, and she turns her profile to us not only in deference to Cubism, but also because she is at once a bust portrait and a profile relief. The other versions of the composition in 1936 are all different — different enough to prove that, although Braque thought in series, he believed firmly in the individual integrity of the work of art.

The largest version, now in the Metropolitan Museum (and formerly in Chicago in the Sam Marx Collection), shows his muse-model actively painting a profile portrait (self-portrait) of a woman. This was transformed in 1937 into a musical encounter in which the woman-painter-muse of the New York canvas becomes a singer-muse, and her canvas is transformed into a piano played by a woman in deep shadow (fig. 3).[8] Although Braque began his Corot series in 1936 with two very small paintings of women as musicians (in the manner of Corot), he quickly altered the conceit, transforming musicmaking into painting, creating analogies between the performance aspects of both arts. All three "painters" of 1936 work to complete a canvas, and, in each case, the "subject" of that canvas is different — a vase in the Sara Lee canvas, a growing plant in the Lyon canvas, and a profile head of a woman in the Metropolitan canvas. But, by 1937, the women no longer paint, but play instruments like their Corot models, and in the last canvas that summarizes the series, *Painter and his Model* (Norton Simon Museum) of 1939, the painter is not the muse, but a shadowy bearded man (surely not Braque himself) who stares fixedly at a seated, nude model-muse. Here, at last, Braque swerved from Corot and took on his arch-rival Picasso, who often drew and

painted artists and nude models, particularly in the 1928 *Painter and Model* (Museum of Modern Art, New York), a work of virtually identical dimensions to the Braque, but one that has little of the historical melancholy of the work of his former friend.

The essence of the "series" of studio interiors with muse-women was best expressed in words by the painter André Lhote, after he saw Braque's exhibition at the Galerie Rosenberg, in which *Woman at an Easel* was first exhibited:

> We were already familiar with the thin silhouette of a woman in an interior. Yesterday, she was unfolding — no pointing out — a score in front of a piano; today, in front of an easel and holding in her hand the draft of a composition, she introduces us warily into a new world of forms invented by the painter, or rather into a new room (they seem to be numerous) in this apartment, in which Georges Braque moves about extraordinarily slowly.[9]

1. See Paul Jamot, *Corot* (exh. cat.), Musée de l'Orangerie, Paris, 1936.
2. This *Woman with a Mandolin (After Corot)* has always been dated 1922–3 and is now in the collection of the Musée National d'Art Moderne, Centre Georges Pompidou, Paris. The better of the two photographs is published in Bernard Zurcher, *Georges Braque: Life and Work*, trans. Simon Nye, New York: Rizzoli, 1988, pp. 214, pl. 173. This photograph was taken in Braque's studio in 1957 by Robert Doisneau.
3. The most recent reproduction and discussion of Corot's studio works can be found in the Metropolitan Museum's exhibition catalogue, *Corot*, New York: The Metropolitan Museum of Art and Abrams, 1996, pp. 314–37.
4. The most complete discussion of the Braque figures-in-studios of the late 1930s can be found Zurcher (1988), pp. 204–27.
5. See *Cahiers d'art*, 8e Année (1933), nos. 1 and 2, Paris, with texts by Christian Zervos, Louis Vauxcelles, Guillaume Apollinaire, André Salmon, Blaise Cendrars, Julius Bissiere, André Lhote, Ardengo Soffici, Jean Cassou, André Breton, H. S. Ede, and Karl Einstein
6. *Cahiers d'art*, 8e Année (1933), nos. 5–6, Paris, see particularly pls. 140, 143, 144.
7. Georges Limbour, "La Théogonie d'Hesiode et de Georges Braque," *Derrière le miroir*, 71, 72, (December 1954–January 1955), unpag., trans. by Simon Nye.
8. *The Duet*, 1937, oil on canvas, 131 × 162.5 cm., Musée National d'Art Moderne, Centre Georges Pompidou, Paris.
9. See André Lhote, "Symbolisme plastique de Georges Braque," *La Nouvelle Revue française*, 48 (May 1937), pp. 795–7 (trans. by Simon Nye).

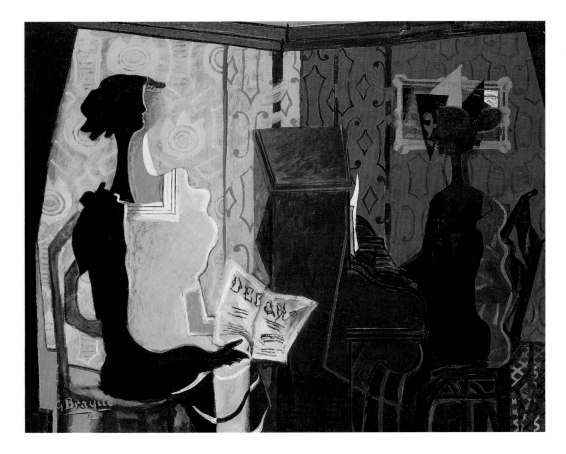

Fig. 3 Georges Braque, *The Duet*, 1937. Collections Mnam-Cci, Centre Georges Pompidou, Paris. © ADAGP, Paris and DACS, London 1999.

6

Marc Chagall (1889–1995)
The White Lilacs (Les Lilas blancs), 1930–34

Oil on canvas, 89.5 × 73 cm. (35 × 28½ in.)
Signed lower left: Chagall/Marc
Meyer 606

Provenance: (?) Goldschmidt; Nathan
Cummings, Chicago; Alan H. Cummings,
Palm Beach, Florida; The Sara Lee Collection;
New Orleans Museum of Art

Exhibitions: Toronto 1955: no. 16 (exhibited as
Vase de fleurs et amoureux); Paris 1956
(exhibited as *Vase de fleurs et amoureux*);
Rome 1956; New York, Findlay Gallery,
13–25 October 1961; Tokyo, National
Museum of European Art, 1 October–10
November 1963; Kyoto, Municipal Museum,
20 November–10 December 1963; New York,
Berlin Gallery, 1967; New London 1968
(exhibited as *Les Amoreux de Vitebsk*);
Washington, D.C. 1970: no. 52 (exhibited as
Lovers of Vitebsk); New York 1971: no. 52:
Chicago 1973: no. 64 (exhibited as *Lovers of
Vitebsk*); Winston-Salem 1990; Memphis
1991; Lakeland 1995, Laren 1997–8

Bibliography: Franz Meyer, *Marc Chagall:
Life and Work*, New York: Harry N. Abrams,
1963, no. 606, pp. 671, 756, repr.
Consolidated Foods Corporation, *Consolidated
Foods Corporation's Nathan Cummings
Collection*, Chicago: Consolidated Foods
Corporation, 1983, p. 16, repr.
Brettell 1986, 1987, 1990, 1993, 1997, pp.
104–5, 147, repr.

Like Joan Miró, Raoul Dufy, and Alexander
Calder, Marc Chagall is a beloved modern
artist. Never difficult or cerebral, Chagall's
works in every medium appeal – and were
intended to appeal – directly and immediately
to the ordinary viewer, demanding no special
knowledge and little critical preparation. In
this way they relate more persuasively to folk
art, which was so important to the artist, than
to the complex and theoretical movements of
Cubism and Surrealism that were current
when Chagall first arrived in France in 1910
from his native Russia. Indeed, Chagall
brought the world of popular Jewish culture
from the rural shtetls and urban ghettos of
Russian Jewish culture to the vibrant
multicultural city of Paris and became one of
the Russian Jewish artists – the others being
Modigliani, Soutine, and Moïse Kisling – who
were included in the School of Paris even
though most of them were foreigners and
Jews. Yet, in fact, Chagall struggled. Like
most great modern artists, he was poor,
worked hard, and waited long for recognition.
However, by the middle of the 1920s his
income was steady and he was given many
opportunities to spread his gentle, peaceful
vision. Making full use of his profoundly
Jewish heritage, Chagall built upon this
tradition to create an iconography of love and
world peace embodied in paintings, prints,
murals, book illustrations, and stained glass.

The White Lilacs, as the painting has been
called since the 1960s, was painted after
Chagall's acceptance as an artist, but before
his virtual canonization, which occurred in the
years after the horrors of the Holocaust
became widely known in Europe and
America. Traditionally dated 1924–5 because
of what was thought to be its Parisian setting
and its similarity to paintings that featured
the Eiffel Tower, flowers, and lovers, *The
White Lilacs* was re-dated in Meyer's
catalogue raisonné to 1930–34. This was a
period in which the artist painted several
other works representing flowers and lovers,
including *Lovers in Lilacs* of 1930 in the
Richard Zeisler Collection. In the Sara Lee
painting the white lilacs seem almost to glow
from their simple bouquet, and we breathe
the powerful scent of spring as it emanates
from a mauve-blue landscape that appears
almost frozen. The city behind the lovers has
been identified both as Paris and as Vitebsk in
the literature. Yet, in spite of the generic
similarity of the church above the lovers to
the basilica of Sacré Coeur in Paris, no other
Parisian building can be identified to secure
this identification. It is more likely to be a
memory of Vitebsk, and the domes are likely

Fig. 1 Marc Chagall, *The Woman and the Roses*,
1929. The Museum of Fine Arts Houston; The
John A. and Audrey Jones Beck Collection, gift of
Audrey Jones Beck. © ADAGP, Paris and DACS,
London 1999.

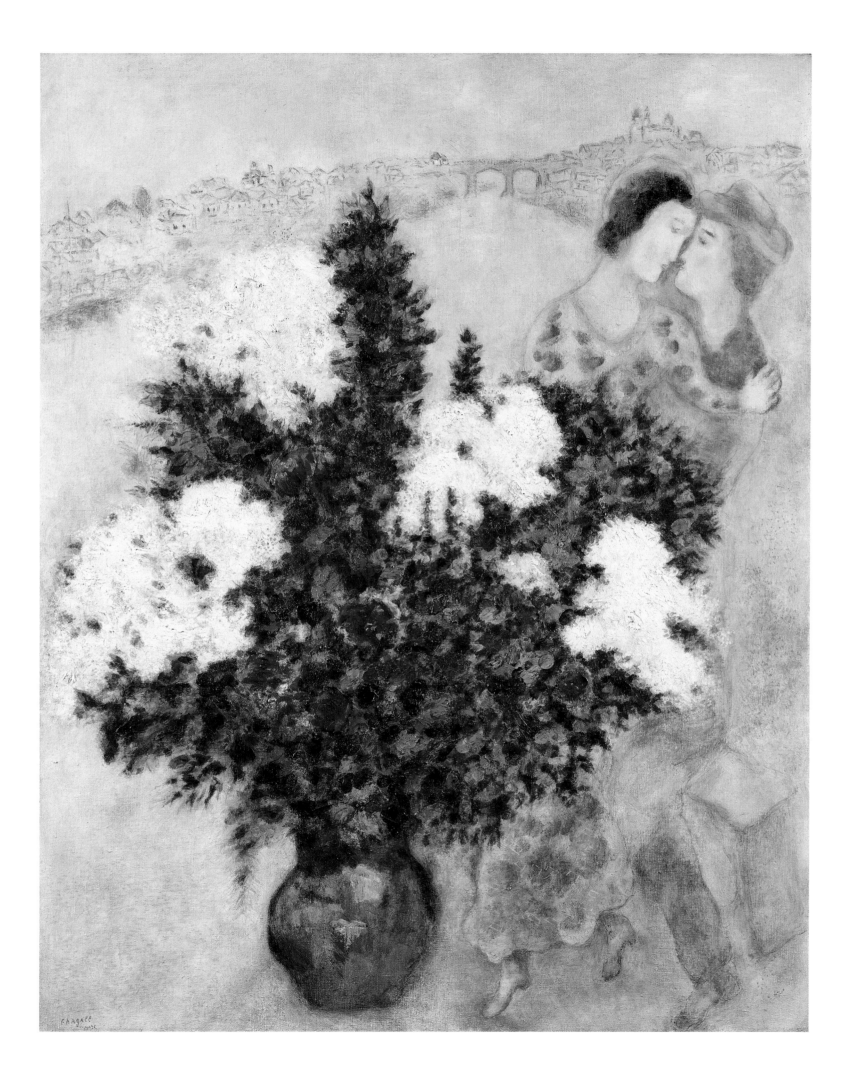

Fig. 2　Russian Lubok folk print, "He's flown up the chimney," 1878. The State Russian Museum, St. Petersburg.

to be those of Vitebsk's Cathedral of the Assumption.[1]

Like so many of Chagall's paintings, *The White Lilacs* is a confection made with autobiographical ingredients, and if the 1930–34 date is correct, it was painted in exactly the period in which Chagall's autobiography *My Life* (written in 1922) was translated into French and published in Paris (1931). The eight years he spent in Russia from 1914 to 1922 (having been forced to return there from Paris at the onset of the First World War) reinforced his powerful bond with his native land, stirred in him passionate feelings for his cultural heritage, and gave him the opportunity to renew his romantic relationship with Bella Rosenfeld and to make her his wife.[2] The man on the bench in *The White Lilacs* is surely Chagall himself and his lover – floating before him – is Bella Rosenfeld Chagall, his wife. "Where is the bench on which I kissed you once upon a time?" asks Chagall in the poetic prose of *My Life*.[3] The sensation of levitation generated by feelings of love ("I felt as it I were taking off . . .")[4] was articulated verbally by Bella in her own memoirs published in 1946, two years after her death, but first assembled in 1935 in a volume called *Brenendicke Licht* (*Burning Lights*). Bella's source for the idea may have been her husband's paintings: he introduced the theme of the floating figure as early as 1912–15 in such paintings as *Over the Town*, (State Tretiakov Gallery, Moscow) and *Over Vitebsk* (Museum of Modern Art, New York). As to Chagall's source for the floating figure, it

can be found in Russian folk art – more precisely, in the Russian *lubok*.

Like many Russian-born artists of his generation – Kandinsky, Goncharova, Larionov, El Lissitzky, and Malevich – Chagall was strongly affected by the *lubok* (Russian folk print or broadsheet). Kandinsky had even included seven *lubki* in his *Blue Rider Almanac* to link their primitive energy to that of his own work and the work of his modernist contemporaries, and Larionov organized a large exhibition of icons and *lubki* in Moscow in 1913. *Lubki* originated in the seventeenth century as cheap paper icons, but the anonymous printmakers soon adopted various themes – political, satirical (fig. 2).[5] One of the most popular themes of the Russian *lubok* was that of "romance," with many prints based on Alexander Pushkin's 1814 poem *Romance*.[6] The flying figures that sometimes populate the fantastic world of the *lubok* may have suggested extraordinary possibilities to Chagall, who allowed the lovers of his spiritual world literally to "get high" on their emotions. Chagall painted floating lovers – with and without flowers, sometimes flying through urban interiors, more often out-of-doors – throughout his long and productive life.

The vase of flowers – also unbound by laws of gravity – is central to the composition of the Sara Lee canvas (as flowers often are in Chagall's paintings). It is likely that the reference is again autobiographical and celebrates the first bouquet of flowers that Bella brought to the artist early in their

relationship.[7] *White Lilacs* will be the first major work by Chagall to enter the permanent collection of the New Orleans Museum of Art. It will add depth to a survey collection of modernist art made by French and foreign artists in France during the first half of the twentieth century.

1. An early twentieth-century postcard with a photograph of the Cathedral of the Assumption in Vitebsk, reproduced in Irina Antonova, Andrei Voznesensky, and Marina Bessonova, *Chagall Discovered*, New York: Hugh Lauter Levin Associates, 1988, p. 14, does indeed suggest that the three green copper domes (one large and two small) are those shown on the cathedral in *The White Lilacs*, and the configuration of the cathedral as well as its situation on a hill match those of the church in Chagall's painting *Nu au-dessus de Vitebsk* (Meyer 605) of 1933.
2. See Susan Compton, ed., *Chagall, Love and the Stage*, London: Merrell Holberton, 1998, especially pp. 9, 13–25.
3. See Marc Chagall, *My Life*, New York: The Orion Press, 1960, p. 140. Chagall's etching opposite p. 76 shows the lovers on that bench – Chagall wearing the same brimmed hat as in *The White Lilacs*.
4. See Bella Chagall, *Burning Lights*, trans. Norbert Guterman, New York: Schocken Books, 1962. Compton (1998) quotes this passage.
5. Susan Compton uses this particular *lubok* in connection with the imagery of Chagall (Compton, 1998, p. 18, fig. 8), as does Natalie Lee in her 1982 M.A. thesis "Vasilii Kandinsky . . ." (Southern Methodist University, Dallas), p. 273, fig. 45. Lee's source for the image is a *lubok* from the collection of Alexander Lieberman reproduced in *A Survey of Russian Painting*, exh. cat., New York: Gallery of Modern Art Including the Huntington Hartford Collection, 1967, p. 26. See also Alla Sytova, *The Lubok: Russian Folk Pictures, 17th to 19th Century*, Leningrad: Aurora Art Publishers, 1984, pl. 169.
6. See Sytova (1984), esp. pl. 132.
7. See Chagall (1960), p. 75.

7

Edgar Degas (1834–1917)
Breakfast after the Bath (*Le Petit Déjeuner
après le bain*), 1895–8

Pastel on paper laid down on board,
92 × 81 cm. (36½ × 32¼ in.)
Atelier stamp
Lemoisne 1205

Provenance: Atelier Edgar Degas, Paris;
Galerie Georges Petit, Paris, 11–13 December
1918; Charles Comiot, Paris; unknown
collector and/or dealer; Nathan Cummings,
Chicago; Alan H. Cummings, Palm Beach,
Florida; Sotheby's New York, sale of 11
November 1987; The Sara Lee Collection; The
Art Institute of Chicago

Exhibitions: Paris, Galerie André Weil, 9–30
June 1939, *Degas, peintre du mouvement*, no.
47; Minneapolis 1965; Miami, Florida, Center
for the Fine Arts, *Edgar Degas: The Many
Dimensions of a Master French Impressionist*,
1 April–15 May 1994; Jackson, Mississippi
Museum of Art, 29 May–31 July 1994; and
Dayton, Ohio, Dayton Art Institute, 12
August–9 October 1994: no. 8; Laren 1997–8.

Bibliography: Galerie Georges Petit,
*Catalogue des tableaux, pastels, et dessins par
Edgar Degas et provenant de son atelier*,
(auction catalogue), Paris: Galerie Georges
Petit, 1918, vol. 1, no. 176, p. 96, repr.
Henry Hertz, "Degas, coloriste," *L'Amour de
l'art*, v, (March 1924), p. 73, repr.
Paul-André Lemoisne, *Degas et son oeuvre*, III,
Paris: Arts et métiers graphiques, 1946–9,
vol. III (1946), no. 1205, p. 700–701, repr.
Brettell 1986, 1987, 1990, 1993, 1997,
pp. 52–3, 147, repr.
Dayton Institute of Art, Ohio, *Edgar Degas:
The Many Dimensions of a Master French
Impressionist*, 1994, p. 42, repr.

In 1946, Degas's great cataloguer, Paul-André Lemoisne, gathered on a single page photographs of four closely related pastels of a woman getting out of a tub in the presence of her maid.[1] All of them had been included in the 1918 Degas studio sale, but were scattered throughout the sale as if to suggest that Degas's repetitiveness needed to be de-emphasized in order to make the works more saleable.[2] Perhaps in response to this, the four works were purchased by four different owners and are now in four collections in three countries.[3] They have never since been grouped, either in publication or exhibition. The three pastels illustrated here belong to a large group of monotypes, prints, and pastels that investigate the manifold relationships between a nude female body and a metal bathing tub, usually in the presence of a maid or attendant, begun by Degas about 1876 and probably completed somewhat after 1900. This series is related by subject, but has an immense expressive variety and includes more than ninety works. Most of them seem to have been entitled after Degas's death, when they were included in the most important artist's studio sale of the first half of the twentieth century. Therefore, their titles do not accurately reflect the intention of their maker, but, rather, the marketing desires of the dealer, Georges Petit, who organized the sale in 1918.

Two of the three illustrated here are in public collections, one in the collection of modern art formed by Duncan Phillips at the Phillips Collection in Washington, D.C. (fig. 1.);[4] the second in the Kunstmuseum in Solothurn, Switzerland, which has a good many other riches from the distinguished collection of the early twentieth-century Swiss collector Joseph Müller (fig. 2).[5] These works seem to have been produced in a concerted burst of activity in the second half of the 1890s, and are closely related to a wax sculpture from the same decade, which seems to have served as the "model" for the figure of the woman.[6] Indeed, the scale of the wax figure is virtually identical to that of her pictorial variants, suggesting that Degas experienced the sculpture with his hands and eyes as he was translating her forms with charcoal onto tracing paper. Interestingly, all three of the pastels represent the figure in the same direction as the wax sculpture, indicating that he did not use the transparency of the paper to "reverse" the figure in any of the pastels.

Two of the pastels include a coffee-bearing maid at the far left of the composition and are, hence, entitled rather decorously, *Breakfast after the Bath*. The suggestion of a "morning bath" is not completely far-fetched, particularly in 1918, when it was made. Yet, the entire series seems to have had its origins in the brothel monotypes that Degas made in the 1870s, when bathing was done neither in the morning nor by very many "proper" women. In fact, the recent literature about Degas's women is all but obsessed with their status as prostitutes and with the "low" and even "dirty" aspects of these bathing rituals. In this, modern writers have taken up Huysman's 1886 view of Degas's bathers as a "piercing damnation of some women who enjoy the deviated pleasures of sex, a curse which makes them violently irrational as they humiliate themselves announcing to all the world the damp horror of a body that no bath can ever clean."[7]

The most detailed modern discussion of what might be called the sexual politics of bathing can be found in Eunice Lipton's lively book of 1986, *Looking into Degas: Uneasy Images of Women and Modern Life*, in which she marshals extensive evidence to demonstrate that most women who bathed in the 1870s and 1880s were prostitutes legally required to do so.[8] This "reading" of urban bathing images was inflected by Hollis Clayson, in both her dissertation and first book, *Painted Love: Prostitution in French Art of the Impressionist Era*.[9] This sociological approach to Degas's nudes has been enriched by Linda Nochlin, Richard Thomson, and Richard Kendall, all of whom have broadened the context of consideration from brothel to bedroom.[10] Degas himself seems to have encouraged a greater ambiguity of social meanings by altering the "context" of the bather from a suite of overtly brothel monotypes created in the 1870s for the private consumption of his male friends to a "suite of nudes" included in the final 1886 Impressionist Exhibition, in which most of the figures are alone, and finally to an unexhibited group of nudes made in the second half of the 1890s in which the interplay between the attendant maid and the nude is emphasized. Each time, the nude is, in a sense, "sanitized" and her identity as a "prostitute" de-emphasized as she is, by the 1890s, "served" coffee or tea by a woman who, in earlier representations, had merely helped her to dry herself.

Like Paul Cézanne, Edgar Degas left an enormous body of "unfinished" work in his studio at the time of his death. Many of the late unsigned works by Degas are now in the collections of the most important public museums in the world, so their being

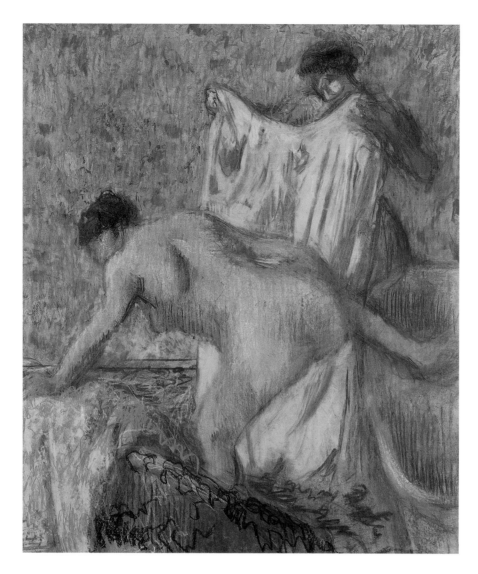

"unfinished" has certainly not "de-signified" them nor relegated them to the status of failed works or studio left-overs. Yet, it is still difficult to know just why Degas elected to sign and exhibit certain late pastels, while he left others of a similar quality and state of finish to languish in his studio. A precise examination of the three works illustrated in this entry – all of which remained in the studio – reveals that the two somewhat smaller works – those in the Phillips Collection and the Solothurn Museum – are more highly worked with colored pastel than is the Sara Lee pastel. In each of the more "finished" works, Degas has used colored pastel throughout the composition, creating interplays of texture and color that are in no way less "finished" than other late pastels that he signed and exhibited. The Sara Lee pastel has the status of a large colored drawing, dominated less by color than by the almost frantically drawn charcoal and black chalk lines that define both figure and setting. We know, however, that Degas had signed and exhibited works even less "finished" than this, and, from all the evidence of his well-studied oeuvre, it seems clear that the artist chose works to sign and exhibit from the large supply available in his studio, but that his choices must have been made because some of these were "on top" or near him rather than because of intrinsic difference in either "finish" or "quality."

The Sara Lee pastel shows evidence of a complex working procedure. It has the uneven "printed" or "impressed" edges of an irregular sheet of paper on three of its four sides, indicating clearly that it was used as part of a "transfer" process in which a second sheet of paper was placed on top of it and run through a printing press. Without precise measurements, it is impossible to tell whether one of the other two sheets under discussion derived directly from the Sara Lee pastel.

The addition of the Sara Lee bather to the collection of works by Degas at the Art Institute of Chicago will enable it to be studied further in a deserving context. Not only does the Art Institute possess one of the largest and most important of Degas's late

Fig. 1 Edgar Degas, *Breakfast after the Bath*, *c*.1895. The Philips Collection, Washington, D.C.

Fig. 2 Edgar Degas, *After the Bath*, 1888. Museum der Stadt Solothurn, Dübi-Müller Stiftung. Photo Schweizerisches Institut für Kunstwissenschaft, Zürich.

Bather compositions, given to the Art Institute in 1955 by Nathan Cummings (see Introduction, fig. 5), but it also has both an impression of the 1879 print by Degas closely related to the series as well as the great *Morning Bath* from the early 1890s, a work that may well have been the impetus for the group of works discussed here.

1. Lemoisne (1946), pp. 701.
2. They were included in Sale I, nos. 176, 255, and 303, and sale II, no. 180.
3. Lemoisne (1946), nos. 1204, 1205, 1206, 1207.
4. Lemoisne (1946), 1204.
5. Lemoisne (1946), 1207.
6. This relationship has been recognized not for the works under discussion here, but for a closely related, but earlier pastel, *The Morning Bath*, in the Art Institute of Chicago. For a pair of photographs that make the case clearly, Richard Kendall in *Degas: Beyond Impressionism* (exh. cat.), London, National Gallery, 1996, pp. 270–71. Interestingly, the pose of the sculpture is reversed from that of the figure in *The Morning Bath*, but is identical to that of each bathing figure in the five works under discussion here.
7. This passage is included here using the same translation provided by Eunice Lipton in *Looking into Degas: Uneasy Images of Women and Modern Life*, Berkeley: University of California Press, 1986, pp.179, 216. Lipton seems to have been the translator.
8. Ibid., pp. 164–86, 213–16.
9. See Hollis Clayson, *Painted Love: Prostitution in French Art of the Impressionist Era*, New Haven and London: Yale University Press, 1991.
10. See Linda Nochlin and Richard Thomson, *Degas: The Nudes*, London: Thames and Hudson, 1988, pp. 207–11. Thomson includes the best recent photograph of the Norton Simon monotype on which all this series is based; see pl. 82. See also Kendall (1996), pp. 141–71.

8

Edgar Degas (1834–1917)
The Russian Dancer (*La Danseuse russe*),
1898–9

Pastel, black chalk, and charcoal on tracing
paper mounted on tracing paper laid down on
cardboard, 67 × 57 cm. (26 × 22¼ in.)
Stamped with signature lower left: Degas
(Lugt 658)
Lemoisne 1193; Minervino 1085

Provenance: Atelier Edgar Degas, Paris;
Galerie Georges Petit, Paris, 11–13 December
1918 (Sale II), lot 122; Collection Veron, Paris;
Nathan Cummings, Chicago; Alan H.
Cummings, Palm Beach, Florida; The Sara
Lee Collection; Museum of Fine Arts, Houston

Exhibitions: Paris 1956: no 8; Rome 1956;
Minneapolis 1965; Washington, D.C. 1970: no.
8; New York 1971: no 8; Chicago 1973: no. 10;
Lakeland 1995; London, National Gallery,
Degas: Beyond Impressionism, 22 May–26
August 1996; and Chicago, The Art Institute
of Chicago, 28 September 1996–12 January
1997: no. 91; Laren 1997–8.

Bibliography: 1946 Paul-André Lemoisne,
Degas et son oeuvre, Paris: Arts et metiers
graphiques, 1946–9, vol. III (1946), no. 1193,
pp. 692–3, repr. (1984 reprint, New York and
London: Garland Publishing)
Franco Russoli and Fiorella Minervino,
L'opera completa di Degas, Milan: Rizzoli
Editore, 1970, no. 1085, pp. 134–5, repr.
Brettell 1993, 1997 (pp. 50–51 and 148 repr.)

9

Russian Dancers (*Les Danseuses russes*), 1899

Pastel on two pieces of tracing paper mounted
on board, 73 × 59 cm. (28½ × 22⅞ in.)
Signed lower left: Degas; atelier stamp on
verso
Lemoisne 1190; Minervino 1082

Provenance: Atelier Edgar Degas, Paris;
Ambroise Vollard, Paris; Galerie Georges
Petit, Paris; Rothschild Collection, Paris;
Nathan Cummings, Chicago; The Sara Lee
Collection; National Gallery , London

Exhibitions: Minneapolis 1965; Washington,
D.C. 1970: no. 9; New York 1971: no. 9;
Chicago 1973: no. 11; Winston-Salem 1990;
Memphis 1991; Lakeland 1995; London,
National Gallery, *Degas: Beyond
Impressionism*, 22 May–26 August 1996; and
Chicago, The Art Institute of Chicago, 28
September 1996–12 January 1997.

Bibliography: Galerie Georges Petit,
*Catalogue des Tableaux, Pastels, et Dessins par
Edgar Degas et provenant de son atelier* (sale
catalogue), Paris: Galerie Georges Petit, 1918,
p. 88.
Paul-Andre Lemoisne, *Degas et son oeuvre*,
Paris: Arts et métiers graphiques, 1946–9, vol.
III (1946), no. 1190, pp. 690–91, repr.; 1984
reprint, New York: Garland Publishing, Inc.
Franco Russoli and Fiorella Minervino,
L'opera completa di Degas, Milan: Rizzoli
Editore, 1970, no. 1082, pp. 134–5, repr.
Brettell 1986, 1987, 1990, pp. 76–7, 138, repr.

Degas's so-called Russian Dancers are at once
much studied and deeply mysterious. Since
Lemoisne first published fourteen pastels from
the series in 1943, scholars have argued about
the identity of these dancers.[1] Were they a
Russian folk-dance troupe who danced at the
Folies Bergère in 1895, as Lesmoine claimed?[2]
Or, at the other end of the chronological
spectrum, were they dancers from the Ballets
Russes, who first arrived in Paris in 1908?
Clearly not the latter, because Julie Manet
reported that Degas showed her a group of
finished pastels representing dancers wearing
Russian costume in July 1899, and Degas is
known to have all but stopped work after
1904–5.[3] Yet, surely there were other
opportunities, many of them undocumented
today, for Degas to have seen "Slavic" or
"Russian" dancers or even French dancers
wearing the Russian costumes, as Manet
implied, and the fact that we do not know
exactly which ones he saw need not trouble us
excessively. In fact, the French romance with
Russia and the Russian romance with France
continued unabated in the last decade of the
nineteenth century, as Russian performers,
composers, painters, writers, and architects
came in large numbers to the cultural capital
of Europe for encouragement and education,
and as Russian collectors began their
systematic acquisition of French vanguard art.
Works by Degas himself were soon to enter
the great Moscow collections of Shchukin and

Fig. 1 Edgar Degas, *Russian Dancers*. Berwick-
on-Tweed Borough Museum and Art Gallery.
Photo The Bridgeman Art Library, London/New
York.

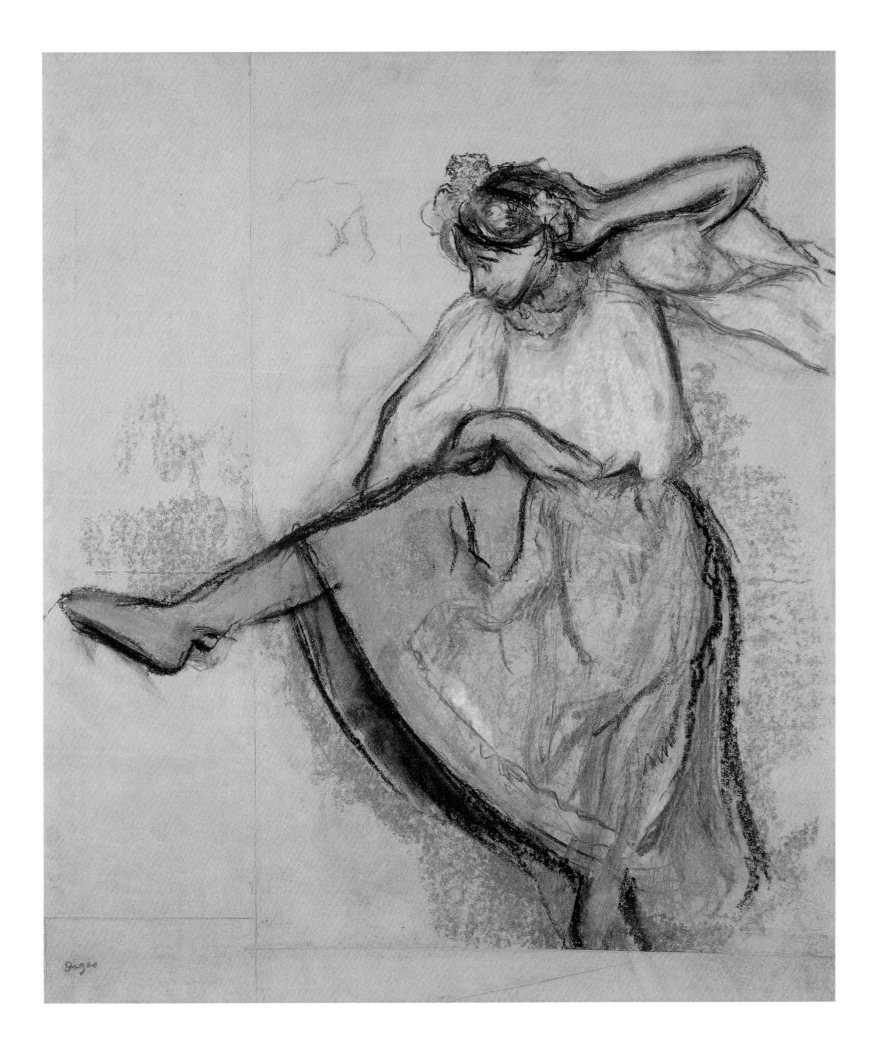

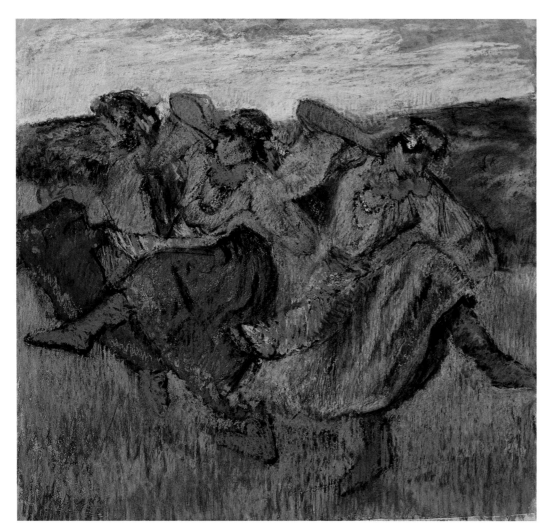

Fig. 2 Edgar Degas, *Russian Dancers*, 1899.
The Museum of Fine Arts, Houston; The John A.
and Audrey Jones Beck Collection.

the figure in both these sheets is never exactly repeated in any one of the elaborate three-, four-, or five-figure compositions that emerged from them.[11] In each subsequent case, she is reclothed, completely reversed, or partially reversed from the model. It is also surprising that Degas seems not to have made wax sculptures of any of these figures, perhaps not needing the tactile reassurance of a "model" when he was so intensely involved with costumes that did less to reveal the body beneath them than visually to exaggerate its movement. Of the two works discussed here, Degas seems to have been more interested in the Sara Lee sheet, which he sent to be remounted, ordering that an additional strip of tracing paper be added to the lower edge. Although he never again took up the sheet to "complete" it, *Russian Dancer* shares a similar level of finish to that of two other pastels, one of a single dancer and the other of two dancers, that Degas had signed and sold to Vollard before his death.[12] It is fitting that the Sara Lee *Russian Dancer* will enter the permanent collection of the Museum of Fine Arts, Houston, the possessor of one of the large-scale finished pastels that Degas showed to Julie Manet in the summer of 1899 (fig 2).

The more heavily worked and complex sheet of *Russian Dancers* in the Sara Lee collection and its "study," now in the Lewyt Collection in New York,[13] are unique in their compression of a group Russian dancers onto a vertical surface. The resulting de-emphasis of the landscape enabled Degas to crowd the figures along the left edge of the composition in a manner that relates clearly to a large group of ballet compositions in which dancers are seen either leaving or entering the stage as part of the *corps de ballet*. In fact, there is one late pastel of ballet dancers that not only shares virtually identical dimensions with the Sara Lee *Russian Dancers*, but was also "enlarged" by Degas with the addition of a strip at the lower edge in precisely the same manner as the Sara Lee sheet.[14] Although there is absolutely no documentary evidence that Degas intended these two works as pendants, their chromatic and iconographic contrasts would have worked admirably if they were presented in such a manner. The Sara Lee *Russian Dancers* will join the group of thirteen other works by Degas in the National Gallery in London. Interestingly, it made its modern "debut" at the National Gallery in London for the exhibition, *Degas: Beyond Impressionism* of 1996.

Morosov within a few years of the *Russian Dancers*.[4]

The two works representing Russian dancers in the Sara Lee Collection were both published by Lemoisne, most likely from photographs made at the time of the Degas sales of 1918, in which eight of the fourteen were included.[5] Interestingly, six others had been sold by Degas, one to Durand-Ruel[6] and five to Ambroise Vollard,[7] who, subsequently, bought another in the studio sales.[8] Since that time, an additional black and red chalk drawing, unknown to Lemoisne and mysteriously omitted from the studio sales, has been published and exhibited, most recently in *Degas: Beyond Impressionism* at the National Gallery in London and the Art Institute of Chicago in 1996.[9] This formidable body of closely interrelated works — together with a small group of pastels representing bathers out of doors, an odd quasi-series of ballet scenes out of doors, and a few pastels representing racehorses and jockeys in the

landscape — are Degas's sole late investigation of an archetypal Impressionist subject — the figure in a natural landscape. Yet, for Degas in the 1890s Impressionism was absolutely dead, and he stressed the artificiality both of nature and of man's role in it. Even the horses cavorting in fields seem to be prancing amidst a landscape that derives as much from painted theater flats as from the natural landscapes, and there is no question in our minds when we look at the Russian dancers that they are not dancing in an actual landscape, but in an imagined one.

The less worked of the two Sara Lee Russian Dancers, the single *Russian Dancer* (cat. 8), is a powerful work of art that relates closely to another, Lemoisne 1192, in a European private collection.[10] Indeed, it seems clear that these two are among the earliest of the group and that, in creating them, Degas began to investigate the interplay of human limbs and heavy drapery that was to consume him for the next few months. Interestingly,

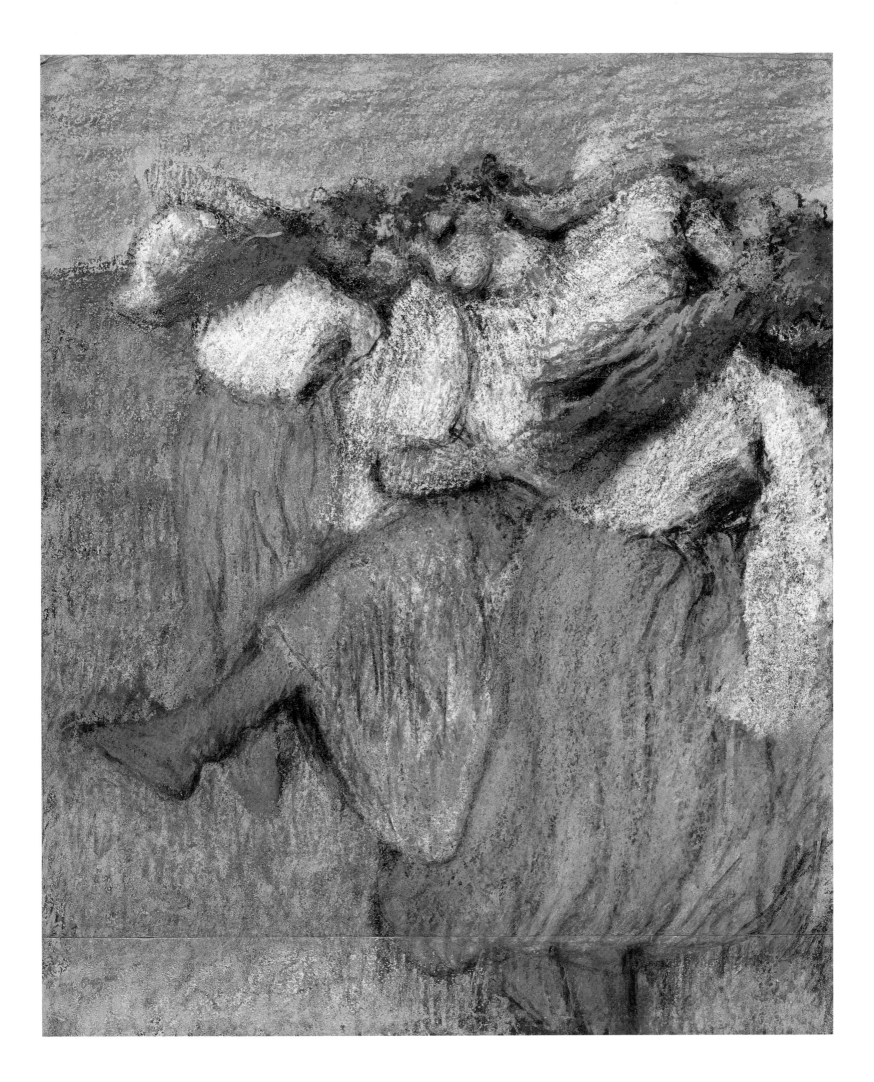

1. Lemoisne 1181–94.

2. Ibid. 1181.

3. The letter from Julie Manet is most accessibly quoted in the catalogue for the Degas exhibition at the Metropolitan Museum. For the most compressed and lucid discussion of the series, see Richard Kendall, *Degas: Beyond Impressionism*, New Haven and London: Yale University Press, 1994, p. 278.

4. Degas even dedicated a pastel to a "M. J. Stchoukine [sic]," presumably the famous Russian collector. For an excellent color reproduction and an intelligent entry, see Götz Adriani, *Degas: Pastels, Oil Sketches, and Drawings*, New York: Abbeville Press, 1985, plate 182, pp. 386–7.

5. These were Lemoisne 1182, 1187, 1189, 1190, 1191, 1192, 1193, 1194.

6. Lemoisne 1181

7. Lemoisne 1183, 1184, 1185, 1186, and 1188.

8. Lemoisne 1190.

9. See London (1996), cat. no. 96., p. 287.

10. See Götz Adriani, *Edgar Degas, Pastelle, Olskizzen, Zeichnungen* (exh. cat.), Tübingen, Kunsthalle, Cologne: Du Mont Buchverlag, 1984 (published in English by Abbeville Press, New York, 1985); and Philippe Brame and Théodore Reff, *Degas et son oeuvre: A supplement*, New York and London: Garland Publishing, 1984.

11. Her closest counterpart is the second figure from the left in the Sara Lee *Russian Dancers* (cat. 9). But, even here, she is reclothed and recoiffed so as to be part of the ensemble.

12. These are Lemoisne 1184, now in the Metropolitan Museum, New York, and Lemoisne 1185, now in the Burrell Collection, Glasgow.

13. These works were first juxtaposed in London (1996).

14. See Lemoisne 1397, formerly Feilchenfelt Collection, Zurich.

Raoul Dufy (1887–1953)
Gust of Wind (*Coup de vent*) [also known as
The Fishermen (*Pecheurs à la ligne*)], 1907

Oil on canvas, 54 × 65 cm. (21¼ × 25¼ in.)
Signed lower right: R Dufy
Laffaille 156

Provenance: Jacques Zoubaloff, Paris; Galerie
Georges Petit, Paris, 17 June 1927, no. 114;
Private Collection, Paris; Genia and Charles
Zadok, Milwaukee; Museum of Modern Art,
New York; Nathan Cummings, New York;
The Sara Lee Collection; The Singer Museum,
Laren, The Netherlands

Exhibitions: New York, Museum of Modern
Art, *Les Fauves*, 8 October 1952–4 January
1953; Minneapolis Institute of Arts, 21
January–22 February 1953; San Francisco
Museum of Art, 13 March –12 April 1953; and
Art Gallery of Toronto, 1–31 May 1953: no. 50
(as *Anglers at Sunset*); San Francisco Museum
of Art, *Raoul Dufy, 1877–1953*, May–June
1954; and Los Angeles County Museum, June-
September 1954: no. 7 (as *Anglers at Sunset*);
Paris, Musée National d'Art Moderne, *Le
Fauvisme français et les debut de
l'Expressionisme allemand*, and Munich, Haus
der Kunst, 1966: no. 45 (as *Pecheurs à la ligne*,
*c.*1908); Lakeland 1995; Laren 1997–8

Bibliography: Galerie Georges Petit, *Collection
Jacques Zoubaloff* (auction cat.), Paris: Galerie
Georges Petit, 1927, n. p., no. 114 (as *Plage de
Trouville par gros temps*), repr.
Georges Duthuit, *Les Fauves*, Geneva:
Editions des Trois Colines, 1949, p. 149 (as *Les
Pecheurs*, 1905, private collection, Paris), repr.
Georges Duthuit, *The Fauvist Painters*, New
York: Wittenborn Schulz, Inc., 1950, n. p.,
pl. 34 (as *The Fisherman*, 1905).
Bulletin of the Museum of Modern Art, xx,
no. 3–4 (1953), no. 50 (as *Anglers at Sunset*), p.
19, repr.
Joseph-Marie Muller, *Le Fauvisme*, Paris: Ed.
Hazan, 1967, no. 124, p. 123, repr.
Maurice Laffaille, *Raoul Dufy: catalogue
raisonné de l'oeuvre peint*, vol. I, Geneva:
Editions Motte, 1972, no. 156, p. 138, repr.
Kim Youngna, *The Early Works of Georges
Braque, Raoul Dufy, and Othon Friesz: The Le
Havre Group of Fauvist Painters* [Ph.D.
dissertation, Ohio State University, 1980] Ann
Arbor, Michigan: University Microfilms, 1980,
p. 390, repr.
Brettell 1993, 1997 (pp. 64–5, 149, repr.).

If this work were shown for identification
(with its signature masked) to virtually any
student of modern art, it would be identified
as a German Expressionist painting, possibly
an early Kirchner, and dated about 1911–12.
The fact that it is the work of the Frenchman
Raoul Dufy, and that it was painted in 1907,
before Dufy ever went to Germany, would
come as a shock to the hypothetical student.
How, one might ask, could Dufy, the painter
of post-Fauve pleasantries and the archetypal
decorative painter of the twentieth-century
French school, create this emotionally
charged, almost melodramatically
Expressionist canvas? Dufy's beach is
represented at sunset, lit by a pentagonal sun
of brilliant orange that seems to wound both
the sky and the water in which its light is
reflected. The fisherman dance in
performance of a strange rite, and the male
figures grab their hats in the wind in another
ritual of nature-worship. The three female
figures – one with a white parasol and the
others with a black umbrella – have all the
power of cult goddesses, reminding us of
André Gide's "culte de la vie."[1]

It is the apparent "Germanness" of this
canvas that was recognized in 1966, when it
was included in the exhibition, *Le Fauvisme
français et les debuts de l'Expressionisme
allemand* (French Fauvism and the Birth of
German Expressionism), held in Paris and
Munich. Perhaps in recognition of this very
"Germanness," the painting was not
requested for the most important exhibition of
Fauve painting of the last generation, *The
Fauve Landscape* in Los Angeles and New
York in 1990. Yet, the first – and in some
ways, most important – critic of Fauvism,
Georges Duthuit, included the painting as the
only Dufy among the sixteen color plates in
his book, published in Geneva in 1949 and in
English in 1950, and it was owned by the
Museum of Modern Art for twenty-four years
(1953–77) before Nathan Cummings became
its owner.[2]

How do we account for this painting?
There is nothing quite like it in Dufy's oeuvre,
which was catalogued by Maurice Laffaille in
1967.[3] Although it is difficult to get a secure
sense either of Dufy chronology or of the
chromatic structure of his works from this
catalogue, its completeness makes up for the
many deficiencies in its arrangement. Of the
Fauve works from 1905–8, there are more
than a hundred, all of which are arranged by
the location of their represented subject rather
than in chronological order. A large number
of these works represent the sea coast, with
the intertwined human rituals of fishing and

tourist leisure, occasionally at moments of
apparent conflict such as that represented in
the *Gust of Wind*. When seen together, even
in black and white, these works are crowded
with figures, who walk, fish, swim, gawk,
drink, play, sell, stare, buy, dance, boat, and
participate in what might be called the
"spectacle" of life. In this way, the works deal
resolutely with "public" life, and the *Gust of
Wind* shares that preoccupation. Yet, in only
one other work from the period is there a
representation of the sun, which so dominates
the *Gust of Wind* and which provides it with
the bright orange that necessitates its opposite
– brilliant blue-green.

Raoul Dufy was thirty years old in 1907,
when this canvas is most often dated.[4] His
earlier paintings derive from a tradition of
French painting from the north of France,
dating back to the 1850s when Monet's
teacher, Eugène Boudin, began recording the
interaction between the sea and its human
users. When one looks at the extraordinary
paintings executed by Boudin's greatest pupil,
Monet, in the summer of 1870 at Trouville, a
little of the boldness of Dufy's painting can be
explained. Yet, the expressionist drama of this
painting has other northern origins, this time
in the paintings of van Gogh, which were
often exhibited in Paris after 1905 and
underlie the achievements of Dufy and his
fellow Fauve painters more importantly than
any other single source. Indeed, the sun in
Dufy's painting can, with other comparable
suns, particularly those of Dufy's friend Albert
Marquet, be clearly related to the resonant
suns, moons, and stars of van Gogh, who, like
Dufy, used complementary colors to express
what he called "the passions of humanity."
When looking at this and other works by
Dufy, we are forced to "remember" also
another northerner, Edvard Munch (see fig.
1), whose representations of the often-
suppressed passions of the bourgeoisie
provided inspiration to the young Dufy.

The very wildness of this painting, which
makes it seem more Expressionist than Fauve
reminds us of the "wildness" of the Fauve
"beasts," who were seen as artists who painted
instinctively (without thinking) and whose
pictorial worlds collided with the conventions
of French bourgeois society. Although most of
the men who were at the center of Fauve
painting were themselves conventionally
married and reasonably secure in the middle
class, their paintings were seen as radical and
revolutionary assaults on middle-class social
conventions. The Fauves read everything
from André Gide and Alfred Jarry to
Strindberg and Nietzsche, all of whom

Fig. 1 Edvard Munch, *The Dance of Life*,
1899–1900. Nasjonalgalleriet, Oslo. Photo: J.
Lathian © Nasjonalgalleriet, Oslo. © Munch
Museum/Munch-Ellingsen Group/DACS, London
1999.

advocated a life of individual passion rather
than social convention, and many of whom
were closely associated with vanguard
culture.[5] It is to this world that we must turn
in order to understand Dufy's powerful *Gust
of Wind*, not the sun-kissed and easy world of
the Mediterranean associated with Matisse.

1. See André Gide, *Les Nourritures terrestres*, Paris,
1947 (first published in 1897). For a full discussion of
this fascinating form of anthropology, see Ellen C.
Oppler, *Fauvism Reexamined*, New York: Garland
Publishing, 1976, pp. 195–200.
2. For the earlier French edition, see Duthuit (1949),
p. 149.
3. See Laffaille (1972); no. 156, was then in the
collection of the Museum of Modern Art, New York,
had been given by Mr. and Mrs. Charles Zadok. It is
reproduced in black and white with considerable glare
in the lower right.
4. The painting has been dated as early as 1905 (by
Duthuit) and as late as 1908 (Museum of Modern
Art). The former is clearly wrong, given the
comparative material available in the catalogue
raisonné. The latter is not impossible.
5. The intellectual context of Fauvism is brilliantly
discussed in Oppler, *Fauvism Reexamined, op. cit.*
Unfortunately, the author applies very little of this
"context" to the interpretation of specific works of art.

11

Raoul Dufy (1887–1953)
Allegory of Electricity (*La Fée Electricité*),
1936–7

Watercolor and gouache on paper mounted on
panel (five panels), 1 × 6 m. (38½ × 235 in.),
overall
Signed and dated, lower center, second panel
from left: Raoul Dufy pinxit 1937
Guillon-Laffaille 1909–13

Provenance: Artist's collection; Galerie
Charpentier, Paris; La Palme, Paris; Nathan
Cummings, New York; Mrs. Robert Mayer
with her son Robert N. Mayer and her
daughter Ruth M. Durchslag; The Sara Lee
Collection; Detroit Institute of Arts

Exhibitions: Washington, D.C. 1970: nos. 53–7;
New York 1971: nos. 53–7; Memphis 1991;
Laren 1997–8

Bibliography: Bernard Dorival, *La Belle
Histoire de La Fée Electricité de Raoul Dufy*,
Paris: La Palme, 1953, n. p., repr.
Fanny Guillon-Laffaille, *Raoul Dufy:
catalogue raisonné des aquarelles, gouaches, et
pastels*, Paris: Editions Louis Carré, 1982, no.
1909–13, pp. 310–12, repr.
Consolidated Foods Corporation, *Consolidated
Foods Corporation's Nathan Cummings
Collection*, Chicago: Consolidated Foods
Corporation, 1983, p.15, fig. 9.
Brettell 1986, 1987, 1990, 1993, 1997,
pp. 112–17, 149–50, repr.

Fig. 1
Installation
photo of
*Allegory of
Electricity* in the
1937 World's
Fair, Paris.

In March 1936 Raoul Dufy was asked to
create an immense historical mural for the
Palais de la Lumière at the 1937 Exposition
Universelle (World's Fair) in Paris. Designed
to dominate a vast interior space in a building
by the noted vanguard architect Robert
Mallet-Stevens (in collaboration with Georges
Pingusson), to be artificially lit with electric
lighting designed by the engineer Salomon,
the mural was the end-process of a lengthy
period of study and work of an intensity and
complexity rare in the history of modern art.
One must look to the Mexican muralists and
to certain of the large-scale public schemes for
America's WPA for comparison. Nothing by
any of the masters of modernism, not even
Picasso's exactly contemporary *Guernica*, nor
Matisse's Barnes murals, nor even Monet's
Nymphéas at the Musée de l'Orangerie could
compete in scale and physical complexity with
Dufy's *Allegory of Electricity* when it was
revealed at the opening of the Exposition
Universelle on 26 June 1937.

The effect must have been astonishing.
The Mallet-Stevens building stood at the end
of the Champs de Mars, directly on axis with
the Eiffel Tower but in every way its opposite.
Whereas the Eiffel Tower was a symbol of
progress in 1889 and light in 1900, it had
become familiar, somewhat dated, and
symbolically tired by 1937, and Mallet-
Stevens's Palace of Light was designed to
complement and, in a way, empower it. The
façade of the building was an immense
horizontal curve, 600 meters (nearly 2,000
feet) square, to be viewed through the arch of
the Eiffel Tower and to be animated night

and day by an electric spark 7.5 meters in
length, which leaped between two solenoid
columns rising from a large reflecting pool in
front of the building. Two staircases led
visitors to an immense interior hall dominated
by Dufy's painting – 60 meters (200 feet) long
and 10 meters (33 feet) high. The power of
the painting was intensified because the space
in which it was placed was completely dark,
with the room's only light a row of intense
spotlights that illuminated Dufy's vast
panorama of electricity (fig. 1).[1] It must have
seemed as if the painting itself emanated
light.

The enormous mural resulted from a
process of reading, research, and preparatory
drawing that was compressed into a period of
only three weeks. In that period, Dufy read –
re-read, he claimed – Lucretius' *De rerum
natura*, visited the power station at Vitry, and
consulted a large variety of texts and people so
as to create a general concept of the work. He
also designed an involved and highly
collaborative process of research and execution
that was to occupy him from March 1936
until 8 May 1937, when he finished the work.
The contract he signed in July 1936 obliged
him to supply the work itself, a smaller
version (2.5 × 25 m.), and fifty drawings or
watercolors, and, although he negotiated a
reduction in the scale of the smaller version
(to 1 × 6 m.) and a slight increase in his fee, he
completed everything in a manner so efficient
that he seemed almost more akin to a
manager than to an artist. The research aspect
of the process was under the direction of
Dufy's brother Jean, and the execution was
ably directed by his assistant André Robert.[2]

The Sara Lee painted drawing of the
composition is not the reduction specified in
his contract (which is now in the collection of
the Musée d'Art Moderne de la Ville de Paris;
fig. 2). Instead, it seems to have been the
initial cartoon for the composition, perhaps
even the work shown to the directors of the
Compagnie Parisienne de Distribution de
l'Electricité, who commissioned the mural
from Dufy. Dufy himself retained ownership
of the Sara Lee version, and it is likely that it
was this version that Dufy used as the basis
for the gigantic work executed in a studio
built in a modified warehouse in Saint-Ouen,
where he worked on a giant easel measuring
10 × 18 meters. For that reason, it is likely that
the Sara Lee study was made in 1936, not
1937 as it is dated, and that Dufy signed and
dated it later, using the date of the "finished"
composition rather than the actual date of the
study. To translate the Sara Lee study to the
final mural, Dufy worked by first sectioning

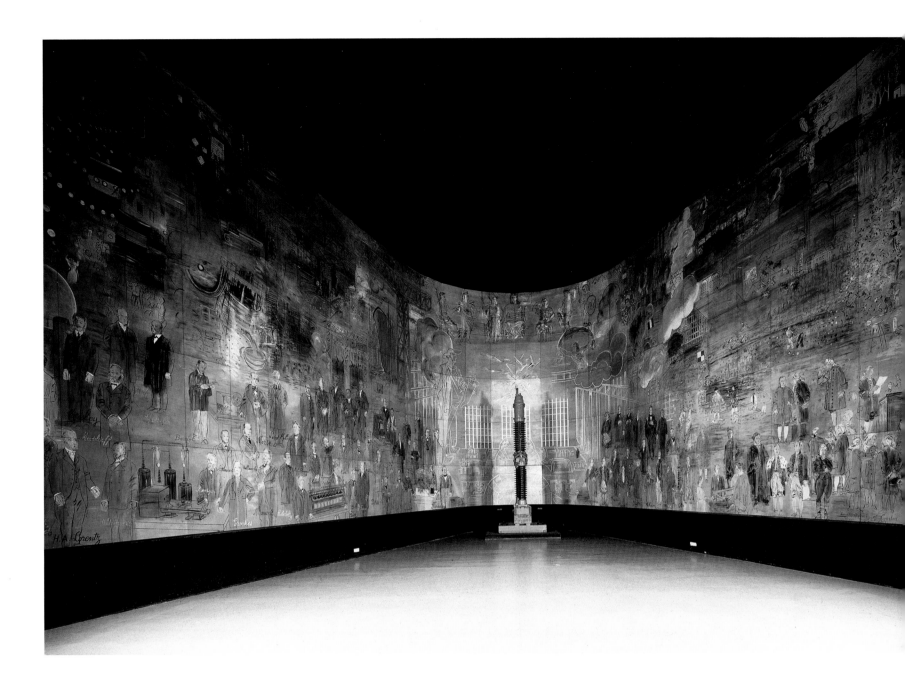

the entire composition (there is evidence of this squaring in all five panels of the Sara Lee version). He then decided on the scale for the sectioned panels of the actual work (1.2 × 2 m.) and created black and white drawings of the section of the composition to be transferred. Next, he projected those drawings onto the panels using an opaque projector, and, finally, painted each of the panels himself from the projected lines. Although Dufy used an assistant to help him in the projection and translation of aspects of the work, the final painting, like the Sara Lee cartoon, is almost completely autograph.

The Sara Lee drawing is one of hundreds of other drawings, gouaches, and watercolors made in preparation for the finished work.[3] Certain of them were compositional studies,

but many more were studies of individual figures in the completed work. There are more than one hundred individual figures, whose names are recorded on the surface of the immense decoration. For most of these Dufy hired models, posed and drew them in the nude, and costumed them before drawing them again. There are, hence, more than 150 drawings that survive and many more that were made in the process of preparation. What is extraordinary about this elaborate process of creation is just how little Dufy allows us to suspect it when we look at the finished work of art. Indeed, like Matisse and others among his artist-friends, Dufy worked hard to create something that appears effortless, practicing each line several times before being assured of its rightness and

Fig. 2 Raoul Dufy, *Allegory of Electricity*. Musée d'Art Moderne de la Ville de Paris. © Photothèque des Musées de la Ville de Paris.

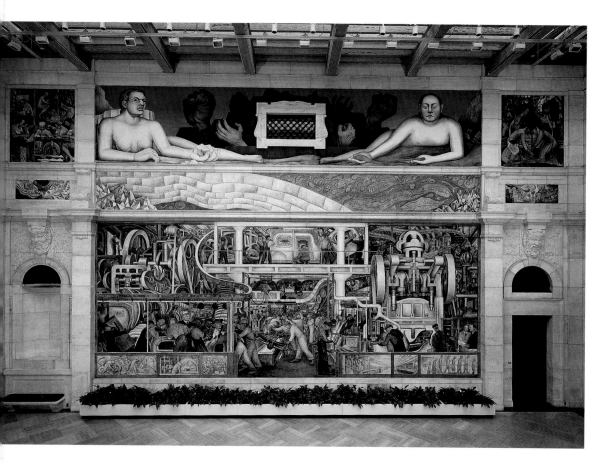

Fig. 3 Diego Rivera, *Mural: Detroit Industry*, 1932–3. Detroit Institute of Arts; Gift of Edsel B. Ford.

1. The most accessible published photograph of this can be found in Dora Perez-Tibi's monograph, *Dufy*, London: Thames and Hudson, 1989, p. 252.
2. This material is summarized from two accounts of the mural: Antoinette Rezé-Huré, "*Le Fée Électricité*, 1937, and *La Seine, l'Oise, et la Marne*, 1937–40," in *Raoul Dufy (1877–1953)*, London: Arts Council of Great Britain, 1984, pp.109–13, Perez-Tibi (1989), pp. 251–64.
3. In spite of the enormously prolific cataloguing "industry" for Dufy (there are published catalogues of the paintings, drawings, watercolors, gouaches, prints, etc.), the drawings done for the *Allegory of Electricity* have not been published *in toto*. The generalizations about them derive from Perez-Tibi (1989).
4. This mode of working has been much discussed in the Matisse literature, and there are many places where Matisse's variously "easy" drawings are discussed in the terms of the "difficulty" he had in making them. However, there is not, to my knowledge, a larger discussion of "scribbled" drawings and *croquis* as a general phenomenon in European vanguard art of the late nineteenth and early twentieth centuries. The tendency to draw quickly (often without looking at the drawing, but, rather, at the motif itself), is pervasive in post-Impressionist artistic process and is in need of a general assessment.
5. The Fribourg campus was being built in an extraordinary architectural complex designed by the great French architect Auguste Peret. Peret was familiar with Dufy's work, and was probably instrumental in the unrealized commission. There is only a hint of this project in Rezé-Huré's essay on the *Allegory of Electricity*. In it, she discusses Dufy's process of "plunging into the mystic and the Holy Fathers for an equally monumental commission for . . . a *Triumph of Religion*." (Rezé-Huré (1984), p. 109).

eloquence. Yet, when the line is "finally" drawn, it has resulted from a process of drawing that makes it inevitable rather than "easy," as it first appears.[4]

In their recent analyses of the working method for the creation of the large-scale painting, Antoinette Rezé-Huré and Dora Perez-Tibi, both consider the work in the context of other large-scale decorations by Dufy (both realized and projected). Mme. Rezé-Huré is particularly tantalizing when she contrasts the 1936–7 electricity mural with a contemporary project called *Triumph of Religion*, commissioned for the Faculty of Theology at the University of Fribourg in Switzerland but never realized.[5] Perez-Tibi is considerably more conscious than Rezé-Huré of the original positioning of the mural and actually publishes a photograph of it *in situ*. Because the original mural has been transferred to three walls of a much smaller room in the Musée d'Art Moderne de la Ville de Paris (fig. 2), it is difficult today to feel the power and elegance of Dufy's original conception.

Dufy's decorations are among the most important sub-genre of his large and well-catalogued oeuvre. The *Allegory of Electricity* has been routinely compared to Dufy's slightly later decorations for the theater bar in the Palais de Chaillot. Yet, it is surely the failed decorations for Fribourg that are more closely associated in their vaunting ambitions and intellectual sweep. Dufy's achievement as a "decorative" painter was to render history and ideas in a form so apparently easy and charming – that is, so "decorative" – that they appeal instantly to an uneducated viewer. He was, in the best sense, a "popularizer," appealing to the large and diverse "crowd" at a vast world's fair.

When this work enters the permanent collection of the Detroit Institute of Arts, it will join a museum collection crowned by the most important large-scale mural by Diego Rivera outside his native Mexico (fig. 3). This work has a fascinating and thoroughly antithetical relationship with Dufy's vast decorative scheme. Whereas Rivera was highly critical of industrial capitalism and painted a composition that demonstrates the combined effects of greed and ambition on the lives of workers, Dufy seems cheerfully historical by contrast. For him, the backbreaking work of peasants will be alleviated by electricity, and the physical work of the past will be replaced by the power of nature harnessed by man. When they are together, these mural conceptions will tell one great story in two completely different ways.

Pacinotti

Gramme

Rateau

12

Paul Gauguin (1848–1903)
Clay Jug and Iron Jug (*Le Pot de terre et le pot de fer*), 1880

Oil on canvas, 55 × 65 cm. (21⅜ × 25¹³⁄₁₆ in.)
Signed and dated lower left on tablecloth:
P Gauguin 80
Wildenstein 47

Provenance: Emile Schuffenecker, Paris;
Unknown owner(s); Nathan Cummings,
Chicago; The Sara Lee Collection; The Art
Institute of Chicago

Exhibitions: Paris, Galerie Charpentier,
Tableaux de la vie silencieuse, 1946: no. 26;
Lyons, Musée des Beaux-Arts, *Les Grands
Courants de la peinture contemporaine*, 1949:
no. 43; Winston-Salem 1990; Memphis 1991;
Lakeland 1995; Laren 1997–8.

Bibliography: Raymond Cogniat, *Gauguin*,
Paris: Editions Pierre Tisné, 1947, pl. 6.
Lee van Dovski [Herbert Lewandowski], *Paul
Gauguin oder die Flucht von der Zivilisation*,
Berne, 1950, no. 23, p. 339.
Georges Wildenstein, *Gauguin*, Paris: Les
Beaux-Arts, 1964, p.22, no. 47, repr.
Elda Fezzi, *Gauguin*, Milan: Rizzoli Editore,
1980, p. 21, repr.
Brettell 1986, 1987, 1990, 1993, 1997 (pp.
38–9, 151, repr.)
1993 Belinda Thomson, ed., *Gauguin by
Himself*, Boston: Little Brown and Company,
1993, p. 56, fig. 32.
James G. Massey, Arthur J. Powell, and Norm
W. Wilson, *Windows and Images: An
Introduction to the Humanities*, Needham
Heights, Massachusetts: Simon and Schuster
Custom Publishing, 1994, cover.

Fig. 1 Norwegian eighteenth-century rootwood
tankard, once the property of Paul Gauguin (ex.
coll. Matte Gauguin). Courtesy of the Trafalgar
Galleries, London.

Like many of Gauguin's early paintings, *Clay Jug and Iron Jug* is at once problematic and deeply original. There is, in fact, nothing quite like it in the history of still-life painting. The Dutch loved to paint still-lifes with contrasting ceramic, metal, and glass containers, but no Dutch picture is close enough to this one to act as a source. Gauguin may also have been looking at works by the greatest French still-life painter, Chardin, but again it is not possible to identify a particular source. Indeed, all the works by the Dutch and by Chardin are artful compositions in which the overlapping volumes of the represented containers resonate in space. Gauguin, as if being contrary, simply placed the two containers next to each other on a table, juxtaposing them with a green piece of fabric, which like the containers themselves, is curiously inert and ungraceful, and placing all of this in front of a wall decorated with another fabric hanging, which has always been identified as "Peruvian" in the Gauguin literature. This supposedly "exotic" element is, in the end, even more banal than the two containers, forcing the viewer back again to the mystery of the foreground.

What, actually, is the subject of this painting? The title in the Wildenstein catalogue raisonné seems to be the only clue – and it is scarcely a reliable one. *Clay Jug and Iron Jug* comes, seemingly, from the painter's first owner, Emile Schuffenecker, who was close to Gauguin and his wife Mette throughout the 1880s. Yet the painting does not seem ever to have been exhibited with that title during Gauguin's lifetime, and the only reason that it is accepted today is that it helps to interpret this otherwise enigmatic painting. Anyone who has ever read fables immediately recognizes it as the title of a fable by La Fontaine, adapted, as are most of his fables, from an earlier text ascribed to the Greek fabulist Aesop. This fable tells the imaginary tale of a clay pot and an iron pot, who are sitting together around a hearth. The iron pot proposes that the clay pot accompany it on a journey. The clay pot demurs, preferring to remain unbroken in the cozy corner near the fireplace where it usually lives. After a good deal of persuasion and with the offer of protection by the iron pot, the clay pot finally accepts the invitation, begins the journey, and eventually breaks. Such, we are told by La Fontaine, is the destiny of both pots.

This story is as enigmatic as the painting it is used to "explain," and, as with a good deal of Gauguin's art, leads the interpreter further into mystery. Yet, if all that is suspected about

Fig. 2 Paul Gauguin, *Sleeping Child*, 1883. Josefowitz Collection.

Fig. 3 Paul Gauguin, *The Painter's Home*, 1881.
Nasjonalgalleriet, Oslo. Photo J. Lathian © Nasjonalgalleriet, Oslo.

this painting is true – its date, its title, and its first owner, Gauguin's decision to paint it begins to make sense in a biographical way. Both Paul Gauguin and Emile Schuffenecker were at that time amateur artists who made money in business. Schuffenecker did well enough with gold investments to put aside a good amount of money by 1880, after which he married, started a family, and turned himself to art full-time. Gauguin went about things the other way. He married and started a family early, before advancing in a business career, and, after meeting Pissarro and becoming involved with the Impressionists in 1879, he turned away from business to painting before having actually made enough money to support his new life. In fact, 1880 was a year of crisis for Gauguin and his Danish wife Mette Gad, and all biographies of Gauguin, particularly the detailed chronological study of David Sweetman[1], make it clear that their marriage was beginning to crumble in 1880, that Gauguin may even have written to his mother-in-law threatening divorce, that Mette's extravagant spending forced them into smaller housing, and that Shuffenecker was the "middle man" in their marital battles.

The subject of the picture is two pots, one definitely made of metal (probably tin or pewter) and the other seemingly of clay. Although the pieces of woven fabric are also elements in this very simple still-life, they are clearly peripheral to the central relationship between the two pots. What is known of those pots? Both belonged to Gauguin, because he used both in other, later still-life paintings. The larger, clay pot has, in fact, been identified with a specific tankard owned by the family of Gauguin's wife (fig. 1). Yet, in the published description of the tankard, it is described as being carved out of wood rather than formed from clay.[2] It is also identified as both a tankard and a tobacco jar. This vessel appears in two important and mysterious later paintings by Gauguin: the identically sized *Sleeping Child* of 1883 (fig. 2) and a larger and more ambitious still-life in a private collection in Switzerland, which Gauguin painted in 1885 in the house of his wife's family in Denmark.

The metal jug, smaller and clearly dented, is hardly a beauty, but it seems already to have survived a good deal of travel beyond its hearth-home. In comparison with the eighteenth-century Scandinavian tankard, the pitcher seems small, ordinary, and resolutely plebian. Gauguin again included it in a still-life painting of 1883 in which it is juxtaposed with a pile of tomatoes. It seems possible that,

for Gauguin, the tankard "represented" Mette, while the metal pitcher is, by contrast, a self-portrait. Alternatively, the painting can be interpreted in geographical terms – with the Peruvian textile, the Scandinavian pot, and the French pot being aspects of Gauguin's life arranged for us to interpret. Yet, the likelihood that the fable is the subject of the painting suggests that that the former reading is more likely true. It seems as if Gauguin painted the still-life as a sort of prediction both of divorce and of its effect upon Mette, and that he gave the biographically symbolic painting to Schuffenecker demonstrates that gentle artist's role as the peacemaker in the Gauguin household. In fact, Schuffenecker appears in the large genre or still-life picture of 1881 (fig. 3), painted in the Gauguin family's small apartment on the rue Blomet to which they moved in 1880. In this painting Schuffenecker leans over the piano while Mette plays; Gauguin himself is absent, his presence suggested by an empty chair.

Seemingly innocent and attractive, this painting, like many in Gauguin's oeuvre, is more complex than it at first appears. It proves again that Gauguin "used" painting as a form of therapy, as a means of working out the tensions of his own life. It also reveals the extent to which he was a painter who sought to fuse art and literature, form and word. Chardin and La Fontaine both stand behind this small, stubbornly original still-life. There is no positive evidence that it was the one chosen by Gauguin for inclusion in the Impressionist exhibition held in 1880 and listed in the catalogue simply as "nature morte" or "still-life." In all likelihood, another small painting of a mandolin resting on a chair was Gauguin's *nature morte* in 1880, and, because it too was unprecedented and mysterious, Edgar Degas bought it for his own collection. It is probable that the Sara Lee canvas was painted in 1880, after the family's move to the rue Blomet and during the marital struggles of that fall and winter. When it was given to (or purchased by) Schuffenecker is not known. Indeed, too little is known about this unconventional and frustratingly elusive "Portrait of a Marriage."

1. David Sweetman, *Paul Gauguin: A Complete Life*, London: Hodder and Stoughton, 1995.
2. *The Art of Paul Gauguin* (exh. cat) Washington and Chicago, 1988, pp. 36–7.

13

Alberto Giacometti (1901–1966)
Diego seated in the Studio, 1950

Oil on canvas, 73 × 60.5 cm. (28½ × 23½ in.)
Signed and dated on the reverse: Alberto
Giacometti 1950

Provenance: Hanover Gallery, London; Sir
Edward and Lady Hulton, London;
Marlborough Gallery, New York; Joanne Toor
Cummings (acquired *c.* 980); Christie's, New
York, sale of April 30, 1996; The Sara Lee
Collection; The Art Institute of Chicago

Exhibitions: London, Tate Gallery, *A Selection
of Pictures, Drawings, and Sculpture from the
Collections of Sir Edward and Lady Hulton,*
August–September 1957: no. 14; Wuppertal,
Kunst-und-Museumsverein, *Sammlung Sir
Edward und Lady Hulton,* 1964; Rotterdam,
Boymans-van Beuningen, November
1964–January 1965; Frankfurt, Kunstverein
Steinernes Haus, February–March 1965;
Munich, Stadtischen Galerie im Lenbachhaus,
April–May 1965; and Dortmund, Museum am
Ostwall, June–August 1965: no. 18;
Stockholm, Moderna Museet, *Hulton
Samlingen,* July–August 1966: no. 14; Saint-
Paul de Vence, Fondation Maeght, *Alberto
Giacometti,* 8 July–30 September 1978: no.
135; London, Lefevre Gallery, *Important
Nineteenth and Twentieth Century Paintings* ,
4 June–11 July 1981: no. 12; Laren 1997–8.

Bibliography: Brettell 1997, pp. 124–5 and
151–2, repr.

Many of the greatest painters of the past
century were also its greatest sculptors, but the
reverse is rarely true. Although Rodin made
numerous drawings, he was not attracted to
oil paint and canvas, and, with the exception
of the fascinating early paintings of Maillol,
the painted oeuvres of the great modernist
sculptors are almost non-existent. The major –
indeed magisterial – exceptions, to this are
Alberto Giacometti and Marino Marini (see
cat. 25). Giacometti's father, Giovanni, was a
distinguished painter, and Alberto's early
teachers included the Swiss painter Cuno
Amiet. In fact, the early work of Giacometti
suggests that he tended more toward painting
than toward sculpture, and it was not until he
arrived in Paris that his true "vocation"
became clear, and by 1925 painting almost
disappeared from his oeuvre. For the next
twelve years (with rare exceptions)
Giacometti all but abandoned painting, but in
1937 he painted a portrait of his mother and
two still-life paintings the subject of which is
a single apple.[1] These three works are greater
by far than anything he had made for several
years. They established Giacometti's "voice"
as a painter, and from them virtually every
painted work of his mature years flowed.
Indeed, with these three paintings, Giacometti
became an artist rather than a sculptor,
creating for himself a manner of painting that
is as distinctive in the independent history of
painted representation as his three-
dimensional style is in the history of sculpture.

Although Giacometti painted sporadically
in the 1940s, often with spectacular results, it
was not until 1949–50, after his marriage to
Annette Arm, that the number of paintings
becomes sufficiently large to constitute the
beginning of an oeuvre. *Diego seated in the
Studio,* comes from the beginning of this
period and is among the principal painted
works from 1950. The year itself was
important for Giacometti because during it
the first large retrospective of his work was
organized by Lukas Lichtenhan and
Christophe Bernoulli for the Kunsthaus in
Basel. For the first time in his life, Giacometti
had the chance to assess his entire previous
oeuvre and, using this knowledge to full
advantage, was able to shape the remainder of
his work. Also during that year, he developed
a close working relationship with the art
dealer Aimé Maeght, who gave him an
exhibition in 1951 and whose skill in selling
works to collectors, museum professionals, and
critics prompted the production of a large
percentage of Giacometti's subsequent oeuvre.

The paintings of 1950 are extraordinary.
Giacometti returned in that year to the subject
of his mother Annetta, seating her in precisely
the same place in precisely the same room in
Stampa where he also placed his new wife
Annette, creating in representation an elision
of two very different women.[2] He also devoted
intense study to his brother, Diego, and
painted an Italian landscape, a studio still-life,
and a studio interior[3] in which his wife,
Annette, is juxtaposed with two works of art
that she, in part, inspired, *The Chariot* and
Four Women on a High Base. It was, indeed,
the relationship between figures and the
spaces they define that obsessed Giacometti in
1950, which is why painting emerged as such
an important part of his oeuvre in precisely
the year in which all of his major sculptures
were multifigural (or, in the case of *The
Chariot,* destined originally for a public plaza
alive with figures). Thus, in 1950 Giacometti
worked with the classic pictorial problem of
western art, the illusion of space, in both
painting and sculpture.

Diego seated in the Studio comes on the
heels of two works of the same subject painted
in the previous year, *Seated Man (Diego)* in
the Morton G. Newman Family Collection,
Chicago, and *Seated Man (Diego)* in the Tate
Gallery, London. In all three, Diego is seated
in the same position – legs crossed
comfortably and hands neatly folded on his
lap. If the paintings can be read as a sequence,
it seems as if Giacometti moved slowly toward
Diego, removing his feet in the Morton G.
Newman picture, and finally settling on his
torso in the Sara Lee picture. Both 1949
paintings place Diego in an area defined by a
painted frame that has roughly equivalent
proportions to that of the canvas on which it is
painted. In the 1949 paintings the torso of
Diego is placed in the absolute center both of
the canvas and of the painted frame. The Sara
Lee painting "destabilizes" Diego, by placing
him at the dead center of the painted frame,
which is placed off-center in the area of the
canvas itself and by creating various framed
regions around the painting-within-the-
painting that force us constantly to consider its
proportions.

This simple pictorial decision activates the
viewer, who becomes a critic of each pictorial
act made by Giacometti. Because of the
restricted palette and of the severely limited
repertoire of gestures, Giacometti demands
that the work be critique in the terms he set
up. Would another line of white paint on the
left collar of Diego's jacket make the image

stronger, more legible, or nearer? Are the black lines that define his knees too strong to stay in place? Are there too many or too few black lines in Diego's hands? Are the objects on the studio table behind Diego too assertive, thereby undermining the intensity of Diego's gaze? Does it make representational sense that Diego's hands are larger than his head? In this way, the viewer is engaged in a never-ending quest to comprehend the painting, a quest that is precisely analogous to that of Giacometti himself. For him, the process of representation is more important than the represented subject, which is, in itself, so banal and obvious as to become uninteresting. Clearly, Giacometti strove to understand himself and his own life through the acts of painting and sculpting. Although he invites us into his world, the sheer iconic power of his works defies interpretation.

When it enters the permanent collection of the Art Institute of Chicago, *Diego seated in the Studio* will augment a group of Giacometti painted portraits that includes the *Yanihara III* of 1956 and the enigmatic 1962 portrait of the last great muse of Giacometti, Caroline, a woman whose surname is still unrecorded. With these three painted portraits as a basis, the Art Institute must search only for a single great landscape and a single great still-life to complete the collection.

1. These paintings are the most important works in that medium by Giacometti to remain in the private domain. Fortunately, they have been frequently reproduced, see *Alberto Giacometti: Sculptures, peintures, dessins*, exh. cat., Paris, Musée d'Art Moderne de la Ville de Paris, 1991–2, nos. 64, 66, 67, pp. 158–61.
2. This pair of works has been often discussed and reproduced. For an accessible pairing on two facing pages, see Yves Bonnefoy, *Alberto Giacometti: A Biography of his Work*, Paris: Flamarion, 1991, pls. 330, 331. The *Annette* is in the Morton G. Newman Family Collection and the *Annetta* is in the Museum of Modern Art, New York.
3. These are *View from the Studio Window, Stampa*, 1950, 54 × 34.5 cm., private collection, Switzerland; *Studio*, 1950, 65.4 × 46.3 cm., James W. and Marilyn Alsdorf Collection, Chicago; and *Annette on a Chariot*, 1950, 73 × 50 cm., private collection.

14

Alberto Giacometti (1901–1966)
Woman of Venice IX (*Femme de Venise IX*),
1956–8

Bronze with black patina, 113 × 18 × 35 cm.
(44⅜ × 6¾ × 13½ in.)
Signed and numbered on the left side of the
base: Alberto Giacometti 4/6
Inscribed on back of base: Susse Fondeur

Provenance: Galerie Maeght, Paris; Galerie
Beyler, Basle (acquired from Maeght in 1958);
World House Galleries, New York (acquired
from Beyler in 1959); Nathan Cummings
(acquired from World House Galleries
c.1961); Christie's New York, sale of 30 April
1996; The Sara Lee Collection; North Carolina
Museum of Art

Exhibitions: New York, World House
Galleries, *Giacometti*, 12 January–6 February
1960: no. 11; New York, World House
Galleries, *Summer International*, June–August
1961: no. 23; Washington, D.C. 1970: no. 71;
New York 1971: no 71; Chicago 1973: no. 78;
Laren 1997–8.

Bibliography: Alberto Giacometti (exh. cat.),
New York, Museum of Modern Art, 1965,
p. 68, repr.
Alberto Giacometti (exh. cat.), Paris, Musée de
l'Orangerie, 1970, p. 79.
Reinhold Hohl, *Alberto Giacometti*, New
York: Harry N. Abrams, 1971, no. 119, repr.
Alberto Giacometti (exh. cat.), Saint-Paul de
Vence: Fondation Maeght, 1978, p. 102.
James Lord, *Giacometti: A Biography*, New
York: Farrar, Straus, Giroux, 1985, repr.
following p. 304.
Herbert and Mercedes Matter, *Alberto
Giacometti*, New York: Harry N. Abrams,
1987, pp. 119–20.
Yves Bonnefoy, *Giacometti*, Paris:
Flammarion, 1991, no. 382, p. 404, repr.
*Alberto Giacometti, sculptures, peintures,
dessins* (exh. cat.), Paris, Musée d'Art Moderne
de la Ville de Paris, 1991, no. 382, p. 333, repr.
Angela Schneider, ed., *Alberto Giacometti:
Sculptures, Paintings, and Drawings*, Munich
and New York: Prestel Verlag, nos. 108–14,
repr.
Brettell 1997, pp. 124–5, 153, repr.

Nathan Cummings bought this extraordinary
Woman in 1961, on what would have been her
fifth birthday. Her title tells us that she is one
of a series of at least eight other Women, all
from – or "of" – Venice, and, when we
examine her carefully, we see that she is one
of at least six casts of the ninth of these
Women. She exists, in a double sense, as a
multiple, and yet she is utterly an individual.
The story of her genesis is complex and
fascinating. She was conceived after the Swiss-
born Giacometti was asked by his adopted
country, France, to represent it in the
Biennale exhibition held in Venice.
Giacometti had rejected an earlier request
from the French in 1950, reportedly because
he felt that they were slighting the man
Giacometti considered to be the greatest
living French sculptor, his friend Henri
Laurens. Laurens had died in 1954, creating a
"space" for Giacometti and allowing the
younger artist to accept the government's
second invitation. He seems to have started
immediately, in January of that year, on a
Woman of Venice, working furiously on
successive figures. Delicate plaster casts
produced by Diego Giacometti of ten of these
were sent from Paris to Venice at the end of
May, where they made their collective debut.
Another five were sent to Berne for a
simultaneous exhibition, and these latter
Women of Venice seem to have been
destroyed after the Berne exhibition. At the
close of the Venice exhibition, Giacometti
"reconsidered" the group, reducing them to
nine, possibly renumbering them, and
ordering bronze casts of each. These casts have
been scattered in private and museum
collections throughout the world and have
virtually lost the collective identity they had
in Venice in 1956.

Discussions of the Women of Venice
abound in the literature. Many writers
associate them with the important mutifigural
bronze of 1950, *The Glade* (fig. 1). This group
of nine separate figures is united by its
presentation on a common bronze base and by
the fact that, although of different scales and
characters, each figure faces the same
direction. *The Glade* raises questions about
individuality and collectivity, about gender,
and about permanence, and its title suggests
that the figures are no more than trees, each
individual and each "planted" in the ground.
Yet the tallest of these figures is about 60 cm.,
and their very miniaturization allows them a
distance from the viewer – and the viewer a
distance from them. Ranging in height from
1.2 m. to 1.5 m., the Women of Venice present
different problems. They approach human

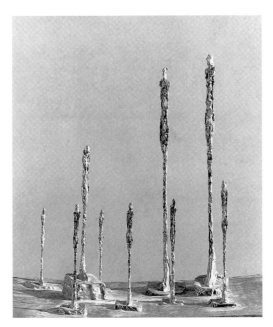

Fig. 1 Alberto Giacometti, *The Glade*, 1950.
Alberto Giacometti Foundation, Kunsthaus Zurich.
© ADAGP, Paris and DACS, London 1999.

scale without quite reaching it, and their
persistently "skinny" physiques mean that
they appear almost as the residue of a "real"
figure, at once shortened and thinned to
become cadaverous. Yet, cadaverous they are
not. Instead, they almost burst with activity,
not their own, but their maker's, and we feel
his hands jabbing at them, cutting into them,
and fretting over their arms, legs, breasts,
heads, and hair.

For most writers about Giacometti, the
Women of Venice represent stages – James
Lord called them "states," as if from prints –
of one figure. In this view, there are nine
manifestations of a single *Woman of Venice*
rather than nine individual Women of Venice,
and there is considerable visual evidence to
support this claim. It is easy to imagine
Giacometti working both with a mental
image of a standing figure and with various
earlier sculptures of vertical female figures
present in the studio, and, after days of work,
reaching a state of "completion" on a new
figure begun on a metal armature. At that
point, he allowed the completed figure to be
cast in plaster by Diego, and when this casting
process was complete Giacometti would
recommence his work, transforming the figure
on the same armature. Hence, the various
Women of Venice are successive rather than
simultaneous creations, and, knowing this, the
viewer is forced to consider them in the
numerical terms set by the artist. This
seriality has a deep history in modern art –
having its origins in the grouping of paintings

of the Gare Saint-Lazare submitted by Monet
to the Third Impressionist Exhibition of 1877.
This idea of exhibiting a series of interrelated
artistic experiments with a single subject
clearly fascinated Giacometti, because, for the
first time in his working life, he chose to
present a number of works with one title as an
exhibition.

The most eloquent description of
Giacometti's process in creating the Women
of Venice is surely that of his friend and
biographer James Lord:

> The famous Women of Venice . . . were
> created in a sustained rush of energy
> during the first five months of 1956.
> Working with the same clay on the same
> armature, as he often did, Giacometti
> concentrated on a single rigidly erect
> figure, a nude woman, her body slender,
> attenuated, head held high, arms and
> hands pressed to her sides, feet outsize and
> rooted to the pedestal . . . In the course of a
> single afternoon the figure would undergo
> ten, twenty, forty metamorphoses as the
> sculptor's fingers coursed compulsively over
> the clay. Not one of these innumerable
> states was definitive, because he was not
> working toward a preconceived idea or
> form. If pleasantly surprised by the look of
> what his fingers had done, he would ask
> Diego to make a plaster cast, the business
> of a few hours. Alberto's purpose was not to
> preserve one state of the sculpture from
> amid many. It was to see more clearly what
> he had seen. In plaster the revelation was
> more luminous than in clay. Once a figure
> existed in plaster . . . it stood apart from the
> flux in which it had developed. It had
> achieved an ambiguous permanence and
> made an apparent claim to survival.[1]

Many exhibitions of Giacometti's work
have included subgroups of the Women of
Venice series. However, never, to my
knowledge, have all nine figures been brought
together and never has the tenth figure – the
one sent in plaster to the 1956 Biennale, but
not cast – been published. It is possible that
Giacometti reduced the number to nine
because he, like many commentators, realized
the link between the Women of Venice and
The Glade. The Sara Lee *Woman of Venice* is
the last of the numbered bronze sequence,
which has been published together only once,
in Yves Bonnefoy's *Alberto Giacometti: A
Biography of his Work*.[2] Only two others (*I*
and *V*) are shorter, and, as in the majority of
the group, the arms and hands of the woman
are brought so close to the body that they
seem one with it. Numbers *I*, *III*, and *V* allow

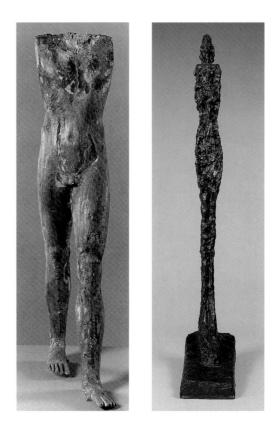

Fig. 2 (*above left*) Egyptian, *Striding Man*,
c.2490–2180 B.C. North Carolina Museum of Art,
Raleigh. Gift of Mr. and Mrs. Gordon Hanes.

the arms their own space, and, in them
Giacometti stresses the thinness of the waist
by allowing space to open up between it and
the two arms, which are reengaged with the
torso at the hips. In these three works the
breasts are also allowed real presence, and
they are thrust powerfully forward and
sideways into the space left by the arms. In
the other six busts, the arms seem either to
obey or to define the dictates of the figure. In
the last two, *VIII* and *IX*, one arm and hand
comes forward near the hip in a gesture of
self-caress. In *III*, *VI*, *VII*, *VIII*, and *IX*, the
hair of the figure makes her identity as his
wife, Annette, clear. In the others, she is
simply "woman."

Woman of Venice IX is the first work by
Giacometti to enter the permanent collection
of the North Carolina Museum of Art. It
comes at the perfect time, because the
museum had another cast of a *Woman of
Venice* on semi-permanent loan until recently.
Giacometti himself would be enthralled to
have this work in the same museum as the
great Old Kingdom masterpiece of Egyptian
wood figural sculpture, *Striding Man* (fig. 2).

1. Lord (1985), p. 304 following.
2. Bonnefoy (1991), p. 404.

15

Alberto Giacometti (1901–1966)
Diego, 1962

Bronze, 63 × 27.4 × 24.7 cm.
(24½ × 10½ × 9½ in.)
Edition of six: 4/6
Signed and inscribed lower right edge: 4/6
Alberto Giacometti Susse Fondeur Paris

Provenance: Galerie Maeght, purchased 30
May 1963; Mr. and Mrs. Nathan Cummings,
Chicago; The Sara Lee Collection;
Minneapolis Institute of Arts

Exhibitions: Washington, D.C. 1970: no. 72;
New York 1971: no. 72; Chicago 1973: no. 77;
Winston-Salem 1990; Memphis 1991;
Lakeland 1995; Laren 1997–8.

Bibliography: Reinhold Hohl, *Alberto
Giacometti*, New York: Harry N. Abrams,
1971, p 265.
Brettell 1986, 1987, 1990, 1993, 1997 (pp.
120–22, 152, repr.)

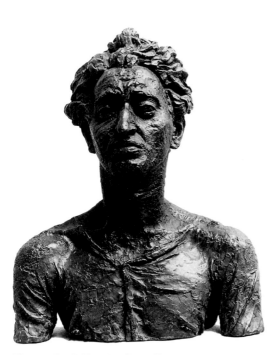

Fig. 1 Jacob Epstein, *Jacob Kramer*, 1921. © Tate
Gallery, London.

The difficulties that Giacometti experienced in front of live models are by now the stuff of legend. The fact that the task of an artist is to make a "surrogate" or "replica" of a living person seemed not to trouble generations of sculptors as it troubled Giacometti, and he was as anxious as an Impressionist painter *en face du motif*, always aware that the representation he made lacked the intensity of the "reality" it embodied. If that was a problem for Monet or Pissarro standing in a mute landscape, it was a greater problem for Giacometti standing in front of another human being. He tried, it seems, to lessen the burden by working mostly from models who were close personal friends or members of his family – his brother Diego and his wife Annette were his most persistent models – but, as anyone who has performed a childhood recital in front of a friend or relative knows, friends and families are often the most critical of witnesses. In fact, it is likely that Giacometti's choice of close family members as models actually compounded his burdens. In the end, he seems to have needed these burdens in order to work.

Giacometti's younger brother, Diego, lived most of his life under the shadow of his famous older sibling. His interests and inclinations took him away from the realm of "fine art" into the esthetically cloudy region of furniture and applied art, of which he became a twentieth-century master whose reputation is at least equal to that of his brother in the fine arts. The brothers were born into an Italo-Swiss artistic family, and their father, Giovanni, was both a major painter and a follower of the northern Italian Divisionist Giovanni Segantini. Like many Swiss artists, the brothers deserted their native country after art school for the greener pastures of Paris and both contributed mightily to that city's supremacy as an international art capital after the Second World War. Diego spent so much time in Alberto's studio that he was persuaded to act as a model for his notoriously shy – and neurotic – older brother, and the Sara Lee bust is one of a large number of representations of Diego made by Alberto after the war in all of his media – oil, pencil, plaster, and bronze.

Students of Giacometti's oeuvre are as obsessed with his "silences" – with those periods in which he seemed unable to work – as they are by the intensely productive periods that interrupted them. The years around 1950, although highly productive, were difficult for Giacometti as a sculptor of single human figures. Not only did he tend to work on groups of figures, but he also shied away from

the uneasy monumentality he had achieved in the late 1940s. Indeed, Giacometti had been championed by existential philosophers just after the war and was the subject of a major essay of 1948 by Jean-Paul Sartre, whom Giacometti had met in 1939 and who admired what he called the artist's "search for the absolute."[1] It is clear that Giacometti felt intense pressure from this intellectual adulation, and although many of his most fascinating multifigural works date from the years around 1950 he seemed temporarily unable to allow human forms to attain their own scale. Sometime late in 1950 Giacometti made what has been called a "decision" to represent specific individuals known to him, rather than to make anonymous "figures." This decision led to a complete transformation of his art and to the series of representations of Diego, of which the Sara Lee bust is one.

Diego Giacometti was more than a brother to Alberto; he was a full collaborator in the act of making sculpture. The many friends and critics of Diego work all stress his active participation in his older brother's oeuvre, and James Lord, the sculptor's most sympathetic biographer, went so far as to say that "his hands touched every sculpture that came from Alberto's".[2] It was in the early 1950s that Diego's assistance became all the more important, because Alberto's career literally "took off," with museum and gallery exhibitions, commissions, and sales becoming so frequent that Alberto no longer had the time both to create works of art and to supervise their casting and patination. These latter tasks were left almost completely to Diego, who was thus intensely involved in the creation of the bronze versions of the very sculptures that represent him. It was also in the early 1950s that Diego emerged somewhat from the shadow of his older brother and became a successful creator of furniture and other bronze decorations, and the simultaneity of his appearance as a "subject" of his brother's sculpture and as an artist in his own right under the name "Diego" is surely no coincidence.

The Sara Lee bronze is one of a number of "heads" of Diego that engage in an intense relationship with the base from which they seem to emerge. Indeed, the head is less than one-third the height of the whole sculpture and is "thinned" so as to engage in a dynamic with the torso on which it sits. The sculpture reads as a head emerging from a torso that, in turn, emerges from a base, and all three parts are integral to the experience of this particular *Diego*. This "trialogue" between base, bust, and head is at the core of Giacometti's

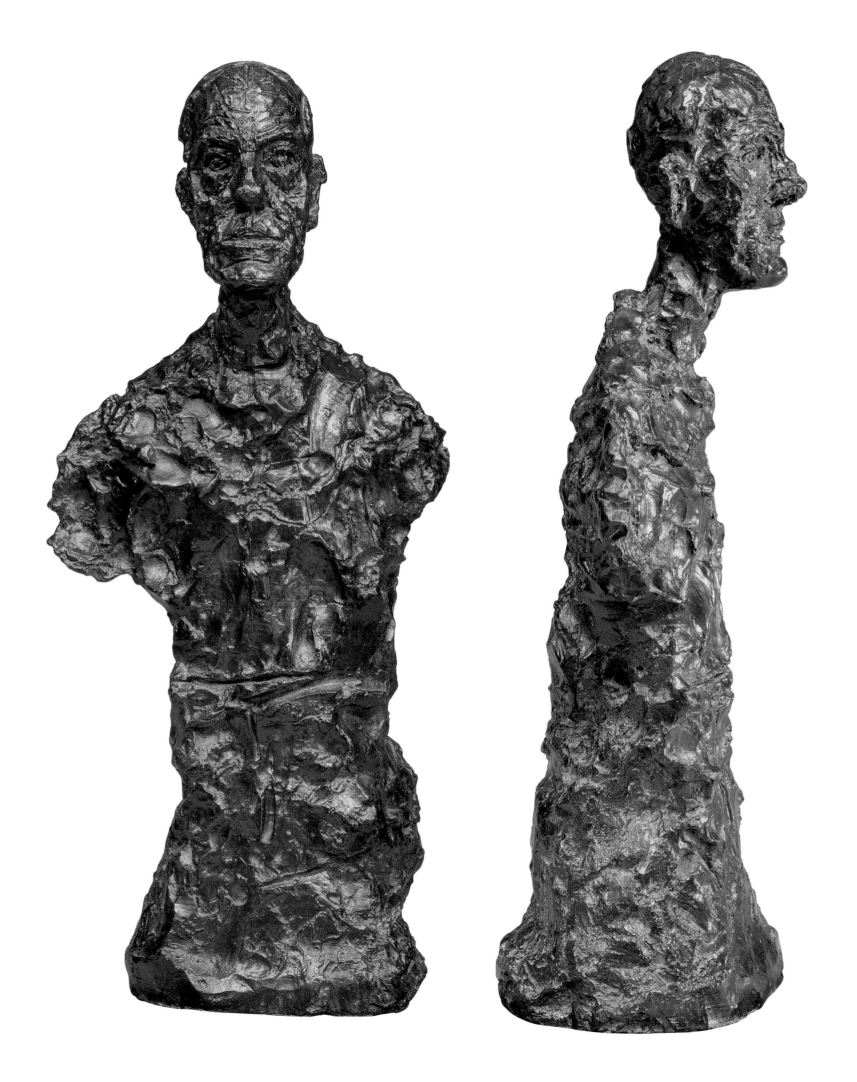

Fig 2 Francis Bacon, *Three Studies of a Human Head*, 1953. Private Collection, Switzerland. © Estate of Francis Bacon/ARS, NY and DACS, London 1999.

Fig. 3 Francis Bacon, *Study for a Portrait*, 1953. Hamburger Kunsthalle. Photo © Elke Walford, Hamburg. © Estate of Francis Bacon/ARS, NY and DACS, London 1999.

sequence of images of his brother, and, in this way, Alberto seems to have been anxious to pay mute homage to his brother's vocation as a producer of "bases" for the human form itself. Although the various portraits of Diego from the 1950s and 1960s have been well represented in Giacometti exhibitions, they have never been properly catalogued and analyzed in their own terms. Nor have they been related to the fascinatingly comparable portrait busts produced in England by Jacob Epstein, nor to the early portraiture of Giacometti's friend Francis Bacon (figs. 1–3). Indeed, the Giacometti literature is dangerously hermetic, as are the numerous exhibitions of his work organized since his death in 1966. His own form of esthetic "essentialism" has isolated him – and his work – from many of the larger issues of post-war modernism.

This head will be the first work by Giacometti to enter the permanent collection of the Minneapolis Institute of Arts and will join the group of nineteenth- and early twentieth-century sculptures in that city's two great public collections, those of the M.I.A. and the Walker Art Center.

Fig. 4 Alberto Giacometti, *Tête Noir*, 1951. Galerie Beyeler, Basel. © ADAGP, Paris and DACS, London 1999.

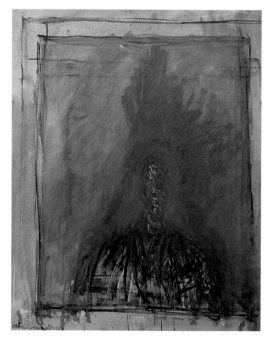

1. See Jean-Paul Sartre, "The Search for the Absolute," in *Exhibition of Sculptures, Paintings, Drawings*, New York, Pierre Matisse Gallery, 1948, p. 6.
2. James Lord, *Giacometti: A Biography*, New York: Farrar, Straus, Giroux, 1985, p. 329.

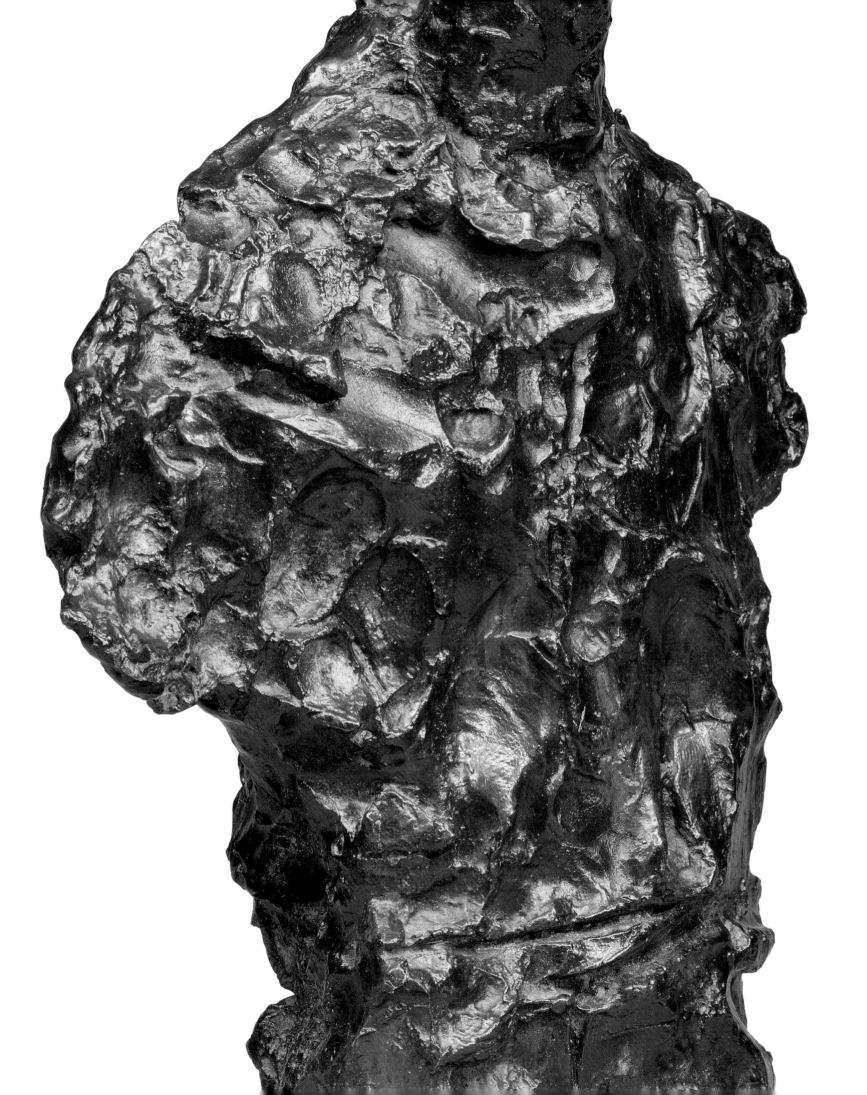

16

Alberto Giacometti (1901–1966)
Annette IV (Buste d'Annette IV), 1962

Bronze, height 59.2 cm. (23 in.)
Edition of six: 6/6
Signed and inscribed lower right edge: Alberto
Giacometti 6/6 Susse Fondeur Paris

Provenance: Galerie Maeght, purchased 19
March 1964; Mr. and Mrs. Nathan Cummings,
Chicago; The Sara Lee Collection; High
Museum, Atlanta

Exhibitions: Washington, D.C. 1970: no. 73;
New York 1971: no. 73; Chicago 1973: no. 80;
New York, Solomon R. Guggenheim
Museum, *Alberto Giacometti: A Retrospective
Exhibition*, 29 March–26 June 1974: no. 103;
Winston-Salem 1990; Memphis 1991;
Lakeland 1995; Laren 1997–8.

Bibliography: Alberto Giacometti (exh. cat.),
New York, Museum of Modern Art, 1965,
p. 64, repr.
*Alberto Giacometti: Sculpture, Paintings,
Drawings 1913–1965* (exh. cat.), London, Arts
Council of Great Britain, 1965, pl. 34.
Alberto Giacometti (exh. cat.), Paris: Ministère
d'Etat Affaires Culturelles, 2nd edn. 1969,
p. 82, repr.
Reinhold Hohl, *Alberto Giacometti*, New
York: Harry N. Abrams, 1971, pp. 263, 267,
repr.
Brettell 1986, 1987, 1990, 1993, 1997 (pp.
120–21, 124, 152, repr.)

Alberto Giacometti and Annette Arm were
married on 12 July 1949 in the town hall of
the 19th arrondissement in Paris. They had
known each other since 1943, when both lived
in Geneva, and Annette had followed
Giacometti to Paris, arriving in 1946 to act as
his secretary and companion. It must have
been an odd marriage. Giacometti seems to
have struggled with homosexual desire and
had lived with his brother for more than
twenty years. Yet a strangely intense
relationship developed between Giacometti
and this much younger Swiss woman, a
relationship that was analyzed
sympathetically by a practicing homosexual,
James Lord, in his biography of Giacometti.
For Lord, Giacometti was Annette's
"patriarchal lover," and, in that conjoining of
opposites, Lord got to the heart of an enduring
– and enduringly complex – relationship.

Giacometti allowed Annette to share his
life in as complete a way as anyone – they
even shared a double bed – and he
documented his obsessive interest in her in
hundreds of drawings, paintings, and prints.
Often, she is allowed simply to stand, and it
was as a *kore* that she entered his art. Like the
archaic Greek sculptors he so admired,
Giacometti allowed women to stand – as erect
and as proud as men. In fact, he seemed to
prefer women standing. Yet, unlike the
Greeks, Giacometti left his women nude – the
archaic Greeks always clothed them – and, in
this way, he created what might be described
as an archaic hermaphrodite in his standing
images of Annette. He also made many busts
of her, including the *Annette IV*, created in
1962 as part of a series of female busts that act
as mute pendants to the series of male busts of
his brother Diego. Giacometti's two forbidden
lover/companions – one a woman and the
other a man – were given "equal space" in his
art.

Of the busts of Annette, *Annette IV* is
among the best known and most frequently
reproduced. It appears in photographs of
Giacometti's studio, and casts of it have been
included in most of the important Giacometti
exhibitions since his death in January 1966.
He made it as part of the most sustained series
of portraits of a single individual in his life.
Even the Diego portraits, though perhaps
more numerous, were not made in such a
concentrated burst of activity. In many ways,
Giacometti made what might be called a
series of a series representing Annette in 1962.
There are six numbered pencil drawings,
made in succession, and at least ten editioned
bronzes, made as if in emulation of the ten
"states" of the plaster Women of Venice that

he had exhibited at the Biennale in 1956. In
the earlier series, Annette seems not to have
been present as the model. In the latter, she
surely was, and it is Annette, his wife-
companion-model-muse-interlocutor-agent
who confronts us in these busts.

Giacometti was sixty-one years old in 1962
(Annette was thirty-nine), but he seemed
older. He fashioned himself as an older
brother, a husband/father, an uncle, a mentor,
to a whole succession of young people
throughout the last years of his life, and his
young wife was among the most important of
these youth-muses. Only Yves Bonnefoy, in
his immense monograph of 1991, considers
this series of numbered bust portraits as an
essential part of Giacometti's oeuvre,
publishing color plates of five of the ten
known busts of Annette.[1] Bonnefoy seems
willful in his desire to make *Annette VIII* the
"masterpiece" of the group, particularly since
he himself admits that he has not been able
actually to see all the others and omits
photographs of five. Yet, in the arrangement
of the five in his book, none of them looks like
the definitive Annette. Rather, they have that
same serial instability sensed in the Women of
Venice. In fact, Bonnefoy publishes a
photograph of another cast of *Annette IV*, this
one in a private collection and possessing a
coppery greenish patina, indicating that Diego
variously patinated the busts so that they
would attain a greater individuality.
Giacometti seems to have preferred this to the
standardized look of an "edition."

Of the published photographs of the
Annette series in Bonnefoy, *Annette IV* is
unique in its insistence on the separation
between base and bust – the others integrate
them into an almost seamless whole. This
very formal liveliness gives the work a jaunty
rhythmic character that stresses the liveliness
of his sitter. Annette's hair in *Annette IV* is
somewhat controlled and prim, rather more
like the hairstyles preferred by Annette's chief
rival, the young Caroline, whose surname is
still unrecorded, and who was the cause of
jealous rages on the part of Annette after
1960, when Giacometti began his artistic and
personal relationship with the younger
woman. Who, it might be asked, was
Giacometti actually representing in *Annette
IV*, his wife or his new, but absent muse?

Neither Lord nor Bonnefoy records
whether the ten busts of Annette were made
in connection with the Venice Biennale of
1962, to which Giacometti sent forty-seven
sculptures and at which he received the Grand
Prix. But the very fact that there are ten such
busts – the same number as the Women of

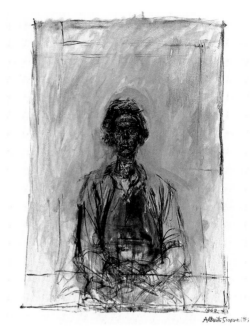

Fig. 1 Alberto Giacometti, *Annette*, 1962. The Museum of Modern Art, New York. The Sidney and Harriet Janis Collection. © ADAGP, Paris and DACS, London 1999.

Venice from his first Biennale in 1956 – suggests that Giacometti was using the occasion to reassert the centrality of Annette to his life through art. The rival, Caroline, was not present in representation or in fact at the Biennale celebrations of 1962, yet we learn from Lord that she was in Italy and that Giacometti had planned every aspect of this trip. Mercifully, the works of art do not communicate very much else about the tangles of Giacometti's personal life, and Annette, whether *IV*, *VII*, or *X*, remains as mute as the sphinx she is.

Interestingly, it seems that Nathan Cummings bought *Annette IV* at the same time that he acquired the earlier bust of Diego, and for that reason the two have always been presented as a pair. While this makes formal sense – and while Giacometti too seems to have paired their relationships in his art-making, these two busts were made as part of completely separate investigations eight years apart from each other. For that reason, they have at last been separated in the Millennium Gift of Sara Lee Corporation and will resume their lives as individual works of art.

1. Yves Bonnefoy, *Alberto Giacometti: A Biography of his Work*, Paris: Flammarion, 1991.

17

Johan Barthold Jongkind (1819–1891)
Moonlight and Boats, 1871

Oil on canvas, 41 × 32 cm.
(16 × 13 in.)
signed and dated lower left: "Jongkind 1871"

Provenance: Nathan Cummings Collection;
Sara Lee Corporation; The Montgomery
Museum of Fine Arts, Montgomery, Alabama

Bibliography: Consolidated Foods Corporation,
*Consolidated Foods Corporation's Nathan
Cummings Collection*, Chicago; Consolidated
Foods Corporation, 1983, fig. 12 (as *Moonlit
Bay*).

This beautifully painted and modestly proportioned waterscape is signed and dated 1871, a year of unmatched difficulty for Jongkind's adopted nation, France. During that year, the French suffered a humiliating military defeat at the hands of the Germans in the Franco–Prussian War and the terrible street revolutions called The Commune rocked Paris. During all this strife, the Dutch painter remained in Paris, living in an odd and seemingly platonic relationship with the wife of his friend, Alexandre Fesser, and their son Jules. While Monet, Pissarro, and Sisley fled Paris for England, the foreigner Jongkind remained, sharing the city with stalwart French citizens who were either too poor or too loyal to flee.

During that year, he painted a series of paintings of his native Holland, both from memory and from the hundreds of *plein-air* watercolors he had made throughout his long working life. These works – skaters on canals, moonlit canals with windmills, and other "typical" scenes – were his "bread-and-butter" paintings, appealing equally to his French and his Dutch clients, all of whom wanted to have "Dutch" works by a "Dutch" painter. Jongkind himself was virtually a French painter, having studied in Paris in the atelier of the great painter Eugène Isabey as early as 1846 and remaining in that country throughout most of the rest of his life, taking frequent short trips back to Holland. Throughout the 1860s and 1870s, Jongkind was active in the same circle of artists as the young Impressionists and came to know Monet particularly well. Yet, he remained apart from the Impressionists, refusing to join his friends Boudin and Monet in the first Impressionist exhibition of 1874 and staying faithful to the Salon.

In many ways, Jongkind was a prototypical socialist artist, whose needs and wants were simple. He is famous for saying that all he needed to earn annually was 3000 francs and that sometimes he could not even achieve that! Yet, he persisted in creating works of art that sold for modest prices to modest collectors, insuring that hand-made objects gained entry into the possession of members of the *petit bourgeoisie* and even the upper echelons of the working class. The resolute modesty of his aims must be contrasted with those of other modernist artists, who strove to compete with museum masters and aspired to be collected by wealthy members of the *haute bourgeoisie* and even the aristocracy. Perhaps only Sisley and Pissarro were similar in this resolutely anti-hierarchical esthetic.

Moonlilight and Boats is a perfect example of Jongkind at his finest. Its effect is of moonlight playing through the clouds on a Dutch night. The waters of the canal sparkle, the canal boat bobs, the windmill moves, and, in the distance, we can see the place-giving spire of the local church and the weighted structure of a drawbridge. The entire scene was painted with great gusto, as Jongkind worked wet paint onto wet paint in a carefully choreographed sequence so as not to spoil his "effect." Monet himself studied such paintings by Jongkind and thought of them as exemplars when, in 1873, he painted his famous *Impression: Soleil Levant* or his nighttime study *Harbor at Le Havre*.

Roger de La Fresnaye (1885–1925)
The Bathers (Les Baigneurs), 1912

Oil on canvas, 162 × 130 cm. (63½ × 50½ in.)
Signed lower right: R de La Fresnaye
Seligman 121

Provenance: Walther Halvorsen, Copenhagen; Richard Bergh, Stockholm; Mrs. Hallström, Stockholm; Svensk-Franska Konstgalleriet, Stockholm; J. K. Thannhauser, New York; Mr. and Mrs. Morton D. May, St. Louis; Washington University and the St. Louis Symphony Society, St. Louis; Parke-Bernet, New York, (Sale of 6 April 1967, lot 63); Nathan Cummings, Chicago; The Sara Lee Collection ; National Gallery of Art, Washington, D.C.

Exhibitions: Paris, Salon d'Automne, 1912: no. 613; Paris, Levesque, 1914: no. 30; Stockholm, Société Interscandinave d'Art Français; Göteborg; Copenhagen; and Oslo, 1931; Paris, Musée National d'Art Moderne, *Roger de La Fresnaye*, 1950: no. 47; Stockholm, Liljevalchs Konstall, *Från Cézanne till Picasso*, 1954; St. Louis Art Museum, *A Galaxy of Treasures*, 1961; San Francisco Museum of Art, *Man: Glory, Jest, and Riddle: A Survey of the Human Form through the Ages*, 10 November 1964–3 January 1965: no. 259; New York, The Museum of Modern Art; Houston, Museum of Fine Arts, *The Heroic Years/Paris 1908–1914*, 1965; Palo Alto, California, Stanford University, April 1969; Paris, Palais Gailliera, September 1969; Washington, D.C., 1970: no. 22; New York 1971: no. 22; Los Angeles County Museum, 15 December 1970–71 February 1971; Chicago 1973: no. 51; Jerusalem, Israel Museum, *Inaugural Modern Art Exhibition: Nathan Cummings Twentieth Century Building*, 2 September–2 December 1990; Chicago, The David and Alfred Smart Museum of Art, *Multiple Perspectives: Cubism in Chicago Collections*, 6 October–2 December 1991; Laren 1997–8.

Bibliography: Roger Allard, *R. de La Fresnaye*, Paris: Editions de la Nouvelle Revue Française, 1912, p. 27, repr.
Germain Seligman, *Roger de La Fresnaye with a catalogue raisonné*, London: Thames and Hudson; and New York: New York Graphic Society, 1969, no. 121, pp. 45, 151, repr.
Consolidated Foods Corporation, *Consolidated Foods Corporation's Nathan Cummings Collection*, Chicago: Consolidated Foods Corporation, 1983, p. 17, fig. 11.
Brettel 1986, 1987, 1990, 1993, 1997, pp. 80–81, 150–51 repr.

Almost all the great modern painters made large-scale works designed as " masterpieces" for public presentation and as visual manifestos of their own particular manners or ideologies.[1] *The Bathers* is one of those works. Its maker, Roger de La Fresnaye, was a wealthy and ambitious young artist (he was twenty-seven in 1912), whose career was to be cut tragically short because of illness as a result of military service (he died in 1925, but had all but stopped large-scale easel painting after the First World War).[2] He is, hence, a secondary figure today, and his name is known only to careful students of avant-garde French painting of the first two decades of the twentieth century. This was not true in 1912 when *The Bathers* made its first appearance in the Salon d'Automne as a manifesto of the social, political, and esthetic doctrines of a new type of art called cubism. In fact, La Fresnaye was at the very center of a group of artists including Fernand Léger, Albert Gleizes, Marcel Duchamp, Jean Metzinger, and others who attempted to bring the esthetic experiments first performed by Picasso and Braque to a wider audience. Certain of these artists accomplished this service in written form, and La Fresnaye's friends Gleizes and Metzinger collaborated in writing *Du cubisme* (About Cubism),[3] the first sustained written analysis of Cubism, published in the same year that La Fresnaye completed and exhibited *The Bathers*.

La Fresnaye, too, was involved in what might be called the esthetic of "public relations" for Cubism. He was one of a group of artists who collaborated on a "Cubist house" (La Maison cubiste) built inside the same Salon d'Automne at which he exhibited *The Bathers* in a conventional gallery.[4] With a fireplace and mantel clock designed in the Cubist manner by La Fresnaye (fig. 1), the Cubist House – with its "salon bourgeoise" or "urban, middle-class living room" – was intended to demonstrate to conventional urbanites that the revolutionary modern art of Cubism was meant for them. By the time that the Cubist House had opened, La Fresnaye was also participating in the group exhibition of the Section d'Or, an exhibition mostly of Cubist artists patterned on the famous Impressionist exhibitions of the 1870s and 1880s, but this time with lectures and gallery talks that were intended to demystify the strange new art for well-educated, if skeptical visitors. Braque and Picasso sat on the sidelines of these earnest efforts, working their esthetic miracles in private for a highly intellectual – and highly international – set of dealers and clients. Their disdain for the

Fig. 1 Roger de La Fresnaye, fireplace in the *Salon bourgeois*, La Maison cubiste, Salon d'Automne, Paris, 1912. Photo Collection Michel Mare, Paris.

public has always appealed to subsequent critics and art historians, who have tended to regard the "public" work of the Section d'Or and "Cubist House" artists with disdain.[5]

In fact, the work of La Fresnaye and a good many of his fellow artists in the Section d'Or anticipates the *rapelle à l'ordre* or "call to order" that came to dominate the post-First World War art of Picasso, Braque, and others.[6] Their pre-war concern with "tradition," with the art of museums, and with the masters of nineteenth-century French art was a sort of progressive conservatism that was considerably more fashionable after the war. Like Picasso, Roger de La Fresnaye was at once academically trained and fascinated with the unofficial avant-garde. By 1910 he had deserted the Ecole des Beaux-Arts (after four years of sporadic attendance), had traveled abroad, and had been apprenticed as a sculptor to the great masters of French classicism, Maillol and Bourdelle. In 1911 he exhibited in the important exhibition of the Society of Norman Artists at the Galerie d'Art Moderne

and sent his first large-scale proto-Cubist painting, *Le Cuirassier* (*The Cavalrymen*), to the Salon des Indépendants earlier in the year. It was 1912, however, that was a turning point both for Cubism and for La Fresnaye. Even Braque and Picasso classicized and "tightened" their Cubism in that year, evolving a form of the style that was soon called "Synthetic Cubism."[7] Yet, their new ambitions were out-done in both scale and ambition by those of La Fresnaye, whose attempts to work on a large scale in a series of canvases were intended to translate the experiments of Cubism into a more permanent form.

La Fresnaye's great "master" was less Braque or Picasso than Cézanne, whose work had spawned the Cubist experiment when it was first shown in quantity in Paris at the 1907 Salon d'Automne. In fact, that exhibition was the first public display of two of the three large late Bathers by Cézanne, those presently in the National Gallery in London (see cat. 36, fig. 1) and the Philadelphia Museum of Art.[8] Yet, La Fresnaye was too deeply educated in the traditions of figural art, particularly in the Franco-Italian tradition, to be carried away completely by Cézanne, and there are deeper references to paintings by Giorgione, Titian, Poussin, and Manet in this remaking of Manet's *Déjeuner sur l'herbe*.[9] Manet's morally problematic combination of two clothed men and two naked women had shocked Paris at the Salon des Refusées of 1863, but it had long been sanitized by its presence in the official museum of modern art, the Musée du Luxembourg. And presumably La Fresnaye had read Zola's great novel of the late nineteenth century, *L'Oeuvre* (The Masterpiece), in which that realist author's hero, the painter Claude Lantier, commits suicide in front of a large painting of modern nudes in a Parisian landscape. In many ways, *The Bathers* is Lantier's failed painting (just as are Cézanne's large late Bathers), and its odd combination of an angular rhythmic style and a heterosexually sensual subject lend the work a contemporaneity that Cézanne's female bathers lack.[10]

The Bathers was part of a lengthy process of work and rework, both in preparatory drawings and on the canvas itself. Three directly preparatory drawings have been published by Seligman in his monograph on La Fresnaye, but there many other representations of the female nude made by La Fresnaye as he readied himself for this "masterpiece."[11] All of them suggest a preoccupation with Cézanne, whose small Bather compositions had been shown in 1910

in the large Cézanne exhibition held at the Bernheim-Jeune Gallery in Paris. Interestingly, the other large canvas chosen by La Fresnaye for the Salon d'Automne of 1912 is equally indebted to Cézanne in both subject and, to an extent, style. *The Card Players* was slightly smaller than *The Bathers* just as the various versions of Cézanne's Card Players are slightly smaller than the three large Bather compositions that had become famous in artistic circles by 1912.[12]

Like all of La Fresnaye's paintings, *The Bathers* seems to have entered a sort of esthetic purgatory in the years after his death, changing hands several times in Scandinavia before finding its way to the United States, where it was fleetingly in two distinguished collections, those of Justin Thannhauser in New York and Morton D. May in St. Louis, before being given by May to two St. Louis charitable institutions for sale. Fortunately, Nathan Cummings snapped it up at a Parke-Bernet auction in 1967 and subsequently made it available to the Collection of Sara Lee Corporation. At last, nearly three generations after its appearance in the 1912 Salon d'Automne in Paris, *The Bathers* will enter the distinguished museum collection of modern French art at the National Gallery in Washington, a museum collection of the type to which its maker consciously aspired.

It is worth noting that foreigners played a significantly larger role in the collecting, scholarship, and criticism of La Fresnaye than did his native Frenchmen. The most important of his canvases from 1910–16 are in Switzerland and the United States, and, of the early collectors of modern art, the Hahnlosers and Joseph Müller of Switzerland and Duncan Phillips and Albert Barnes of the United States each purchased major works by La Fresnaye. Today, the Metropolitan Museum of Art, the Museum of Modern Art, and, now, the National Gallery of Art in Washington have major works by this great French artist. Of the great paintings of the Cubist years, only one is in the national collection of twentieth-century art in La Fresnaye's native France.

1. This includes certain works by Manet, Bazille, Caillebotte, Degas, Monet, Pissarro, Renoir, Seurat, Cézanne, Gauguin, Vuillard, Bonnard, Matisse, Picasso, etc. Interestingly, although they are canonical works, they have never been grouped either in an exhibition of "modern masterpieces" or in book form. Their internal conversations and their debts to the history of art are worthy of sustained analysis.
2. The La Fresnaye bibliography is small, but the 1969 monograph by Germain Seligman is a model study. For an adequate and accurate chronology of the painter's life see Seligman (1969), pp.101–5.
3. Albert Gleizes and Jean Metzinger, *Du cubisme*, Paris: Figuiere et Cie, 1912.
4. The most complete discussion of this odd and unsuccessful collaboration can be found in Nancy Troy, *Modernism and the Decorative Arts in France: Art Nouveau to Le Corbusier*, New Haven and London: Yale University Press, 1991, pp. 79–90. An illustration of La Fresnaye's mantel and mantel clock is on p. 88. A more recent discussion of the same subject – with an emphasis on socio-political interpretation – can be found in David Cottington's essay, "The Maison Cubiste and the Meaning of Modernism in Pre-War France," in Eve Blau and Nancy Troy, eds., *Architecture and Cubism*, Cambridge: MIT Press, 1997, pp. 17–40.
5. A glance at the vast bibliographies devoted to Picasso and Braque compared to the puny literature on the "Puteaux" (Duchamp-Villon, Villon, Gleizes, Metzinger, La Fresnaye, and others) artists makes this clear. Indeed, the only important proponents of these artists in the last generation of scholars have been two Americans, Daniel Robbins and William Camfield, neither of whom has come close to the kind of esthetic deification of Braque and Picasso practiced by their colleagues. The most succinct statement of this bias can be found in Douglas Cooper's book and exhibition *The Essential Cubism , Picasso, Braque and Their Friends, 1907–20*, London, Tate Gallery, 1983, in which not a single work by Gleizes, Metzinger, La Fresnaye, or Villon is included.
6. This phenomenon is of particular interest to revisionist historians of modern art, and the most sustained recent investigation of the "conservative" tendencies in art after 1919 can be found in Romy Golan, *Modernity and Nostalgia: Art and Politics in France between the Wars*, New Haven and London: Yale University Press, 1995.
7. The fascinating parallels between Synthetic Cubism and the work of the Puteaux Cubists has rarely been discussed in a way that is at all sympathetic to the latter.
8. See Rewald and Feilchenfelt, *Paul Cézanne: A Catalogue Raisonné*, New York, 1997, nos. 855, 857.
9. The discussions of Manet's sources, many of which are found in public collections in Paris, are numerous. The most ambitious and interesting are to be found in Michael Fried, *Manet's Modernism, or, The Face of Painting in the 1860s*, Chicago: University of Chicago Press, 1996.
10. There is no sustained discussion of La Fresnaye's imagery in this painting except in terms of its clear precedence in earlier art. Seligman reproduces it splendidly, but ignores it in his lengthy, if subjective discussion of what he calls "The Great Figure Compositions, 1912–14" (see Seligman, 1969, pp. 43–52). He prefers the *Card Players* (private collection, Paris) and *Conjugal Life* (fig. 2), and stresses that the physical accessibility of the figures to the viewers contrasts markedly with their psychological remoteness. This, to Seligman, creates what he calls "emotional stress" in the paintings, and he attributes this as much to the artist's patrician reserve as he does to the esthetics of Cubism. Both *Conjugal Life* and *The Bathers* deal with the issue of clothing, sexuality, and modern life both in and out of doors. With the other works in the series of large canvases, they add up to a sustained critique of bourgeois life using the esthetic conventions of vanguard artists from the late nineteenth century. They are far from aristocratic in their imagery, in spite of the artist's patrician family. Like Toulouse-Lautrec, La Fresnaye was from an ancient French family, and spent most of his life repudiating the values most often associated with the aristocracy in early twentieth-century France.
11. Seligman (1969) pp. 150, 180–83.
12. Cézanne's smaller version of *The Card Players*, now in the Metropolitan Museum of Art, New York, had also been included in the 1910 exhibition at the Bernheim-Jeune Gallery.

Fig. 2 Roger de la Fresnaye, *Conjugal Life*, 1912. The Minneapolis Institute of Arts, The John R. Van Der lip Fund.

19

Marie Laurencin (1885–1956)
Young Woman with a Guitar (Jeune fille à la guitare), 1936–8

Oil on canvas, 61 × 50.2 cm. (24 × 19¾ in.)
Signed upper right: Marie Laurencin

Provenance: Mr. and Mrs. V. de Margoulies; Kende Galleries, New York, auction sale of 24 March 1949; Nathan Cummings; loaned to Mr. and Mrs. Norman Cahners, 1952; Mr. and Mrs. Robert B. Mayer, Chicago; The University of New Brunswick, Fredericton, N.B., Canada, 1961; Christie's, London, sale of 24 June 1991, lot 42; The Sara Lee Collection; The National Museum for Women in the Arts, Washington, D.C.

Bibliography: "Auction Calendar," *The Art Digest* (New York), XXIII, no. 12 (15 March 1949), p. 23, repr.
Daniel Marchesseau, *Marie Laurencin, 1883–1956: catalogue raisonné de l'oeuvre peint*, Tokyo: Editions du Musée Marie Laurencin, 1986, no. 1173, p. 476, repr.
Christie's, *Impressionist and Modern Paintings and Sculpture*, London: Christie's, 1991, no. 42, pp. 114–15, repr.

Marie Laurencin is chiefly known today for the short and scarcely productive phase in her career from 1907 until 1916. These dates coincide with the beginning and ending of her passionate love affair with the poet Guillaume Apollinaire and with her direct involvement in the Parisian avant-garde around Pablo Picasso. In fact, she and her friend the American writer and collector Gertrude Stein were the only women to be included in the "inner circle" of the male-dominated vanguard scene that transformed world art in the years around 1910. She was one of the *invitées* for the most selective of artist events, the dinner given in honor of the painter Henri Rousseau in 1908, where the other guests included her friends Picasso, Juan Gris, Max Jacob, Jean Metzinger, Apollinaire, André Salmon, Maurice Raynal, Daniel Kahnweiler, Leo Stein, and Gertrude Stein. Her two paintings of the *groupes d'artistes* from 1908, one in the Musée National d'Art Moderne in Paris and the other in the Cone Collection of the Baltimore Museum of Art, are the most authentic artistic "documents" of the Parisian vanguard produced by one of its members.

Yet it was in 1916, when Laurencin forced an end to her emotionally draining affair with Apollinaire, that her career blossomed. By 1920, after the bloodiest war in European history, she had created an utterly and self-consciously "feminine" art that played itself out, seemingly without change or progressive development, until her death in 1956. Not only did she paint mainly women, flowers, and fantasy animals, but she restricted her palette to the pastel hues that had already been "feminized" both by the fashion industry and by such other women artists as Berthe Morisot. Like those of a male artist, Laurencin's muses were women – playing instruments, holding flowers, fanning themselves, and even riding horseback. They stare out from her canvases with blank, darkened eyes – without irises or pupils, as if blind and "sighted" at the same time. Thus, their "gazes" are directionless and, hence, genderless, creating a politics of "seeing" that is unprecedented and fascinating.

Feminist scholars have shied away from Laurencin. There is one forceful book in English and French (Charlotte Gere, *Marie Laurencin*, Milan: Rizzoli, 1977), which does more than any other work to "recover" Laurencin from the "feminization" that she sought and "constructed." What it makes abundantly clear is that Laurencin can be fully understood only within the context of the feminism connected with the performing arts – with the dance and the theater – and with the embodied "illustration" of texts (generally by male authors). It is, indeed, Laurencin's aggressive courting of "femininity" that gives relevance to her work and links it to that of her greatest French prototype, Berthe Morisot, who was also known mainly as a friend – and possibly lover – of a great male artist, Edouard Manet, and wife of his brother Eugène. While it is as difficult to "remove" Apollinaire from Laurencin or Morisot from Manet as it is to discuss Simone de Beauvoir without Jean-Paul Sartre, every effort must be made to do so in the post-modern assessment of Laurencin's work.

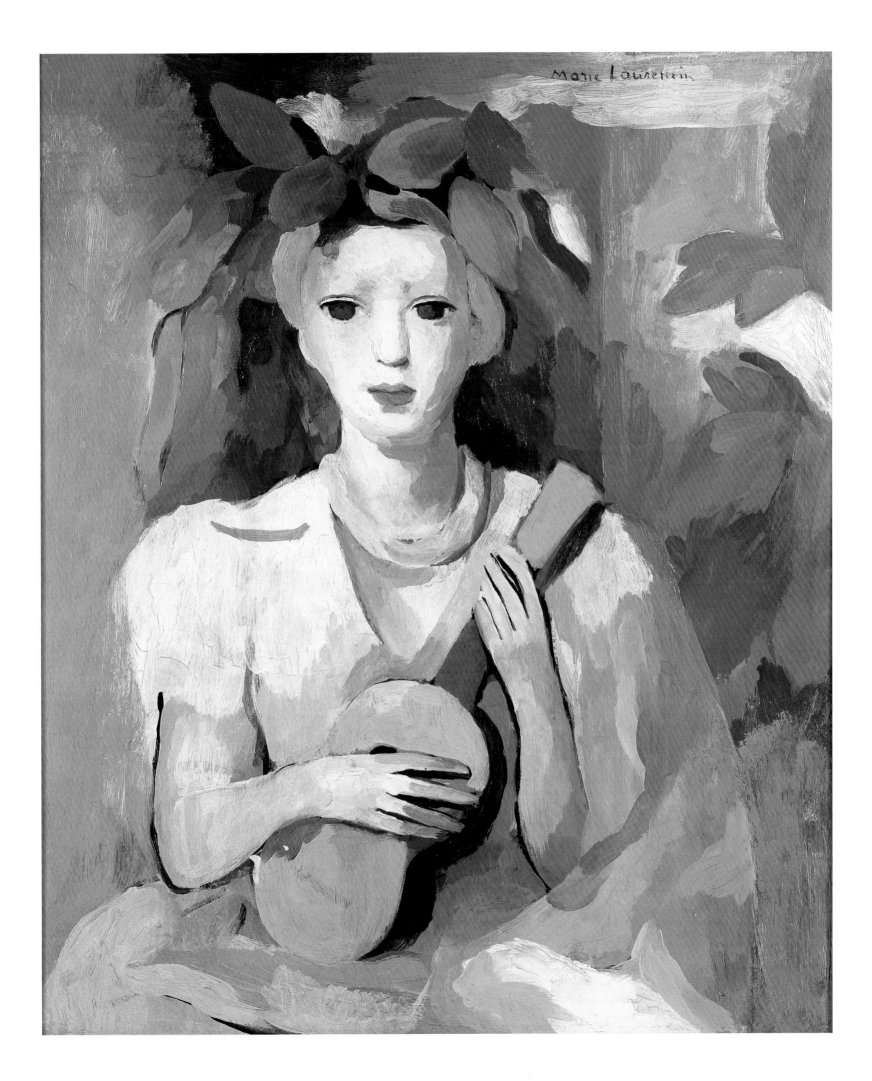

Fernand Léger (1881–1955)
Reclining Woman (*Femme couchée*), 1922

Oil on canvas, 64.5 × 92 cm. (25½ × 36¼ in.)
Signed and dated lower right: F LÉGER/22

Provenance: Galerie Simon, Paris; Gimpel and
Hanover: Anne Rotzler, Switzerland; Galerie
Beyler, Basel; Nathan Cummings; Beadleston
Fine Art, New York, 1979; Galerie Louise
Leiris, Paris, 1981; Private Collection, United
States; The Sara Lee Collection; The Art
Institute of Chicago

Exhibitions: Minneapolis 1965; Washington,
D.C. 1970: no. 43; New York 1971: no 43;
Laren 1997–8

Bibliography: Douglas Cooper, "Cummings
Event in Washington," *ARTnews* 69
(Summer 1970), p. 36, repr.
Frank Elgar, "Le primitif des temps
modernes," in *Homage à Fernand Leger*,
Paris: XXe Siècle. 1971, n. p. [32], repr.
Claude Laugier and Michele Richet, *Léger:
Oeuvres de Fernand Léger (1881–1955)*, Paris:
Musée National d'Art Moderne and Centre
Georges Pompidou, 1981, p.51, repr.
Brettell 1993, 1997 (pp. 94–5, 153–4, repr.).

Fig. 1 Jean-Auguste-Dominique Ingres, *Grande
Odalisque*. Louvre, Paris. Photo © RMN.

Fig. 2 Henri Matisse, *Odalisque with Red
Pantaloons*, 1921. Collections Mnam-Cci, Centre
Georges Pompidou, Paris. © Succession H.
Matisse/DACS 1999.

For Fernand Léger, the decade of the 1920s
was a time of intense productivity, both in the
representational arts of painting and drawing
and in the areas of film, performance,
architecture, and criticism. The relative peace
and prosperity of that decade – elusory as they
proved to be – were essential to the
development of the Paris-based international
vanguard, which experienced something of a
"golden age" before the global depression of
the 1930s and the Second World War all but
destroyed experimental culture in Europe.
Léger's contribution to that vanguard was
celebrated then and continues to be potent to
this day, and works by Léger from the 1920s
can be found in art museums throughout the
world.

Many writers about the 1920s in France –
and about Fernand Léger's contribution to the
"image" of that decade – have noted a
particular kind of post-war conservatism that
has been called a *rappel à l'ordre* or "call to
order."[1] This cultural discourse celebrated the
rational, the mechanical, and the geometric
and its traces can be found in architecture,
product design, graphic arts, and fine arts.
Much of this visual culture of the 1920s is
stamped by an undeniable traditionalism,
which for Léger is rooted in his fascination
with museum art, which became intensely
important for all Parisian artists when the
Louvre gradually reopened in 1920–21.[2]
Although the stories of the closing of the
Louvre during the First World War are
common enough, it is worth remembering
that in many ways the primary audience for
the Louvre was less the general public or the
numerous tourists than the artists – French
and foreign – of Paris. After seven years
without this "palace of arts," artists of all
types flocked to the Louvre, and among them
was the unashamed modernist Fernand Léger.

Almost all of Léger's paintings from 1921
and 1922 bear the signs of these visits. In
them, Léger turns away from the fragmentary
compositions and jazzy urban subjects of
1918–20 toward, instead, the representation of
the human body, both indoors and out, in
ways that have as much to do with the art of
Poussin, David, and Ingres as with the
syncopated modernist visual culture of 1920s
Paris. *Reclining Woman* is one of the works
that manifests Léger's profound debt to
museum art. "I wanted," Léger wrote, "to
mark a return to simplicity by means of an art
that was direct – unsubtle – understandable to
all. I liked David's work because . . . he
obtained the maximum that it is possible to
derive from *imitation* . . . I like the dryness in
the work of both Ingres and David. Here was
my road. It left its mark on me." [3]

Although her body appears almost to have
been "machined" by Léger, the figure of the
woman is clearly legible as a form, as she
reclines on a decidedly modernist sofa made
comfortable with two huge blue and white
pillows. Here is a "modern" Venus, with clear
allusions to such well-known works by Ingres
as the *Grande Odalisque* in the Louvre (fig. 1).
Her yellow pantaloons, though monochrome,
suggest the harem women of Delacroix,
recently remembered by Léger's rival Henri
Matisse, and it is worth remembering that
Matisse's *Odalisque with Red Pantaloons* of
1921 (fig. 2) was purchased for the Musée du
Luxembourg from the Bernheim-Jeune
Gallery early in 1922 and that it was
published in a collection of photographic
reproductions of Matisse's work by Charles
Vildrac in 1922.[4]

Matisse was more confident of his
orientalist paintings than was Léger, who
exhibited none of his 1922 works during that
year.[5] But Léger had created a major

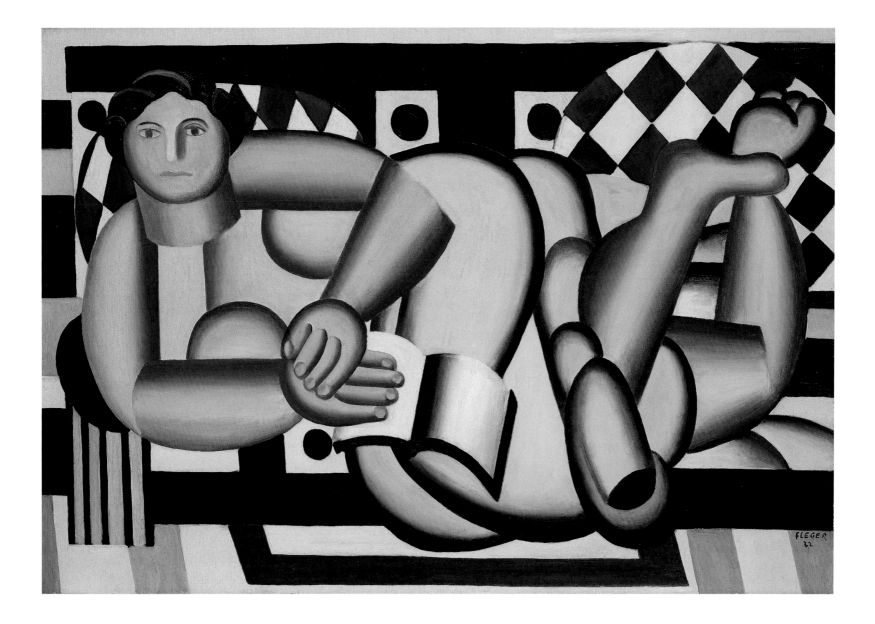

masterpiece in his new idiom in 1921, when, after a long working process, he completed the large version of *Le Grande Déjeuner* (Museum of Modern Art, New York) and exhibited it at the Salon d'Automne. This defiantly classical painting of a three women in an interior was followed by a period of experimentation with representations of single and paired women, who read and rest on sofas in a manner that again links the imagery of Léger with that of his stylistic opposite, Matisse. This experiment was broadened in 1922 to include women out of doors, sometimes in the presence of children, and in one case with a male figure, and this series also culminated in a large "masterpiece" of 1922, *Woman and Child* (Kunstmuseum, Basel). However, Léger did not send this canvas to public exhibition until 1926.

When it enters the collections of the Art Institute of Chicago, *Reclining Woman* will be the first work of 1921–2 in that institution's important collection of paintings by Léger. Chicago has long been involved with Léger's work, which was included in the Armory Show held at the Art Institute in March and April of 1913. Every year from 1926 to 1935 (with the exception of 1932) the Arts Club of Chicago organized exhibitions that included Léger and in 1941 it mounted a solo Léger exhibition that traveled to a number of different venues across the country. In 1953 the Art Institute produced a survey exhibition of Léger's oeuvre that traveled to the San Francisco Museum of Art and to the Museum of Modern Art in New York. Interestingly, among the paintings by Léger in private collections in Chicago is a major work in the manner of *Reclining Woman* in the collection of Stanley and Ursula Johnson, *The Red Corsage* (fig. 3).

1. See Romy Golan, *Modernity and Nostalgia: Art and Politics in France between the Wars*, New Haven and London: Yale University Press, 1995.
2. For a guide to the Louvre after its post-war reopening, see L. D. Luard's translation of Louis Hourticq's *A Guide to the Louvre: Painting, Sculpture, Decorative Arts*, Paris: Librarie Hachette, 1923. This reopening is fascinating to the modernist because, for the first time, nineteenth-century French art was removed from the Luxembourg Museum and placed in the Louvre itself. Works by Manet, Fantin-Latour, Monet, Renoir, Morisot, Cézanne, and Degas were for the first time integrated into the larger history of art. This "marriage," critical to French modernism of the twenties and thirties, was a short one. After the Second World War, French art after Manet was moved first to the Jeu de Paume and then to the Musée d'Orsay, thereby permanently separating modern French painting from its historical precedents.
3. Quoted in Peter de Francia, *Fernand Léger*, New Haven and London: Yale University Press, 1983, p. 198.
4. Charles Vildrac, *Seize Reproductions d'après tableaux de Henri Matisse*, Paris: Les Editions de Bernheim-Jeune, 1922.
5. This statement is documentable only through Georges Bauquier's *Fernand Léger: catalogue raisonné*, Paris: Adrien Maeght, Editeur 1920–24. Indeed, the earliest documented exhibition of a 1922 painting in the catalogue is in 1924 at Léonce Rosenberg's Galerie de l'Effort Moderne.

Fig. 3 Fernand Léger, *The Red Corsage*, 1922. Ursula and R. Stanley Johnson Family Collection, Chicago. © ADAGP, Paris and DACS, London 1999.

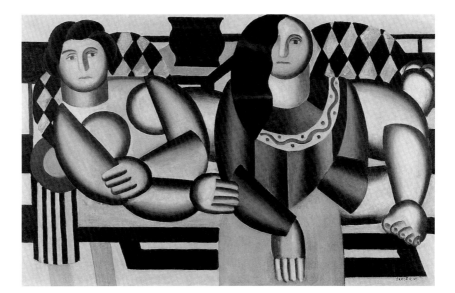

Fernand Léger (1881–1955)
Still-Life (*Nature morte*) [also known as *Still-Life with Compass* (*Le Compas*)], 1926

Oil on canvas, 92 × 73 cm. (36¼ × 28¾ in.)
Signed and dated lower right: F. LÉGER-26;
inscribed on verso: Nature-Morte/F Léger/26
Bauquier, vol. III, 460

Provenance: Galerie Louise Leiris, Paris;
Galerie Simon, Paris; G. David Thompson,
Pittsburgh; Bucholz Gallery, New York;
Parke-Bernet Galleries, New York, sale of 24
March 1966; Nathan Cummings, New York;
The Sara Lee Collection; The Art Institute of
Chicago

Exhibitions: Kunsthalle Bern, *Fernand Léger*,
10 April–25 May 1952: no. 35; The Hague,
Haags Gemeentemuseum, 1961: no. 110;
Turin, Galleria Civica d'Arte Moderna, 1961:
no. 77; Pittsburg, Carnegie Institute, 1961;
New York, Solomon R. Guggenheim
Museum, *Fernand Léger: Five Themes and
Variations*, 28 February–29 April 1962; New
London, Connecticut College, Joanne and
Nathan Cummings Art Center, April 1969;
Paris, Palais Galliéra, *Fernand Léger*,
February–March 1969; Washington, D.C.
1970: no. 42; New York 1971: no. 42; Chicago
1973; Winston-Salem 1990; Memphis 1991;
Lakeland 1995; Laren 1997–8.

Bibliography: E. Tériade, *Fernand Léger*,
Paris, Editions Cahiers d'art, 1928, p. 76, repr.
Brettell 1986, 1987, 1990, 1993, 1997, pp.
96–7, 154, repr.
Georges Bauquier, *Fernand Léger: catalogue
raisonné*, Paris, Adrien Maeght, Editeur, vol.
III (1925–8), 1993, no. 460, repr.

Fig. 1 Fernand Léger, *Abstraction*, 1926.
Honolulu Academy of Arts, Gift of Robert Allerton
through Friends of the Academy, 1945. © ADAGP,
Paris and DACS, London 1999.

The great Greek-born critic and publisher
Tériade wrote the first important book on
Léger in 1928. Published by the highly
experimental *Cahiers d'art*, the book was
among the most beautiful monographs of the
decade, and its fascinating critical text pushed
the study of Léger and of Parisian modernism
to a new level. Among its rigorous selection of
works by Léger chosen for reproduction is *Le
Compas*, a work that seems otherwise to have
escaped notice until it was first exhibited in
1952. Clearly, Léger himself was its owner in
1928, and, although Tériade failed to write
about specific works of art, his text helps
toward an understanding of this thoroughly
modern still-life. It was Tériade who gave the
work the title "*Le Compas*," which Bauquier
has followed in the definitive catalogue
raisonné of paintings by Léger. The artist,
however, chose the more neutral – and more
suggestive – title *Nature morte*, which he
inscribed on the back of the painting.

When reading the extensive bibliography
devoted to Léger in the 1920s, two concerns
predominate. The first is that he was a
northerner, a man whose outlook toward life
was determined, in the eyes of his
commentators, by his Norman origins.[1]
Léger's art is contrasted with the
"Mediterranean" art of Picasso, and the
contrast is succinctly summarized by Tériade
in these terms: "Picasso is the liberator. Léger
is the constructor."[2] This northern
preoccupation with "construction" is taken to
the next level in many texts where writers

associate the art of Leger directly with
architecture. "The art of Léger," Tériade tells
us, "is the art of space. Consequently, he is
very close to an architect."[3] And Léger
himself often wrote about architecture and
about his close associations with the great
French architect-painter Le Corbusier, with
whom he routinely collaborated in the mid-
1920s.

Still-Life is, in this sense, an
"architectural" still-life, because among the
elements that define it is a clearly
recognizable compass, a tool routinely used by
architects and engineers to produce regular
curved forms and to measure and "point up"
or "point down" the proportions of an object
or represented form. Because Léger had been
apprenticed to an architect in his teens, before
deciding firmly on his vocation as a painter,
his passion for precision, balance, and order
has often been ascribed to that period. Yet is
Léger's *Still-Life* really "about" architecture?
The answer is decidedly not.

Teriade referred to Léger's works as "his
constructions, his machines, his picture-
objects, his objects in space."[4] Of these four
"categories," *Still-Life* is clearly not a
machine (nothing moves or functions as do
the elements of Léger's films or performances
of the 1920s), nor is it an "object in space." It
is a "construction," made up from elements,
"representational and abstract," and it is also
surely a "picture-object." Like most of Léger's
thirty-three surviving paintings from 1926, it
is at once abstract and representational, and it
partakes of the artist's struggle with
abstraction during the year in which he flirted
most aggressively with "pure" abstraction in
works such as those entitled *Mural Painting*
and one work even entitled *Abstraction* (fig.
1). In this work, perhaps more than any other
of his career, Léger comes closest to the type
of geometric abstraction developed in The
Netherlands and Paris by Piet Mondrian and
Theo van Doesburg. In fact, Mondrian's
paintings had already been exhibited with
those by Léger in the Salle de l'Effort
Moderne of May 1921, although, at that time,
Léger shied away from abstraction, preferring
to apply the lessons of geometric composition
to the "construction" of works with clearly
recognizable forms.[5]

In *Still-Life* three forms are recognizable as
"representations," two segments of a compass,
on the left, and one mechanical element at the
upper right. The mechanical element is
deliberately ambiguous in its function, indeed
almost functionless, but the elements of the
compass can clearly be identified.[6] These
representational forms seem to float in front

Fig. 2 Gerald Murphy, *The Razor*, 1924. Dallas Museum of Art, Foundation for the Arts Collection, gift of the artist. © 1999 Honoria Murphy Donnelly.

1. This view is discussed extensively in the most intelligent monograph on Léger in English, Christopher Green's *Léger and the Avant-Garde*, New Haven and London: Yale University Press, 1976. For a more succinct discussion, see Green's essay on "La Femme et l'enfant," in *Fernand Léger*, Paris: Centre Pompidou, 1997, pp. 114–17.

2. Tériade (1928), p. XI.

3. Ibid., p. XIII

4. Ibid., p. IX

5. A photograph of this installation is included in *Fernand Léger*, Paris: Centre Pompidou, 1997. p. 306.

6. Léger's compass may represent a nod to his friend El Lissitzky, who also used the compass as a motif in certain works of 1922–7, and to other of Léger's associates among the Russian Suprematists and Constructivists, who used the compass as a tool in creating circles in their art from 1919 forward. (In 1922 Léger supplied an article defining the essence of Constructivism to the inaugural edition of Ilya Ehrenburg and El Lissitzky's art journal *Vesch* [Object], and that same year Ehrenburg used a reproduction of a Léger design on the cover of his Constructivist tract *A vse takin ona vertitsia* [And yet the world goes round]. See Matthew Affron, "Léger's Modernism: Subjects and Objects," p. 126, and Kristen Erickson, "Chronology," p. 267, in Carolyn Lanchner et al., *Fernand Léger*, New York: Museum of Modern Art, 1998. See also Anatol Goldberg, *Ilya Ehrenburg*, New York: Viking, 1984, pp. 86–7.)

7. There are many discussions of Leger's interest in De Stijl/Neo-Plasticism, but an easily accessible one is Carolyn Lanchner et al., *Fernand Léger*, New York: Museum of Modern Art, 1998, p. 189.

of a totally abstract composition of flat elements in black, white, gray, red-orange, yellow, and a sort of fleshy orange-pink. Every element of the "abstraction" is rigidly geometric, and, with the exception of the two circular elements at the center of the composition and the representational forms, the painting could almost be mistaken for a Mondrian. Even the colors allude to De Stijl or "Neo-Plasticism," as Mondrian called his art.[7] Yet they only allude to rather than directly approach Mondrian's primary colors. Léger's "red" is not actually a primary hue; there is no blue; the flesh color would have made Mondrian faint; and the odd misalignment of forms gives them a collage-like layering that further complicates any attempt to link the painting with Mondrian's planar art. Indeed, Léger's painting is more an approach-avoidance to/of Mondrian's Neo-Plasticism than it is an endorsement of the style. The fact that it celebrates a mechanical element that creates the very circles that Mondrian hated makes clear Léger's disdain for the Dutchman.

In many senses, there are three artists who are particularly close to the Léger of 1926: the Frenchman Amedée Ozenfant, the Swiss Le Corbusier, and the American Gerald Murphy. The first two are well known, and they worked, with Léger's complicit collaboration, to give form to a "style" called "Purism." This was essentially a form of industrial classicism in which the artists represent certain

utilitarian objects, which, by the very fact that they are absolutely utilitarian, attain the status of "pure," almost platonic forms. The pitchers, beakers, glasses, and tables of "Purist" still-lifes were adopted by Léger, who added to them a wonderfully diverse "catalogue" of painted forms, such as balustrades, accordions, umbrellas, ball bearings, siphons, pitchers, books, ink pots, bottles, bowler hats, and typewriters. In this, Léger seems almost to have followed the American painter Gerald Murphy, whose Villa America on the Riviera brought the "northern" Léger down south. Murphy, whose father owned and ran the Mark Cross Company (an American luxury goods company now owned by Sara Lee Corporation), was deeply familiar with industrial processes and had been disappointed when his father lost the battle for the safety razor to a Mr. Gillette in the early 1920s. Perhaps because Murphy was not, in his own view, a "natural" painter, he was attracted to the precise, almost mechanical art of Léger, and the two collaborated on a host of projects in the mid-1920s. By 1924 Murphy had already painted "still-lifes" of everyday, industrially produced forms, and both *The Razor* of 1924 (fig. 2) and *The Watch* (Dallas Museum of Art) of 1925 not only predate Léger's industrial still-lifes of 1926, but employ the very same mixture of "abstraction" and diagrammatic representation that is characteristic of *Still-Life*.

Aristide Maillol (1861–1944)
Phryne, 1903 (?)
Terracotta, height: 39 cm. (15⅛ in.)

Provenance: Madame André, Paris; Nathan Cummings, Chicago; The Sara Lee Collection; David and Alfred Smart Museum of Art, University of Chicago

Exhibitions: Washington, D.C. 1970: no. 65; New York 1971: no. 65; Winston-Salem 1990; Memphis 1991.

Bibliography: Brettell 1990, 1993, 1997, pp. 74–5, 154–5, repr.

Perhaps the most mysterious and famous female figure in France is the *Venus de Milo* (fig. 1). Since the Louvre opened to the public after the French Revolution, this serene but armless female torso, with her legs covered in drapery, has mystified artists, critics, historians, and general visitors. It has always been given pride of place and is one of the five or six works of art to which every visitor to the Louvre makes a pilgrimage. Where does she come from? How old is she? Who carved her? Why were her arms cut off? In what positions were they? Hiding her firm breasts? Behind her back? Raised in a gesture of speech? Reaching to hold up the drapery that covers her legs? Almost every great figural sculptor has wrestled with these questions, and, one of the most distinguished of these artists was the French sculptor Aristide Maillol, who

grappled with the *Venus de Milo* many times in his long career as France's most honored sculptor after Rodin.

Interestingly, Maillol never intended to be a sculptor. Born in 1861 and raised in a family of farmers who cultivated olives and vines on the slopes of the Pyrenees near the Mediterranean, Maillol arrived in Paris in 1882 to study painting at the Ecole des Beaux-Arts with Manet's nemesis, the academic painter Alexandre Cabanal. He was soon bored by this regimen and befriended a series of more radical and inventive artists, including Puvis de Chavannes, Paul Gauguin, and Maurice Denis. Maillol seems to have become attracted to sculpture following Gauguin's example in 1894–5, but was essentially a painter and a maker of tapestries until 1900, when the strain to his eyes was so

Fig. 1 *Venus de Milo.* Louvre, Paris. Photo © RMN.

Fig. 2 Aristide Maillol, *Young Bather Standing.* Fondation Dina Vierny – Musée Maillol, Paris. © ADAGP, Paris and DACS, London 1999.

great that he was forced to give up tapestry production and turned almost full time to the most tactile of arts. He was nearly forty years old when he "became" a sculptor. Yet, already in 1898, after his marriage, Maillol had used his new wife as a nude model and created his first major work of figural sculpture, *The Source* (Musée Maillol, Paris). By 1899 he had already perfected the firm and utterly material classicism that he was to transform and develop throughout the remainder of his life. It is perhaps not an accident that his first canonical woman was *Eve holding the Apple* and that the bronze cast of it is today in the Musée Maillol, which opened in 1995, fifty years after the artist's death.

By 1904 Maillol began to exhibit his figural sculpture in the Salon, and his work was praised by artists, critics, and historians including André Gide, Gauguin, Rodin, Denis, and Roger Fry. It was Gide who put it best: "Maillol does not proceed from an idea, which he claims to express in marble"; he wrote in 1905, "he starts from the material itself, be it clay or stone; you feel he has contemplated it for a long time, then rough hewn it and then emancipated it with forceful caresses. Every one of his works retains an elementary heaviness."

Phryne represents a young woman who is, in essence, the *Venus de Milo* (with arms) in miniature. She has been conventionally dated to 1903 and if this date is accepted she is the first of several small figures that deal with the same sculptural problem. John Rewald published two other terracotta sculptures in his monograph.[1] Rewald refused to date the *Young Bather Standing*, who has no arms, now in the Maillol Museum (fig. 2) but dates the second terracotta, also called *Young Bather Standing*, to "about 1914." His discussion of these works makes no mention of the entitled subject of the *Phryne*, who was a fourth-century B.C. Athenian *hetaera* or cultivated courtesan, reputedly used as a model by the sculptor Praxiteles and the painter Apelles. She is, thus, the first known muse in western art, and her appeal both to a sculptor and a painter must have surely attracted the attentions of Maillol, who had started as one and "converted" to the other.[2]

If Maillol indeed made the Sara Lee terracotta in 1903, when he worked extensively in that medium, he seems not to have turned his attention to the figure of *Phryne* again until 1910, when he cast the same figure in bronze (fig. 3).[3] Although the reasons for the delay are not spelled out in the Maillol literature, it is perhaps not accidental that the great German sculptor Wilhelm

Lehmbruck had exhibited a plaster of his own "solution" to "the Venus de Milo problem" in the Salon d'Automne of October 1910.[4] This work, *Standing Female Figure*, a bronze cast of which is now in the collection of the National Gallery in Washington may have prompted Maillol to pick up his terracotta (or a plaster version of the figure) and to render it in bronze, which "softens" the form.

1. John Rewald, *Maillol*, London, New York, Paris: Hyperion, 1939, pp. 118–19.
2. Maillol himself preferred slightly earlier Greek sculpture to that of Praxiteles, actually admitting a greater admiration for the sculpture at Olympia than for that of Praxiteles at the Parthenon. See Denys Chevalier, *Maillol*, Paris: Flammarion, 1970, p. 18. Interestingly, Maillol's *Phryne* is a good deal more like the Olympia sculpture than it is like the Hellenistic work on which it is based.
3. See Bertrand Lorquin, *Aristide Maillol*, Geneva: Skira, 1995, p. 64. This sculpture is now in the Musée Maillol, Paris.
4. See Reinhold Heller, *The Art of Wilhelm Lehmbruck*, Washington: National Gallery of Art, 1972, p. 20.

Fig. 3 Aristide Maillol, *Phryne*, n.d. The Museum of Fine Arts Houston; Museum purchase with funds provided by the Houston Friends of Art. © ADAGP, Paris and DACS, London 1999.

Giacomo Manzù (1908–1991)
Skating Girl, 1959
Bronze, height: 175.5 cm. (68½ in.)
Stamped with signature and foundry mark

Provenance: Collection of the artist; Nathan
Cummings; The Sara Lee Collection

Exhibitions: London, Tate Gallery, *Giacomo
Manzù Sculpture and Drawings*, 1 October–6
November 1960: no. 51; Phoenix Art Museum,
Arizona, *Exhibition of Sculpture and Drawings
by Giacomo Manzù*, 14 April–28 May 1978;
and San Diego, California, Fine Arts Gallery
of San Diego, California, 14 September–29
October 1978; no. 57; Winston-Salem 1990;
Memphis 1991; Laren 1997–8.

*Bibliography: Giacomo Manzù Sculpture and
Drawings* (exh. cat.), London: Arts Council of
Great Britain, 1960, plate v.
Giacomo Manzù: Skulpturen Zeichnungen
(exh. cat.), West Berlin: Staatliche Museen zu
Berlin, 1960, p. 40.
Brettell 1986, 1987, 1990, 1993, 1997 (pp.
140–41, 155, repr.).

Fig. 1 Giacomo Manzù, *Young Girl*, 1958.
Galleria d'Arte Moderna, Rome.

Nathan Cummings was a friend and major
patron of the Italian sculptor Giacomo Manzù,
and his collection included several important
bronzes by that noted figurative artist. The
Sara Lee Collection includes two of these,
each of which represents a major aspect of
Manzù's work – one from his secular figural
sculpture and the other from his sacred
oeuvre.[1] *Skating Girl* is a full-scale bronze
figure cast in 1959 and sold almost
immediately to Nathan Cummings, who may,
in fact, have financed its production; it was
among his favorite bronzes and has come to be
almost an icon for Sara Lee Corporation.

Throughout his long life, Manzù was
fascinated with erotic and quasi-erotic female
figures, who were intended to titillate male
viewers with a youthful – one might say
"innocent" – sensuality. In this, his oeuvre
can be related to that of the great Polish-
French painter Balthus, who was responsible
for the estheticization of female adolescent
sexuality in ways that are closely related to
the fiction of Vladimir Nabokov. The
implications of this trend in European arts
and letters in the decades before, during, and
after the Second World War have not been
fully analyzed by cultural critics. Although
many of Manzù's young women and girls
have names – Tebe, Inge, Emy, and Beata, for
example – others are nameless models whose
very anonymity removes any sense of male
guilt from their adoration. Hence, an esthetic
experience with them on the level of "art" is
akin to a chance encounter, which leaves
powerful memories, but little shame. Manzù
reproduced the delicate dance called
"striptease" in drawings and sculptures
throughout the 1960s and 1970s, making it
clear that these pubescent girls and young
women are indeed "available," if only in art.

Skating Girl has several important sources,
both inside and outside Manzù's own oeuvre.
The artist himself had made a blue pastel of
an adolescent girl playing with her skirts in
1957 called simply *Young Girl* (fig. 1).[2] This
work does not deal with skating, which
Manzù waited to investigate until the period
1958–60, during which he made both the Sara
Lee bronze and a beautiful black chalk
drawing of 1960, *Skating Girl*.[3] Yet, it is not to
Manzù himself – or to the example of Balthus
– that we must turn for the most powerful
prototype; it is to the nineteenth-century
painter and sculptor Edgar Degas. Degas's
only exhibited sculpture, *Little Dancer at Age
Fourteen* (fig. 2), has many of the same
qualities of pose, form, and adolescent
sexuality, all of which have been exhaustively
analyzed by feminist historians of

Fig. 2 Edgar Degas, *Little Dancer at Age
Fourteen*, 1880-81. Sterling and Francine Clark Art
Institute, Williamstown, Massachusetts.

Impressionism.[4] Degas's sculpture, arguably
the single most famous of nineteenth-century
modernism, is well known to any European or
American artist of the twentieth century, and
posthumous casts of it can be found in
collections throughout the world, many of
which were known to Manzù. Degas's
deliberate selection of a fourteen-year-old girl
working in a profession associated with
prostitution has been widely acknowledged in
the vast literature on this work, and the fact
that the first "modernist" sculpture was a
three-quarter-size figure of an adolescent girl
associated with the dance was certainly not
lost on Manzù when he decided to transform
his young girl playing with her skirt into the
infinitely more titillating *Skating Girl*. As if to
alert us to his "quotation," Manzù elected to

position his skater's arms and hands in the odd, but identical position, of those in Degas's *Little Dancer*.

In choosing to create a skater, Manzù added the elements of speed, instability, cold, and imbalance to a figure that, without these, has less *frisson* or excitement than the skating girl. By making her full scale, so that we look almost directly at her when she is on a base, Manzù enabled her to enter the realm of the viewer directly. This very deliberate balance — between girl and woman, athlete and temptress, standing and moving, warm and cold, public and private — was deliberately sought by Manzù, who transformed Degas's little "rat," as she was called in 1881, into an image of grace that is, in the end, more dangerous than we suspect at first glance. We meet her in a public place, as she skates in her own world, and we confront our own prurient imaginations.

1. This aspect of Manzù's oeuvre is discussed most fully in the catalogue *Sacred and Profane*, La Jolla, California: Tasende Gallery, 1989.
2. This is famous drawing, reproduced in several prominent Manzù catalogues including the 1978 Phoenix and the great Edinburgh exhibition of 1987–8, *Manzù*, edited by Linia Velani, Milan: Electa, 1987.
3. Galleria Nazionale d' Arte Moderna, Raccolta Manzù, Ardea, *Skating Girl*, black chalk, 1960, 51.3 × 38.3 cm.
4. This bibliography has been usefully summarized and, in certain cases, criticized by Richard Kendall in *Degas and The Little Dancer*, New Haven and London: Yale University Press, 1998. The bibliography can be found on pp. 185–8. A discussion of the "sexuality and "class" ideology of the work can be found on pp. 45–76.
5. There is a vast literature on "the male gaze" and male-dominant and gendered viewing in modern representation, but little of it has focused on the adolescent girl, in spite of the enormous popularity of this subject among figural artists in the nineteenth and twentieth centuries. The adolescent girl is in some ways a counter to the feared and hated *femme fatale*, but her charms have been discussed more in terms of androgyny than of sexual guilt.

24

24

Giacomo Manzù (1908–1991)
Seated Cardinal (*Cardinale seduto*), 1962

Bronze, height: 47.5 cm. (18½ in.)
Stamped with raised signature on right side of
base: Manzù

Provenance: Nathan Cummings (acquired
from the artist before 1968); Christie's, New
York, sale of 30 April 1996; The Sara Lee
Collection; Vatican Museums: Museum of
Modern Religious Art

Exhibitions: New London 1968; Washington,
D.C. 1970: no. 68; New York 1971: no. 68;
Chicago 1973: no. 82; Laren 1997–8.

Bibliography: Brettell 1997, pp.138–9, 155–6,
repr.

Giacomo Manzù and Marino Marini were the
greatest figural sculptors produced by Italy in
the twentieth century. Each was fully engaged
with major issues of modernism, but, more
than their counterparts in other European
countries, each keenly felt the burden of the
past embodied in the Italian artistic heritage.
Manzù dealt with the past most importantly
in his "catholic" art, and, unlike that of the
profoundly secular Marini, his oeuvre is
incomprehensible without a clear
understanding of the Catholic Church and his
representations made for it. The so-called
"sacred" portion of Manzù's oeuvre is without
doubt the most distinguished, and his long
engagement with the Church reached its
highest plateau when Manzù befriended Pope
John Paul and began to work concertedly for
the Vatican under the personal patronage of
that great pope.

Every reader of the Manzù biography
knows the famous story of his impression of a
1934 service at the Vatican where he first saw
the seated cardinals that were to obsess him
until his death in 1991. He was then thirty-six
years old, and it was the first trip of the
northern Italian sculptor to Rome: "The first

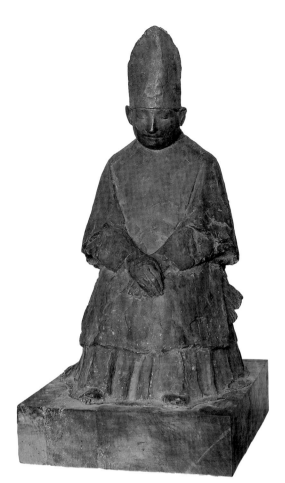

Fig. 2 Giacomo Manzù, *The Cardinal*, 1948. ©
Tate Gallery, London.

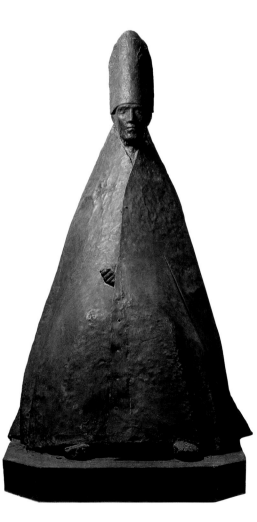

Fig. 1 Giacomo Manzù, *The Cardinal*, 1956.
Galleria d'Arte Moderna, Venice. Photo SCALA.

time I saw the cardinals . . . in St. Peter's in
1934, I was struck by their rigid masses, like a
lot of statues, a series of cubes lined up. The
impulse to create my own version in sculpture
of that ineffable reality was irresistible."[1]

And sculpt them he did. The earliest of the
surviving works is a bronze of 1938 now in the
Galleria Nazionale d'Arte Moderna in Rome.
Here, the cardinal is a "bottom-heavy" and
weighty mass, whose bulk is relieved by the
extremely attenuated shape of his cope and
whose face is a stern, paternal mask
culminating in the mitre. This work was
further refined nearly ten years later, when
Manzù once again took up the subject and
made a bronze cast that was immediately
bought by the Tate Gallery in 1948 (fig. 2).
This later *Cardinal* seems less an observation
than an idea, suggesting that the concept had
"matured" after sitting nearly a decade in the
memory of Manzù, affected by his experiences
of Fascism, war, and their aftermaths. All of
this seems to have brought the sculptor back
again to the healing presence of the Church
and to a stylized Cardinal lacking the
authoritarian aspect of the earlier figures.

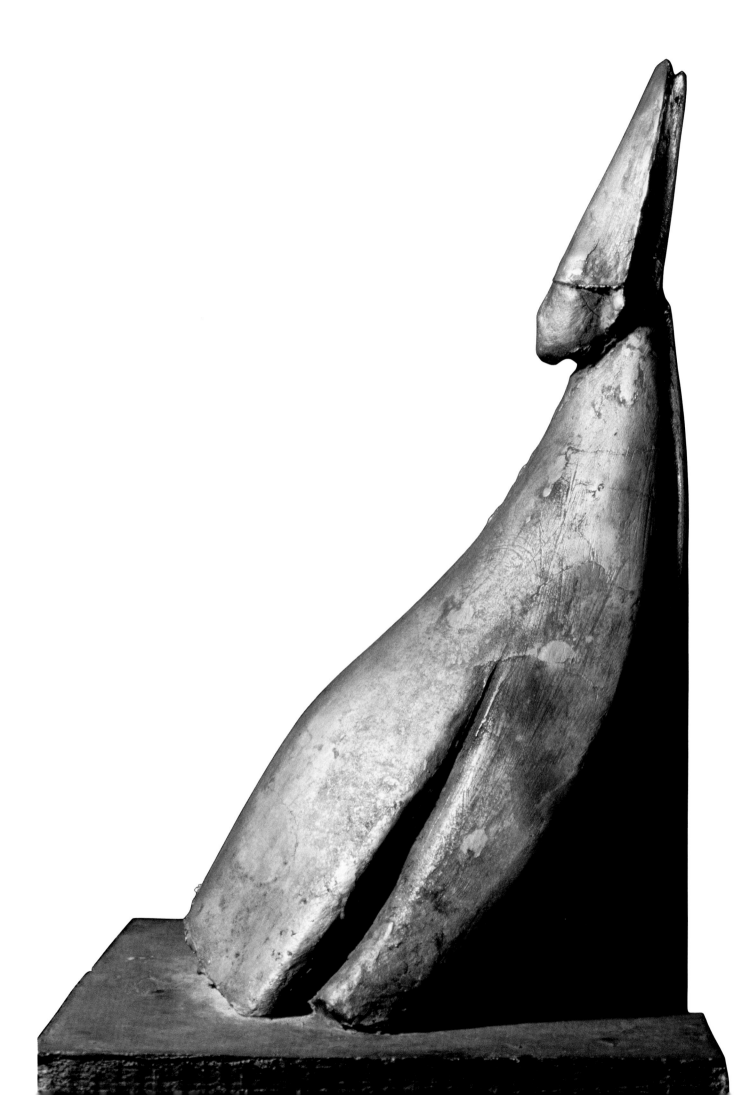

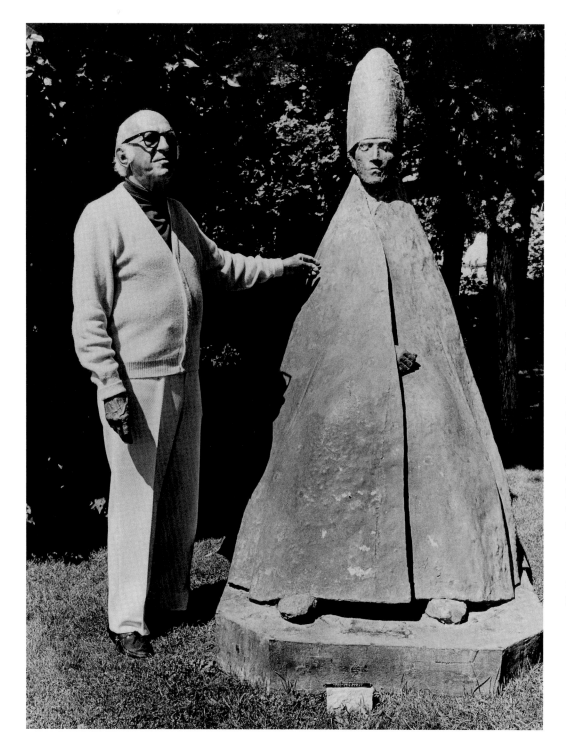

Moderna, Raccolta Manzù, in Ardea. In making the large seated *Cardinal*, Manzu began to abstract the volumes of the great cape and to play with the directionality of the cope in such a way that he was able by 1962 to create a small bronze that locates a rhythmic torsion in what had been the "cubic" mass of the cardinal, freeing the figure – and the Church it embodies – from the rigors of gravity and the earth. This work, a superb golden cast of which is now in the Sara Lee Collection, was one of several small, table-top Cardinals that Manzù made for collectors and museums throughout the world, who clamored for a representation of the Church as modern – as vital and as full of movement – as any figural representation of the twentieth century.

When the sequence of Seated Cardinals is seen together, it is clear that Manzù's sense of the Catholic Church altered from that of a supplicant in an authoritarian religion around 1937–8, to that of a man who became a church "intimate" and for whom the expression of religious values could be accompanied by a sense of grace, elegance, and vitality. It is for that reason that the Sara Lee Corporation has been given permission to donate this object to the Museum of Modern Religious Art at the Vatican, the very place in which Manzù had his first vision in 1934 of the Church embodied in a Seated Cardinal.

1. See *Manzù*, ed. Livia Velani, Milan: Electa, 1987, p. 98.

Fig. 3 Nathan Cummings with the *Monumental Seated Cardinal*. Photo Sara Lee Corporation.

In 1952 Manzù created another, more abstracted bronze *Cardinal* at a small scale. The process of refinement prompted the sculptor to conceive of a vast, over-lifesize version, which he created in 1954–5 and cast with financial help from his friend and patron Nathan Cummings (fig. 3). Of the monumental *Seated Cardinal*, there are only three casts – one in the collection of the Cummings heirs, another in the Galleria d'Arte Moderna, Ca Pesaro, Venice (fig. 1), and the third in the Museo Nazionale d'Arte

Marino Marini (1901–1980)
The Resurrection (*La risurrezione*), 1954

Oil on paper mounted on a larger canvas and
reworked extensively in oil, 109.3 × 84
(42¾ × 32¾ in.)
Signed bottom right: Marino
Read-Waldberg-di San Lazzaro 198

Provenance: Drs. Fritz and Peter Nathan,
Zurich (acquired from the artist); Nathan
Cummings (acquired from the above in 1963);
The Sara Lee Collection; Tel Aviv Museum

Exhibitions: Zurich, Kunsthaus, *Marino
Marini*, 23 January–25 February 1962.

Bibliography:
Franco Russoli, *Marino Marini: Paintings and
Drawings*, London: Thames and Hudson,
1965, p. 102, repr.
Herbert Read, Patrick Waldberg, G. di San
Lazzaro, *Marino Marini: Complete Works*,
New York: Tudor Publishing, 1970, no. 198,
pp. 199, 421, repr.
Brettell 1997, pp. 136–7, 156, repr.

The oeuvre of the great Italian sculptor
Marino Marini is inconceivable without the
image of a horse and horseman. In his long
and productive career he represented horses
and riders in every medium, beginning most
powerfully with a monumental sculpture of
1937 and continuing until his death – many
hundreds of horsemen later – in 1980. Such an
obsession is scarcely surprising in a country
that "recycled" both the great classical bronze
horses in the Christian context of St. Mark's in
Venice and the greatest surviving antique
equestrian bronze of Marcus Aurelius, whose
High Renaissance setting in Rome was
designed by Michelangelo.

Marini always represented the relationship
between horse and rider as a kind of struggle.
For him, the battle for "dominance" between
physical and mental strengths was symbolized
by the horse and rider, and he used this motif
as a constantly changing visual metaphor for
the human condition. In each variation on the
"theme," the horse and the rider have slightly
different relationships. Sometimes, there is a
suggestion of struggle, and the two seem
overcome by invisible external forces that
drives them to battle together against an
unseen enemy rather than against each other.
In certain of the works the rider is almost as
large as the horse, and the relationship
switches from one of mind versus matter to
matter versus matter. Indeed, the theme was
such an enduring part of Marini's legacy that
the great publication of *Marino Marini:
Complete Works* in 1970 has a section on
horses and riders that stretches for forty pages
and includes as many pages in the catalogue
section. Interestingly, these works have never
been intelligently grouped in an exhibition,
nor have they been clearly related to the
revival of equestrian sculpture in Europe and
America in the nineteenth and early
twentieth centuries.

The Resurrection is both large and
wonderfully subtle. Although it appears to be
a simple painting on canvas, the work is in
fact considerably more complex and speaks of
a two-stage process of creation. The work
began as a large drawing on paper, which so
fascinated Marini and so suggested
enlargement that he literally pasted the sheet
of paper (100 × 75 cm.) on an even larger
canvas (108 × 83 cm.) and used this "double"
support for the transformation of the drawing
into a painting. It is fascinating that Marini
himself seems to have entitled this work very
differently from the majority of his equestrian
representations. Rather than "Horse and
Rider" ("Cavaliere"), it is called
"Resurrection." Unfortunately, there is no

explanation for this in the Marini literature,
and one must speculate as to whether Marini
intended to suggest a Christian reading of the
image, as both horse and rider stand erect as if
witnesses to the Resurrection. Alternatively,
the work can be read as the representation of a
horse and rider who have fallen and have
regained their positions – or been
"resurrected."

Resurrection will enter the permanent
collection of the Tel Aviv Museum of Art.
This, the most important urban art museum
in Israel, has major collections of nineteenth-
and twentieth-century art and is particularly
rich in sculpture and painted and drawn
works by sculptors. The museum recently
acquired a major equestrian bronze by Marino
Marini, and the two will enable this
important museum to have a major work of
that motif in both painting and sculpture.

Fig. 1 (*below left*) Marino Marini, *Man on a
Horse*. Collection of the Tel Aviv Museum of Art;
Bequest of Alma Margenthau, New York. © DACS
1999.

Fig. 2 Marino Marini, *Composition*, 1955.
Collection of the Tel Aviv Museum of Art; Gift of
Helen and Zygfryd Wolloch. © DACS 1999.

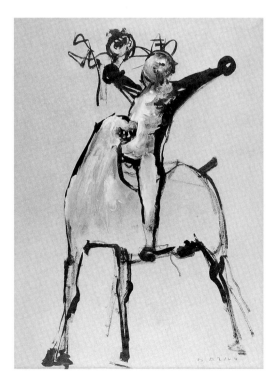

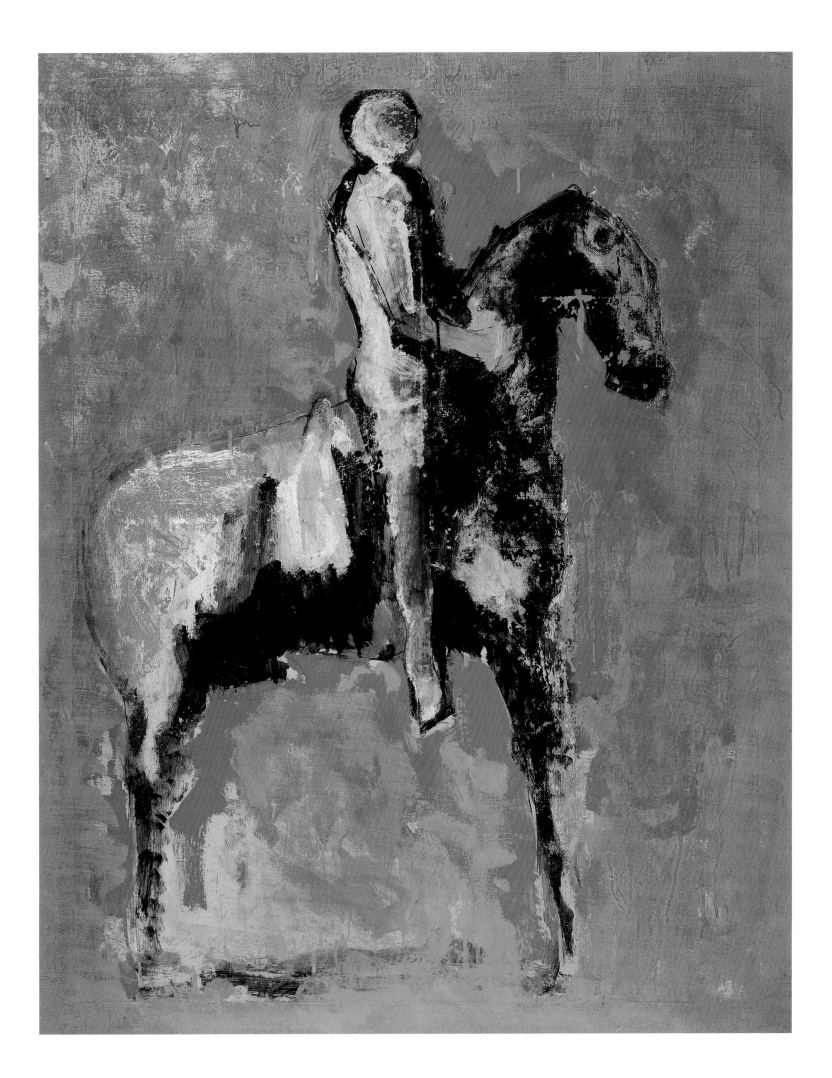

Albert Marquet (1875–1947)
The Quays at Rouen (Les Quais à Rouen),
1912

Oil on canvas, 63.5 × 81.9 cm. (25 × 31¼ in.)
Signed lower right: Marquet

Provenance: Galerie E. Druet, Paris; Galerie
Bernheim-Jeune, Paris; Private Collection,
Paris; Art de France, 1961; Nathan
Cummings; The Sara Lee Collection; St. Louis
Art Museum

Exhibitions: Paris, Galerie E. Druet, unknown
date: no. 7.519; Paris, Galerie Berheim-Jeune,
unknown date: no. 24.463; Kunsthaus Zurich,
*Gedachtnis-Ausstellung, Albert Marquet,
1875–1947*, 1948: no. 65 (as *Rouen, les quais*).
The Metropolitan Museum of Manila, The
Philippines, 20 September–20 November
1976; Laren 1997–8.
Brettell 1997, pp. 92–3, 156, repr.

Bibliography: Consolidated Foods Corporation,
*Consolidated Foods Corporation's Nathan
Cummings Collection*, Chicago: Consolidated
Foods Corporation, 1983, pl. 21 (as *Harbor
Scene*).

Fig. 1 (*below left*) Albert Marquet, *The Quai de
Paris at Rouen*, 1913. Collections Mnam-Cci,
Centre Georges Pompidou, Paris. © ADAGP, Paris
and DACS, London 1999.

Fig. 2 Camille Pissarro, *The Pont Boieldieu,
Rouen*. Musée d'Orsay, Paris. Photo © RMN.

Marquet was already a major landscape
painter in 1912, when he traveled to Rouen to
paint this masterly study in gray. He had
exhibited widely in Paris between 1905 and
1910, attracting the attention of critics and
collectors.[1] Marquet distilled from the juicy
and painterly preoccupations of the
Impressionists an essentially flat and subtle
mode of representation. Gone are the
hundreds of figures, the cloud-filled skies, the
color reflections in the water, and the plethora
of visual incidents that fill the urban views of
Monet, Caillebotte, Renoir, and Pissarro.
Instead, Marquet schematized and flattened
forms, often reducing his palette to the barest
essentials, concentrating only on the
necessities of form and space before
committing a mark to the surface of the
canvas.

Marquet worked in Rouen in two separate
campaigns in 1912, the first in May, June, and
July, when he was accompanied by the poet
René Fauçhois (who complained of the
inclement weather) and, again, in October and
November, when he returned alone to finish
the series.[2] Many of these canvases were
exhibited in a series of exhibitions in the
United States, including the famous 1913
Armory Show held in New York, Chicago, and
Boston. The Sara Lee painting is similar to a
signed and dated work, *The Quai de Paris at
Rouen*, painted in the same season and now in
the Musée National d'Art Moderne in Paris.
This painting was selected for the Salon des
Indépendants in 1913, where it was
immediately acquired by the state for the
Musée du Luxembourg (fig. 1).[3] It is probably
not accidental that Marquet chose to paint the
same bridge and quay that had been selected
by Camille Pissarro in 1896 for his series of
Rouen views, which had been exhibited in

that same year in Paris – and perhaps seen by
Marquet, then a student in the city. Yet, it is
also likely that Marquet had been reminded of
these works when he saw Pissarro's *The Pont
Boieldieu, Rouen, Sunset, Misty Weather* at
Durand-Ruel's Paris gallery in 1910 (fig. 2).[4]

*Pont Boieldieu, Rouen, Sunset, Misty
Weather* is a study of the colors within gray,
and, in contrast to the flat grays of Marquet,
Pissarro's canvas is filled with lavenders,
oranges, purples, pale blues, greens, deep
blues, and ivories. Where Pissarro sought
complex harmonies of color in a luxuriously
thick application of painted marks, Marquet
strove for a minimalism of color and gesture,
thereby engaging in an implicit critique of
Impressionism. Uncountable figures vie for
attention in Pissarro's picture; Marquet
singles out eight or, at most, nine for our
delectation, asking us to consider the
placement of each in the composition
rather than to engage in a pictorial
"recreation" of the actual life of the quays in
Rouen. Indeed, everything in Marquet's
picture is "placed," suggesting that he
concerned himself more with the abstract
logic of picture-making than with the
recording of a particular site at a particular
time. *The Quays at Rouen* is almost as
abstract as a Cubist Picasso or a Fauve nude
by Matisse.

This large and important painting was
made before Marquet's work had become
formulaic in the years after the First World
War. It enters the permanent collection of the
St. Louis Art Museum, which is very strong in
the work of French, German, and American
artists of the first half of the twentieth
century, and will be the first painting by
Marquet in this major collection.

1. For a full study of Marquet's exhibitions, see Judi Freeman et al., *The Fauve Landscape* (exh. cat.), Los Angeles County Museum and New York, Metropolitan Museum, 1990, pp. 59–123, 306–10.
2. See Michele Paret et al., *Albert Marquet, 1875–1947*, Lausanne: Fondation de l'Hermitage, pp. 40–41.
3. See *Albert Marquet, 1875–1947*, Paris: Éditions de museés nationaux, 1975, no. 52., p. 100.
4. See Richard R. Brettell and Joachim Pissarro, *The Impressionist and The City: Pissarro's Series Paintings*, New Haven and London: Yale University Press, 1992, pp. 3–49, particularly no. 3, p. 11.

27

Henri Matisse (1869–1954)
The Dance (*La Danse*), 1906–11
Bronze, height with base: 41.5 cm. (16⅛ in.)
Edition of ten: 9/10
Signed and numbered HM 7 on the left side of
the bronze base; stamped "Cire-Valsauni-
perdue" on the back of the bronze base

Provenance: Theodore Ahrenberg, Stockholm;
Sotheby's London, sale of 9 July 1960, lot 30;
Eric Estorick, London (through the Grosvenor
Gallery); Seven Arts Ltd., London; Nathan
Cummings, Chicago; The Sara Lee Collection;
The Norton Gallery of Art, West Palm Beach,
Florida

Exhibitions: Washington, D.C., 1970: no 66;
New York 1971: no. 66; Chicago 1973: no. 9;
Winston-Salem 1990; Memphis 1991; Laren
1997–8.

Bibliography: Albert E. Elsen, *The Sculpture of
Henri Matisse*, New York: Harry N. Abrams,
1972, no. 133, repr.
Brettell 1986, 1987, 1990, 1993, 1997 (as
Standing Nude, pp.78–9, 157, repr.)
Claude Duthuit, (with the collaboration of
Wanda de Guebriant; preface by Yve-Alain
Bois), *Henri Matisse: catalogue raisonné de
l'oeuvre sculpté*, Paris: Claude Duthuit Editeur,
1997. no. 54. pp.154–7, on p. 361, Duthuit
includes a complete bibliography of all
mentions of this particular bronze, beginning
with the first in 1953, more than forty years
after Matisse had made it. Similarly, the
exhibition history (beginning in late 1949) of
all casts is listed on pp. 327–8.

Fig. 1 Henri Matisse, *La Danse*, 1907. Musée
Matisse, Nice; Gift of Madame Henri Matisse,
1960. © Succession H. Matisse/DACS 1999.

When Henri Matisse started his own private
art school in 1908, his students (mostly
Americans) concentrated as much on sculpture
as on painting, and, as if in a synergy with his
students, Matisse continued to produce – and
exhibit – sculpture.[1] He tended to work
directly from the model, but the liberties he
took with what might be called "normal" or
"conventional" proportions and poses were
often so extreme that many early viewers
assumed that he avoided the model
altogether. Clearly, Matisse did not want to
make a "replica" in clay or wax of an actual
human body. Rather, he was well aware that
he was producing sculpture, and because
sculpture is by nature stable he composed it so
that the figure "worked" in the 360 degrees of
a viewer's gaze – a challenge that was
formidable indeed. Not only did Matisse
sculpt, but he began to represent his
sculptures in his paintings, creating a dialogue
between sculpture and painting that is more
complex than that of any previous French
artist, including Daumier, Degas, or Maillol.
Because working in three dimensions was at
the root of Matisse's practice, it is tempting to
think of his sculpture as part of a preparatory
process rather than as an independent part of
his oeuvre, but this would be wrong.[2] Matisse
himself began to exhibit his sculpture as early
as 1904. In 1908 he sent thirteen sculptures to
the Salon d'Automne, and this practice
continued in exhibitions in France, England,
Germany, and the United States until 1915,
when he seems to have begun a decade-long
"rest" from the exhibition of sculpture.[3] Yet
Matisse's sculpture received very little critical
commentary until 1928, when Christian
Zervos devoted an article in *Cahiers d'art* to
"The sculpture of today's painters."[4]

The Dance was first exhibited in Lucerne
in 1949 as *The Dancer*. Matisse himself, in the
inscribed drawing of the sculpture in his
notebook devoted to the casting of his
sculpture, failed to title it, and, perhaps as a
result, it is difficult to know whether we are
looking at a dancer, at a representation of
"dance" itself, or, more simply, at a female
nude.[5] When it entered the Sara Lee
Collection, it had acquired the rather more
neutral title, *Standing Nude*, and this seems to
have been the title of preference for much of
its exhibition history. Yet, in the definitive
catalogue raisonné produced by the painter's
grandson, Claude Duthuit, the title *The Dance*
(*La Danse*) has been reinstated. It is a valid
point because we respond very differently to
the figure if we know that Matisse conceived
of it as a dancer or as a statuette of a standing
nude, and, given the authority of Claude

Duthuit, it is probably most intelligent to
think of it as a representation of "The Dance."

The Dance occupies an unsettled place in
the bibliography devoted to Matisse's bronzes.
Although included in all the major studies, it
is seldom discussed, and there seems to be no
positive evidence in print that conclusively
demonstrates the accuracy of either its title or
its date. Matisse does not seem to have
authorized a cast of the figure until "about
1930," when two of the editions were cast by
Valsauni; all of the remaining bronzes,
including the Sara Lee bronze, were cast in
the early 1950s.[6] If, indeed, two casts were
made in 1930, Matisse does not seem to have
liked them well enough to include them in
the first important exhibition of his sculpture
for a number of years at the Galerie Pierre in
Paris. And, as if in "proof" of this confusion,
the object is variously entitled in the literature
and dated anywhere from 1906 to 1911. As
late as 1958, after it had been "redated" to
1911 in most of the respectable literature, no
less a figure than Jean Cassou, then Curator at
the Musée d'Art Moderne in Paris, persisted
with the earlier date. There is only one
paragraph-length descriptive discussion of the
bronze – in Albert E. Elsen's *The Sculpture of
Henri Matisse* – but it contains absolutely no
proof of the date or title.[7]

Matisse had been fascinated by dancing
figures since the early years of the twentieth
century, and his first fully formed
representation of the dance is the background

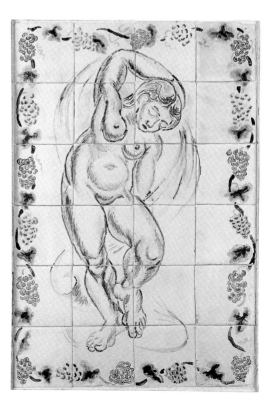

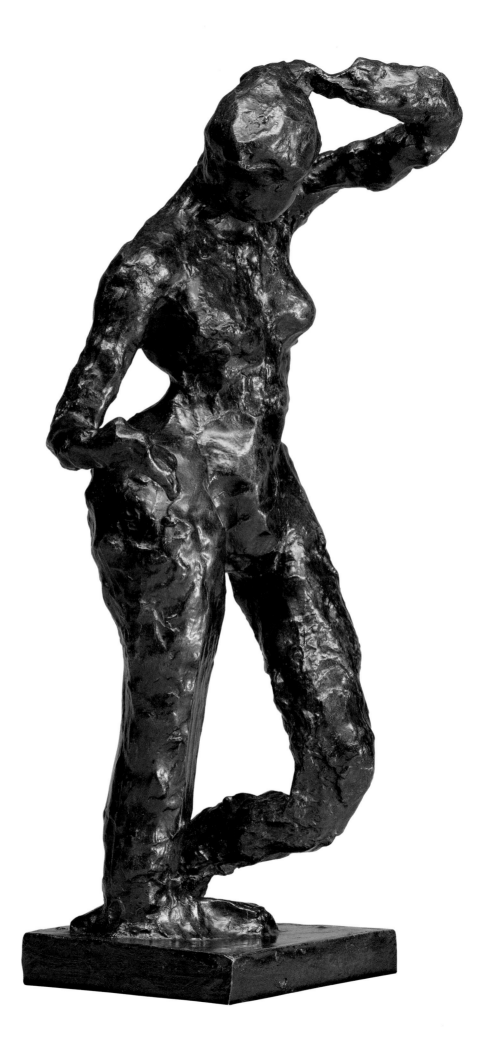

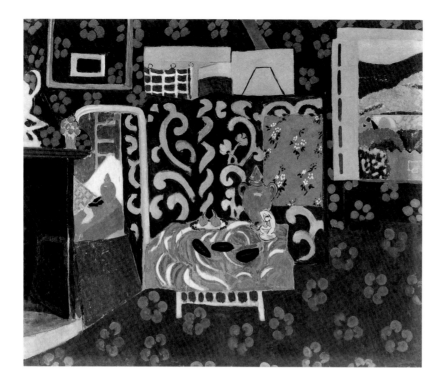

Fig. 2 Henri Matisse, *Still-Life with Eggplant*, 1911. Musée de Grenoble. © Succession H. Matisse/DACS 1999.

With its bowed head, ambiguous gestures, and massive right leg, the figure does indeed accord with Xavier Girard's 1990 description: "the posture a little heavy"[10] – and the fact that the freer of the two legs is firmly stuck to the base adds to this leaden effect. There is absolutely nothing of the liquid mobility of the great Dance decorations in New York or Russia, and only the fact that the figure on the mantelpiece of the Geneva painting is dancing permits the use of this title. So little is known of Matisse's practice in casting – only that he cast quite a number of works in 1908 and that he waited until 1929–30 to send others to be cast. Nothing in the published literature indicates the materials of the "originals" or Matisse's rationale in deciding when and where to cast what.[11] The Sara Lee figure was probably begun in 1911, subsequently reworked extensively, and cast in 1929–30. Just when and why it was reworked is a mystery that requires a book on Matisse's own practice as a sculptor – rather than on the casts of his sculptures.

of his self-conscious masterpiece of 1906 in the Barnes Collection, *Lux, Calme, et Volupté*. In 1907 he experimented with dancing figures in wood and ceramic, and it is perhaps the 1907 ceramic mural, *La Danse* (fig. 1), that comes closer than anything else in his oeuvre to the figure in the Sara Lee bronze. If this figure is compared to the bronze and, from there, the comparison is broadened to include other figurative bronzes of 1906–7, it might be tempting to reconsider the earlier date. Yet, all the most reliable authorities insist on 1911, and there is one unusual piece of evidence that might even justify this date. When it was published in the sale catalogue of the Ahrenberg Collection in 1960, the entry includes the tantalizing (and unique) reference to the "fact" that the sculpture was represented on the mantelpiece in Matisse's masterpiece of 1911, *Still-Life with Eggplant* (fig. 2).[8] Indeed, there is a sculpture in that position, but it is so different in pose from *The Dance* that, if it is *The Dance*, there is only one possible explanation. Because *The Dance* is closer than any surviving Matisse sculpture to the one represented in the painting, the figure in the painting must be an earlier version. It is even possible that Matisse was working on the clay or wax version (the figure in the painting is yellowish) while he was painting the Grenoble decoration. We know that he sold this painting in 1911 to Sarah and Michael Stein, thereby suggesting that the figure cast in bronze in 1930 was not completed before 1911.[9]

1. The most famous photograph of Matisse with his students shows them working on a sculptural problem with a large male model. See *Henri Matisse, 1904–1917* (exh. cat.), Paris: Centre Pompidou, 1993, p. 68, and Hilary Spurling, *The Unknown Matisse*, New York: Alfred A. Knopf, 1998, p. 377.
2. This view of sculpture as part of a process of artistic education and preparation has its roots in the sculpture of Edgar Degas, which was, with a single exception, unexhibited within his lifetime. Rather, Degas seems to have made sculpture as part of a process of "understanding" a figure (or a horse) in three dimensions so as better to represent it pictorially.
3. The recent catalogue raisonné of Matisse's sculpture (Duthuit, 1997) includes a massive exhibition history of each sculpture on pages 305–38. There is, to my knowledge, no analysis of Matisse's exhibitions of sculpture.
4. Christian Zervos, "Sculptures des peintres d'aujourd'hui," in *Cahiers d'art*, no. 7, 1928, pp. 227–89.
5. Duthuit (1997), pp. 327–8.
6. Ibid., pp. 154–6.
7. Elsen (1972), p. 103.
8. *Forty-Nine Bronzes by Matisse*, Sotheby's London, 7 July 1960, no. 30.
9. It is possible that the figure represented in *Still-Life with Eggplant* is a plaster cast of an *ecorché* figure common in artists' studios. If so, then it would be easier to accept the date of 1906–8 – which seems more likely on stylistic evidence – for *The Dance*.
10. Xavier Girard, *Henri Matisse, 1869–1954: sculpture et gravure* (exh. cat.), Kunstmuseum, Berne, 1990, p. 98.
11. The closest one can come to a knowledge of the "originals" made by Matisse himself before casting is the handful of plasters, particularly those for *The Backs*, in the published literature.

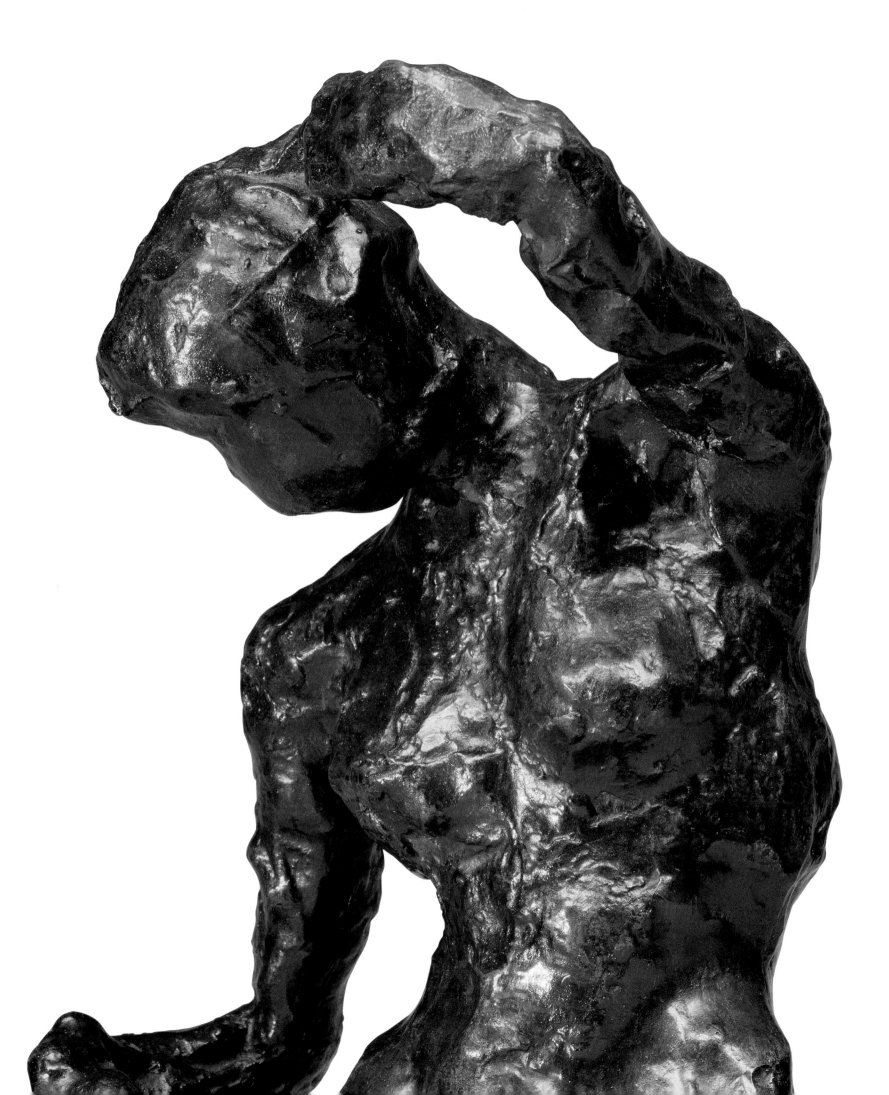

Henri Matisse (1869–1954)
Henriette I (Grosse Tête), 1925

Bronze, 29.5 × 23 × 18 cm. (11⅝ × 9 × 7⅛ in.)
Duthuit 66

Provenance: Ahrenberg Collection; Parke-
Bernet Galleries, Inc., New York, sale of 15
April 1965; Mr. and Mrs. Nathan Cummings;
The Sara Lee Collection; The Hermitage
Museum, St. Petersburg

Exhibitions: New London 1968; Washington,
D.C. 1970: no. 67; New York 1971: no. 67; New
York, Museum of Modern Art, *The Sculpture
of Henri Matisse*, 24 February–8 May 1972;
Minneapolis, Walker Art Center; and Berkley,
University of California, University Art
Museum, 20 June–6 August 1972: no. 56:
Chicago 1973: no. 30 (as *Large Head of
Henriette*); Winston-Salem 1990; Memphis
1991; Lakeland 1995; Laren 1997–8.

*Bibliography: Impressionist and Modern
Paintings, Sculpture, Drawings* (sale cat.) New
York: Parke-Bernet Galleries, Inc., 1965, p. 17,
lot 19, repr.
Albert E. Elsen, *The Sculpture of Henri
Matisse*, New York: Harry N. Abrams, 1972,
no. 219, repr.
Alicia Legg, *The Sculpture of Henri Matisse*
(exh. cat.), New York: Museum of Modern
Art, 1972, p. 36.
Isabelle Monod-Fontaine, *The Sculpture of
Henri Matisse* (exh. cat.), ed. Catherine
Lampert, trans. by David Macey, London:
Arts Council of Great Britain, 1984, no. 57.
Pierre Schneider, *Matisse*, trans. Michael
Taylor and Bridget Stevens Romer, New
York: Rizzoli International Publications, 1984,
p. 560.
Brettell 1986, 1987, 1990, 1993, 1997, pp.
98–9, 157–8, repr.
Xavier Girard, *Les Chefs-d'oeuvres du Musée
Matisse* (exh. cat.), Dijon; Musée des Beaux-
Arts. 1991, pp. 224–9.
Claude Duthuit (with the collaboration of
Wanda de Guebriant; preface by Yve-Alain
Bois), *Henri Matisse: catalogue raisonné de
l'oeuvre sculpte*, Paris: Claude Duthuit Editeur,
1997, no. 66, pp. 190–93. On page 364,
Duthuit includes a complete bibliography of
all mentions of this particular bronze,
beginning with the first in 1959.

Henri Matisse seems to have met Henriette
Darricarrere in Nice in 1920, and she posed
for him at least until 1928, serving as one of
his most persistent model-muses.[1] Her
generous body and massive head appear in
countless paintings, drawings, and prints, and
she is the subject of Matisse's second "series"
of portrait sculptures.[2] In 1910, Matisse started
his first serial investigation of a single model
in sculpture. He began this series from the
model, Jeanne Vaderin. Then, after
completing two heads, he continued his
investigations of "Jeannette" without her
services as a model, creating three additional
bust sculptures in 1911 and 1912, which,
together with the first two, he numbered
Jeannette I–V. Matisse exhibited *Jeannette I,
II, III,* and *IV* at the Grafton Galleries in
London in 1912 and in New York in 1915, and
they became the first serial sculpture he
exhibited.[3] His decision to create a second
series of portrait heads from another model
seems also to have been a gradual, unplanned
endeavor, begun in Nice in 1925,
recommencing two years later with the second
head (fig. 1), and coming to a conclusion in
1929 with the third and last of the series (fig.
2).[4] The first and possibly the second *Henriette*
were sculpted from the model herself, but the
third was made after she had ceased modeling
for Matisse. The second of the series was
exhibited in 1930 and 1931, but the three
were not grouped until 1949.[5]

In the cases of both *Jeannette* and
Henriette, the models remained unidentified
in the artist's lifetime, allowing the viewer to
know only that they were portraits of
unnamed figures. This practice stems from
a longstanding tradition of the public
exhibition of "anonymous" portraits (the
most famous being Sargent's *Madame X*)
that has its origins in the official Salon
exhibitions of the late seventeenth century
and continued throughout the nineteenth
and early twentieth centuries. Its discretion
has proven unacceptable to late twentieth-
century viewers, who insist on knowing
the name of the sitter, their relationship to
the artist, and age and social position
before interpreting the work of art. Thus,
Henriette is identified precisely by Aragon
in 1971, while earlier writers respect
Matisse's own title as a sufficient clue to
interpretation.[6]

Henriette I has often been subtitled *Large
Head (Grosse Tête)*, while the second is
subtitled *Archaic Head (Tête archaique)*, and
the third is *Large smiling Head (Grosse Tête
souriante)*. The first title is perfectly apt, as
Matisse stresses the massive proportions of the

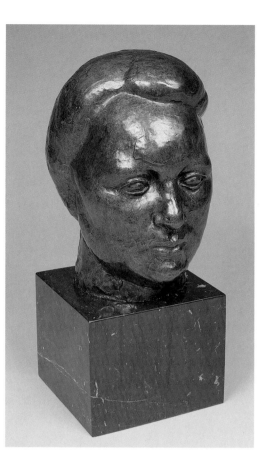

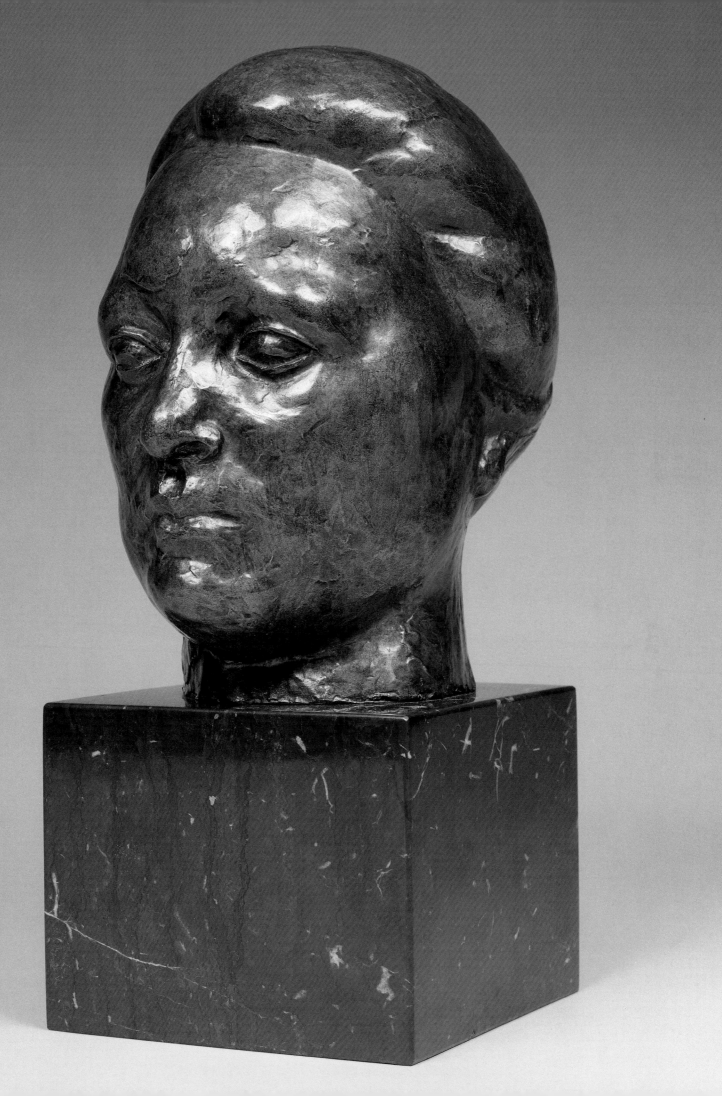

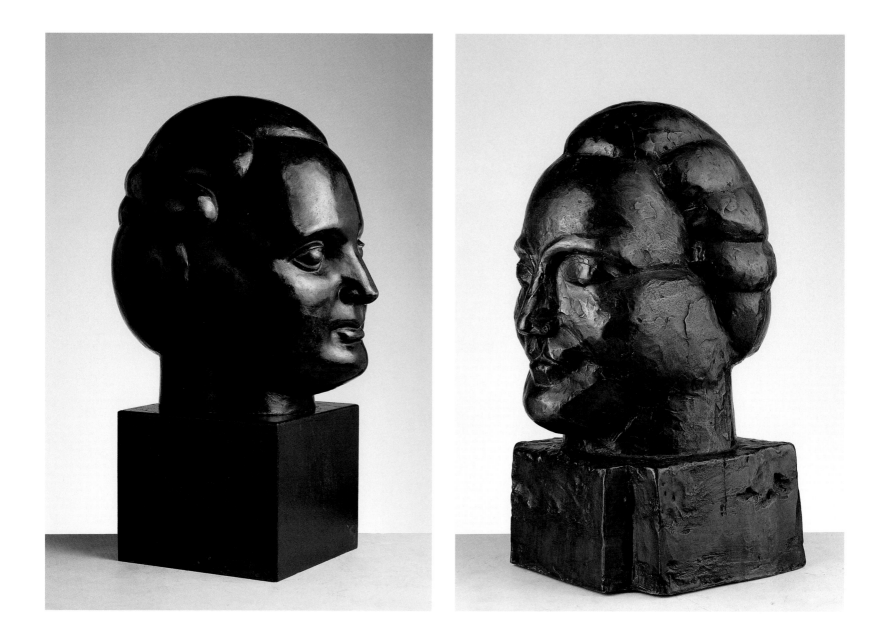

Fig. 1 (*above left*) Henri Matisse, *Henriette II*, 1927. Musée Matisse, Nice. © Photo Galerie Maeght, Paris. © Succession H. Matisse/DACS 1999.

Fig. 2 Henri Matisse, *Henriette III*, 1929. Musée Matisse, Nice. © Photo Galerie Maeght, Paris. © Succession H. Matisse/DACS 1999.

model's head, hair, and features, which he exaggerates by leaving a large piece of plaster or clay on her forehead, thereby stressing the weight and materiality of the head. There is an undeniable gravity about the head, and it seems clearly related to the sculpture of Aristide Maillol, whom Matisse is known to have admired. Not only did Matisse and Maillol share pride of place in the Moscow mansion of Ivan Morosov, but Matisse had also contributed a work of art in 1912 to raise funds for Maillol's monument to Cézanne.[7] He had particular occasion to think about the radically simplified and massive sculpture of Maillol in 1925, when he asked Henriette to pose for *Henriette I*. In that year, the first two French monographs on Maillol appeared virtually simultaneously, one by Maurice Denis and the other by Christian Zervos, and presumably these books brought the sculptor's example to the front of Matisse's mind and

may even have given rise to Matisse's second period of intense sculptural activity between 1925 and 1930. Nevertheless, even a casual comparison of Maillol's most important bust of the 1920s, *Head for the Monument of Port-Vendres* of 1923 (fig. 3) makes clear the generalizing or classicizing character of Maillol's art, and one must wait for Maillol's considerably later portrait busts of Dina Vierny for a real comparison with Matisse's sculpted portraits of Henriette.

Another sculptor who might be brought into the mixture of sources for Matisse's heads of Henriette is Jacques Lipchitz, whose resolutely non-Cubist bust of Gertrude Stein, completed in 1920 (fig. 4), was well known to Matisse. Isabelle Monod-Fontaine has already noticed the similarity between that bust and the second of Matisse's Henriettes.[8] Interestingly, the sculptor whose career actually intersects with *Henriette I* is Alberto

Giacometti, and, from the casting history recorded by Claude Duthuit, it seems as if the first cast of the head was made in 1962 as part of an exchange of bronzes between Matisse and Giacometti. If Giacometti – rather than Matisse – chose this head, it is an odd choice indeed. No series of sculptures in Matisse's career is less like the existential anorexia of Giacometti's sculpture. Yet, it was perhaps less the "style" than the "sculptural presence" of *Henriette I* that appealed to Giacometti, who was struggling in 1962 with a series of busts and heads of his brother and wife (see cats. 15 and 16).

It is a fascinating twist of fate that the Matisse *Henriette I* will join the most distinguished permanent collection of paintings by Matisse in the world, that at the Hermitage Museum in St. Petersburg. Although the Hermitage benefited from the breakup of the Museum of Modern Western Art in Moscow, receiving a treasure trove of paintings from the Shchukin and Morosov collections, it has never had a group of Matisse's sculptures, largely because neither of the great Moscow collectors bought them. In 1971 Lydia Delectorskaya (Matisse's Russian model, secretary, studio assistant, and friend) gave a cast of *Henriette III* to the Hermitage, and, with the gift of *Henriette I*, two stages in Matisse's serial practice will be represented in this great collection.

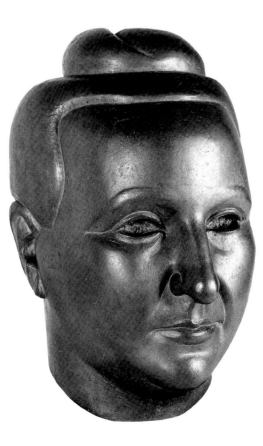

Fig. 3 Aristide Maillol, *Head for the Monument of Port-Vendres*, 1923. Fondation Dina Vierny – Musée Maillol, Paris. © ADAGP, Paris and DACS, London 1999.

Fig. 4 (*right*) Jacques Lipchitz, *Gertrude Stein*, 1920. Baltimore Museum of Art: The Cone Collection, formed by Dr. Calribel Cone and Miss Etta Cone of Baltimore, Maryland.

1. See Monod-Fontaine (1984), p. 35.
2. For Matisse's most complete discussion of his relationship with models, see "Notes of a Painter on his Drawing," translation of a 1939 essay by Jack Flam, reprinted in *Matisse on Art*, Berkeley: University of California Press, 1995, pp. 129–32.
3. This series is most fully published in Duthuit (1997), nos. 50, 51, 52, 53, and 55 (bibliographies and exhibition histories of the works are recorded separately in the back of the catalogue).
4. This is the "standard" narrative, but is contradicted in several ways in the literature. John Elderfiled, in his massive chronology prepared in connection with the MoMA Matisse exhibition of 1992, asserts that Matisse "probably makes the first two of three sculpted heads of Henriette" in the autumn of 1925. Elderfield, *Henri Matisse: A Retrospective*, New York, Museum of Modern Art, 1992, p. 294. The most detailed publication devoted to the *Henriette* heads is Girard (1991), pp. 224–9. Girard accepts the 1925, 1927, and 1929 dates for the trio, but he publishes a photograph of Matisse working on *Henriette II*, which he dates 1925. It seems, from all of this, that Elderfield is correct to say that both *Henriette I* and *II* were made in 1925.
5. See Duthuit (1997), nos. 66, 70, 75. There is, however, an ambiguity in this material. The exhibition histories of all three sculptures indicate that they were shown together in 1949 at the Musée des Beaux-Arts, Lucerne (nos. 292, 290, and 295 respectively). However, none of the recorded casts of *Henriette I* was produced until 1952, suggesting that Matisse exhibited an unrecorded plaster in 1949.
6. Aragon's two volume book, *Henri Matisse: A Novel*, London: Collins, 1971 (trans. John Stewart) is among the strangest and most interesting books on Matisse. In the second volume, Aragon devotes a fascinating chapter to Matisse's love of models of a type called by Aragon "the thyroid type." The chief among these is Henriette, who is discussed in terms of her deeply psychological relationship to Ingres's Mme. de Senonnes (pp. 109–18).
7. Morosov commissioned four full-scale sculptures of the seasons from Maillol and installed them immediately beneath the great Matisse decorations in his Moscow salon.
8. There are several casts of Lipchitz's *Gertrude Stein*, but the most accessible in America are at the Yale University Art Gallery and the Baltimore Museum of Art. For her publication of this comparison see Monod-Fontaine (1994), p.170.

29

Henri Matisse (1869–1954)
Lemons on a Pewter Plate (*Les Citrons au plat d'etain*), 1926 (between July and October); reworked 1929

Oil on canvas, 55.6 × 67.1 cm. (21⅝ × 26⅛ in.)
Signed lower right: Henri-Matisse
Cowart-Fourcade 149

Provenance: Pierre Matisse Gallery; Mr. and Mrs. Lee Ault, New Canaan, Connecticut; Nathan Cummings; Mrs. Joanne Toor Cummings; Christie's, New York, sale of 30 April 1996; The Sara Lee Collection; The Art Institute of Chicago

Exhibitions: Berlin, Galerien Thannhauser, *Henri Matisse*, February–March 1930: no. 56; Basle, Kunsthalle, *Henri Matisse*, 9 August–15 September 1931: no. 78; Paris, Petit Palais, *Les Maitres de l'Art Independent, 1897–1937*, June–October 1937: no. 46; New York, Pierre Matisse Gallery, *Henri Matisse: Paintings and Drawings of 1918–1938*, November–December 1938: no. 2; San Francisco, M. H. de Young Memorial Museum, *Seven Centuries of Painting: A Loan Exhibition of Old and Modern Masters*, 29 December 1939–28 January 1940: no. Y–184; New York, Pierre Matisse Gallery, *Henri Matisse: Retrospective Exhibition of Paintings, 1898–1939*, February 1943: no. 18; New York, Valentine Gallery, *The Lee Ault Collection: Modern Paintings*, 10–29 April 1944: no. 28; Philadelphia, Philadelphia Museum of Art, *Henri Matisse: Retrospective Exhibition of Paintings, Drawings and Sculpture*, April–May 1948: no. 69; New York, Museum of Modern Art, *Henri Matisse*, 13 November 1951–13 January 1952; Cleveland Museum of Art, 5 February–16 March 1952; The Art Institute of Chicago, 1 April–4 May 1952; and San Francisco Museum of Art, 22 May–6 July 1952: no. 61; Los Angeles, Municipal Department of Art, *Henri Matisse: Selections from the Museum of Modern Art Retrospective*, July–August 1952; and Portland, Oregon, Portland Art Museum, September–October 1952: no. 38; Los Angeles, University of California at Los Angeles Art Gallery, *Henri Matisse*, 5 January–27 February 1966; Chicago, Art Institute of Chicago, 11 March–24 April 1966; and Boston, Museum of Fine Arts, Boston, 11 May–26 June 1966: no. 65; New York, Museum of Modern Art, *Henri Matisse: Sixty-four Paintings*, July–September 1966: no. 47; New London 1968; London, Hayward Gallery, *Matisse 1869–1954: A Retrospective Exhibition*, July–September 196: no. 100; Washington D.C. 1970: no. 31; New York 1971: no. 31; Chicago 1973: no. 28; Washington, D.C. National Gallery of Art, *Henri Matisse: The Early Years in Nice, 1916–1930*, 2 November 1986–29 March 1987: no. 149; Laren 1997–8.

Bibliography: "Henri Matisse (Galerien Thannhauser)," Paris: *Cahiers d'Art*, V, 1930, p. 107, repr.
Christian Zervos, ed., *Henri Matisse*, Paris: Cahiers d'Art; and New York: E. Weyhe, 1931, repr. facing p. 96.
Alfred H. Barr, Jr., *Matisse: His Art and His Public*, New York: Museum of Modern Art, 1951, pp. 215 and 450, repr.
UNESCO, *Catalogue des reproductions en couleurs de peintures, 1860–1959*, Paris: UNESCO, p. 237.
Mario Luzi and Massimo Carrá, *L'opera di Matisse, dalla rivolta 'fauve' all'intimismo, 1904–1928*, Milan: Rizzoli 1971, no. 449, p. 104, repr. (trans. as *Tout l'oeuvre peint de Matisse, 1904–1928*, introduction by Pierre Schneider, Paris: Flammarion, 1982).
Nicholas Watkins, *Matisse*, Oxford: Phaidon Press, 1977, pl. 34.
Pierre Schneider, *Matisse*, trans. Michael Taylor and Bridget Stevens Romer, New York: Rizzoli, 1984, no. 449, repr.
Guy-Patrice and Michel Dauberville, *Matisse: Henri Matisse chez Bernheim-Jeune*, vol. II, Paris: Editions Bernheim-Jeune, 1995, p.1256, repr.
Brettell 1986, 1987, 1990, 1993, 1997 (pp. 100-03 and 158–9 and front cover).

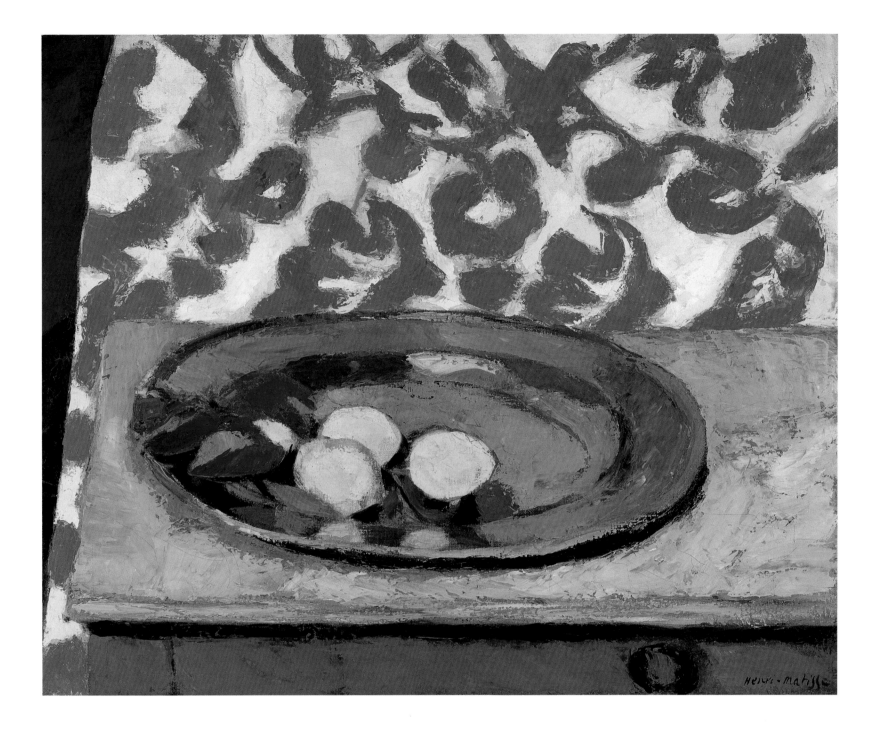

Fig. 2 (*facing page*) Paul Cézanne, *Dish of Apples.* The Metropolitan Museum of Art, The Walter H. and Leonore Annenberg Collection, Partial Gift of Walter H. and Leonore Annenberg, 1997.

One of the central mysteries of twentieth-century art history is the absence of a reliable catalogue raisonné for Henri Matisse. Although there are wonderful catalogues for such major artists as Picasso, Léger, and Pollock and minor ones, including Herbin and La Fresnaye, there is only one modest publication that attempts to gather the known paintings by Matisse and to place them in a plausible chronological order. This, a book prepared in Italy in the late 1960s and published in Milan in 1971, is inaccurate and incomplete.[1] When we turn its large pages of tiny black-and-white photos to the section on Matisse in the second half of the 1920s, we are confronted with what can be interpreted only as an extraordinary fact – that this famously "fluent" and "natural" painter seems to have had real difficulty completing paintings during those years and, for 1926, only five paintings are listed. [2]

It is in this context of a sort of pictorial crisis that *Lemons on a Pewter Plate* must be placed. Unknown to the authors of the catalogue, this work, conventionally dated 1927 in the previous literature and published

by them as a 1927 work, was in fact photographed by Matisse's dealer Bernheim-Jeune in October of 1926, thereby adding one more to the "short-list" of five paintings previously ascribed to that year,[3] making a grand total of six paintings, only one of which is of an ambitious scale, in one year of production from an artist who did little but work. If this tiny production is compared to that of 1921 or 1922 – or any of the years in the first half of the decade, the difference is even more marked. In the early 1920s Matisse's production is more like that of the Impressionists or his friendly rival Picasso, and he averaged around twenty completed paintings per year, with a "high" in 1922 of thirty. Even his friendliest early critic, Alfred Barr, wrote of the "unabated energy" with which Matisse worked from 1920 to 1925, "producing scores of paintings and hundreds of drawings."[4] The big decline in 1925 – with nine works – became worse in 1926, with six. From then, Matisse seemed temporarily to have regained his resolve in 1927 (seven works) and 1928 (eleven works), before completely losing faith in himself as a painter in 1929, when he managed to finish only one painting. This "difficulty" – so seemingly un-"Matissian" – is central to the experience of many modern artists, who become their own worst critics, encountering ever more difficult obstacles until the act of creation itself becomes so painful as to make production impossible.[5]

In the absence of a complete biography[6] or of the publication of most of Matisse's letters, it is possible only to speculate on the reasons for such a decline. Yet, there are clues in the scant chronological material. Matisse was given his first major retrospective in the fall of 1924, an exhibition organized for the Ny Carlsberg Glyptotek in Copenhagen by Leo Swane.[7] The eighty-seven paintings in the exhibition provided Matisse with the first "objective" assessment of his oeuvre, a survey skewed by the fact that none of the great masterpieces from the Museum of Modern Western Art in the Soviet Union was made available to Swane. Yet, that exhibition and the fact that Matisse was awarded the French Légion d'honneur in July 1925 seem to have been enough to stop Matisse in his tracks and to force him to reassess. In 1926 he moved into a large new apartment in Nice, more or less severing connections with his wife, who remained in Paris. And he also began to work concertedly on sculpture (see cat. 28), creating over a period of nearly five years a work, *Large Seated Nude* (New York, Museum of Modern Art), that has become one of the

Fig. 1 Photograph of Matisse's studio.

canonical objects of twentieth-century art. If the surfaces of his 1926 paintings are any indication, he worked and reworked – and reworked again – the same five or six paintings, rivaling Cézanne or Degas in his fretful obsession.[8]

Lemons on a Pewter Plate appears – mysteriously twice – in a photograph of Matisse's studio taken in the dining room of the fourth-floor apartment rented by the artist on the place Charles-Félix in Nice in June of 1929 (fig.1).[9] This "document" presents us with two conundrums. First, the painting is clearly visible twice – on the wall at the lower left, and on the floor just beneath the "hung" version. Is the lower "painting" actually a full-scale photograph? Or, more tantalizingly, did Matisse work simultaneously on two versions of the painting, ultimately destroying one? The former – and more convenient – explanation is correct. Although there are enough small differences between the two to suggest that one is not a photograph of the other, we know from Wanda de Guebriant at the Matisse Foundation that Matisse had been approached by a maker of texturized full-scale reproductions and that he had allowed *Lemons on a Pewter Plate* to be the "guinea pig" for this process (presumably because of its more-or-less uniform surface texture). It is, in fact, this photographic reproduction that appears in the 1929 photograph, and its position on the floor indicates that Matisse had rejected it.

Interestingly, the "real" Matisse in the photograph is different from the painting of today. Matisse sent the completed painting to Berlin late in 1929 or early in 1930 for a retrospective held at the Galerien Thannhauser in February and March of 1930. In the published photographs of that exhibition, the triangular strip at the left of the composition looks as it does today, composed, that is, of two equally dark sections of deep brown and midnight blue.[10] In the 1929 photograph the same section of the painting has a pronounced value difference between these two zones, indicating that, even though Matisse had had the painting photographed in October of 1926, he continued to tinker with it until it finally left his studio more than three years later.

Matisse gave a famous interview to Jacques Guenne in 1925, an interview that might help explain the obsessive reworking of this painting. In it, he talked of his "god" Cézanne.[11] "Notice," he says, "that the classics went on redoing the same painting and always differently. After a time, Cézanne always painted the same canvas of the *Bathers*.

Although the Master of Aix ceaselessly redid the same painting, don't we come upon a new Cézanne with the greatest curiosity?"[12] Matisse continued in the 1925 interview to discuss his "influences," mentioning Chardin and Delacroix in addition to Cézanne. He spoke also of "dominating" his influences, struggling with them as he struggled with himself in the act of painting. Again, he evoked Cézanne: "We shouldn't be surprised that Cézanne hesitated so long and so constantly. For my part, each time I stand before my canvas, it seems that I am painting for the first time . . . Dangerous, his influence? So what? Too bad for those without the strength to survive it . . . I believe that the artist's personality affirms itself by the struggle he has survived."[13]

Here, in 1925, Matisse seems almost to ready himself for a period of struggle that was to start shortly after he gave the interview and was to last at least five years; as this painting indicates, it was a struggle with the greatness of his predecessors. *Lemons on a Pewter Plate* evokes a host of other artists – Chardin, Courbet, Manet, Cézanne, and Gauguin. Matisse struggles not only with a still-life, but with the earlier artistic examples. He created a painting – although small – as thick, as "weighty" and as deeply serious as any he painted. It was, in the end, Cézanne who was dominant in his mind when he painted this work, because Matisse's dealer, Bernheim-Jeune, gave the "Master of Aix" a serious

retrospective in their Paris gallery in June of 1925. With fifty-eight major paintings by Cézanne, it was the most serious exhibition of that painter's work in Paris in the mid–1920s, and Matisse struggled mightily to make a few canvases that could measure up to the Cézanne he had restudied in Paris.[14]

Although they cannot be called his "favorite" fruit, Cézanne did paint lemons, occasionally, most probably in deference to their greatest visual poet, Manet, who liked their color, texture, shape, and their suggestion of sharp acidity, of a biting taste. At the Bernheim-Jeune exhibition, Matisse had seen Cézanne's *Apples* (fig. 2), with its playful dialogue of elaborate wallpaper and fruit. He may well also have seen the great Cézanne self-portrait (private collection, Paris), whose rose background comes closest to the patterned background of *Lemons on a Pewter Plate*. This comparison becomes even more important when we look closely at the Sara Lee still-life, for, behind the red in the patterned fabric background is a pale orange hue very like that used by Cézanne, indicating that Matisse changed the color of the background dramatically while working on the painting. Curiously, the bold red and white textile background appears in no other painting by Matisse, or in any of the published photographs of his studio – which is odd, because he tended to repeat his patterns and to base them closely on screens, wall-coverings, or textiles in his Nice apartment.

Fig. 3 Paul Gauguin,
Women of Tahiti, 1891.
Musée d'Orsay, Paris.
Photo © RMN.

The aspect of this "background" that is most interesting is its comparative randomness of "pattern." Although several forms do appear to repeat, as if in a printed textile, each version is somewhat different, and the placement of the elements is not regular, suggesting that this "background" was invented as much as it was observed. Also, by shifting the hue of the pattern from pale orange to red, Matisse introduced Gauguin into his melange of sources, and there are many similar printed textiles in the paintings of Gauguin's first Tahitian voyage – for example, *Women of Tahiti* of 1891 (fig. 3) – a voyage that Matisse himself was to repeat in 1930.[15]

There is yet another artist in this jostling mix of influences, one who has more to do with the *facture* or painting technique of Matisse in this painting than with his imagery. Although Matisse had used a palette knife in one painting of 1924, the tiny *Little Pianist* at the Musée Matisse, it was not until 1926 that he actually explored this technique concertedly. *Lemons on a Pewter Plate* and *Odalisque with a Tambourine* in the Museum of Modern Art, New York, were both painted in 1926, and both make extensive use of the palette knife in preference to the brush. This makes them seem flatter and more confrontational than previous paintings from the Nice period, and they defy the easy, relaxed gestures of his painting from the early 1920s. In fact, one of the photographs of Matisse taken in the mid-1920s in Nice shows him with his prized painting by Courbet, *Young Women on the Banks of the Seine*.[16] This painting is among the numerous works by Courbet from the mid-1850s painted with

both a brush and a palette knife. It was surely this, together with the organizational ideas of Cézanne, the imagery of Manet and van Gogh,[17] and the color of Gauguin that forms the cluster of prototypes with which Matisse struggled when he painted *Lemons on a Pewter Plate*. Yet, in interpreting this supremely confident still-life as an homage to his predecessors, we must remember that Matisse's stated purpose was to dominate his sources. In *Lemons on a Pewter Plate*, he succeeded.

The work will enter the permanent collection of the Art Institute of Chicago, where it will join a fine group of paintings and drawings by Matisse, including a fluid still-life of 1916, *Apples*, and the major *Large Interior, Nice* of 1918–19. What may be more important about its new "company" in Chicago will be the paintings by Courbet, Manet, Cézanne, van Gogh, and Gauguin that will surround the Matisse.

great *Decorative Figure on an Ornamental Ground* in the Musée National d'Art Moderne, Paris, and *Pineapple in a Basket* in the collection of Mme. Jean Matisse.
4. New York (1951), p. 208.
5. Perhaps the most extreme example of this – an example well known to all French artists of the late nineteenth and early twentieth centuries – is that of Emile Zola's fictional artist, Claude Lantier, who in *The Masterpiece*, sets himself such an impossible task that he has no choice but to hang himself in front of his unfinished "masterpiece."
6. Unfortunately, Hilary Spurling's *The Unknown Matisse* (New York: Alfred A. Knopf, 1998) cannot help solve the puzzle of Matisse's decline in production in the second half of the 1920s, because this excellent new book covers only the early years of the painter's life (1869–1908). But the attention that Spurling draws to the importance of fabrics in Matisse's paintings (throughout his career) is certainly relevant to *Lemons on a Pewter Plate* in which the dramatic red-and-white wall hanging takes up nearly one half of the canvas. (Spurling points out that Matisse's passion for textiles came naturally, as he was born and bred in a region of northern France famous for the manufacture of textiles and was himself descended from weavers and textile workers [pp. 27, 78–9, 85, 359, 364–5, 420–2].)
7. The factual information in this paragraph all comes from the detailed chronology prepared by John Elderfield and his assistants for the landmark exhibition catalogue, *Henri Matisse: A Retrospective* (New York, 1992). The year 1926 is on pages 294–5. Unfortunately, very little of the "facts" in the chronology are documented in notes. Were it not for the impeccable reputation of John Elderfield, one would be cautious in accepting all of them as true.
8. A systematic study of "incompletion" in modern painting has not been written. However, in creating works that show evidence of the artist's own corrections, doubts, and alterations, Matisse was following a distinctly modernist "method" pioneered by the Impressionists and made even more important by Degas and Cézanne, both of whom worked and reworked compositions, often over periods of years.
9. See Washington (1987), p. 40, fig. 42.
10. The photographs of this exhibition are published in Margrit Hahnloser-Ingold's well-documented essay "Collecting Matisse of the 1920s in the 1920s" in Washington (1986–7) pp. 261–2. The Sara Lee painting is shown at the far left of fig. 41, p. 262.
11. Jacques Guenne, "Entretien avec Henri Matisse," *L'Art vivant*, 18 (15 September 1925), pp. 1–6. Its most accessible recent republication in English is in Jack Flam's *Matisse on Art*, Berkeley: University of California Press, 1995, pp. 78–82.
12. Flam (1995), p. 80.
13. Ibid.
14. This exhibition is detailed in John Rewald's *The Paintings of Paul Cézanne: A Catalogue Raisonné*, New York: Harry Abrams, 1996, vol. i, p. 597.
15. The Gauguin painting with a red-and-white *pareu* skirt that was most accessible to Matisse was *Deux femmes sur la plage*, of 1891 (W.434), which entered the Musée du Luxembourg in 1923 and is now in the Musée d'Orsay.
16. This photograph was reproduced by John Elderfield in *Henri Matisse: A Retrospective*, exh. cat. New York, Museum of Modern Art, 1992, p. 295. The painting is no. 209 in Robert Fernier, *La Vie et l'oeuvre de Gustave Courbet: Catalogue raisonné*, 2 vols., Lausanne and Paris, 1977. Linda Nochlin in

1. Luzi and Carrà (1971). In fact, the book includes paintings both before 1904 and after 1928, although the authors argue completeness only for the portion of the catalogue that falls within the chronological confines of the title.
2. These are nos. 438 (Metropolitan Museum, New York, Gelman Gift), 439 (Private collection, Switzerland), 440 (Cone Collection, Baltimore Museum), 441 (Museum of Modern Art, New York, Paley Collection), and 442 (private collection, New York). But 443 (Musée des Beaux-Arts, Algiers) is dated 1926–7.
3. The painting is dated 1927 in the first magisterial study of Matisse, Alfred H. Barr Jr.'s *Matisse: His Art and His Public*, (New York, 1951), p. 450–51. The existence of the October 1926 photograph is recorded in the catalogue entry for the painting in Washington (1987), p. 324, no. 149. Two other paintings are also listed as having been photographed at that time, the

110

Courbet Reconsidered, New York: The Brooklyn Museum, 1988, p. 134, mentions that Matisse also owned a tracing made by Courbet of the dark haired reclining woman in Fernier 209, and points out that the tracing "displays a remarkable affinity with [Matisse's] own drawing style."

17. Two 1887 canvases by Vincent van Gogh are remarkably close to *Lemons on a Pewter Plate*. Van Gogh's *Still-Life with Lemons on a Plate* shows five lemons clustered on the left side of a plate near the corner of a (?) table top (Matisse's four lemons on the left side of a plate are set near the corner of the top of a chest). In *Still-Life with Decanter and Lemons on a Plate* van Gogh added a decanter and two additional pieces of fruit that rest directly on the table, but he also added a boldly patterned wall covering to establish the limits of the shallow space, just as Matisse did in *Lemons on a Pewter Plate*. Could Matisse have known either of these two van Gogh paintings, which are both now in the Van Gogh Museum, Amsterdam? This we do not know, but we do know that Matisse became aware of the work of van Gogh within less than a decade after these pictures were painted, and he helped organize the first official van Gogh exhibition, a retrospective of forty-five works within the 1905 Salon des Indépendants, to which he lent van Gogh drawings from his own collection (see Spurling, 1998, pp. 119–21, 127, 138, 296).

Jean Metzinger (1883–1956)
The Harbor (*Le Port*), 1916–17 (or 1912)

Oil on canvas, 85.7 × 101 cm. (33½ × 39½ in.)
Signed lower right: Metzinger

Provenance: Nathan Cummings; The Sara Lee
Collection; The Dallas Museum of Art

Exhibitions: Greenwich, Connecticut, New
York Graphic Society, 19–29 December 1967;
Madison, Wisconsin, University of Wisconsin,
Elvehjam Art Center, *Inaugural Exhibition:
Nineteenth and Twentieth Century Art from
Collections of Alumni and Friends*, 11
September –8 November 1970: no. 58;
Chicago 1973: no. 49; University of Chicago,
David and Alfred Smart Gallery, *Jean
Metzinger in Retrospect* 23 January–9 March
1986: (not in catalogue); Winston-Salem 1990;
Memphis 1991; Lakeland 1995; Laren 1997–8.

Bibliography: Consolidated Foods Corporation,
*Consolidated Foods Corporation's Nathan
Cummings Collection*, Chicago: Consolidated
Foods Corporation, 1983, p. 23, fig. 18.
Brettell 1986, 1987, 1990, 1993, 1997 (pp.
82–3, 159, repr.).

Not one of the other young contemporary
painters has known as much injustice or
displayed as great a resolution as the
exquisite artist Jean Metzinger, one of the
purest artists of our time . . . The true value
of that great painter is still not
understood."

Guillaume Apollinaire,
The Cubist Painters, 1913

Jean Metzinger was among the most actively
involved, intellectually influential, and
earnest artists associated with Cubism in its
formative years. While Picasso and Braque
painted in their studios, sharing their art with
a small – and snobbish – circle of dealers and
collectors, Metzinger painted and wrote about
painting in a circle of writers, architects, and
painters who aimed collectively to introduce
the broad Parisian and international public to
the new art of Cubism. In 1912 he joined with
his close friend Albert Gleizes to publish a
book called *Du "Cubisme,"* the first systematic
attempt to create a verbal esthetics for a new
pictorial "style."[1] Thus, they can be linked
with such luminaries in French modernist
criticism as Edmond Duranty, Felix Fénéon,
and Paul Signac. The book was instantly
translated and read by curious amateurs and
artists in Europe and America and was for
many years considered to be a fair
"translation" of Cubism into words. Yet, by
1930 the authority of Gleizes and Metzinger
was called into question on both sides of the
Atlantic, and the men and women who
"defined" modern art for most of the
twentieth century came to dispute the claims
of these two painter-critics and to disparage
their work as well.[2] No works by Gleizes or
Metzinger hang on a permanent basis at the
Museum of Modern Art in New York, the
Tate Gallery in London, or the Centre
Pompidou in Paris, although all those
museums have works by these artists in their
permanent collections.

The painting of Metzinger has made a
comeback since the First World War, but a
modest one indeed, and the only sustained
analysis of his work is to be found in an
exhibition catalogue produced by Joann Moser
in 1985.[3] This essential book begins with a
brilliant, but bristlingly defensive
introductory essay by the late Daniel Robbins,
who, after having written an important
dissertation on the work of Albert Gleizes in
the early 1970s, had become the chief
apologist for these decidedly secondary
Cubists. The Iowa catalogue publishes nearly
250 paintings by Metzinger and thus
constitutes the first step towards a catalogue
raisonné. Unfortunately, Ms. Moser did not
know of the whereabouts of *The Harbor* when
she completed her work, although the
painting was included in the Chicago venue of
the exhibition in the Smart Gallery of the
University of Chicago. It is thus a work of art
whose position both in Cubism and in the
oeuvre of Metzinger is insecure.

The single most frustrating aspect of
Metzinger studies – and the major reason that

his work is difficult to discuss in relationship
to the better documented work of his friends
and colleagues – is that he failed to date the
vast majority of his works. Moser, who
attempted to correct the chronological
problems of his career, was hobbled by her
method – stylistic analysis – and by her
decision to consider the work not as a whole,
but in terms of subject. Thus, the Cubist
section of the catalogue segregates figure
paintings from landscapes and still-lifes, as if
Metzinger himself painted them in this way.
Each of these groups is arranged in
chronological order by Moser, who suggests
rather than insists upon dates. Yet, what is
most frustrating is a complete lack of archival
work on the actual exhibitions to which
Metzinger contributed so frequently
throughout his working life. Although these
exhibitions are listed in the chronology of the
catalogue, few works are actually associated
with them. For that reason, only a handful of
works that are specifically mentioned in the
contemporary criticism marshaled by Robbins
can be dated precisely.

What, then, of *The Harbor*? Like almost
every other work by the artist, it is at once
undated and dissociated from any early
exhibition. Surely, however, this latter
condition will change with new archival
research, because *The Harbor* is among the
largest and most ambitious of Metzinger's
Cubist landscapes.[4] Metzinger, like many
vanguard artists of the late nineteenth and
early twentieth centuries, tended to give his
works generic titles, making it difficult to link
a particular work with one listed in an
exhibition catalogue without a precise
contemporary description or some sort of
physical evidence on the back of the work
itself. Unfortunately, there is nothing to help
with *The Harbor*, and attempts to link it
stylistically with other published works are
hampered by the fact that they, too, are
undated and unlinked to dateable
contemporary exhibitions.

The earlier publications of the collection of
Sara Lee have argued for a 1912 date and
have done so largely out of the sense that a
1912 Metzinger is somehow a "better"
Metzinger – or at least one more central to the
collective enterprise of Cubism – than a 1915
or a 1917 work. Yet, after several years of
reflection and after having studied other
works in the original, it seems more likely
that the painting was made in 1916–17, when
his friend Gleizes was away in New York and
Metzinger wrote him about a "new kind of
perspective I have talked so much about . . .
not the materialist perspective of Gris nor the

Fig. 1 Jean Metzinger, *Landscape*, 1916–17. The Saint Louis Art Museum.
Gift of Mr. and Mrs. Sydney M. Schoenberg, Sr., and
Mr. and Mrs. Sydney M. Schoenberg, Jr., by exchange.
© ADAGP, Paris and DACS, London 1999.

Fig. 2 Jean Metzinger, *Landscape* (*Composition Cubiste*), 1916–17.
Courtesy of the Fogg Art Museum, Harvard University Art Museums.
Gift of Mr. and Mrs. Joseph H. Hazen. © ADAGP, Paris and DACS, London 1999.

Romantic perspective of Picasso . . . rather, a metaphysical perspective."[5] It was then, surely, that the great landscapes in the St. Louis Museum and the Fogg Museum at Harvard University (figs. 1 and 2) were made, and the latter is particularly close in its banded structure and in its simultaneous acceptance of esthetically different modes of representation in one work of art. However, one must not be too doctrinaire in settling on this later date. In fact, the portrait of Gleizes in the Museum of Art of the Rhode Island School of Design (fig. 3) is dated 1911–12 by Moser, presumably because both drawings for it are dated 1911. There is a decided affinity between the banded structure of that distinguished portrait and that of *The Harbor*.[6]

The majority of the industrial "landscapes" produced by Gleizes date from 1916 and 1917, while the war raged and while the absent Gleizes gloried in the combination of safety and stimulation he found in New York. Metzinger stayed in France, experiencing the war and representing a world in which "nature" and "industry" needed the kind of reconciliation they can only achieve in painted landscapes. We have no idea now just which "harbor" Metzinger represented. There are clues — it had mountains, stores, and a combination of sail and motor-powered craft. It is, therefore, not Le Havre or Bordeaux — nor, indeed, any of the harbors on the north or west coasts of France bereft of mountains. As far as the mountainous south is concerned, the harbor seems too small for Marseilles and too industrial for Nice or St. Tropez. In fact, Metzinger's harbor was most likely not an actual harbor, but a represented harbor — represented, that is, less from "visual evidence" as in an Impressionist painting than from images of the mind. One of Metzinger's largest landscapes, *The Harbor* is also among his finest, and, perhaps when it enters the permanent collection of the Dallas Museum of Art with its small, but excellent group of works from the Cubist years by Picasso, Braque, and Gris, Metzinger's achievement will be more widely recognized. Indeed, Gris's wonderful painting, *Guitar and Pipe* of 1913, in Dallas, although smaller than Metzinger's brooding landscape, shares many affinities of form, and is a reminder of just how closely those two artists were associated in the days when they exhibited together with the "mathematical" Cubists in the Section d'Or. [7]

Fig. 3 Jean Metzinger, *Albert Gleizes*, 1912.
Museum of Art, Rhode Island School of Design.
Museum Purchase. © ADAGP, Paris and DACS,
London 1999.

1. See Albert Gleizes and Jean Metzinger, *Du
"Cubisme,"* Paris, 1912 (translated into English in
1913).
2. See particularly Christopher Green, *Cubism and its
Enemies: Modern Movements and Reaction in French
Art, 1916–1928*, New Haven and London: Yale
University Press, 1987.
3. Joann Moser and Daniel Robbins, *Jean Metzinger
in Retrospect*, University of Iowa Museum of Art,
Iowa City, 1985.
4. In fact, only two other published landscapes can
compete, *The Bathers*, 1912–13, from Philadelphia
Museum of Art (146 × 106 cm.) and *Landscape*,
1916–17, St. Louis Museum of Art (81.6 × 99.4 cm.).
5. Moser and Robbins (1985), p. 21.
6. Even from the published photographs in Moser's
book, I have serious question about the accuracy and
validity of the 1911 dates on the two drawings.
Neither looks at all like other published works from
1911 and both dates look as if they were added later.
7. Interestingly, both artists have already been seen
together in Dallas, in the exhibition curated by the
Chicago dealer/collector, R. Stanley Johnson, *Cubism
and La Section d'Or*, Chicago-Dusseldorf:
Klees/Gustorf Publishers, 1991 (DMA dates were
1 June–28 July 1991).

Claude Monet (1840–1926)
Jean Monet on his Mechanical Horse (*Jean Monet sur son cheval mécanique*), 1872

Oil on canvas, 59.5 × 73.5 cm. (23¼ × 28¾ in.)
Signed and dated lower right: Claude Monet/1872
Wildenstein 238

Provenance: Blanche Hoschedé-Monet (Mme. Jean Monet), Giverny; Wildenstein & Co., Paris and New York; Mrs. Huttleson H. Rogers, New York, c.1948; Mr. and Mrs. Nathan Cummings, c.1952; P. & D. Colnaghi Ltd., New York, 1983; George Farkas; William Beadleston Fine Arts; The Sara Lee Collection; The Metropolitan Museum of Art

Exhibitions: Paris, Musée de l'Orangerie, *Monet*, 1931: no. 20; Paris, Galeries Durand-Ruel, *Monet de 1865 à 1888*, 1935: no. 11; New York, Wildenstein & Co., *Children of France*, 1942; Zurich, Kunsthaus, *Monet*, May–June 1952: no. 27; Paris, Galeries des Beaux-Arts, 19 June–17 July 1952: no. 21; and The Hague, Gemeentemuseum, July–September 1952: no. 23; Paris 1956: no. 3; Rome 1956; Edinburgh, Royal Scottish Academy (sponsored by the Edinburgh International Festival), *Claude Monet*, August–September 1957; and London, Tate Gallery, 26 September–3 November 1957: no. 30; Palm Beach, Florida, Society of the Four Arts, *Paintings by Claude Monet: Paintings from the Collection of Mrs. Mellon Bruce*, 1958; no. 7; Minneapolis 1965; New York, Wildenstein & Co., *Olympia's Progeny: French Impressionist and Post-Impressionist Paintings*, 28 October–27 November 1965: no. 9; Washington, D.C. 1970: no. 11; New York 1971: no. 11; New York, Wildenstein & Co., *Faces from the World of Impressionism and Post-Impressionism*, 2 November–9 December 1972: no. 47; Chicago 1973: no. 3; The Art Institute of Chicago, *Paintings by Monet*, 15 March–11 May 1975: no. 30; New York, Acquavella Galleries, *Claude Monet*, 26 October–28 November 1976: no. 14; Rotterdam, Museum Boymans-van Beuningen, *De Fiets* (*Bicycles*), 7 April–12 June 1977: no. 76; Boston, Museum of Fine Arts, *Prized Possessions: European Paintings from Private Collections of Friends of the Museum of Fine Arts, Boston*, 17 June–16 August 1992: no. 93; The Art Institute of Chicago, *Claude Monet, 1840–1926*, 14 July–26 November 1995: no. 27; Laren 1997–8.

Bibliography: "French Art for Children," *The Connoisseur*, 109 (July 1942), p. 147.
Maurice Malingue, *Claude Monet*, Monaco: Les Documents d'art, 1943, pp. 58, 146.
Oscar Reutersvärd, *Monet, en konstnärshistorik*, Stockholm: A. Bonniers, 1948, p. 279.
George Besson, *Claude Monet (1840–1926)*, Paris: Les Editions Braun & Cie., 1949, fig. 2.
B. Champignelle, "Apothéose de Claude Monet," *France Illustration* 351 (5 July 1952), p. 20, repr.
Raymond Cogniat, *Monet and His World*, London: Thames and Hudson, 1966, p. 50.
Yvon Taillander, *Monet*, New York: Crown Publishers, 1967, p. 33, repr.
"Art Across America," *Apollo*, 92 (September 1970), p. 230, repr.
Joseph Butler, "The American Way with Art," *The Connoisseur*, 175 (October 1970), p. 133, repr.
Douglas Cooper, "Cummings Event in Washington," *ARTnews*, 69 (Summer 1970), p. 36, repr,
Marie-Claude Wren, "In the Art Market, Nobody Doesn't Like Mr. Sara Lee," *Life*, 69, pt. 2 (23 October 1970) pp. 76–80, repr. p. 76.
Daniel Wildenstein, *Claude Monet: bibliographie et catalogue raisonné*, vol. I, Lausanne: La Bibliothèque des Arts, 1974, pp. 216–17, no. 238, repr.
The Art Institute of Chicago, *Paintings by Monet* (exh. cat.), Chicago, The Art Institute of Chicago, no. 30, p. 84, repr.
Paul Hayes Tucker, *Monet at Argenteuil*, New Haven and London: Yale University Press, pp. 131, 134 (fig. 104), and 139.
John House, *Monet: Nature into Art*, New Haven and London: Yale University Press, 1986, pp. 34–5, pl. 44.
Karin Sagner-Düchting, *Claude Monet, Ein Fest für die Augen*, Cologne, 1990, p. 75.
Denis Rouart, *Monet*, Zurich: Nathan, 1990, p. 47.
Sophie Fourny-Dargere, *Monet*, Paris: Ste Nouvelle des Editions du Chêne, 1992, fig. 19.
Alan G. Artner, "Lasting Impressions" and "Rethinking Monet," *Chicago Tribune Magazine* ("The Arts"), 9 July 1995, p. 11, repr.
Paul Hayes Tucker, *Claude Monet: Life and Art*, New Haven and London: Yale University Press, 1995, pp. 65–6 (fig. 74), and 68.
Daniel Wildenstein, *Monet or the Triumph of Impressionism*, Cologne: Benedikt Taschen and Wildentstein Institute, 1996, vol. I, pp. 95 and 98, repr.; and vol. II. pp. 104–5, no. 238, p. 105, repr.
Brettell 1986, 1987, 1990, 1993, 1997 (pp. 31–3, 159–60, repr.)

With its aggressively large signature and date, this portrait of Claude Monet's first son, Jean, assumes an almost dynastic status. Rarely in the history of western art have painters so depicted their own sons, and, even in Monet's own career, the painting has special significance. It is particularly unusual – given the scale and placement of both the signature and the date. Monet seems neither to have exhibited the painting during his lifetime nor given it to a relative. Indeed, his own father and mother were already dead in 1872, when it was painted, and the family of his wife, Camille Doncieux, is not recorded as ever having owned it. From this, it can only be concluded that the painting's significance was personal and that Monet was confronting – and attempting to comprehend – his son in the only way he knew – by painting him.

In fact, the portrait is one of six, possibly seven, representations of Jean, made during his childhood, making him the best-documented Impressionist child except for Julie Manet, Berthe Morisot's daughter.[1] Only Pissarro's daughter, Jeanne, comes close with six portraits, but these date mostly from the last two years of her short life and seem to have been made as an unconscious memorial.[2] There are also the numerous portraits of Paul Cézanne's son, most of which date from the late 1870s and early 1880s, but none of these was finished, signed, or dated, and all are of a very small scale. The many portraits by Gauguin of his own children from the late 1870s and early 1880s constitute another chapter in Impressionist family portraiture,[3] but none of these has the sheer iconic power – the sense of self-importance – that is such an important aspect of the Sara Lee portrait.

The birth of Jean Monet was an event that combined joy and conflict. Monet had been living with Camille Doncieux, for more than a year when she gave birth on 8 August 1867, to a male child who was registered three days later as Jean-Armand-Claude Monet. Although Monet was registered as the father, the couple did not marry until 1870, and Monet's father was known to have disapproved of the liaison, actually suggesting that his son abandon Doncieux when he learned of the pregnancy in April of 1867. Indeed, Monet was separated from Doncieux for virtually all of her pregnancy, perhaps at the insistence of his father. Yet he did manage to be with her in Paris at the birth and registration of the first of their two sons. He seems to have returned to the north coast of France just after the registration, leaving Camille alone with the child in Paris, and making short visits to Paris from his rented

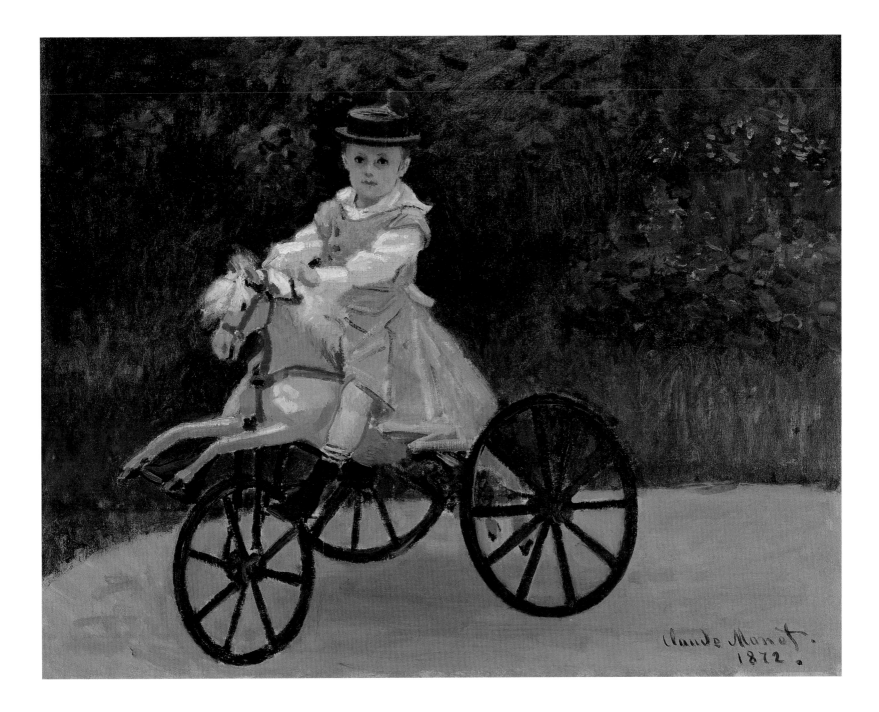

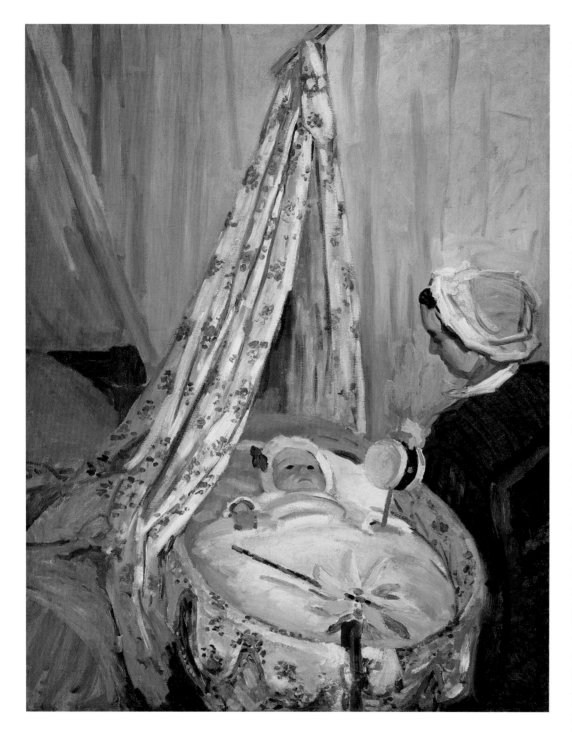

whom have pointed out that she could not be Camille Doncieux because she would not appear dressed as a servant.[4] Charles Stuckey, in the recent chronology in the catalogue of the 1995 Monet retrospective at the Art Institute of Chicago, suggested that the figure might be Julie Vellay, Camille Pissarro's common-law wife of several years, who was the godmother of the child.[5] Yet, it seems more likely that the woman was a servant and that her appearance near the elaborately dressed crib was intended to suggest the financial stability of the child's future at a time when the opposite was true. Most probably Monet painted this large canvas in the spring of 1868, possibly even in connection with the baptism, rather than at the time of Jean's birth, and the sheer fact that Monet omitted the child's mother from the painting suggests that he was more interested in pictorially claiming his paternity than in celebrating the bond of mother and child. Indeed, the painting seems to be more about the "image" of successful paternity than about the "reality" of family instability and even insolvency.

Monet again painted his son in the crib later in 1868 in a small painting in the Ny Carlsberg Glyptotek, Copenhagen (fig. 4) and three times more sitting at the dining table – first as an infant with his mother in the large and ambitious Salon painting *The Luncheon*, then again as an infant with his mother at night in *The Dinner* (Bührle Foundation, Zurich), and finally alone at a slightly more advanced age in a small canvas, now in a private collection, that suggests Jean's independence.[6] I know of no painter's child whose infancy was so carefully recorded in a series of paintings, all of which were prominently signed by their artist. All of these paintings deal with issues of family loyalty and paternity and all of them were painted before the marriage of Claude Monet and Camille Doncieux in June of 1870 (when Jean was nearly three) and, as importantly, before the death of Monet's disapproving father on 17 January 1871, while the younger Monets were living in London.

This is a necessary background for a full interpretation of *Jean Monet on his Mechanical Horse*. Without it, this work might be seen as a playful act of fatherly devotion rather than as a significant step in a father's pictorial analysis of his paternity and his son's growth. The single portrait of Jean that separates the group just discussed from the Sara Lee picture is a small frontal portrait of the little boy wearing a distinctive bonnet with a pompom (fig. 3).[7] In this work, for the

studio room in Sainte-Adresse on the north coast of France. It was not until 2 April 1868 that Claude and Camille arranged for the baptism of their child, and this event, held at the church of Sainte-Marie-des-Batignolles, was clearly an act of defiance of Monet's father and a clear acceptance on Monet's part of his paternal responsibility.

The clear proof of this is Monet's first painting of Jean (fig. 1), a large canvas that represents Jean in his crib – wide awake and staring into the day – with the figure of a nurse seated next to him. The nurse has always puzzled Monet scholars, several of

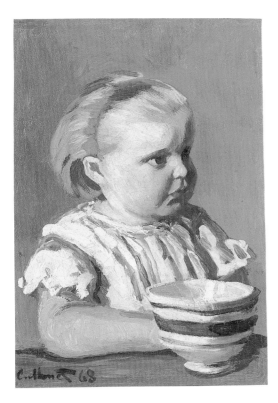

first time, Jean is old enough to "pose" for his father, and this very fact suggests his complicity in the act of representation. Indeed, of the three single "portraits" of Jean that postdate the large baptism canvas, each seems to be separated from the other by a period of about a year, suggesting that they might even be birthday portraits. Unfortunately, the date of 1868 on the second of these paintings makes this theory impossible to prove, because the child seems

clearly older than one year and even older than the one-and-a-half-year-old he would have been at the very end of that year. Yet we know that Monet himself often later misdated paintings, and it seems at least possible that the painting representing the child asleep with a doll (fig. 4) was painted on his first birthday in 1868. We know that the second (fig. 2), was painted when he was two in the summer of 1869 (in spite of its 1868 date). The third, was painted in the summer of 1870 when he was three and old enough to sit still for a small portrait. Even if we reject this notion of "birthday portraits," it is clear that Monet intended to investigate the growth and development of his son through representation and that these works lead up to the Sara Lee portrait.

Jean Monet was five years old on 8 August 1872, and Monet probably painted the portrait as an embodied memory of his son's birthday. In many European cultures, the fifth birthday is celebrated as a passage from infancy to boyhood, and the notion that Jean had become a "little man" was surely not far from Monet's mind when he painted this work. We see the little boy beautifully dressed in a *complet*, with a skirt, shirt, vest and matching hat, sitting jauntily astride a mechanical horse. This toy was clearly a present from the now prosperous father, and its newness is evident not merely from its novelty in 1872, but also from its shiny blue wheels and absolutely unsullied red harness. If Monet was uncertain about the fate of his son at his birth and baptism, those fears were put to rest by the summer of 1872, when the Monets' financial picture was very bright indeed, and this work

Fig. 2 Claude Monet *Child with a Cup: Portrait of Jean Monet*, 1869. Private Collection. Photo Christies Images.

Fig. 3 (*below left*) Claude Monet, *Jean Monet in a Bonnet*, c.1870. © Fondation Bemberg, Toulouse.

Fig. 4 Claude Monet, *The Artist's Son*, 1868. Ny Carlsberg Glyptotek, Copenhagen.

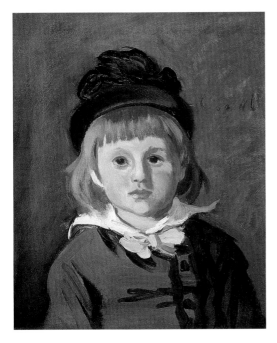

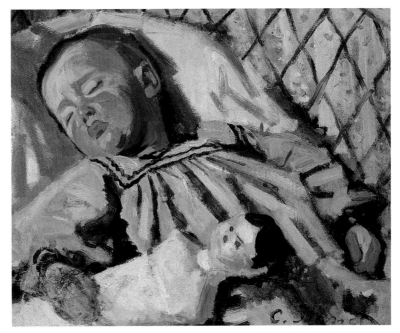

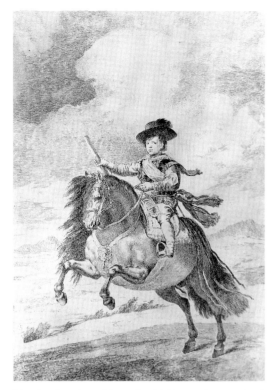

Fig. 5 Goya's etching after Velázquez's portrait of Prince Balthazar Carlos, 1779.

Fig. 6 Edouard Manet, *The Monet Family in their Garden at Argenteuil*. The Metropolitan Museum of Art. Bequest of Joan Whitney Payson, 1975.

– a private statement never meant for exhibition – embodies all the pride of paternity that Monet could muster.

This work was perhaps the most famous in Nathan Cumming's collection. It adorned the cover of at least one catalogue of his collection and has been included in numerous exhibitions devoted the career of Monet. Yet few writers have recognized its position in this extraordinary series of portraits of the artist's son, and few have linked it to its most obvious source in the history of western art – Velázquez's equestrian portrait of Prince Balthazar Carlos.[8] In it, the infante is astride a small horse and is juxtaposed with a vast landscape that contrasts markedly with Monet's *hortus conclusus*. In fact, Monet, who never traveled to Spain, would not have seen the Velázquez original, but would have known the composition most probably through Goya's etching of it (fig. 5), a print well known in mid-nineteenth-century France.

Unfortunately, we have absolute silence from Monet on the subjects both of the portrait and of its source. In fact, the "source" is identifiable completely from powerful circumstantial evidence and there is no documentary proof. Surely Monet, anxious as he had been about the representation of his son's development, would have searched for prototypes before hitting upon this contrived and, in the end, unique portrait.

Jean Monet on his Mechanical Horse will join *The Monet Family in their Garden* (painted two years later by Edouard Manet) in the French Impressionist collections of the Metropolitan Museum of Art (fig. 6).

1. Portraits by Berthe Morisot of her daughter, Julie Manet, begin shortly after her birth and continue at regular intervals throughout the remainder of Morisot's life. Julie is first represented with her wet-nurse in a painting of 1880, *Nourrice et Bébé* (Ny Carlsbert Glyptotck, Copenhagen), and there are numerous painted representations of Julie with her father, Eugène Manet. Her adolescence and young womanhood is perhaps the best documented in the history of art. These are catalogued in Alain Clairet, Delphine Montalant, and Yves Rouart, *Berthe Morisot, 1841–1896: Catalogue Raisonné de l'oeuvre peint*, Paris, 1997. Interestingly, Renoir, who was rather late in becoming a father, seems to have taken after Morisot in the extensive documentation of his children. This has been studied as part of the intensely documented exhibition catalogue by Colin H. Bailey, *Renoir's Portraits*, New Haven and London: Yale University Press, 1997, pp. 40–43, entries for catalogue nos. 54, 57, 58, 59, 61, and 63.
2. See Ludovic-Rodo Pissarro and Lionello Venturi, *Camille Pissarro: son art, son oeuvre*, Paris, 1939, nos. 96, 151, 192, 193, 197, and 232.
3. The Gauguin family portraits can be found in Georges Wildenstein, *Gauguin*, Paris, 1964, nos. 10, 24, 42, 51, 52, 53, 67, 81, 81bis, 82, 135, 176, and 187. There are also numerous representation of children, many of which can easily be interpreted as "surrogates" for Gauguin's absent children.
4. See Daniel Wildenstein, *Monet: Catalogue Raisonné*, Cologne: Taschen, 1996, w101, pp. 52–3.
5. See Charles F. Stuckey, *Claude Monet, 1840–1926*, Chicago: Art Institute of Chicago, 1995, p. 36.
6. Wildenstein, *op.cit.*, w108, p. 55; w132, p. 63; w129, p. 62; and w131, p. 63.
7. *Ibid.*, w142, pp. 68–9.
8. Paul Hayes Tucker made the analogy in *Monet at Argenteuil* (1982), pp. 134–5, figs. 104, 105, and again in *Claude Monet: Life and Art*, (1995), p. 65. Tucker's lead was followed by Daniel Wildenstein (1996), vol. I, p. 95.

Henry Moore (1898–1986)
Upright Motive No. 8, 1955–6

Bronze, 199.3 × 61.5 × 56.5 cm.
(78 × 24 × 22 in.)
Founder: Corinthian
Edition of seven (cast from a plaster maquette
now in the collection of the Art Gallery of
Ontario)

Provenance: Dominion Gallery, Montreal;
Nathan Cummings; The Sara Lee Collection;
South Carolina Museum of Art, Columbia

Exhibition: Laren 1997–8

Bibliography: Will Grohmann, *The Art of
Henry Moore*, London: Thames and Hudson,
1960, pl. 159.
Henry Moore (exh. cat.), New York: M.
Knoedler and Co.; and London: Marlborough
Fine Art, 1962, pp. 18–19, repr.
*Henry Moore: A Retrospective Exhibition of
Sculpture and Drawing* (exh. cat.), Tucson:
University of Arizona Art Gallery, 1965, n. p.,
repr.
Ionel Jianou, *Henry Moore*, trans. Geoffrey
Skelding, New York: Tudor Publishing, 1968,
pl. 48.
David Mitchinson, ed., *Seventy Years of Henry
Moore* (exh. cat.), Otterlo, Rijksmuseum
Kröller-Müller 1968, no. 89, repr.
John Russell, *Henry Moore*, London: Allan
Lane, The Penguin Press, 1968, pp. 141–57.
Robert Melville, *Henry Moore: Sculpture and
Drawings, 1921–1969* (exh. cat.), London:
Thames and Hudson, 1970, fig. 506.
Philip James, ed., *Henry Moore on Sculpture:
A Collection of the Sculptor's Writings and
Spoken Words*, New York: Viking Press, 1971
(first published 1966).
Henry J. Seldis, *Henry Moore in America*
(exh. cat.), New York: Praeger Publishers in
association with the Los Angeles County
Museum, p. 150, repr.
David Finn, *Henry Moore: Sculpture and
Environment*, New York: Harry N. Abrams,
1976, p. 392, repr.
Alan Bowness, ed., *Henry Moore: Sculpture
and Drawings* (catalogue raisonné), vol. III,
New York: George Wittenborn, 1977 (1st edn.
London: Lund Humphries, 1965), pls. 23–4,
no. 388.
David Mitchinson, ed., *Henry Moore:
Sculpture*, introduction by Franco Russoli,
New York: Rizzoli International Publications,
1981, p. 135, fig. 271.
Edward H. Teague, *Henry Moore:
Bibliography and Reproductions Index*,
Jefferson, N.C.: McFarland, 1981, pl. 6.
Brettell 1986, 1987, 1990, 1993, 1997 (pp.
132–3, 161, repr.).
David Mitchinson, ed., *Celebrating Henry
Moore: Works from the Collection of the Henry
Moore Foundation*, Berkeley: University of
California Press, 1998.

Henry Moore's career in the mid-1950s was
intensely productive. In the years
immediately around 1955, he worked on two
projects or series of closely related sculptures –
one devoted to the reclining figure and the
other to the standing figure. These form a
stark contrast in his oeuvre and provided him
with a sculptural counterpoint that pushed his
achievements in both series to a higher level.
Of the two groups, the better studied and
documented is that of reclining figures. The
contrasting series of "totems" or, to use
Moore's own title, Upright Motives, are at
once more elusive and more fascinating and,
perhaps because of their complexity, are in
need of renewed attention.

Moore seems to have begun the series in
1954, when he was asked to create a
commissioned sculpture for the new Olivetti
headquarters in Milan. His own account of the
site visit indicates that the combination of the
profound horizontality of the building itself
and the sight of a lone poplar tree near the
building made him realize that a vertical
sculpture or series of vertical sculptures was
necessary for the site.[1] The commission
resulted in his production, in a very short
period, of twelve small vertical maquettes
called Upright Motives, as well as a
corresponding series of nine wall reliefs
featuring upright motives arranged in parallel
sequences.[2] Interestingly, none of this work
resulted in Moore's completion of the Olivetti
project, which came increasingly to annoy the
artist as he concentrated on the formal
implications of vertical forms. However, as he
continued to work on the reliefs and maquette
in 1955, several occasions presented
themselves for the creation of monumental
groups of Upright Motives, three of which
were combined into a large work, casts of
which are in Scotland, The Netherlands and
the United States. These have been called The
Glenkiln Cross because the "central" Motive
has a cruciform shape and because of the
remote location of one cast in Scotland. The
other two groups of three Upright Motives can
be found at the Kröller-Müller Museum in
Otterlo, The Netherlands, and in the plaza of
the Amon Carter Museum in Fort Worth,
Texas (fig. 1). Moore himself summarized this
process best:

> I did a series of Upright Motives around
> 1955. They came about because I was asked
> to do a sculpture to stand in front of
> Olivetti's new office building in Milan. I
> went to see the building – it was a
> horizontal building which I thought
> needed contrast. This lead me to do a lot of

variations on the Upright Motive theme, which I enjoyed doing in contrast to the Reclining Figure rhythm. But I never carried out the commission. I lost the wish to do it as I realized that the sculpture would always be surrounded by motor cars.[3]

The three *Upright Motives* combined by Moore to form the "Glenkiln Cross" are nos. 1, 2, and 7. These, at the large scale chosen for the three locations, are 335 cm., 320 cm., and 320 cm. respectively, and the two "subsidiary" Motives function like the crucified thieves on either side of Christ at Golgotha, although Moore himself discouraged viewers from making this obvious link.[4] Moore also chose to enlarge two other of the twelve maquettes, nos. 5 and 8, but these are somewhat smaller at 213 and 198 cm. respectively and have never, to my knowledge, been grouped with the larger bronzes. Of the two enlarged "individual" Motives, nos. 5 and 8, both produced in an edition of seven, the latter has had a greater success as an individual object. There are casts at the Fogg Museum at Harvard University and the National Museum of Wales in Cardiff and another on loan to the Allen Memorial Art Gallery at the University of Rochester, New York. In 2000 the Sara Lee cast will be the first major sculpture by Moore to enter the permanent collection of the South Carolina Museum of Art in Columbia.

The twelve maquettes, each cast in editions of nine, together with the nine reliefs, are completely original creations. Moore himself connected them to the totem poles produced along the Northwest coast of the United States and Canada.[5] This affinity is a loose one and can be more strongly felt in some than in others. In the "totemic" ones, there are three to six stacked elements that both merge and are juxtaposed as the entire is read "Motive." Moore's choice of the word "motive/motif" instead of "totem" is surely deliberate, because it removes the works from specifically sacred or memorial contexts and attaches them to the cooler realms of modernist art. Only in no. 1, the so-called Glenkiln Cross itself, does one make specific links to Christian forms, and this time Moore himself encouraged us to think of Celtic crosses or, as he put it, "a kind of worn-down body and cross merged into one."[6] There are surely other powerful links with the major series of large-scale vertical figures being created in the early 1950s by Moore's rival for the title of greatest modernist sculptor, Alberto Giacometti, and it is fascinating that both artists were working on serial vertical forms in

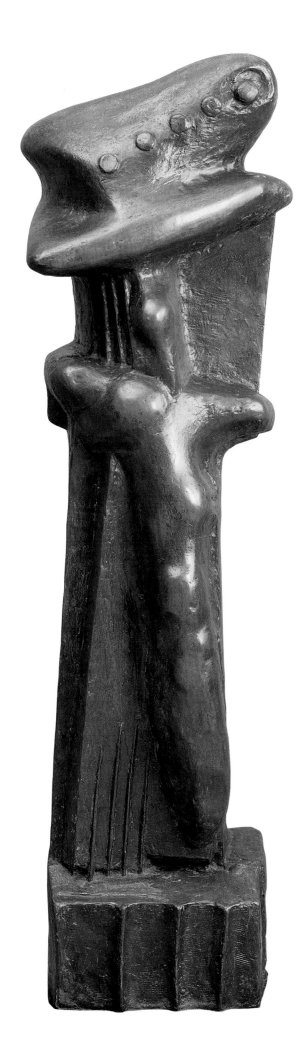

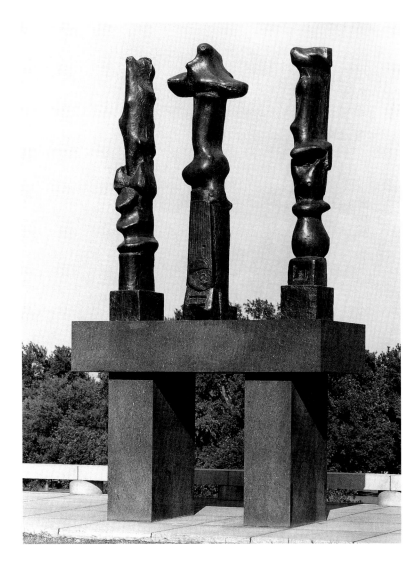

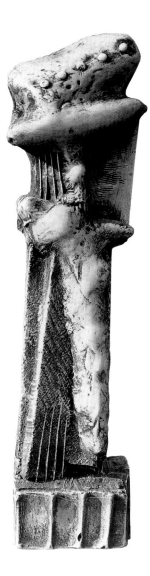

Fig. 1 (*above left*) Henry Moore, *Upright Motives, Nos. 1, 2, 7*, 1955–6. Amon Carter Museum, Fort Worth, Texas. Reproduced by permission of the Henry Moore Foundation.

Fig. 2 Henry Moore, plaster *Upright Motive, No. 8*, 1955. Reproduced by permission of the Henry Moore Foundation.

1955–6, Moore the Upright Motives and Giacometti the Women of Venice (see cat. 14).

The only sustained discussion of the Upright Motives in the vast Moore literature is in John Russell's 1968 monograph.[7] Russell is at pains to point out that, in all the Upright Motives, "the unity of the whole overrides the individuality of the parts,"[8] a formal aspect that is encouraged by their being cast integrally in bronze rather than "assembled" from elements. For Russell, the key problem faced by Moore in the freestanding Upright Motives was "how to bring to that human figure the freedom and audacity and manifold reverberations of the abstract idiom."[9] One also feels Moore joining Brancusi and Giacometti in their relentless challenge to the ubiquity of the base in western sculpture by subsuming the base into the sculpture itself. In the Upright Motives, the base is simply an element in the stacked forms – more or less biomorphic – that give the work its character. Although Russell and others want the viewer to relate the Upright Motive to the human form, Moore seems at pains to discourage this

inevitable interpretive strategy by employing either too few or too many elements to "reconstitute" a human body. It is difficult to find heads, loins, arms, or other elements of the body when searching for meaning among the sculptural elements in Moore's Upright Motives.[10]

1. Accounts of this visit are legion in the vast – and repetitive – Moore literature. An accessible source is Russell (1968), p. 141.

2. These are summarily catalogued in Bowness (1977), pp. 20–22.

3. Finn (1976), p. 392.

4. Russell (1968), p. 143. "I do not especially expect others to find this symbolism in the group."

5. "I started by balancing different forms one above the other – with results rather like the Northwest American totem poles – but as I continued the attempts gained greater unity." Quoted in Donald Hall, *Henry Moore*, New York: Harper & Row, 1966, p. 137.

6. Henry Moore, originally cited in *Henry Moore: Drie Staande Motieven*, Otterlo: Rijksmuseum Kröller-Müller, 1965.

7. Russell (1968), pp. 141–57.

8. Ibid., p. 156.

9. Ibid.,

10. Curiously Moore himself contradicts this in his description of *Upright Motive No. 8*: "This sculpture has in it an idea of a cross (as in the Glenkiln Cross), but the silhouette of it in the distance does not read as a cross, and so would not have been right for the Glenkiln site. The top can be looked on as a head, a face with eyes!" Quoted in Finn (1976). I find this unacceptable when standing in front of the actual object.

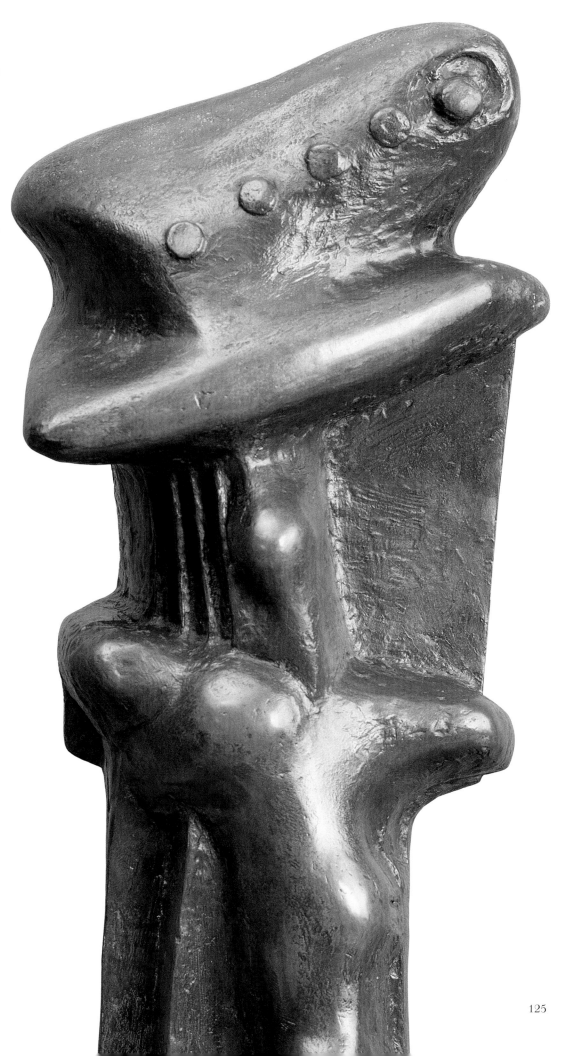

33

Henry Moore (1898–1986)
Falling Warrior, 1956–7

Bronze, 119.5 × 153.2 × 80.5 cm. (46¾ × 59¾ × 31½ in.)
Founder: Fiorini, London
Edition of ten: 3/10
Bowness 405

Provenance: Marlborough Fine Art, London; Mr. and Mrs. Maurice Cooke, Bangor, Wales; New Art Centre, London; The Sara Lee Collection; The Art Institute of Chicago

Exhibitions: Cardiff, National Museum of Wales, *Sculpture 1961*, 1961; Swansea; Aberystwyth; and Bangor, 1961: no. 43; Winston-Salem 1990; Memphis 1991.

Bibliography: Will Grohmann, *The Art of Henry Moore*, London: Thames and Hudson, 1960, pls. 166–8.
Henry Moore: An Exhibition of Sculpture from 1950–1960 (exh. cat.), London, Whitechapel Art Gallery, 1960, no. 50, repr.
Henry Moore (exh. cat.), Paris, Musée Rodin, 1961, pl. 30 (as *Guerrier tombant*).
Henry Moore (exh. cat.), New York: M. Knoedler and Co.; and London: Marlborough Fine Art, 1962, n. p., repr.
Robert Melville, "Moore at Lynn," *Architectural Review*, 136 (November 1964), p. 369, repr.
Alan Bowness, ed., *Henry Moore, Complete Sculpture, 1955–64*, London: Lund Humphries 1965, vol. III, no. 405, pls. 27–30; 2nd ed. New York: George Wittenborn, 1977.
Herbert Edward Read, *Henry Moore: A Study of His Life and Work*, London: Thames and Hudson, 1965, p. 209, pl. 192.
John Hedgecoe, ed., *Henry Spencer Moore*, New York: Simon and Schuster, 1968, pp. 267–9, repr.
Ionel Jianou, *Henry Moore*, trans. Geoffrey Skelding, New York: Tudor Publishing, 1968, pl. 68.
John Russell, *Henry Moore*, London: Allan Lane, The Penguin Press, 1968, pl. 136.
Henry Moore (exh. cat.), London: The Arts Council of Great Britain, 1968, no. 99, pp. 133, 135, figs. 120, 122, repr.
Keith Roberts, "Current and Forthcoming Exhibitions: London," *Burlington Magazine* 110 (September 1968), p. 528, fig. 52.
Robert Melville, *Henry Moore: Sculpture and Drawings, 1921–1969*, London: Thames and Hudson, 1970, figs. 538–40.

Philip James, *Henry Moore on Sculpture*, New York: Viking, 1971 (first published in 1966), p. 24.
Georgia Masson, "Moore in Florence," *Architectural Review*, 152 (August 1972), p. 126, fig. 4.
Giulio Carlo Argan, *Henry Moore*, trans. Daniel Dichter, New York: Harry N. Abrams, 1973, pls. 135–6.
Kenneth Clark, *Henry Moore: Drawings*, London, Thames and Hudson, 1974, p. 155.
David Finn, *Henry Moore: Sculpture and Environment*, New York: Harry N. Abrams, 1976, repr.
David Mitchinson, ed., *Henry Moore Sculpture*, introduction by Franco Russoli, with comments by the artist, New York: Rizzoli International Publications, 1981, pp. 138–9, figs. 275–9.
Edward H. Teague, *Henry Moore: Bibliography and Reproduction Index*, Jefferson, N.C.: McFarland, 1981, p. 7.
William S. Lieberman, *Henry Moore: Sixty Years of His Art* (exh. cat.), London: Thames and Hudson; New York: The Metropolitan Museum of Art, 1983, p. 84, repr.
Henry Moore: The Reclining Figure (exh. cat.), Columbus Museum of Art, Ohio, 1984, p. 143, fig. 33.
Roger Berthoud, *The Life of Henry Moore*, London: Faber and Faber, 1987, pp. 368–9.
Susan Compton, *Henry Moore* (exh. cat.), New York: Charles Scribner's Sons; London, Royal Academy, 1988, p.239, n. 138, repr.
Brettell 1990, 1993, 1997 (pp. 134–5, 161–2, repr.).

Falling Warrior is perhaps the highpoint in Henry Moore's lifelong attempt to engage with classical Greek sculpture. As an art student in London in the 1920s and as a leading modernist in Britain before the Second World War, Moore followed the lead of most vanguard modernists in rejecting the Greco-Roman tradition of the academy. Instead, like Gauguin, Picasso, and Brancusi, he turned to non-western sculpture as the impetus for a new universal modernism. Indeed, as Moore himself put it in an essay of 1930: "The removal of the Greek spectacles from the modern sculptor (along with the direction given by the work of such painters as Cézanne and Seurat) has helped him to realize again the intrinsic emotional significance of shapes instead of seeing mainly a representation value."[1]

Yet, that Henry Moore of 1930 – a young and aggressively modern artist – was very different from the older Moore who had lived through the horrors of the Second World War. Indeed, when the British Museum opened the now famous gallery devoted to the Elgin Marbles in 1949, Moore was one of its first visitors,[2] and this reacquaintance with major Greek sculpture that had been hidden away during the war impelled the painter to make his famous trip to Greece itself in 1951, where he was introduced to archaic sculpture in abundance and where he had "four or five of his top visual experiences."[3]

The *Falling Warrior* resulted from a highly complex preparatory process in which many strands of Moore's career came together for the first time. It was not merely his increasing openness to Greek sculpture, both in London and Athens, but also his long – and suppressed – memories of the academic practice of sculpture in which the nude male model plays a dominating role, as well as his own direct experiences with the reclining, but active male figures that he drew both in the coal mines of Britain and in the Underground tunnels of the city where Londoners of all types and ages huddled in fear in the war during the German bombings. These three strands were linked first in 1953, when Moore, prompted by a small stone he picked up in his garden, began to conceive the *Warrior with Shield* (fig. 1). This, the first overtly "Greek" of Moore's mature works, was the subject of many remarks by the artist: "My excitement was due to the fact that, apart from being concerned with the male figure in my coal-mining drawings, this was the first single male figure I had done in sculpture since my student days. In working on the 'Warrior with Shield,' all the knowledge gained from the life

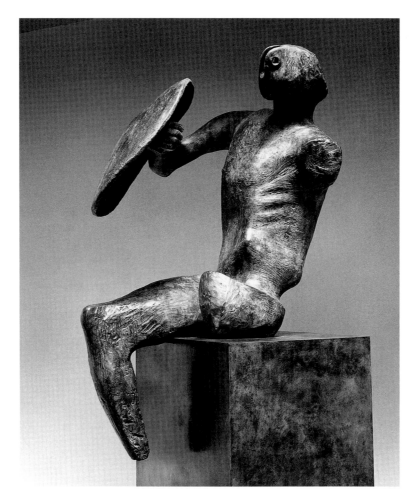

Fig. 1 Henry Moore, *Warrior with Shield*, 1953–4. Reproduced by permission of the Henry Moore Foundation.

Fig. 2 Henry Moore, *Fallen Warrior*, 1956. Reproduced by permission of the Henry Moore Foundation.

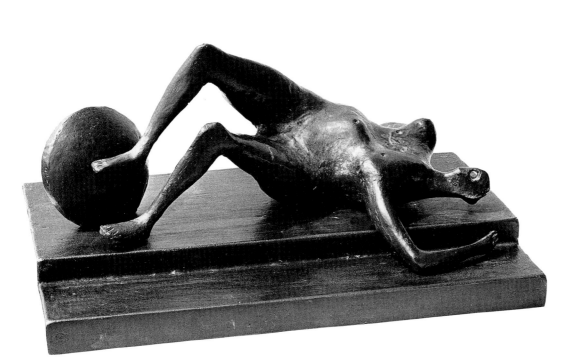

drawing and modeling I had done years before came back to me with great pleasure."[4]

Interestingly, Moore's initial conception of the *Warrior with Shield* was a reclining figure, which, as he worked and reworked in preparation for the bronze, gradually assumed the "heroic" upright position of a living man who has survived the destructions of war. This process was to be, in an odd sense, repeated in the preparations for *Falling Warrior*, which began in 1956 when Moore worked on a maquette of a reclining male figure with a shield to which he gave the title *Fallen Warrior* (fig. 2).[5] The adjective in both cases is crucial; the definitive "fallen" was replaced in the title and form of the final bronze with the active adjective "falling." And Moore became involved with the drama of the process of death rather than with its finality. As he himself said, "In the 'Falling Warrior' sculpture I wanted a figure that was still alive. The pose in the first maquette was that of a completely dead figure and so I altered it to make the action that of a figure falling, and the shield became a support for the warrior, emphasizing the dramatic moment that precedes death."[6]

There have been many attempts to relate *Falling Warrior* directly to precedents in classical sculpture. The most commonly cited sources for the shield and the figure are found in the metopes for the Parthenon, South IV and South XXVIII, both well known to Moore.[7] There are also numerous generic sources to be found in the wounded pedimental figures found in Athens, London, Munich, and other places. Indeed, it seems that Moore, like many modern artists, subsumed his source without the need or the desire to quote it directly, hence giving the work an independence from "academic" method in which the identity of the source is part of the meaning of the modern work. Many commentators have said that Henry Moore knew the contents of the British Museum (which he visited twice weekly throughout much of his life) as well as any director or curator in its history, and the sheer frequency of his visits produced a complex, polyvalent attitude to the human past rooted in the study of original objects at different times and moods, in different lights, and as part of different sequences.[8] This, together with the fact that Moore found formal "rhymes" in the natural world that triggered memories of works of art he had seen in museums and photographs, creates the sense of a "thick time" that approaches the "timeless."[9]

As Moore created *Falling Warrior*, working with metal, wood, plaster, and burlap to build

up the figure, he began crucial discussions with Harry Fischer at Marlborough Fine Art in London, which resulted in a partnership that enabled the artist to conceive of the work as a large-scale "editioned" bronze that was first shown at the gallery in 1958.[10] Hence, unlike most of Moore's other large-scale works, the *Falling Warrior* was not conceived for a particular place and purpose, but as a placeless and universalizing "work of art." Interestingly, one of the earliest purchasers of a cast of the *Falling Warrior* was the Bechtler Foundation in Zollikon near Zurich. The Bechtler brothers wanted the work to be installed in a park by the lake near Zurich, but the municipal authorities, responding to what they saw as the memorial nature of the work, proposed that it be placed in the town cemetery. The Bechtlers found this placement both limiting and wrong, and, after some research, discovered that a Finnish aviator had crashed into the lake and been killed, enabling the work to be placed in a lakeside park and to retain its "memorial" quality.[11]

In addition to a cast at Clare College, Cambridge and in several private collections, three other casts of the *Falling Warrior* can be found in museums – two in Europe and one in America. In each context, the sculpture takes on a different character – in Liverpool, at the Walker Art Gallery, it is linked to its British heritage, and particularly to Moore's own experiments with the reclining male figure in school, in the mines, and in London. In Munich, at the Glyptotek, it plays a role in one of the great summary collections of classical sculpture in Europe and can be compared directly to the fifth-century B.C. recumbent warrior with a shield from the Temple of Athene Aphaia on Aegina (fig. 3) also in the Glyptotek. In Washington, at the Hirshhorn Museum, it assumes its place of pride in the strongest public collection on permanent display in America of European and American modernist sculpture.

When this cast enters the permanent collection of the Art Institute of Chicago in 2000, it will join the most important modernist collection in America that is part of a general art museum and school. Indeed, Chicago will be the ideal location for Moore's self-conscious masterpiece in the universalizing context of "art" to which Moore aspired.

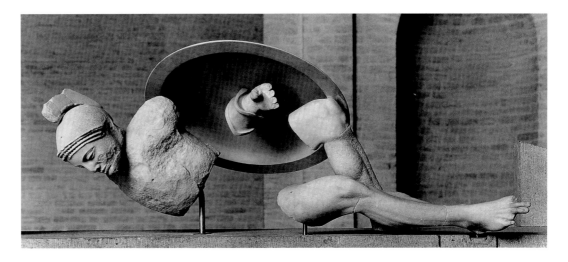

1. Henry Moore, "The Nature of Sculpture," in James (1971), p. 39.
2. See Henry Moore, *Henry Moore at the British Museum*, New York: Harry N. Abrams, 1982. See also Compton (1988), pp. 238–9.
3. Quoted from Compton (1988), p. 234. Her source is James (1971), p. 47.
4. Henry Moore in Hedgecoe (1968), p. 236.
5. The most complete summary of this is Compton (1988).
6. See Mitchinson (1981), p. 139.
7. Compton (1988).
8. See Donald Hall, *Henry Moore: The Life and Work of a Great Sculptor*, New York: Harper & Row, 1966, p. 45.
9. There are fascinating parallels – most probably unconscious and possibly non-existent in Moore's own mind – between his obsession with the fallen warrior and that of French artists just before and after the French Revolution: Jean-Germain Drouais's *The Dying Athlete* (Paris, Louvre) of 1785 and the unfinished painting by David, *The Death of Bara* (Avignon, Musée de Beaux-Arts) leap immediately to mind; see Thomas Crow, *Emulation: Making Artists for Revolutionary France*, New Haven and London: Yale University Press, 1995, pp. 55 and 181. Although it is difficult to imagine the modernist Moore in sympathy with this thoroughly "academic" art, a comparison between the David and the Moore is particularly fascinating and fruitful.
10. See Berthoud (1987), p. 278.
11. This story is told most fully in Berthoud (1987), p. 368. It is also amplified with a direct quotation from Moore in Finn (1976), p. 120. In it, Moore is quoted as saying, "I never made my sculptures to fit a particular place. Each one is made for its own sake, as an individual piece of sculpture. Nor was there any topical connections with anything happening at the time."

Fig. 3 Greek, fifth century, *Recumbent Warrior*. Staatliche Antikensammlungen und Glyptothek, Munich. Photo H. Koppermann.

34

Henry Moore (1898–1986)
Moon Head, 1964
Bronze, height with base: 57.2 cm. (22½ in.)
Founder: Noack, Berlin
Edition of nine plus one: 9/9

Provenance: New Art Centre, London; Nathan
Cummings; The Sara Lee Collection;
Singapore Art Museum

Exhibitions: Rome, Marlborough Galleria
d'Arte, *Henry Moore*, 1965; London,
Marlborough, *Henry Moore*, July–August
1966; Otterlo, Rijksmuseum Kröller-Müller,
Henry Moore, 4 May–7 July 1968: no. 116;
London, Tate Gallery, *Henry Moore*, 17
July–22 September 1968; Washington, D.C.
1970: no. 75; New York 1971: no. 75; Florence,
Forte di Belvedere, *Mostra di Henry Moore*,
1972; Madrid, Palacio de Velazquez, *Henry
Moore Exposition Retrospectiva: Esculturas,
Dibujos y Grabados, 1921–1981* May–August
1981: no. 42; New Delhi, National Gallery of
Modern Art, October–November 1987;
Winston-Salem 1990; Memphis 1991; Laren
1997–8.

Bibliography: Herbert Edward Read, *Henry
Moore: A Study of His Life*, London: Thames
and Hudson, 1965, pl. 234.
Art d'Aujourd'hui, 9 (July 1965), p. 59.
Domus, 428 (July 1965), p. 54.
Henry Moore (exh. cat.), London,
Marlborough Fine Art, no. 15, pl. 15.
John Hedgecoe, ed., *Henry Spencer Moore*,
New York: Simon and Schuster, 1968,
pp. 466–7, repr.
Ionel Jianou, *Henry Moore*, trans. Geoffrey
Skelding, New York: Tudor Publishing 1968,
pls. 24–5.
John Russell, *Henry Moore*, London: Allan
Lane, The Penguin Press, 1968, p. 209,
pls. 218–19.
Henry Moore: Carvings/Bronzes (exh. cat.),
New York: M. Knoedler and Co. and
Marlborough Gallery, Inc., 1970, pp. 52–3,
pl. 15.
Robert Melville, *Henry Moore: Sculpture and
Drawings, 1921–1969*, London: Thames and
Hudson, 1970, figs. 683–5.
Alan Bowness, ed., *Henry Moore: Sculpture
and Drawings* (catalogue raisonné), vol. IV:
Sculpture, 1964–73, London: Lund Humphries,
1977, pp. 38–9, no. 521, repr.
Henry Moore: Eightieth Birthday Exhibition
(exh. cat.), City of Bradford Art Galleries and
Museums, 1978, n. p., no. 37, repr.
David Mitchinson, ed., *Henry Moore
Sculpture*, New York: Rizzoli, 1981, p. 177,
repr.
Henry Moore and David Finn, *Henry Moore
at the British Museum*, New York: Harry N.
Abrams, 1982, pp. 13, 47.
William S. Lieberman, *Henry Moore: Sixty
Years of His Art* (exh. cat.), London: Thames
and Hudson; New York: Metropolitan
Museum of Art, 1983, p. 94, repr.
Brettell 1990, 1993, 1997 (pp. 126–9, 162–3,
repr.).

In the first years of the 1960s Henry Moore's
sculpture went through a gradual
metamorphosis away from the rough surfaces
and darkly associationist forms of late
surrealism to a smooth-surfaced elegance in
which volume and contour form a seamless
whole. This new elegance seemed to fit the
esthetic aspirations of Moore's increasingly
prominent clients, and the largest masterpiece
in this style, *Knife Edge Two Piece* of 1962–5
(fig. 1), produced in an edition of three, was
bought by the City of Westminster, Queen
Elizabeth Park in Vancouver, and Nelson
Rockefeller. Moore's obsession in this period
was with the interaction of two forms that
respond to – and reflect – one another, and he
worked on both small and very large scales to
study the relationships between two forms in
variously contrasting ways.

As Moore worked on the large-scale *Knife
Edge Two Piece*, he began to experiment on a
smaller scale with similar forms, vertically
arranged, and placed parallel to one another.
In 1962 he made a tiny head, 17.78
centimeters high, called *Head and Hand*
(fig. 2), in which two disc-like forms, one with
a mouth-like side opening that seems to speak
and the other with a claw-like vertical
opening that seems to gesture – hence *Head
and Hand*. Then, in his own words,

> when I came to make it full size, about
> eighteen inches high [*sic*; it is actually a
> little more than 22 inches], I gave it a pale
> golden patina, so that each piece reflected a
> strange, almost ghostly, light on the other.
> This happened quite by accident. It was
> because the whole effect reminded me so
> strongly of the light and shape of the full
> moon that I have since called it "Moon
> Head."[1]

In fact, both the head and the hand of
Moore's original conception remain in the
enlarged piece, which might have been better
titled *Moon Head and Hand*.

Moore produced the *Moon Head* in an
edition of nine and also oversaw the
production of a smaller edition in white
porcelain in the size of the original *Head and
Hand* (fig. 3).[2] Both of these have been related
by Moore and his friend, the writer and
photographer, David Finn, to Cycladic
sculpture. In a letter to Finn written in June
of 1969, just five years after the production of
the sculpture, Moore specifically relates the
"white two-form sculpture I call Moon Head"
to "sharp-edged Cycladic idols," and
encourages the photographer to make that
link photographically.[3] The results are not
terribly convincing, suggesting that Moore

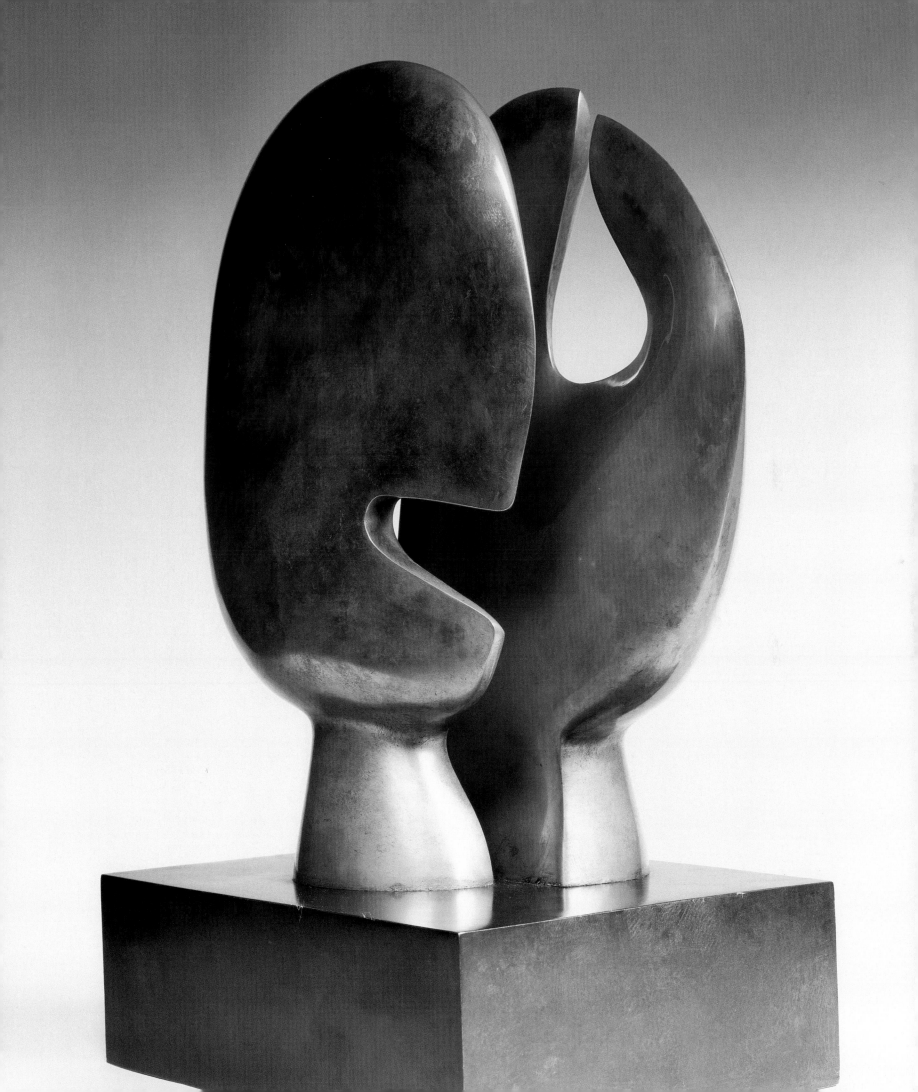

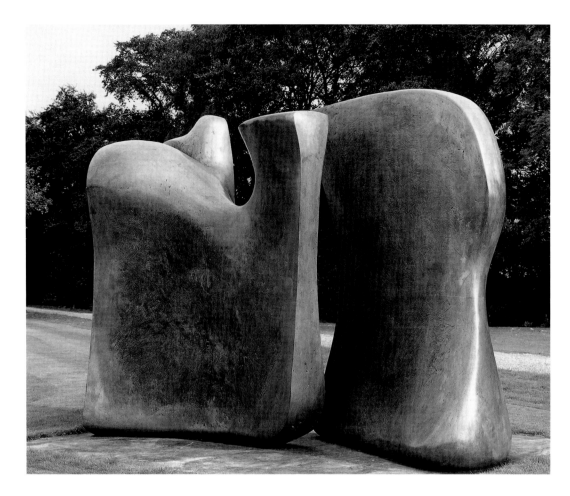

sheen and protection; we should be thankful that neither Nathan Cummings nor Sara Lee Corporation made such a request. Given the historical links between Great Britain and Singapore, the piece is an appropriate addition – the first work by Moore – to the collection of art in the Singapore Art Museum, and it will join a major monumental bronze *Reclining Figure* of the same period, part of the city's collection of monumental outdoor sculpture.

1. Henry Moore in Hedgecoe (1968), p. 466.
2. An unnumbered edition of six was created in porcelain in 1964, but the artist did not keep any sales records for these sculptures.
3. Moore and Finn (1982), pp. 13, 47.
4. Moore and Finn (1982), p. 14.
5. Hedgecoe (1968), p. 466.

Fig. 1 Henry Moore, *Knife Edge Two Piece*, 1962–5. Reproduced by permission of the Henry Moore Foundation.

strained to make a connection that is derived more powerfully from the general qualities of form in Cycladic sculpture than it is to any specific object. Yet Moore insisted on linking Cycladic sculpture to that of Brancusi,[4] of whose highly polished reflective bronzes Moore was also thinking when he worked on *Moon Head*. It is perhaps easier to link the *Moon Head* to Inuit and Eskimo sculpture that Moore is also known to have admired. The link of terrestrial and celestial as well as the use of thin, barely perforated disc shapes in mask-like configurations in Inuit sculpture is even more powerful than between *Moon Head* and the better known Cycladic tradition.

In writing about the *Moon Head* and its patination Moore suggests that the particular golden color of the patina was crucial to an understanding of the piece as lunar. Yet, published photographs of various casts suggest that they vary widely both in color and in the relative luster or shine of the surface. The Sara Lee cast has a dull satin-like sheen, while others, such as that published by John Hedgecoe in 1968,[5] have a high-gloss finish that has a considerable effect on the look of the piece. It is likely that certain owners requested that their bronzes be lacquered for

Fig. 2 (*right, top*) Henry Moore, *Head and Hand*, 1963. Reproduced by permission of the Henry Moore Foundation.

Fig. 3 (*right, bottom*) Henry Moore, *Moon Head*, 1964. Reproduced by permission of the Henry Moore Foundation.

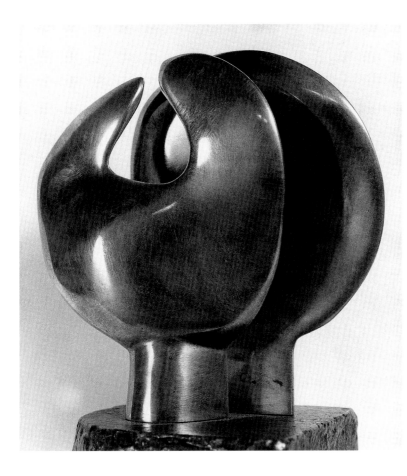

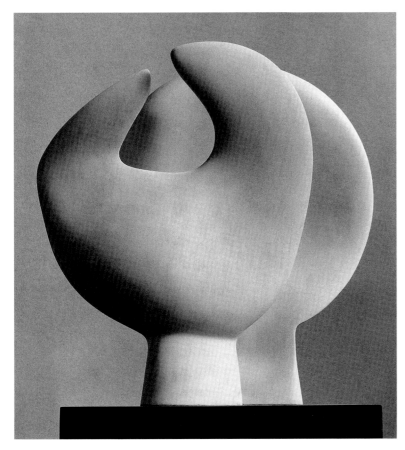

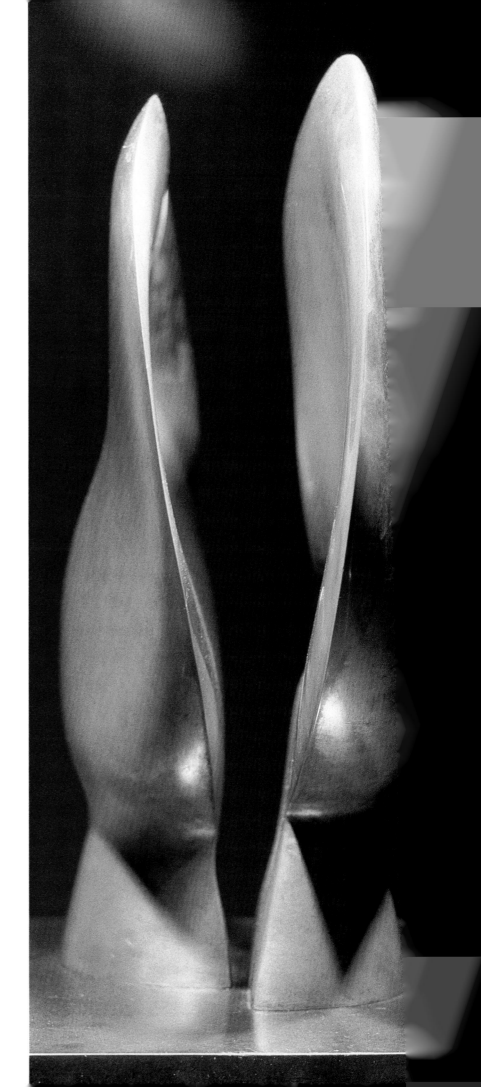

35

Berthe Morisot (1841–1895)
The Garden (Le Jardin), 1882–3

Oil on canvas, 123 × 94 cm. (48⅜ × 36¾ in.)
Angoulvent 155; Bataille-Wildenstein 142;
Clairet-Montalant-Rouart 143

Provenance: Ernest and Julie Manet Rouart,
Paris; Mr. and Mrs. Denis Rouart, Paris;
Nathan Cummings, Palm Beach, Florida; Mrs.
Robert B. Mayer with her son Robert N.
Mayer and her daughter Ruth M. Durchslag;
The Sara Lee Collection; The Art Institute of
Chicago

Exhibitions: London, Dowdeswell and
Dowdeswell, Impressionist exhibition
organized by Durand-Ruel, 1883: no. 1; Paris,
Galerie Durand-Ruel, *Berthe Morisot
(Madame Eugène Manet): exposition de son
oeuvre*, 1896: no. 1; Paris, Galerie Durand-
Ruel, 1902; Paris, Salon d'Automne, 1907: no.
1; Paris, Manzi, Joyant et Cie., 1912: no. 41;
Paris, Galerie Durand-Ruel, *Cent oeuvres de
Berthe Morisot (1841–1895)*, 7–22 November
1919: no. 21; Paris, Galerie Marcel Bernheim,
Réunion d'oeuvres de Berthe Morisot, 20
June–8 July 1922: no. 1; Paris, Galerie
Bernheim-Jeune, *Expositions d'oeuvres de
Berthe Morisot*, 6–24 May 1929: no. 1; Paris,
Musée de l'Orangerie, *Exposition Berthe
Morisot*, 1941: no. 43; Copenhagen, Ny
Carlsberg Glyptotek, *Berthe Morisot: Malerier
Akvareller og Tegningen*, 20 August–18
September 1949: no. 24; London, The Arts
Council of Great Britain, *Berthe Morisot: An
Exhibition of Paintings and Drawings*, 1950:
no. 27; Art Gallery of Toronto, *Berthe Morisot
and Her Circle: Paintings from the Rouart
Collection*, New York, Metropolitan Museum
of Art; Toledo, Ohio, Toledo Museum of Art;
Washington, D.C., Phillips Collection;
Minneapolis Institute of Arts; San Francisco,
Palace of the Legion of Honor; and Oregon,
Portland Museum of Art; September
1952–October 1954: no. 5; Paris 1956;
Washington, D.C. 1970: no. 14; New York
1971: no. 14; Chicago 1973: no. 12;
Washington, D.C., National Gallery of Art,
Berthe Morisot Impressionist, 6 September–29
November 1987; Fort Worth, Kimbell Art
Museum, 14 December 1987–22 February
1988; and South Hadley, Mass., Mount
Holyoke College Art Museum, 14 March–9
May 1988: no. 45; Winston-Salem 1990;
Memphis 1991; Laren 1997–8.

Bibliography: Anonymous review in *Artist*
(London), quoted in Kate Flint, *Impressionists
in England: The Critical Reception*, London:
Routledge and Kegan Paul, 1984, p. 61.
M. Dormoy, "La Collection Ernest Rouart," in
Formes, no. 24 (April 1932), pp. 256–7.
Monique Angoulvent, *Berthe Morisot*, Paris:
Editions Albert Morancé, no. 155, pl. 54.
L. Rouart, *Berthe Morisot*, Paris: Plon, 1941,
p. 31. repr.
François Mathey, *Six Femmes peintres: Berthe
Morisot, Eva Gonzales, Séraphine Louis,
Suzanne Valadon, Maria Blanchard, Marie
Laurencin*, Paris: Editions du Chêne, 1951,
fig. 1, p. 6.
"Berthe Morisot and Her Circle," *Bulletin of
the Minneapolis Institute of Arts*, vol. XLII,
no. 25, (7 November 1953), p. 127, repr.
Marie-Louise Bataille and George
Wildenstein, *Berthe Morisot: catalogue des
peintures, pastels et aquarelles*, Paris: Les
Beaux-Arts, 1961, no. 142, pl. 54.
Consolidated Foods Corporation, *Consolidated
Foods Corporation's Nathan Cummings
Collection*, Chicago: Consolidated Foods
Corporation,1983, p.12, fig. 7.
Brettell 1986, 1987, 1990, 1993, 1997
(pp. 40–43, 163–4, repr.).
Alain Clairet, Delphine Montalant, and Yves
Rouart, *Berthe Morisot, 1841–1895, catalogue
raisonné de l'oeuvre peint*, Paris: Collection le
catalogue, Cera-nrs éditions, 1997, p. 184,
no. 143, repr.

The Garden is among the principal
masterpieces of the career of Berthe Morisot.
Its long and distinguished exhibition history
and its provenance assure it a position of real
eminence not only in Morisot's oeuvre, but in
the general production of the Impressionists.
Its scale and ambition link it with earlier and
contemporary paintings by Manet, Renoir,
and Mary Cassatt, but, because it has never
before been in a public collection, it has not
been subjected to the kind of scholarly
scrutiny of lesser works by Morisot or of major
works by her contemporaries. When it enters
the collection of nineteenth-century paintings,
drawings, and prints by Morisot and her
friends in the Art Institute of Chicago, a
century of neglect will end, and *The Garden*
will assume its rightful place in the pantheon
of major suburban genre paintings by the
Impressionists. At once a portrait, a still-life, a
genre scene, and a landscape, it eludes easy
classification in any of those categories of
painting by partaking in aspects of them all.
In this way, it looks forward to the paintings
of Matisse done in the 1920s, when the genres
of French painting are combined, approached,
and avoided all at once.

Berthe Morisot spent several months in
early 1882 in Nice with her daughter Julie
Manet. By late February of that year Morisot's
husband, Eugène Manet, the brother of
Edouard Manet, was in Paris and involved
with his new civil-service job, with the
construction of their new house on the rue de
Villejust, and with the organization of
Berthe's submissions to the 1882 Impressionist
exhibition. This latter project was a huge
success for the Impressionists, in spite of the
defection of Degas and his protégée Mary
Cassatt. Morisot, in distant Nice, was kept
abreast of developments in a stream of letters
from Eugène, one of which surely stands
behind the painting of *The Garden*, the
largest and most ambitious painting yet made
by Morisot. "Don't be upset," Eugène wrote in
an undated letter written in March of 1882,
"because the newspapers don't mention you.
The fact is, you cannot be seen while all your
colleagues have done their utmost to be seen.
Make a special effort. You can do two
canvases size twenty or thirty in a week. Your
landscape of the Villa Arnulfi is charming,
and you did it in no time. Get Esther to sit for
you in her big hat, or one of the young
American ladies. They will be flattered."[1]
Clearly, what Eugène wanted his wife to do
was to paint a large canvas, and he urged her
to do so from a single posed model in a rapid
working session. *The Garden* is Morisot's
answer to that letter.

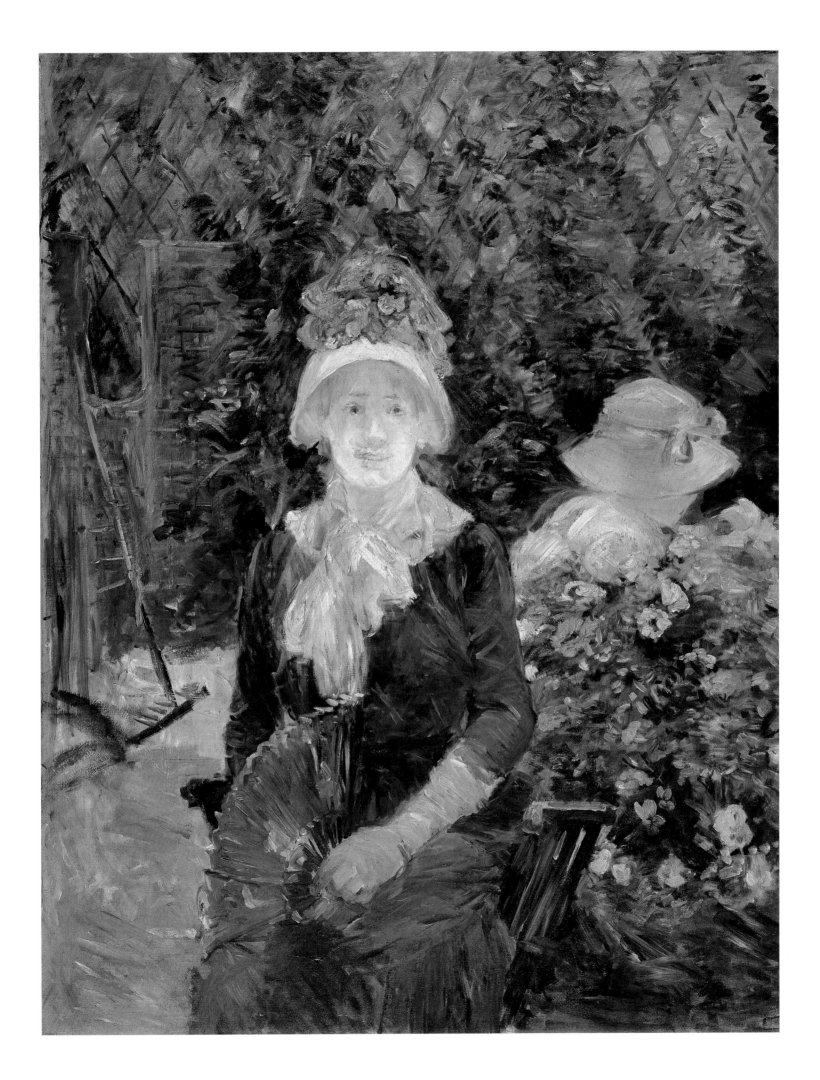

Fig. 1 Photograph of Eugène Manet, his wife, Berthe, and their daughter, Julie, at Bougival, 1880. Musée Marmottan-Claude Monet, Paris. Photo Giraudon.

The Garden is always dated 1883, mostly because it seems to have been sent to London for an exhibition, *Paintings, Drawings, and Pastels by Members of the "Société des Impressionistes,"* organized by Durand-Ruel at Dowdeswell and Dowdeswell in April of that year. This exhibition resulted from the failure of the Impressionists to organize their own exhibition in 1883, and their most fervent dealer took advantage of the situation by sending the submissions he did have to London to "test the waters." The exhibition appeared to largely favorable reviews, and artistically sophisticated Londoners seem to have been thoroughly prepared for it by the appearance in January of a lengthy and highly intelligent essay called "The Impressionists" by Frederick Wedmore in the *Fortnightly Review*. Like most of the French critics of the 1870s and early 1880s, Wedmore did little more than mention Morisot, but another anonymous review of the exhibition in *Artist* actually discusses *The Garden*: "Mme. Morizot's [sic] *Femme dans un jardin* is another out-of-door study of thoroughly accurate tone, and is rendered with a judicious

subordination, though at the same time with a complete suggestion of detail that is worthy of the highest praise."[2]

What is known about this important painting? Oddly, very little, and certain "facts" in the few published accounts of it contradict those in others. Its setting has been identified both as the garden of the artist's new house on the rue de Villejust and as the garden of her rented summer house in Bougival. The model has been positively identified as Milly in certain sources, but remains unidentified in the most authoritative work on Morisot, including the recently produced catalogue raisonné.[3] Which garden is it? Which model is it? It seems the wisest course to accept the latest version – that the garden is indeed that in Bougival, where the family spent the summer of 1882, when the painting was surely begun, and that the model must remain unidentified. The matter of the garden seems the simplest, because the Manet family did not move into the rue de Villejust property until the winter of 1883, according to the chronology in the most recent catalogue raisonné, and, by then, the painting was

already in London.[4] Yet, Higgonet, in her biography of Morisot, which she prepared with the full collaboration of the family, says that they moved into the house just after the death of Edouard Manet in May and before their departure for Bougival in July; but this is also too late for *The Garden*.[5] The matter might be cleared up by the survival of a family photograph of Eugène, Berthe, and Julie Manet taken in the same garden (fig. 1), but even this photographic clue leads nowhere because, in its frequent reproduction, it too is dated from 1880 to 1883 and is identified as both Bougival and Paris. Yet, it is possible to solve this conundrum simply by noting the age of Julie, who is no more than two in the photograph, and, as she was born in November of 1878, this places the photograph into 1880 or 1881 at the latest, two or three years before they moved into the house on the rue de Villejust.

As for the model, in the works that represent the model called Milly in the catalogue raisonné, she does indeed have a regular, oval face and reddish blond hair. Yet, there are enough differences in her features and her hairstyle to make a conclusive identification of her as Milly impossible. It seems, instead, that the model is just as likely to be the family's maid Pasie, who appeared in many works with her charge, Julie. Pasie also had blond hair and, more importantly, bangs, like the model in *The Garden*.[6] Yet, the young woman of *The Garden* with her fine hat and fan is clearly not a maid. Our inability to identify the model "conclusively" would surely have suited Morisot perfectly well. Although it has been called *The Garden* in all the literature, the painting was first exhibited as "Femme dans un jardin" (Woman in a Garden), a title that stresses the anonymity of the sitter, refusing to allow us to interpret it as a "portrait." For us, as for Morisot, she must remain simply a "model," whose identity is unimportant to an interpretation of the painting.

The most surprising fact about this extraordinary painting is its almost complete absence from the spate of articles and books on Morisot written by feminist scholars in the last decade. Although it is the most ambitious work executed by Morisot to that date, *The Garden* is not reproduced, discussed, or even mentioned in the essays and books on Morisot written by Kathleen Adler, Tamar Garb, Anne Higonnet, Linda Nochlin, Anne Schirrmeister, Beatrice Farwell, or Suzanne Glover Lindsay.[7] This "absence" is in direct contradiction to the "presence" of the picture in the exhibitions, catalogues, and books

produced in the two generations after Morisot's death. It was given the "place of honor" as number 1 in the catalogue of the posthumous retrospective organized by her dealer, Durand-Ruel, in 1896 and is featured prominently in every major Morisot exhibition of the two ensuing decades. Is it that the picture does not serve as easily to advance a particular theory about Morisot's status as a woman artist? Only Charles Stuckey, in his intelligent ramble through Morisot's career written for the exhibition catalogue produced by Mount Holyoke College and the National Gallery of Art in 1987–8, devotes any space to the painting, and his analysis deserves full quotation:

Whereas Morisot's treatment of color in the 1870s was predominantly descriptive or decorative, these Bougival pictures are characterized both by the calculated interplay of opposing complementary tones that resonate and thus heighten the illusion of space and by the contrasting interplay of closely related tones with just the opposite effect . . . The most ambitious and moving picture of this group . . . is *The Garden*, the largest work Morisot had ever painted. As she had with *Interior*, painted a decade earlier, Morisot posed a fashionably dressed model on a chair as if for a formal portrait, although the informal garden background here – with an abandoned rake and a child wandering off – is at odds with the demands of conventional portraiture. The sitter's dark blue dress seems to cast a shadow in the light flooded setting, while an inanimate expression only adds to the atmosphere of melancholy, a mood that is comparable to the air of distraction of the modern woman in Tissot's psychologically melodramatic genre scenes or to the states of mind of the so-called Sphinxes portrayed in Stevens's genre pictures. The unedited appearance of the setting in Morisot's painting and the seeming spontaneity of the brushwork notwithstanding, the artist calculated every nuance. In terms of color, she sought stringent, slightly discordant juxtapositions of nearly identical tones: the blue fan against the blue dress, the green leaves against the green trellis and fence, the straw hat with its highlighted brim darkening the pale blond face.

Stuckey goes on to say that *The Garden* may have been among the three paintings by Morisot included in the London exhibition, and then moves dramatically to the death of Morisot's great friend and brother-in-law Edouard Manet on 30 April and his funeral on

3 May. Yet, no one among the commentators on Morisot has noticed the odd rhymes between Morisot's *The Garden* and Manet's *The Railway* of ten years earlier (fig. 2). Morisot seems to have been "reintroduced" to this masterpiece in 1881, when her acquaintance, the opera singer Jean-Baptiste Faure, sold it to Durand-Ruel, and she painted horizontal and rural rhymes of it in the summer of 1882 in *The Balcony* and *The Tea*. Yet, it was in *The Garden* that she grappled in the most complex way with Manet's earlier masterpiece. First of all, the two works are of a similar size (Manet's is 100 × 114 cm. and Morisot's is 125 × 94 cm.), but, in virtually every other way, they are the opposite: Manet's is horizontal, Morisot's is vertical; Manet's is urban, Morisot's is rural; Manet's is a world of women observed by a man, Morisot's is a world of women observed by a women. In both, the female figures stare at the viewer, but the effect of each model is completely different. Far from the "atmosphere of melancholy" that Stuckey notes in *The Garden*, Morisot's model seems actively to be posing, her posture erect and her fan opened, supremely aware that she is the subject of representation.[8] Manet's anonymous model (we now know that she was the famous Victorine Meurent) slouches in an ugly urban

Fig. 2 Edouard Manet, *The Railway*, 1873. © 1999, Board of Trustees, National Gallery of Art, Washington. Gift of Horace Havemeyer in memory of his mother, Louisine W. Havermeyer.

"garden" and looks up from her reading as if the viewer has just walked out a door and into the scene. Both paintings include little girls, and both these little girls turn from us, seemingly unaware of the viewer. The attribute of Manet's girl is her splendid bow, while Morisot is content to allow the gender of her daughter-sitter to be embodied in a straw hat that seems almost to float above the flowers. It is perhaps no accident that these two works, one painted, most probably, in unconscious homage to the other, hung together in the London exhibition of Impressionism in April of 1883, as Manet was dying and Morisot was witnessing what she called "death in one of its most appalling forms."[9]

There is no melancholy in Morisot's wonderful garden painting – pace Stuckey. Indeed, The Garden evokes and summarizes other works by Manet and Morisot, painted in the idyllic summers of 1880, 1881, and 1882, while the two families summered near each other in the series of villages just west of Paris favored by wealthy Parisians in the second half of the nineteenth century. In all these works the garden is closed to the world – a true hortus conclusus. Yet, if always confined, it is equally always paradisaical, filled to overflowing with flowering plants and given scale by folding wooden chairs, rakes, and watering cans that make this paradise so very accessible that we want to rush into it. Never does a male figure enter these gardens – Morisot's in Bougival, Manet's in nearby Bellevue or Reuil – except as a family member or painter-viewer partaking invisibly of its delights. How one would long to see Morisot's The Garden with the largest and most enigmatic of Manet's garden paintings, Young Woman in a Garden, reported by Morisot herself to have been painted in Bellevue in the summer of 1880.[10] Somewhat larger even than Morisot's painting, this sublime decoration was purchased from the

Manet estate sale by Berthe Morisot herself and remains in the collection of her descendants along with another unfinished painting, among the last painted by Manet, of his niece Julie playing in a garden with a watering can.[11] With Manet's death in the very month that it was exhibited, that of his brother Gustave one year later, and his (and Eugène's) mother the month after that, The Garden was made before a series of deaths that forever changed Morisot's world – and her painting of it.[12]

Perhaps the last word about this painting must come from Morisot herself, but this time from a text written before its production. Early in 1882 Berthe Morisot, her husband, Eugène Manet, and their daughter, Julie, made a trip to Italy, ending their visit in Florence, where they rented a villa in what turned out to be the cold of an Italian February. (Manet had suggested this trip to Morisot, and was berated by his brother for the choice of February.) Yet, on that trip, Morisot wrote a letter that, as much as any text, explains these garden paintings by Manet and herself:

> In Italy in times past, painters lived in delightful little towns with warm climates and beautiful architecture, surrounded with people who had nothing to do; from this they created marvels. Today, little girls take five or six classes a week, are gradually exposed to the world, then marry and must devote themselves to their husbands. So no more models, no more of the pretty contours of idleness, of picturesque languor. You must bustle, move. No one understands anymore that nothing is more valuable than two hours spent reclining in a chaise-longue. Dreaming – this is life, and dreaming is more reality than reality. In the dream world, you interact with yourself, your real self. If you have a soul, that is where it is.[13]

1. See Denis Rouart The Correspondence of Berthe Morisot, trans. Betty W. Hubbard, London: Lund Humphries, 1957, pp. 107–8.
2. All known articles and reviews of Impressionist exhibitions in English have been admirably collected by Kate Flint in Impressionists in England: The Critical Reception, London: Routledge & Kegan Paul, 1984. Wedmore's article is pp. 46–55 and the anonymous review with the section on Morisot is p. 61.
3. Clairet, Montalant, and Rouart (1997), p. 184, no. 143. The absence of a positive identification is clearly deliberate, because the model is identified as Milly in Bataille and Wildenstein (1961), p. 32 , no. 142.
4. Clairet, Montalant, and Rouart (1997), p. 92.
5. Anne Higonnet, Berthe Morisot, A Biography, London: Collins, 1990, pp.170–71.
6. See Clairet, Montalant, Rouart (1997), nos. 109 (Young Woman sewing in a Garden), 125 (The Balcony), and 139 (The Tea). Yet, in no. 126 (Le Thé), which represents a similar woman with bangs, the sitter is identified as a "professional model," presumably because she has an upturned nose unlike Pasie's. Perhaps this nameless woman is our model, because, even though the painting is frontal, her nose is similarly upturned.
7. This includes the two books by Anne Higonnet, the monograph by Adler and Garb, and the collection of feminist papers called Perspectives on Morisot published by Hudson Hills Press in association with the Mount Holyoke Museum of Art in 1990.
8. Interestingly, Manet used an identical modern replica of an Italian Renaissance folding chair (had Morisot bought hers in Italy or are they the same chair?) in his wonderfully loose painting of George Moore in a garden (Rouart-Wildenstein 297).
9. Rouart (1941) p. 116.
10. See Denis Rouart and Daniel Wildenstein, Edouard Manet: catalogue raisonné, Paris: La Bibliothèque des Arts, 1975, no. 343, pp. 262–3. This large painting (151 × 115 cm.) has never, to my knowledge, been reproduced in color and has not been exhibited since the early 1950s. However, a reproduction in the same source of a closely related painting from the same summer, Portrait of Mme Manet at Bellevue, (no. 345, pl. 1), makes its connections with Morisot's experiments perfectly clear.
11. Rouart and Wildenstein, Edouard Manet, op. cit., no. 399, pp. 292–3.
12. This is beautifully evoked in Anne Higonnet's wonderfully fluent biography, in a chapter called simply "Loss," Higonnet (1990), pp. 169–74.
13. Clairet, Montalant, and Rouart (1997), p. 90.

Pablo Picasso (1881–1973)
Female Torso (*Torse de femme*), Summer/Fall 1908
Gouache on paper, 63.3 × 48.3 cm.
(24⅝ × 18¾ in.)
Signed in pencil, upper right: Picasso

Provenance: Galerie Kahnweiler, Paris; Joseph Müller, Soleure; Galerie de Berri, Paris; Nathan Cummings, New York; Sotheby's, New York, sale of 12 November 1988; The Sara Lee Collection; San Francisco Museum of Modern Art

Exhibitions: Paris, Galerie de Berri, 1951; Tokyo, National Museum of Modern Art, *Pablo Picasso Exhibition/Japan*, 23 May–5 July 1964; Kyoto, National Museum of Modern Art, 10 July–2 August 1964; and Nagoya, Prefectural Museum of Art, 7–18 August 1954; Minneapolis 1965: (as *Torse d'une jeune fille*); Israel, Tel Aviv Museum, *Pablo Picasso*, 1966: no. 7; Washington, D.C. 1970: no. 38 (as *Torso of a Young Girl*); New York 1971: no. 38, (as *Torso of a Young Girl*); Chicago 1973: no. 45 (as *Portrait of a Young Person*); Tokyo, Seibu Bijutsukan, *Picasso intime*; Osaka, Navio Gallery; Kyoto, Shimbun Gallery; Yokohama, Takashimaya Art Gallery; Kurume, Ishibashi Museum; Seoul, National Museum of Art; Niigata, Niigata Daiei Art Gallery; Koochi, Toden Seibu Gallery; Onomichi, Onomichi City Museum; and Hong Kong, Hong Kong Museum of Art, 1982–3: no. 69; Winston-Salem 1990; Memphis 1991; Chicago, Richard Gray Gallery, *Picasso Masterworks: 1903–1969*, 9 May–30 June 1995: no. 3; Lakeland 1995; Laren 1997–8.

Bibliography: Franco Russoli and Fiorella Minervino, *L'opera completa di Picasso cubista*, Milan: Rizzoli Editore,1972, p. 93. Pierre Daix and Joan Rosselet, *Picasso: The Cubist Years, 1907–1916*, trans. Dorothy S. Blair, London: Thames and Hudson, 1979. Brettell 1990, 1993, 1997, pp. 76–7, 164, repr. *Picasso Masterworks: 1903–1969* (exh. cat.), Chicago, Richard Gray Gallery, 1995, no. 3, n. p., repr.

On 1 October 1907 the Salon d'Automne opened in Paris. Amidst the handful of advanced works by Fauve artists and the almost countless "academic" and "late Impressionist" paintings was the first major retrospective of Cézanne, who had died in October of 1906, as well as a wonderful group of Rodin drawings. The Cézanne retrospective forever changed the shape and character of vanguard art in Paris, and this major work by Picasso from 1908 is proof of the extraordinary impact of Cézanne's paintings on Picasso. The struggle to dominate the female nude that had impelled Picasso forward in 1906-7 to create *Les Demoiselles d'Avignon* (Museum of Modern Art, New York) is well known, but these extraordinary, rhythmic nudes were made before Picasso had seen either of the two great groups of nudes by Cézanne first exhibited in the fall of 1907. Cézanne's enormous canvases, now in the National Gallery London (fig. 1) and the Philadelphia Museum of Art, must have made the young Spanish painter wince in the fall of 1907, even after he had completed his "philosophical brothel." Cézanne's nudes were not only unprecedented, but also at once ambitious and a-sexual in a way that fascinated Picasso, who began to reform his representations of the nude in the fall and winter of 1907–8.

In this, Picasso was not alone. Indeed, no major artist working in France was able to ignore the lessons of the Master of Aix, and artists from Derain and Matisse to Picasso and Braque began to rethink their representations of the "classic" subject of French modernism, the female nude. Yet, one must not be too hasty in ceding the entire "discourse" to Cézanne. In fact, both Matisse and Derain had exhibited major works representing the female nude in the Salon des Indépendants in the spring of 1907, before they ever saw Cézanne's large-scale nudes, and, with the "late entry" of Cézanne to this battle for male dominance of the female, Picasso and his friend Braque had little choice but to respond.

And respond they did. Braque finished his *Large Nude* (collection of Alex Maque, Paris) in the spring of 1908, and his friendly rival Picasso was already hard at work on his *Dryad* (Hermitage, St. Petersburg), begun in the spring and finished in the fall of that same year.[1] In conceiving of these studies of a single female nude in a landscape setting, both artists shied away from the complex multifigural problems tackled by Cézanne, and it was with the integration of several figures into a setting that they attempted to rival the Master of Aix. Picking up on the energy of Derain's *Bathers* of the spring of 1907, Picasso began to formulate a composition with three nude figures that would transcend the almost academic composition of Derain and replace it with a complex, integrated composition in which the three figures related not only to each other, but also to their setting. To prepare for this, Picasso treated the figure less as an erotic ensemble of curvilinear forms than as a geometrically conceived body "in sync" with her setting. During this process, Picasso executed literally hundreds of drawings, watercolors gouaches, and oil studies, all of which culminated in the monumental *Three Women* (fig. 2).[2]

In order to insert the figures into their setting and to create an integrated composition, Picasso began to represent his figures as polygonal and curvilinear volumes

Fig. 1 Paul Cézanne, *The Bathers*, 1900–04. National Gallery, London.

Fig. 2 Pablo Picasso, *Three Women*, 1908–9. The Hermitage, St. Petersberg. Photo The Bridgeman Art Library, London/New York. © Succession Picasso/DACS 1999.

Fig. 3 Photograph of Joseph Müller next to an African sculpture, 1970.

in incessant interplay with the equally polygonal "voids" of the composition. To understand and communicate the power of the female form as a compositional element (rather than as an erotic indicator), Picasso studied figure after figure in notebooks, on small sheets of paper, and on expensive larger sheets, refining, adapting, and altering his project as he worked. The Sara Lee sheet descends from a long line of these studies, which began in his notebooks of early summer 1907 (fig. 4) shortly after he saw the Cézanne retrospective, and continued unabated until he allowed himself to fracture the nude into hundreds of spatially ambiguous geometric units in his analytical Cubists paintings in the fall of 1909. The *Female Torso* sheet sits firmly in the middle of this investigation and was of such independent quality that it was purchased from the artist by the dealer

Kahnweiler, who sold it to the great Swiss collector of modernist painting and African sculpture, Joseph Müller (fig. 3).[3] The vast majority of the Picasso sheets made as part of the *Three Nudes* project remained in the artist's collection and are today in the permanent collection of the Musée Picasso in Paris or in the estate of the artist's granddaughter Marina Picasso.

In the month by month drama of Picasso's artistic development, historians have successfully placed works in the "spring" or "summer" of the year. Zervos, in the second volume of his massive catalogue of works by Picasso, dates the Sara Lee sheet to the spring of 1908. Yet, in looking through the more recent publications of the drawings in the Musée Picasso, many of which are more precisely dated, it seems just as likely that the sheet was made in the summer or even the fall of 1908, when Picasso was working in his Paris studio on the rue des Bois. One sheet in the Musée Picasso, *Standing Nude* and *Study of a Foot* is particularly close to *Female Torso* in its polygonal treatment of the breasts and the great belly of the nude. In the smaller sheet in the Musée Picasso, Picasso gave the great nude a mask-like face whose long nose and circular mouth have clearly African origins and whose hair is almost Pharaonic. In the Sara Lee sheet the head is a simple oval with minimal markings defining the nose, mouth, and eyes.[4]

This major gouache painting by Picasso will enter the collection of the most ambitious museum of modern art to open in the United States since MoMA itself opened in 1929. The San Francisco Museum of Modern Art has rooted its contemporary collection in the modernist achievement of major artists of the late nineteenth and early twentieth centuries. This will be the first work from the crucial years 1907–9 to enter the permanent collection of the museum, joining Matisse's *Women with the Green Hat* as a sentinel of early twentieth-century modernism.

Fig. 4 Pablo Picasso, *Study of a Nude*, 1907. Musée
Picasso, Paris. Photo © RMN. © Succession
Picasso/DACS 1999.

1. See William Rubin, *Picasso and Braque: Pioneering
Cubism* (exh. cat.), New York: Museum of Modern
Art, 1989, pp. 87 and 103.
2. See Michèle Richel, *The Picasso Museum, Paris:
Drawings, Watercolors, Gouaches, and Pastels*, New
York: Abrams, 1993, pp. 69–101.
3. Joseph Müller was among the greatest collectors of
modern and tribal art in the first half of the twentieth
century. His ownership alone assures the quality of
this work. Only one, privately printed book deals with
this collector, who deserves careful documentation in
the form of a major exhibition and publication.
4. A related and identically sized nude study of a
female nude from the back was included in Rubin,
Picasso and Braque, op. cit., p. 109.

Camille Pissarro (1830–1903)
Vase of Flowers (Bouquet de fleurs – pivoines et seringas), 1877–8

Oil on canvas, 82 × 64.2 cm. (32 × 25 in.)
Initialled lower right: C.P.; fragments of an earlier signature (C. Pissarro) visible in lower right corner
Pissarro-Venturi 467

Provenance: Ludovic-Rodo Pissarro, Rouen; Richard Semmel, New York; Sam Salz, New York; Nathan Cummings, New York; Mrs. Robert B. Mayer, Chicago; The Sara Lee Collection; Van Gogh Museum, Amsterdam

Exhibitions: Paris, Galerie Durand-Ruel, *C. Pissarro*, February–March 1898; Paris, Musée de l'Orangerie, *Centenaire de la naissance de Camille Pissarro*, February–March 1930: no. 138; Paris, Galerie Charpentier, *Tableaux de la vie silencieuse*, 1946; Toronto 1955; Minneapolis 1965; Davenport 1965; New London 1968; Washington, D.C. 1970: no. 4; New York 1971: no. 4; Winston-Salem 1990: Memphis 1991; Lakeland, 1995; Laren 1997–8.

Bibliography: Ludovic-Rodo Pissarro and Lionello Venturi, *Camille Pissarro, son art, son oeuvre*, vol. II, Paris: Paul Rosenberg, 1939, no. 467, p. 46, pl. 95; rep., San Francisco: Alan Wofsy Fine Arts, 1989.
Consolidated Foods Corporation, *Consolidated Foods Corporation's Nathan Cummings Collection*, Chicago: Consolidated Foods Corporation, 1983, p. 8, fig. 2.
Brettell 1986, 1987, 1990, 1993, 1997, pp. 36–7, 165, repr.
Joachim Pissarro, *Camille Pissarro*, New York: Harry N. Abrams, 1993, p. 273, fig. 322.

Camille Pissarro made more than four hundred paintings in the 1870s, the most experimental and interesting decade in his entire career. It was during this period that he engaged in the longest and most concentrated collaborative working relationship of his life – that with the younger Provençal painter Paul Cézanne, and Pissarro's oeuvre throughout the decade can be read as a long esthetic dance with the younger man's work. Pissarro started the 1870s in much the stronger position – as the clear "teacher" of Cézanne; but by the mid-1870s Cézanne emerged with an artistic arsenal of real power, and for the remainder of the period their relationship can be characterized as a friendly rivalry, from which Cézanne emerged with a clear pictorial voice – the victor – by 1878–9.[1]

Although the landscape in and around Pontoise and its neighboring town Auvers was the chief field of esthetic battle, lesser skirmishes took place indoors – perhaps when the weather was inclement or when one or the other artist needed diversion. It was in the area of flower painting – perhaps the lowest rung in the hierarchy of genres in the nineteenth century – that the battle for dominance continued. Legend has it that Cézanne painted his first floral still-life in 1873, at the behest of the famous homeopathic physician and amateur artist Dr. Gachet, who had reputedly set up a vase of flowers to paint before being interrupted by Cézanne, who assumed the role of painter.[2] According to Gachet, this session was at once so satisfying and so protracted that he advised Cézanne to reduce the size of his canvases so as to work more efficiently. This resulted in two smaller canvases (R 226 and 227) in addition to the initial, and larger floral still-life that Cézanne reputedly gave to a grocer in Pontoise, from whose collection it began a short journey that ended in 1911, when it was given to the Louvre (fig. 1).[3] Yet, if we read Cézanne's oeuvre in terms of that of Pissarro, three works by Pissarro (PV 198 and 199, and *Bouquet of Flowers: Chrysanthemums in a China Vase*, National Gallery of Ireland, Dublin) should be added to this dialogue of flower paintings.[4] Frustratingly, only one of these six paintings is dated, Pissarro's *Bouquet of Peonies and Roses* now in the Ashmolean Museum in Oxford, signed and dated 1873 (fig. 3). It is fascinating that this work is of virtually identical dimensions to Cézanne's "Gachet" still-life and that the other two works by Pissarro are, like those by Cézanne, smaller.

This pictorial interaction occurred in 1873, when the two artists saw each other almost daily and when their relationship was at its most intense. Yet none of these works was painted in the presence of the other artist – Cézanne painted all of his in Auvers working from Delft vases in the collection and flowers from the garden of Dr. Gachet, while Pissarro seems to have worked at home in Pontoise with three different ceramic containers – one Chinese, one Dutch, and one a contemporary French neo-Rococo design. Two of the three works by Cézanne were almost immediately brought to Pontoise – in payment for grocery bills? – and one of them was sent to Pissarro's house to await a signature.[5] In looking at the six works, it seems that Pissarro started the competition by painting the two smaller of his still-lifes (Atlanta and Dublin), perhaps as early as 1872 and that Cézanne "answered" with the Orsay still-life, painted in a much bolder manner, more clearly rooted in the 1860s floral still-lifes by Manet, the largest and most important of which had been exhibited publicly in 1865 and 1867 and had been acquired from Manet in 1872 by Pissarro's dealer Durand-Ruel.[6] This produced a counter-response by Pissarro, who painted his boldest and largest floral still-life in a manner even more like that of Manet in 1873. Interestingly, Pissarro kept at least two of his three paintings, and Cézanne painted a responding still-life four years later in Pissaro's studio, using the same vase that Pissarro had used in 1873. From this exchange and the group of 1877 floral still-lifes by Cézanne, comes the Sara Lee still-life by Pissarro.

In 1877 Pissarro and Cézanne seem to have resumed close contact, largely because of their commitment to the Impressionist exhibition held in the spring of that year. Although there are no written documents to prove it, several works by Cézanne painted in Pontoise seem to date from the spring of 1877 (R 302, 311, 312, and 484), probably just before the Impressionist exhibition. All of these works by Cézanne remained in the collection of Pissarro, whose widow sold the floral still-life in 1904 after the painter's death. Cézanne's *Two Vases of Flowers* has never been published in color, neither has it been included in a major exhibition of the works of Cézanne. Nor has the brilliantly neo-Baroque *Bouquet of Lilacs* by Pissarro, signed and dated 1876, that seems to have inspired it (PV 377).[7] Both of these brilliant, but virtually unknown floral still-lifes are closely related to the unsigned and undated *Vase of Flowers* in the Sara Lee Collection.

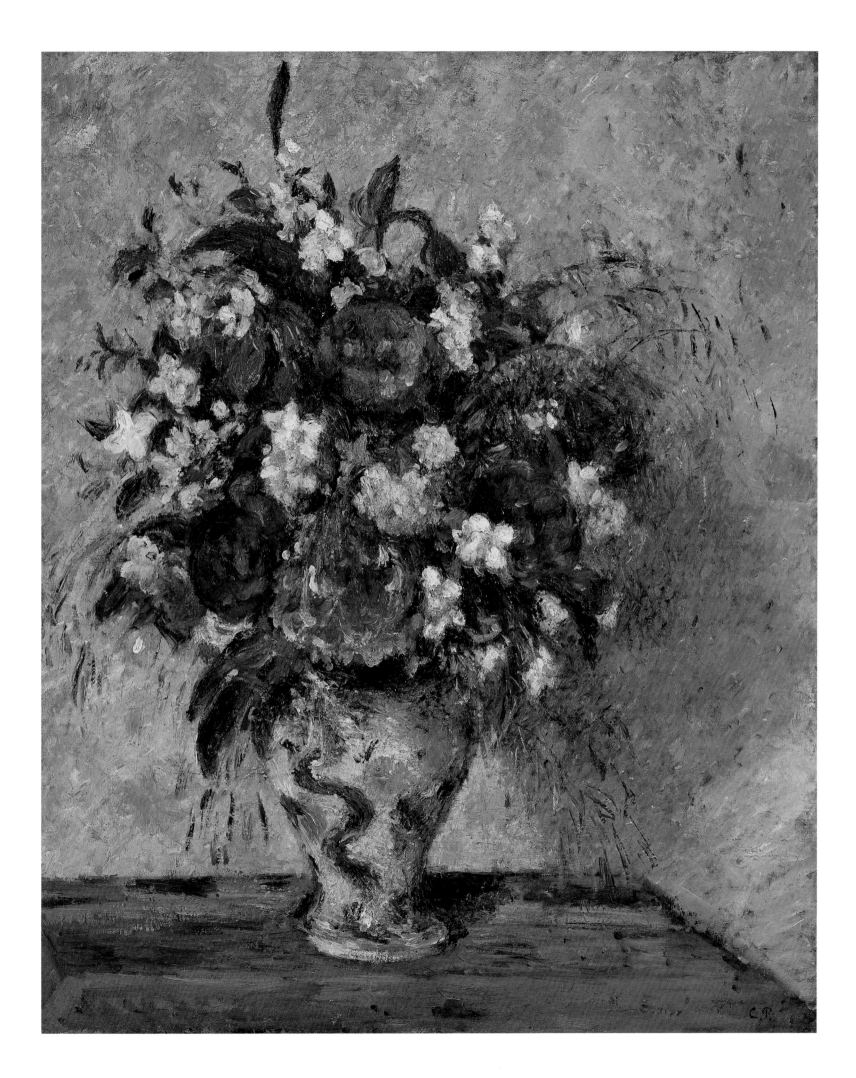

Conventionally dated to 1878, this work was surely begun earlier and played as integral a part in the Cézanne/Pissarro dialogue as did the earlier Ashmolean still-life. The dialogue of 1876–7 includes three and possibly four paintings by Pissarro (PV 377, 378, 428 [a work similar to, but smaller than the Sara Lee work, known only from a drawing by Pissarro], and 467) and as many as six works by Cézanne, two of which were included under the generic titles "Etude de fleurs" in the 1877 Impressionist exhibition.[8] Of these, only R 315 in the Hermitage, St. Petersburg, has ever been published in color, and none of these works has been included in monographic exhibitions of the work of either artist since the Second World War.[9] For that reason, the brilliant and intense competition of two friendly rivals as flower painters remains little known to this day, and it is difficult to reach precise conclusions about the

chronology of the group. However, it seems clear that in 1873 and 1877 Cézanne and Pissarro came very close together as painters of flowers. Again, Cézanne's works entered the public domain at this early point because two of them – probably those in the collection of Victor Choquet – were included in the April 1877 Impressionist exhibition. Pissarro seems to have withheld these works from exhibition in 1877–8 just as he did in 1873–4, and only one of the four floral still-lifes of the second group, the Sara Lee painting, was exhibited in Pissarro's lifetime – in an exhibition held at Durand-Ruel's gallery in Paris in the spring of 1898, more than twenty years after it had been painted.[10] The fact that the partly overpainted earlier signature can be linked to Pissarro's signatures of 1872–4 suggests that this painting was completed when Pissarro and Cézanne worked together, and that it was later heavily reworked. It is likely that

Fig. 1 (*top*) Paul Cézanne, *Dahlias*, 1873. Musée d'Orsay, Paris. Photo © RMN.

Fig. 2 (*above*) Paul Cézanne, *Les Deux Vases de Fleurs*, *c.*1877. Private Collection.

Fig. 3 Camille Pissarro, *Bouquet of Peonies and Roses*, 1873. Ashmolean Museum, Oxford.

Pissarro saw the Cézanne still-lifes in the 1877 Impressionist Exhibition and was inspired by them to repaint his own earlier work. Hence the painting can be plausibly dated to 1877–8.

Pissarro's floral still-lifes are the least-studied group of works in his considerable oeuvre. The wonderfully painted wallpaper behind the vase of flowers in the Sara Lee canvas is a veritable symphony of pure color with no representational function, and the flowers themselves quiver with life. The dominating reds, pinks, and deep greens of the still-life are countered by complementary oranges, yellows, and blues in the background, and the whole composition has a chromatic intensity that elevates it to the highest level of the painter's achievement. Perhaps because the subject itself was so "low," so little invested with social, political, or moral associations, Pissarro himself seems to have neglected it, but few of his works from the mid-1870s are finer, and because the *Vase of Flowers* is essentially an exercise in the expressive domain of pure color it is surely appropriate that it should be the first work by Pissarro to enter the permanent collection of the Van Gogh Museum in Amsterdam. Van Gogh himself might have seen the painting in one of his visits with the Pissarros, and its deep affinities with the paintings of Cézanne must not be neglected when we think about the place that van Gogh's own sunflower paintings occupy in that artist's crucial, if difficult relationship with Paul Gauguin.

1. This interaction is the subject of a forthcoming dissertation by Christopher Campbell for Brown University and of an exhibition curated by Joachim Pissarro and Richard R. Brettell for the Yale University Art Gallery.
2. This story is most recently retold in John Rewald, *The Paintings of Paul Cézanne: A Catalogue Raisonné*, New York: Abrams, 1996, vol. I, p. 163.
3. See Ibid., vol. I, nos. 223, 226, 227, pp. 163–6.
4. Pissarro and Venturi (1939), vol. I, pp. 106–7. The Dublin still-life has been most recently published in color in Pissarro (1993), p. 269.
5. Rewald (1996), p. 163.
6. This is Edouard Manet's *A Vase of Flowers* (*Peonies in a Vase*), 1864, at the Musée d'Orsay. See Henri Loyrette and Gary Tinterow *Impressionisme: Les Origines* (exh. cat.), Paris: Réunion des musées nationaux, 1994, p. 402, no. 97.
7. See Pissarro and Venturi (1939), vol. I, no. 377, p. 133.
8. See Charles Moffitt et al., *The New Painting: Impressionism 1874–1886* (exh. cat.), Art Museum of San Francisco, 1986, pp. 203–4.
9. The most recent – and definitive – of these was the London, Paris, and Philadelphia exhibition, *Cézanne*, Paris: Reunion des Musées Nationaux, 1995.
10. This information was unknown to Ludovic-Rodo Pissarro when he published the catalogue of 1939.

Camille Pissarro (1830–1903)
Bountiful Harvest (*Belle Moisson*), 1893

Oil on canvas, 44.3 × 55.7 cm. (17¼ × 21¾ in.)
Signed and dated lower right: C. Pissarro 93

Provenance: Nathan Cummings, Chicago
(acquired 1945); Alan H. Cummings, Palm
Beach, Florida; The Sara Lee Collection; The
Israel Museum, Jerusalem

Exhibitions: Paris 1956: no. 1; Coral Gables,
Florida, The Joe and Emily Lowe Art Gallery
of the University of Miami, *Renoir to Picasso
1914*, 8 February–10 March 1963: no. 29;
Winston-Salem 1990; Memphis 1991; Laren
1997–8; Tokyo, Isetan Museum, *Camille
Pissarro and the Pissarro Family*, 5 March–7
April 1998; Umeda, Daimaru Museum,
29 April–11 May 1998; Hukuoka, Mitsukosi
Gallery, 20 May–10 June 1998.

Bibliography: Consolidated Foods Corporation,
*Consolidated Foods Corporation's Nathan
Cummings Collection*, Chicago: Consolidated
Foods Corporation, 1983, p. 9, fig. 3.
Brettell 1986, 1987, 1990, 1993, 1997,
pp. 54–5, 166, repr.

Fig. 1 Camille Pissarro, *In a Meadow at Eragny*,
1893. Musée d'Art et d'Histoire, Neuchâtel.

This wonderfully fresh and lively landscape
was unknown to the artist's careful son
Ludovic-Rodo Pissarro when he published the
near-definitive catalogue of his father's
paintings in 1939. It will make its "debut" as
a fully authentic work in the modern
updating of that classic catalogue being
prepared by the painter's great-grandson
Joachim Pissarro, for future publication by the
Wildenstein Foundation. For that reason,
little is known about its early history. Yet,
there is a great deal of lore about the painting,
because it is known to the family and friends
of Nathan Cummings as the first important
painting purchased by the collector – in Paris
after seeing it in a shop window – in 1945. At
that time, Cummings was fond of saying that
he had not even heard of Pissarro, and the
purchase of this delightful painting launched
him on a lifelong process of art acquisition
and education that ended only with his death
in 1985.[1]

The Pissarro landscape bought in 1945 had
been painted more than half a century earlier
and almost exactly ten years before the artist's
death in the autumn of 1903. It is a part of a
large series of landscapes painted on variously
sized canvases in various seasons from the
window of his farmhouse or studio in rural
Normandy. Because these works have not
been grouped in the twentieth century, they
constitute one of the last "frontiers" in
Pissarro scholarship.[2] The "flood" of
landscapes from the 1890s and early years of
the twentieth century resulted from a
painfully unproductive interlude in the
painter's career in which he experimented
fervently with the dotted *facture* and laborious

preparation associated with Neo-
Impressionism. Pissarro started this process in
the autumn of 1885, when his productivity
began a steady decline as he worked longer
and harder on each canvas. (Pissarro's Neo-
Impressionist phase is the subject of a recent
scholarly appraisal by Professor Martha Ward
of the University of Chicago.[3]) This phase
ended in 1890–91, when Pissarro began to
paint a large series of watercolor landscapes
from the window of his Eragny studio, over
160 of which he mounted in large portfolios in
1891.[4] This most "English" of media seems to
have provided Pissarro with a release from the
"painter's block" he had experienced as a
Neo-Impressionist, and, after the series of
watercolors, the venerated elder statesman of
Impressionism felt free to paint his sensations
again.

The year 1893 was crucial to the
establishment of Pissarro's late style. In it, he
began his first series of urban paintings made
from hotel windows in the northern Parisian
neighborhood around the Gare Saint-Lazare.
These works, several of which were very
rapidly painted on small canvases, were
countered both by rural landscapes such as
Bountiful Harvest and by a series of figure
paintings that describe the integrated rhythms
of rural life. Pissarro's "liberation" of the
early 1890s had been described in loving
detail in the catalogue to his major one-man
exhibition held early in 1892 at the Durand-
Ruel Gallery, and Pissarro himself responded
with a small one-man exhibition held in
March of 1893, also at Durand-Ruel.[5] This
later project included his first "series" of
"Views from my window in Eragny," one of
which may well have been the Sara Lee
Bountiful Harvest.[6] The 1939 catalogue
raisonné includes sixteen such paintings, five
of which were included in the 1893 exhibition
and all of which were painted with the same
short, wrist-curved brushstrokes in palettes
with a wide chromatic range and a mastery of
color juxtaposition that resulted directly from
Pissarro's Neo-Impressionist experiment.

There is much discussion in the Pissarro
literature about the significance of these rural
elegies in the context of Pissarro's avowed
anarchist politics. Contemporary writers and
several of their modern proponents read the
paintings as part of a deeply committed social
utopian vision in which work and leisure are
representationally balanced, as they are in an
ideal life. Thus, we learn from Edmond
Cousturier that, "readied for hours of
profitable work by a life of rural simplicity, as
much in the village as in the city, M. Pissarro
'amuses himself' by painting three hours

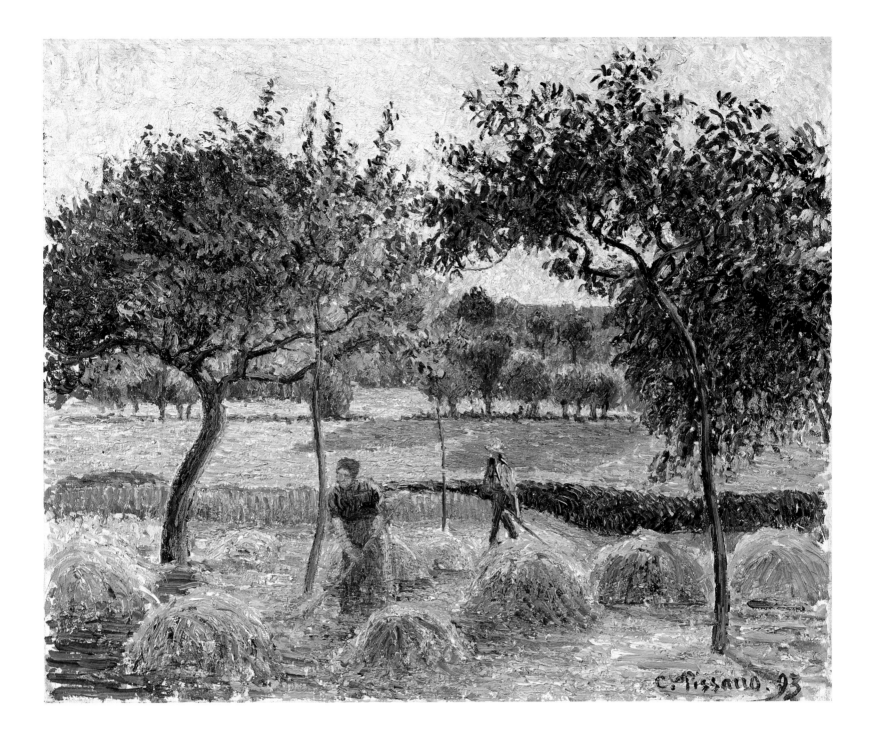

every day just as he 'amuses himself' the rest of the time thinking about painting."[7] This equation of work and leisure, with an equilibrium of the physical and the mental, played a large role in socialist and anarcho-communist theories of modern life to which Pissarro eagerly subscribed. Yet, for all this rhetoric, the paintings have a calm detachment from rural life rooted in the European notions of "pastorale."

Bountiful Harvest represents a couple of rural workers forming piles of freshly cut hay. The painter observed this scene either in the late summer of 1892 before signing and dating the painting for the 1893 exhibition or, more likely, in the summer of 1893 after the exhibition's success. It will join the group of paintings by Pissarro that has been assembled over the past generation at the Israel Museum in Jerusalem. These include a perfect context for the Sara Lee work in landscapes of 1890 and 1899 respectively: *Sunset at Eragny*, 1890, promised gift of Johanna Lawrence to the Israel Museum, and *Morning, Sunlight Effect, Eragny*, 1899, bequest of Mrs. Neville Blond to the British Friends of the Art Museum of Israel (fig. 2).

1. This story was told countless times by Nathan Cummings himself and was the feature story of his talk given at the opening of the Cummings Collection exhibition at the National Gallery in Washington. It is most recently retold in the introduction to Brettell (1997), p.15.

2. The best selection in a recent exhibition can be found in Stephanie Rachum and Joachim Pissarro's *Camille Pissarro: Impressionist Innovator*, at the Israel Museum and the Jewish Museum, New York, 1994–5, nos. 93–6 and 99–106. Joachim Pissarro has also included a wonderful group in his recent monograph, *Camille Pissarro*, New York: Abrams, 1993, chap. 9: "Late Landscapes," pp. 224–41.

3. See Martha Ward, *Pissarro, Neo-Impressionism and the Spaces of the Avant-garde*, Chicago: University of Chicago Press, 1996.

4. See Pissarro, *Camille Pissarro, op. cit.*, p. 225.

5. Ward, *Pissarro, op. cit.*, chap. 11, pp. 241–61.

6. The problem with such an identification is that the current titles of paintings by Pissarro often bear little resemblance to those under which the works were first exhibited. In the absence of strong circumstantial evidence or of gallery stickers or archival references, it is difficult to identify precisely which works he exhibited.

7. Ward *Pissarro, op. cit.*, p. 248. The translation is Dr. Ward's. Dr. Ward also has a thorough discussion of the twentieth-century literature about the significance of Pissarro's late urban oeuvre.

Fig. 2 Camille Pissarro, *Morning, Sunlight Effect, Eragny*, 1899. Israel Museum, Jerusalem.

39

Camille Pissarro (1830–1903)
Woman bathing her Feet (Le Bain-de-pied),
1895

Oil on canvas, 73 × 92 cm. (28½ × 36 in.)
Signed and dated, lower left: C.Pissarro 95
Pissarro-Venturi 903

Provenance: Albert Pontremoli, Paris; Dr.
Janos Plesch, Berlin; Paul Rosenberg and
Company, New York; Mrs. John Astor, New
York; E. and A. Silberman Gallery, New York;
Nathan Cummings, Chicago; Sara Lee
Corporation; The Art Institute of Chicago

Exhibitions: Paris, Galerie Durand-Ruel,
L'Oeuvre de C. Pissarro 7–30 April 1904: no.
93 (exhibited as *Femme au bord de l'eau*); New
York, E. A. Silberman Gallery, April–May
1955; Chicago, Art Institute of Chicago,
Treasures of Chicago Collectors 15 April–7
May 1961: (exhibited as *Girl Beside a Stream*);
Paris, Institute of Fine Arts, 1962; New York,
Wildenstein & Co., April 1962; Waltham,
Mass., Brandeis University, 10 May–13 June
1962; Chicago, Union of American Hebrew
Congregations, 16–21 November 1963;
Minneapolis 1965; New London 1968;
Winston-Salem 1990; Memphis 1991;
Jerusalem, The Israel Museum, *Camille
Pissarro, Impressionist Innovator*, 11 October
1994–9 February 1995; and New York, The
Jewish Museum, 26 February–15 July 1995:
no. 92; Laren 1997–8.

Bibliography: Ludovic-Rodo Pissarro and
Lionello Venturi, *Camille Pissarro, son art, son
oeuvre*, Paris: Paul Rosenberg, 1939, vol. II,
no. 903, p. 206, pl. 183.
*Catalogue des tableaux modernes . . . aquarelles,
dessins, sculptures (156) numeros, composant la
collection Albert Pontremoli*, Paris, sale of June
11, 1924, lot 136, repr.
Christopher Lloyd, *Camille Pissarro*, New
York: Rizzoli, 1981, p. 119 and dustjacket.
Consolidated Foods Corporation, *Consolidated
Foods Corporation's Nathan Cummings
Collection*, Chicago: Consolidated Foods
Corporation, 1983, p. 7, fig. 1.
Brettell 1986, 1987, 1990, 1993, 1997,
pp. 56–9, 166–7, repr.
Joachim Pissarro, *Camille Pissarro*, New York:
Rizzoli International Publications, 1992,
pl. 13.
Joachim Pissarro, *Camille Pissarro*, New York:
Harry N. Abrams, 1993, p. 170, fig. 181.

In 1894–5, Camille Pissarro began a series of
bathers, nude and clothed, that is
unprecedented in his career. Although he had
often represented the human figure, this
project was rooted in the traditions of genre
and portraiture, and, throughout his early life
and middle years, Pissarro assiduously –
almost prudishly – avoided the nude figure.
This all changed in 1894, when he painted the
first small canvas of nude bathers, after which
he began a small series of bathers, completed
in 1896.[1] These works are rarely discussed in
the Pissarro literature and, when they are,
they tend to be related to the bathers in the
great Cézanne exhibition held in November
and December of 1895 at Vollard's gallery in
Paris.[2] We know that Pissarro saw this
exhibition and that he was both irked and
delighted by the sudden prominence it gave to
the reputation of the Provençal painter (his
former colleague and friend). Yet to link the
series of bathing compositions painted by
Pissarro between 1894 and 1896 to the
Cézanne exhibition is fundamentally to
misunderstand both artists.

To begin with, all or most of Pissarro's
1894–5 bather compositions were completed
before the opening of the Cézanne exhibition
in November of 1895. This would account for
the fact that there are absolutely no precise
parallels to be drawn between any single
Cézanne bather composition and one by
Pissarro. It also must be remembered that, of
the more than one dozen canvases by Cézanne
in Pissarro's possession, five represent bather
compositions and had been in Pissarro's
collection for at least twenty years by the time
of the 1895 exhibition.[3] In other words,

Pissarro was one of the few French artists of
the 1890s who actually did not need to see the
Cézanne exhibitions to understand Cézanne.
He already did.

Woman bathing her Feet is the largest,
most fretfully worked, and most ambitious of
the 1894–5 bather compositions. Indeed, when
looking at its numerous reproductions in the
Pissarro literature, Cézanne is not very much
at the front of our minds. Rather, the painting
appears to be a highly complex study of a
single female model, whose pose and costumes
have been achieved after a complex working
process. Even a cursory physical examination
will reveal the extent to which Pissarro
altered the arms, legs, and hands of the model
while working on the painting, and, when we
delve more deeply into the Pissarro literature,
we find two other paintings and one great
chalk drawing that relate directly to *Woman
bathing her Feet.*[4] The smallest – and possibly
earliest – of these is a canvas from the
previous year (fig. 1), that is related to two
other small paintings and series of prints also
made in 1894.[5] Pissarro seems to have been
fascinated by the small canvas, because he
evidently hired a model and posed her, both
nude and clothed (fig. 2), so that he could
continue his mastery of this motif in two
larger paintings, the Sara Lee canvas and its
nude "equivalent" in the Metropolitan
Museum of Art (fig. 3).

Both the wonderfully subtle chalk drawing
for the Sara Lee painting in the Ashmolean
Museum, Oxford, and its painted nude
cognate in the Metropolitan Museum suggest
eighteenth-century prototypes far from the
example of Cézanne. The drawing has a

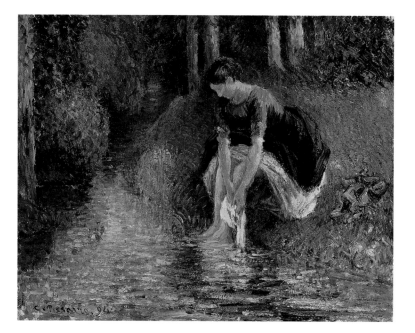

Fig. 1 Camille
Pissarro, *Woman
washing her Feet in the
Brook*, 1894.
Indianapolis Museum of
Art. Gift of George E.
Hume.

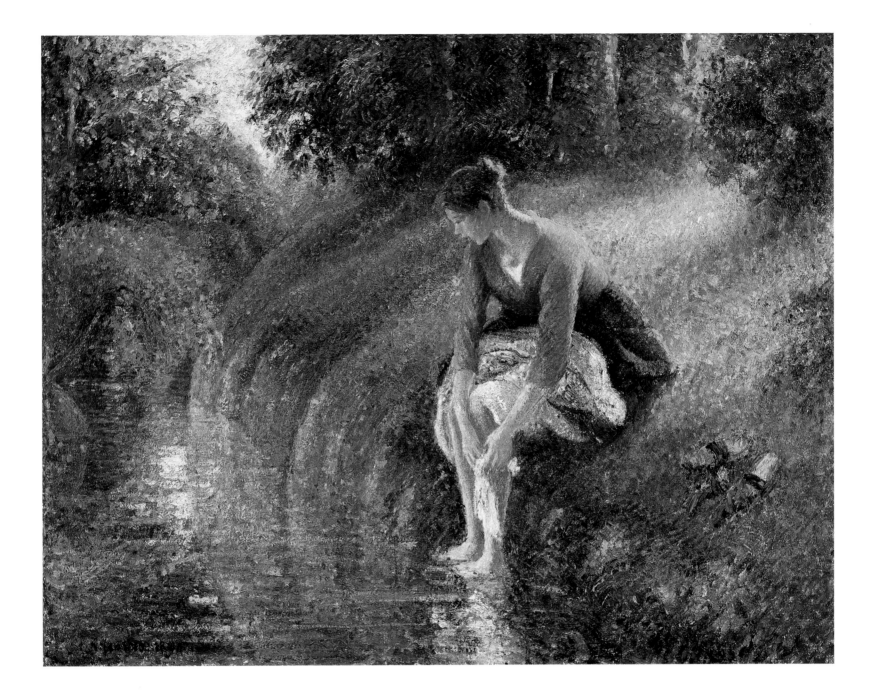

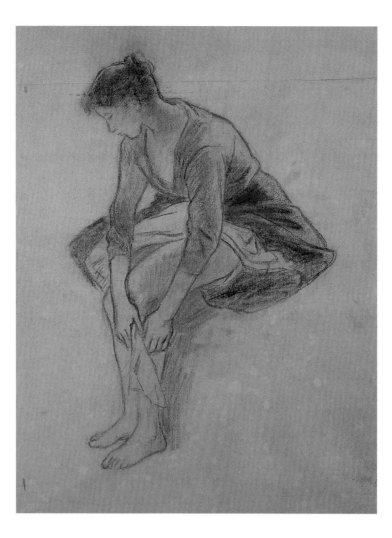

Fig. 2 Camille Pissarro, *Study of a Young Woman bathing her Legs.* Ashmolean Museum, Oxford.

Fig. 3 (*below*) Camille Pissarro, *Bather in the Woods*, 1895. The Metropolitan Museum of Art, H.O. Havemeyer Collection, Bequest of Mrs. H.O. Havemeyer, 1929.

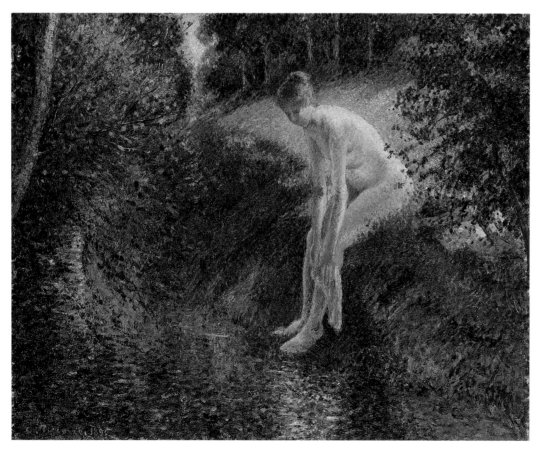

French *dix-huitième siècle* quality that is rare in Pissarro's art, while the coincidence of nude and clothed versions of the figure immediately suggest the famous nude and clothed *majas* by Francisco Goya, a painter known and admired by virtually every French vanguard artist after Manet. Yet Pissarro was careful to paint his two "versions" of the composition on canvases of different size, forcing us to look at them as individual works of art rather than as a pair, and, as if in recognition of this, the works have never been exhibited together. Joachim Pissarro published them together in his important 1993 monograph, where regrettably the two paintings were reproduced in identically sized rectangles, forcing the reader to interpret them as the "pair" that Pissarro himself was at pains to deny.[6]

Pissarro had never been to Spain, despite his familiarity with Goya's oeuvre, (acquired mostly through prints and photographs), and had, thus, never seen the great "pair" of paintings in the Prado. Yet, in spite of his insistence on two different sizes for his modern variant, there is no more compelling homage to Goya's masterpieces in the entire history of French modernism than Pissarro's 1895 investigation of an identically clothed model placed in an identical landscape, once while nude and once while clothed. He distinguished between the models not by their proportions or pose, but by their hair color – the Sara Lee bather having dark brown hair, while the Met. bather is a blonde. Both are represented as self-absorbed and, hence, unaware of the presence of a viewer, making the representations curiously anti-modern and uncritical of the earlier traditions of bather painting. In this way, they are most decidedly different than the Goya prototype, where the model looks candidly and openly into the eyes of the beholder-painter. In spite of all these differences, Pissarro clearly wanted to make works of art with a deep art-historical resonance – both to such Old Testament scenes as Susanna at the Bath[7] and to the supremely secular bathers of Boucher, Fragonard, Manet, and Renoir.[8] In fact, by 1894–5, when Pissarro began this new series, his former student Paul Gauguin had all but outstripped him in the representation of the bathing nude, and another student, Paul Cézanne, was to steal his thunder later in 1895.

What no writer about these paintings has stopped to describe or analyze is the sublimely beautiful and complex landscapes in which the awkward, but easily likable figures are set. The *Woman bathing her Feet* canvas is a

chromatic symphony, with a scumbled crust of brilliant color so thick, so expertly handled, and so rich that it defies description. Even the great Monet would have stopped admiringly in front of Pissarro's water or his shaded bank of lawn, dappled with unseen light. If Pissarro failed ultimately to create a seamless link between figure and ground in this ambitious painting, he succeeded in making the ground so beautiful and the figure so lovingly awkward that we accept the two in spite of him.

Fig. 4 Rembrandt, *Bathsheba at the Bath*. Louvre, Paris. Photo © RMN – Jean Schormans.

7. Pissarro's depiction of the young woman of *Woman bathing her Feet* is particularly close to Rembrandt's image of *Bathsheba* (fig. 4). The unclothed Bathsheba, like Pissarro's clothed model, sits at the right of center on a river bank, engaged in a foot bath with her head slightly inclined and in full profile facing the left side of the canvas. In both cases the bather's legs also face left but the upper torso is turned toward the viewer. And in both cases, some article of clothing (a shawl and a shirt in the Rembrandt and a pair of shoes in the Pissarro) rests on the bank at the right side of the canvas. While Rembrandt's Bathsheba holds King David's letter in her right hand, Pissarro's model holds a washcloth in her two hands, which are brought together. The Pissarro foot-bather bends farther from the waist than does Rembrandt's Bathsheba, and her arms form a loop over one knee. For this gesture, one might look to another Louvre painting, Leonardo's *The Virgin, the Child, and Saint Anne*, in which the Virgin's arms loop around one knee as she reaches toward the Child. Pissarro's use of the Leonardo as a source is even more clear in his charcoal drawing *Four Peasant Women Resting* of 1885 and in a lithograph of 1896, *The Woodcutters* (both now in the Israel Museum). In the mid-nineteenth century Rembrandt's painting was known in France as *Suzanne au bain*. It came into the Louvre (where, of course, Pissarro would have seen it) by bequest from Louis La Caze in 1869 (see Jan Kelch "Bathsheba with King David's Letter," no. 39, in *Rembrandt: The Master and his Workshop*, New Haven and London: Yale University Press, 1992, pp. 242–5). The Leonardo has been in the Louvre since 1516 when it joined the royal collections of François I (see Michel Laclotte and Jean-Pierre Cuzin, *The Louvre: European Paintings*, London: Scala Books, 1993, p. 175).

8. It is perhaps because of their sheer oddness in the overall context of Pissarro's "return" to Impressionism in the 1890s that these works were never exhibited in Pissarro's lifetime. *Woman bathing her Feet* made its debut in the posthumous exhibition held the year after the painter's death at the Paris gallery of his dealer, Durand-Ruel. It was not included in the great centenary retrospective devoted to Pissarro at the Orangerie in 1930, nor did it appear in the great retrospective of 1980, in spite of its size and evident ambition. Only in the 1990s has it emerged from obscurity, making its "debut" in the context of Pissarro's oeuvre in the Jerusalem/New York retrospective organized by the painter's great-grandson Joachim Pissarro.

1. See Pissarro and Venturi (1939), nos. 898, 900–04, 937–9, 940–41.

2. The only exceptions are the short paragraphs in Pissarro (1993), pp. 160–70. He reproduces a generous sampling of bathers, including *Woman bathing her Feet*, but says remarkably little about them.

3. These can be found in John Rewald, *The Paintings of Paul Cézanne: A Catalogue Raisonné*, New York: Abrams, 1997, nos. 114, 123, 162, 250, 371.

4. See Pissarro and Venturi (1939), nos. 901, 904, and Richard Brettell and Christopher Lloyd, *The Drawings of Camille Pissarro in the Collection of the Ashmolean Museum*, Oxford and London: Morely Gallery, 1977.

5. The majority of Pissarro's superb prints of bather subjects also seem to have been done in 1894, when he referred to a bather lithograph in a letter to his son written in January of 1894, well before anyone had any inkling of a Cézanne exhibition. See Barbara Shapiro, *Camille Pissarro: The Impressionist Printmaker* (exh. cat.), Boston Museum of Fine Arts, 1973, no. 39.

6. Pissarro (1993), p. 170.

40

Camille Pissarro (1830–1903)
The Pont Neuf (Le Pont Neuf), 1902

Oil on canvas, 54.6 × 64.8 cm. (21½ × 25½ in.)
Signed and dated lower right: C. Pissarro 1902
Pissarro-Venturi 1210

Provenance: Dr. Max Emden, Hamburg, 1931;
Mrs. Michael van Beuren; Knoedler & Co.,
New York; Lili Wulf, September 1944;
Richard N. Ryan (acquired from the above,
November 1944); Sotheby's-Parke-Bernet,
New York, sale of 9 October 1968; Nathan
Cummings, New York; Acquavella Galleries,
New York; Carlos Hank; The Sara Lee
Collection; Musée des Beaux-Arts, Palais
Saint-Pierre, Lyon

Exhibitions: Washington, D.C. 1970: no. 5;
New York 1971: no. 5; Chicago 1973; The
Dallas Museum of Art, *The Impressionist and
the City: Pissarro's Series Paintings,*
15 November 1992–31 January 1993:
no. 118; Laren 1997–8.

Bibliography: Ludovic-Rodo Pissarro and
Lionello Venturi, *Camille Pissarro, son art, son
oeuvre*, Paris: Paul Rosenberg, 1939, no. 1210,
pl. 238; 1989 rep. San Francisco: Alan Wofsy
Fine Arts, vol. II, no. 1210, pl. 238.
Brettell 1997, pp. 60–61, 167 repr.

Fig. 1 Claude Monet, *The Pont Neuf,* 1872.
Dallas Museum of Art, The Wendy and Emery
Reves Collection.

The Exposition Universelle (World's Fair) of
1900 had just opened in Paris when the
elderly Impressionist Camille Pissarro rented
an apartment at the end of the Ile de la Cité as
an urban studio and living quarters.[1] He had
established a practice of working in the city
during the autumn and winter, and spending
the warmer months in the country where he
kept a farm in the Normandy village of
Eragny. Hence, his last decade as painter can
be neatly divided into "urban" and "rural"
campaigns, each of which produced a large
body of works that came to be justly
celebrated in the painter's lifetime. As his
success grew, Pissarro "upgraded" his living
accommodations, having started in hotel
rooms and small suites in the period 1894–8,
but graduating to a rather grand two-storey
apartment at 204 rue de Rivoli overlooking
the Tuileries late in 1898.[2] All of the windows
of this apartment faced south and had
essentially the same view, and Pissarro had
exhausted the motifs of the Louvre and the
Tuileries gardens by early 1900. This
deficiency was corrected when he rented the
large apartment on the Ile de la Cité with
windows facing both north and east and views
extending from the Mint on the left bank
across the square du Vert-Galant and the
distant Pont des Arts, along the flanks of the
Louvre, and up the *quais* or the Right Bank, to
the newly constructed department store
Samaritaine across the Pont Neuf. Pissarro
was to paint more than sixty canvases –
including his last self-portrait, from this
apartment in the years between 1900 and
1903, when he rented his final Parisian
apartment on the quai Voltaire just months
before his death in October of that year.

Historically, the *quartier* chosen by Pissarro
for his largest urban series was associated
almost completely with the rule of Henri IV,
whose nineteenth-century equestrian statue
had been placed in the square du Vert-Galant
because of its position next to a bridge and on
an axis with a royal square constructed in his
reign. Even the building in which the
Pissarros spent the winters of 1900–1, 1901–2,
and 1902–3 was constructed under the reign
of Henri IV as part of the development of the
place Dauphine, the first modern square in
Paris and the first urban development in the
city both controlled (and partially financed)
by the crown.[3] Its combination of a modern
bridge, a square with an equestrian statue of
Henri IV, and regularly conceived houses and
shops along its perimeter made it unique in
the architecturally chaotic and crowded
medieval capital. It also assumed its position
at the west end of the largest and most
historically important island in the Seine, and
the two buildings on the end of the place
Dauphine became the most prestigious
addresses in Paris. The northern of those two
buildings contained the apartment that
Pissarro rented nearly three hundred years
after its construction. The Seine rejoined at
this point, forming a splendid "grand canal"
from the vantage point of the apartment, and
the great stone bridge, the Pont Neuf, now the
oldest bridge in Paris, carried a never-ending
stream of traffic in front of the apartment.
Hence, Pissarro could experience both vista
and bustle at their urban best from his
windows.

The view from the north windows looked
across the Pont Neuf to a section of Paris that
had appealed to tourists and artists throughout
the nineteenth century. The row of shops and
towering, irregular houses on the Right Bank
just west of the bridge housed small shops that
sold pets, birds, and associated supplies, and
most tourists walk along this *quai* on their
ritual movements between the Louvre and
Notre-Dame cathedral. There were also small
studios and apartments in these buildings,
and, from one of these, both Renoir and
Monet had painted views looking north across
the Pont Neuf to the Ile de la Cité in 1872,
when they returned to Paris after the Franco-
Prussian War and the Commune (fig. 1).[4] No
Impressionist had revisited the site since that
date, and in choosing it Pissarro annexed into
his own "portrait" of Paris a section of the city
more completely associated with tourism than
almost any other comparable area.

All in all, thirteen canvases of the north
view survive. To these may be added
Pissarro's last self-portrait (fig. 2), in which

Fig. 2 Camille
Pissarro, *Self-Portrait*,
1903. © Tate Gallery,
London.

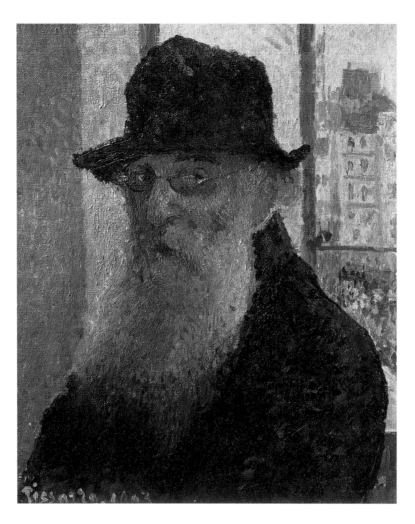

Fig. 3 (*below*) Camille
Pissarro, *Pont-Neuf,
Snow*, 1902. National
Museum of Wales,
Cardiff.

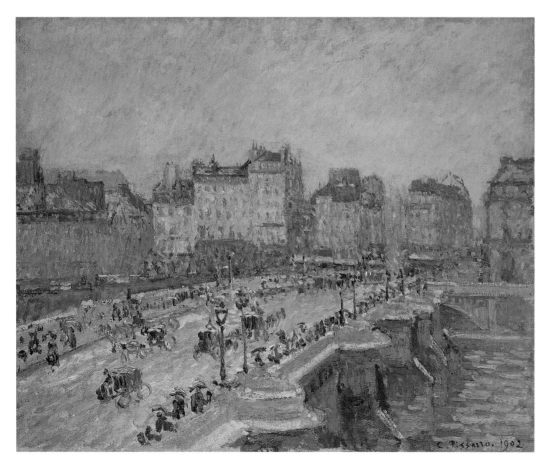

the elderly painter is seated in front of the very window from which this group of urban views was painted. (The buildings in the window are reversed from those in the painting because Pissarro was looking in a mirror when painting the self-portrait.) Of the thirteen, six were painted in the 1900–01 season and are dated 1901; another six were painted the next season and are dated 1902, and a single work is dated 1903, when the self-portrait was completed. The Sara Lee painting is among the second group of six, five of which are published in color in *The Impressionist in the City: Pissarro's Urban Series.*[5] Five of the six are horizontal canvases of three different sizes, and the Sara Lee painting, the second largest in scale, has an apparent "pair" in *The Pont-Neuf: Snow* in the National Museum of Wales, Cardiff. The largest painting of this group, also entitled *The Pont Neuf*, is now in the Hiroshima Museum of Art. Although the quality throughout this group is very high – often at the level of Pissarro's greatest urban series of the avenue de l'Opéra – there is no evidence that any of the thirteen canvases was either sold or exhibited in Pissarro's lifetime, and most did not make an appearance in any exhibition until after the Second World War. This is surely because Pissarro was known overwhelmingly as a painter of rural life, and his superb late paintings of Paris, Rouen, Le Havre, and Dieppe were not gathered and published until 1992–3, almost exactly one hundred years after Pissarro had started the urban series.

Interestingly, the Sara Lee *Pont Neuf* will recross the Atlantic for a final time when it joins the important permanent collection of the Musée des Beaux-Arts (Palais Saint-Pierre) in Lyon.

1. Pissarro detested this "mess" of international commercialism, and moved as far from it as he could. See Dallas (1992), p.147.
2. Dallas (1992), pp.103–4.
3. There is a superb discussion of Henri IV's urbanism in Orest Ranum, *Paris in the Age of Absolutism: An Essay*, New York: John Wiley, 1968, pp.72–5. Ranum also reproduces the Merion plan of Paris of 1615 in which the place Dauphine features prominently (pp. 6–7).
4. See Daniel Wildenstein, *Monet: catalogue raisonné*, Paris: Editions des Beaux-Arts, vol. II, p. 89, no. 193.
5. Dallas (1992), pp.147–57.

41 42

Auguste Renoir (1841–1919)
The Blacksmith (Le Forgeron [Le Feu]), 1916
Bronze, height: 28.5 cm. (11 in.)

The Laundress (La Blanchisseuse)
Height: 27.7 cm. (10⅞ in.)

Provenance: Private Collection, Canada;
Parke-Bernet Galleries, Inc. New York,
sale 25 January 1961; Nathan Cummings,
Chicago; The Sara Lee Collection; Museo
d'Arte de Ponce, Ponce, Puerto Rico

Exhibitions: Washington, D.C. 1970: no. 63
(*The Blacksmith*); no. 64 (*The Laundress*, as
Washerwoman); New York 1971: no. 63 (*The
Blacksmith*); no. 64 (*The Laundress*); Winston-
Salem 1990; Memphis 1991; Lakeland 1995;
Laren 1997–8.

Bibliography: Parke-Bernet Galleries,
Paintings, Drawings, modernist Sculptures
(sale cat.), New York: Parke-Bernet Galleries,
1961, p. 26, repr., lot 39.
Renoir: peintre et sculpteur (exh. cat.),
Marseilles, Musée Cantini, 1963, n. p., fig. 67.
Brettell 1986, 1987, 1990, 1993, 1997,
pp. 84–5, 167–8, repr.

In 1913 the art dealer, Ambroise Vollard hatched a plan that led to Renoir's late entry into the field of sculpture. We know from his own account that Renoir had been interested in sculpture from his earliest years and that, even before meeting his fellow Impressionists, he had frequented the sculpture galleries of the Louvre, "hardly knowing why . . . I stayed there for hours, day dreaming." He is also said to have made decorative sculpture for his great patrons, the Charpentiers, in 1875, but these do not survive in any form. Yet, in 1907, before arthritis began its slow progress in his hands, Renoir made his earliest surviving sculpture, a plaster relief bust of his youngest son, Coco, which was transformed into a bronze and set into the family fireplace.

Renoir had himself been the subject of a major bust sculpture by his friend Aristide Maillol in 1906, and he seems to have been esthetically invigorated by this process. In fact, it is clear that his work with Maillol lead him to classicize and idealize his own painted figures in the years following their meetings. Realizing that this connection between Maillol and Renoir was a deep one and that Renoir was becoming fascinated by sculpture, Vollard contrived to hire Renoir's Spanish studio assistant, Richard (Ricardo) Guino to work with Renoir on the production of his own sculpture in 1913. The *modus operandi* was as follows: Renoir met with Guino and selected a figure in one of his paintings to be "translated" into sculpture. Guino performed the translation at a small scale, after which Renoir worked with the young sculptor to reconfigure and improve the work. Guino then either enlarged or reworked the figure for Renoir's approval. Vollard paid Guino directly and was responsible for all costs involved in casting and for the size of the editions. Renoir approved the final results and profited from the sales.

Perhaps because of Guino's extensive involvement, art historians have long been squeamish about this late sculptural production, but they are surely wrong.[1] Renoir was fully engaged in the process and produced a distinguished small body of sculptural works first with Richard Guino and, subsequently, after 1918, with another assistant, Louis Morel from Cagnes, who worked on several relief sculptures with Renoir. All modern sculpture is a collaborative production and even the greatest sculptors, such as Rodin, Bourdelle, and Maillol, made extensive use of studio assistants and technical crews in the creation of bronze sculptures. Thus, the degree to which any bronze of the nineteenth or early twentieth century is "autograph" is limited. If one simply accepts the fact that Renoir found this aspect of his late work both pleasurable and interesting, it is possible to reconsider his three-dimensional oeuvre in new and exciting ways.

Renoir was scarcely alone as a "painter-sculptor" and was himself supremely aware of the sculpture of Daumier, Degas, Gauguin, and even Matisse and Picasso by the time that he took up the medium seriously in 1913. Interestingly, Renoir has deep affinities with Gauguin in that both artists made important contributions to what might be called "decorative" sculpture and recognized that sculpture plays an essential role in the modern "interior." *The Laundress* and *The Blacksmith* are examples of this hybrid sculptural type. Renoir conceived of them shortly after he had completed work with Guino in 1914 on a bronze clock with three figures, the most important cast of which is found today in the National Gallery of Ireland in Dublin. He then decided to try his hand at the other major type of nineteenth-century French decorative sculpture, a pair of fire dogs, and chose two figures, one male and the other female, one symbolizing fire and the other water, as the motifs for two extraordinarily successful decorative works that also function very well as independent table-top sculptures.[2] Interestingly, the first cast of one of the bronzes acquired by an American museum is the figure of *The Blacksmith*, which has been in the collection of the Los Angeles County Museum of Art since the early 1950s.[3]

These two bronzes will enter the permanent collection of the most distinguished art museum in the Caribbean, the Museo d'Arte de Ponce in Puerto Rico. Their manifold resonances with European tradition from Rubens through Boucher and Clodion to Maillol will be easily measured in a collection rich in Old Masters.

1. The only accessible and well-documented discussion of Renoir's sculpture is Barbara Ehrlich White's indispensable book, *Renoir: His Life, Art, and Letters*, New York: Abrams, 1984, pp. 261–80.
2. See Pierre Auguste Renoir, *Paintings, Drawings, Prints, and Sculpture*, Los Angeles County Museum of Art, 1955, p. 38.
3. Ibid., pp. 75–6.

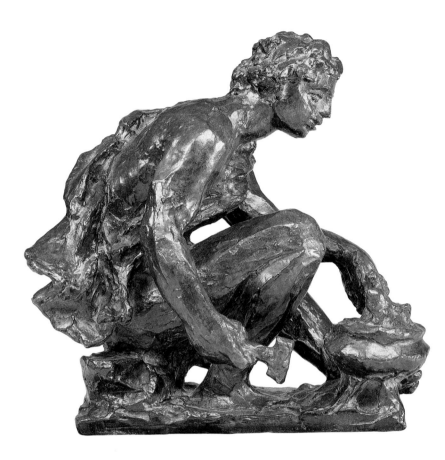
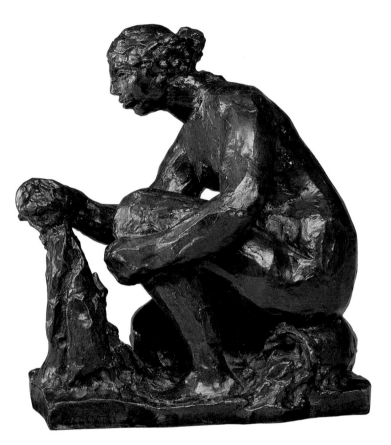

43

Georges Rouault (1871–1958)
The Circus (Le Cirque), 1936

Oil on canvas, 70.5 × 108.6 cm.
(27½ × 42½ in.)
Signed, center right: G. Rouault

Provenance: Ambroise Vollard, Paris; Mme.
Seifert, Paris; Galerie Charpentier, Paris;
Daniel Varenne, Paris; Nathan Cummings,
Chicago; The Sara Lee Collection; Musée des
Beaux-Arts, Montreal

Exhibitions: Paris, Galerie Charpentier,
Rouault: Peintures inconnus ou célèbres, 1965;
New London 1968; Washington, D.C. 1970:
no. 36; New York 1971: no. 36; Chicago 1973:
no. 33; Winston-Salem 1990; Memphis 1991;
Lakeland 1995; Laren 1997–8.

Bibliography: Brettell 1986, 1987, 1990, 1993,
1997, pp. 106-7, 168, repr.

Fig. 1 Henri de Toulouse-Lautrec, *At the Circus:
Work in the Ring*, 1899. The Art Institute of
Chicago. Gift of Mr. and Mrs. B.E. Bensinger.

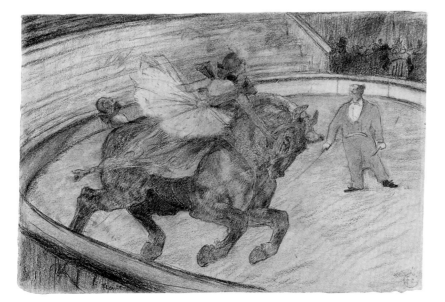

When the Museum of Modern Art in New
York mounted its first great exhibition of
paintings and prints by Georges Rouault in
1945, the war raged in Europe, and New
Yorkers flocked to see the majestic and
profoundly religious paintings and prints by
the French master.[1] Money and supplies were
at such a low level in 1945 that the museum
could not even produce a catalogue, and James
Thrall Soby's book on Rouault prepared in
conjunction with the exhibition did not
appear until 1947, when the war was over. It
was the first serious study of Rouault to
appear in English, superseding Lionello
Venturi's slight monograph of 1940.[2] Rouault
himself was still alive when the MoMA
exhibition took place, but was unable to make
the journey to New York, and he continued to
work on various artistic projects in Paris until
his death there in 1958 at the age of eighty-
seven.[3]

When the MoMA exhibition opened, this
wonderful painting, *The Circus*, was in a
private collection in France and was
unavailable for loan. It had been purchased in
1936 from Rouault himself by his greatest
dealer and friend, Ambroise Vollard, for
whom Rouault produced a magisterial body of
prints before the dealer's death in 1939. Oddly
– and perhaps because it was by then already
in the Nathan Cummings collection, it
remained unknown to the artist's daughter
Isabelle Rouault when she published a
summary catalogue of her father's painting in
1961, just five years after his death.[4]
Unfortunately, this catalogue has never been
superseded or updated, making it difficult to
study Rouault's remarkable painted oeuvre in
a detailed and well-documented manner.

All students of Rouault note his fascination
with popular performers and, most
particularly, with the circus. In this, he
descends in a direct line from the first great
popular artist of modern France, Honoré
Daumier, whose works Rouault used as a
touchstone of quality and humanity
throughout his life and to whom he is most
often compared. Rouault had made
watercolors of circus performers as early as
1902 and had drawn, painted, and printed
images of clowns, acrobats, and *commedia
dell'arte* figures, many of whom performed
with circuses, throughout the next five
decades. This series of works reached a climax
in 1938, when Vollard published a large
collection of etchings, printed drawings, and
woodcuts with a text by Rouault called *Cirque
de l'étoile filante* (Circus of the shooting star).[5]
Rouault is said to have worked from
childhood memories of the circuses that
performed in both fixed and portable
buildings in the northern section of Paris
where he was born. In this reliance on
memory, his circus becomes a mythic rite,
whose performers are as hieratic as the
attendants in an Egyptian funerary ritual or
the celebrants of Mass. Gone are the smells,
the straining muscles, the graceful leaps, and
the whirling motion that had been the staple
of circus imagery in French art for more than
a century. The circuses of Toulouse-Lautrec
occupied that artist in his last years and
constitute the last great sequence of circus
images in French art before Rouault. Yet,
while the circus was a source of endless
movement and diversion for the alcoholic
aristocrat, the working-class Rouault annexed
the circus to the church, creating by the jewel-
like colors and deep black lines an image that
has more to do with medieval enamels and
stained glass than it does with the tawdry
mechanics of the actual circus.

The Sara Lee *Circus* is among the very few
canvases by Rouault that actually represent
the circus as a spectacle. Rouault preferred to
isolate the circus performers from their public
activities and to represent them as judges of
humanity. Hence his clowns, pierrots,
acrobats, jugglers, musclemen, and horse
ballerinas are given their own pictorial arenas
in the vast majority of prints and paintings
that represent the circus. Yet, in four
paintings, of which the Sara Lee *Circus* is the
largest by far, Rouault shows groups of
performers together in the act either of
performance or of preparation for the
performance (figs. 2 and 3).[6] Although the
Sara Lee canvas is published as a work of 1936
and the other three are somewhat later, it

Figs. 2 and 3 Georges Rouault, two illustrations from "Cirque de l'étoile filante," 1938. © ADAGP, Paris and DACS, London 1999.

must be remembered that Rouault had a habit of working on his canvases – and the sequences of prints to which they are almost always related – over very long periods of time, and it was not uncommon for him to keep a single work in the studio for more than a decade, working on it gradually to attain the luminosity of hue and the moral grandeur that he sought.

It is known from various witness accounts and from the wonderfully evocative prose of his most serious student, Pierre Courthion, that Rouault allowed no one into his studio, which was a private realm in which the painter lived with his work.[7] Courthion tells us that Rouault worked on a table rather than an easel, and this is easily verifiable simply by looking at the crusty surfaces of his paintings. Often, the paint in works by Rouault is so thick and so multilayered that, if the canvas had been painted vertically, the paint would have drooped under its sheer weight. Instead, Rouault worked flat, allowing the paint to dry thoroughly in layer upon layer and scumbled over-layers onto textured bases of pure color, to create an interplay of color that has real precedent only in the scumbled surfaces of Monet. Yet, if, for the older Impressionist, color was actually a manifestation of natural light, Rouault's color has its roots in stained glass, enamels, and jewelry. Hence, his paintings glow not with the light of day, but with the holy light of the imagination.

The Circus will enter the permanent collection of the Musée des Beaux-Arts in Montreal, the city in which Nathan Cummings spent his youth and young adulthood and where members of family still live.

1. For a checklist of the exhibition, see James Thrall Soby, *Georges Rouault: Paintings and Prints*, New York, 1947.
2. The great art historian Lionello Venturi had actually approached Rouault, requesting permission to prepare a serious monographic on his work after seeing a Rouault exhibition in 1938. The book appeared in English in 1940, published by Weyhe, New York. Venturi was well equipped for the task, having completed the catalogues raisonnés for Cézanne and Pissarro in 1936 and 1939 respectively.
3. The most thorough and accurate biography of Rouault was prepared by Pierre Courthion and published in English in 1961, *Georges Rouault*, New York: Abrams, 1961.
4. The catalogue is contained as an appendix to Courthion (1961), pp. 401–71. It does not contain sequential numbering and has many discrepancies and mistakes that come from hasty editing.
5. Georges Rouault, *Cirque de l'étoile filante*, Paris: Ambroise Vollard, 1938. It contains seventeen color etchings printed by Roger Lecourriere, eighty-two drawings by Rouault engraved by G. Aubert, and seventeen small prints by Rouault himself. The short text was also composed by Rouault.
6. The other three are CC 312, 72.39 × 53.3 cm. (Vollard to Gottlieb Collection, New York), CC445, 59 × 45 cm. (Vollard, p.c. Paris), and CC 460, 67.9 × 52 cm. (Vollard, p.c. New York). I give the dimensions here with the suggestion that numbers CC 312 and CC 460 might even have been intended to function as vertical pendants to the Sara Lee *Circus* (figs. 2 and 3).
7. See Courthion (1961), pp. 11–13.

44

Georges Rouault (1871–1958)
Pierrot, completed by 1938

Oil on canvas, 89.5 × 62.3 cm. (35 × 24¼ in.)
Signed lower right: G. Rouault
Courthion 293

Provenance: Ambroise Vollard, Paris; De
Gallea, Paris; Nathan Cummings, New York;
Mrs. Robert B. Mayer with her son Robert N.
Mayer and her daughter Ruth M. Durchslag;
The Sara Lee Collection; The Museum of Fine
Arts, Boston

Exhibitions: San Francisco 1953; Toronto
1955: no. 21; Paris 1956: no. 21; St. John,
Canada, New Brunswick Museum, 22
April–21 May 1958; Minneapolis 1965;
Davenport 1965; Paris, American Embassy,
Art in Embassies (organized by the Museum
of Modern Art, New York), 1968; New
London 1968; Paris, Palais Galliéra,
September 1969; Washington, D.C. 1970: no.
35; New York 1971: no. 35; Chicago 1973: no.
35; Winston-Salem 1990; Memphis 1991;
Lakeland 1995; Laren 1997–8

Bibliography: Pierre Courthion, *Georges
Rouault*, New York: Harry N. Abrams, 1961,
pp. 432, 467, no. 293, repr.
Consolidated Foods Corporation, *Consolidated
Foods Corporations' Nathan Cummings
Collection*, Chicago: Consolidated Foods
Corporation, 1983, p. 11, fig. 5.
Brettell 1986, 1987, 1990, 1993, 1997, pp. 108-
9, 168, repr.

Fig. 2 Georges Rouault, *Clown*, 1920. Stedelijk
Museum, Amsterdam. © ADAGP, Paris and
DACS, London 1999.

In the summer of 1937 the Petit Palais in
Paris opened an exhibition called *Maîtres de
l'art indépendant*, in which forty-two paintings
by Georges Rouault were included in a mini-
retrospective of his painting since 1905.
Although Rouault was scarcely unknown in
that year, it was the first time that his work
was shown in impressive quantity in his
native city. His exhibitions in Chicago, New
York, Munich, Brussels, and other cities had
ensured him an international reputation, but
the Parisian audiences had not yet had a
chance to see the extraordinary achievement
of Rouault as a painter. The reviews of the
exhibition were overwhelmingly positive, and
it seems likely that even Rouault was pleased
by the generally favorable criticism, because
he signed and, thus, completed, an
unprecedented number of canvases in late
1937 and throughout 1938, including the
powerful *Pierrot* of Sara Lee Corporation.

What little is known about Rouault's
working method makes it clear that he
continued to make changes and adjustments
to paintings over many years, and certain of
his canvases betray their lengthy gestation
period by the sheer thickness of their *facture*.
Because Rouault was uninterested in fashion,
he also elected not to date the paintings,
allowing them to stand as works that exist
outside of contemporary time. In this, his
work can be contrasted to that of Picasso,
Braque, Léger, and others who give the date
of a work of art – even to the day – on the
canvas. This *Pierrot* is one of more than
twenty paintings from 1937 and 1938 that are
included in the catalogue raisonné prepared
by Rouault's daughter in 1961.[1] There are, in
effect, more painted representations of Pierrot
completed in those two years than in the
nearly four decades of an active career that
preceded them. Surely, it was the sense of
critical acceptance and of the professional self-
confidence that so often accompanies this that
lead Rouault in his late sixties to allow a large
number of canvases to leave his private studio
and to enter the art market.

All of Rouault's Pierrots, like all actual
pierrots, are virtually identical. Each man (or
woman) who donned the ancient white
costume of the *commedia dell'arte* clown
literally became pierrot, losing his or her own
identity as the costume and make-up were
applied. For that reason, every individual
becomes pierrot while in costume. This,
together with other guises and entertainment
uniforms, fascinated Rouault throughout his
working life. The reasons for this are obvious.
Rouault's letters, critical prose, and interviews
make it clear that, far from being a naïve or

self-absorbed artist, he was absolutely
knowledgeable about the history of art, and no
modern Frenchman was unfamiliar with
Antoine Watteau's great full-length *Pierrot* in
the Louvre (fig. 1). This work had affected
French artists from Courbet and Manet to
Rouault and Braque, and there is little doubt
that each time Rouault began to work on a
Pierrot, he did so with the Watteau Pierrot
very close to the front of his mind.

Fig. 1 Jean-Antoine Watteau, *Pierrot*. Louvre,
Paris. Photo © RMN.

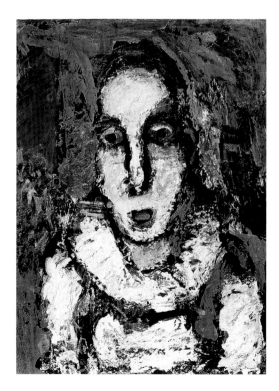

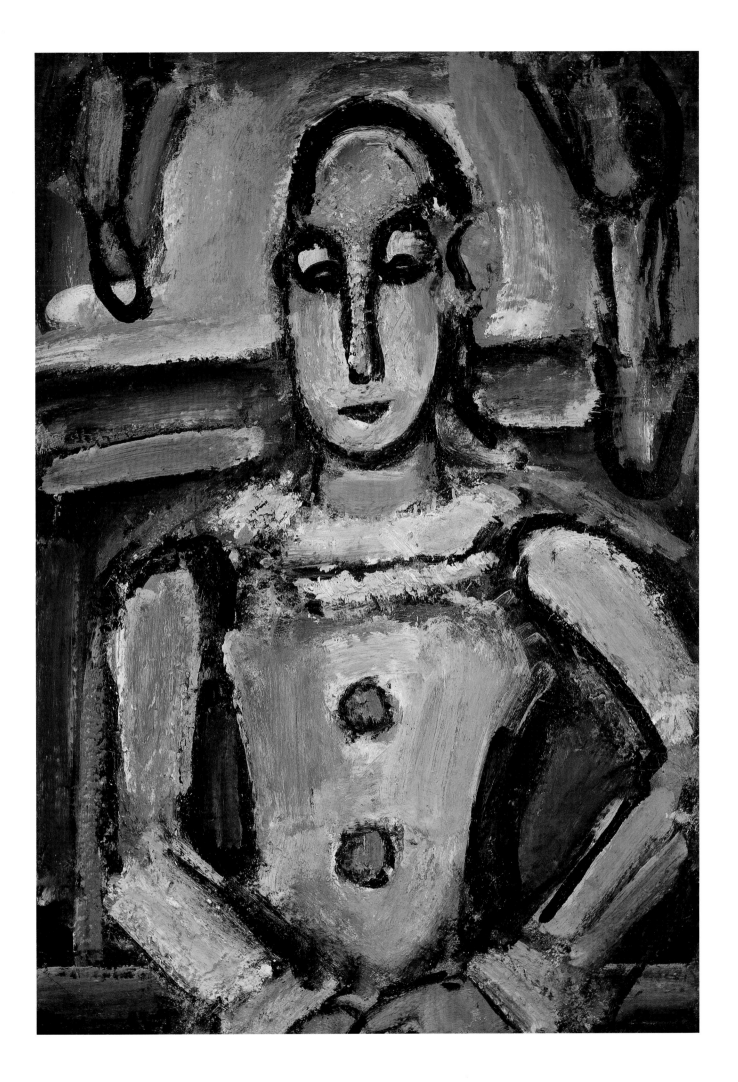

The earliest published representation of Pierrot by Rouault is a large oval gouache painting of 1911. Almost a decade later in 1920, he completed and signed a major oil painting of the clown, even larger than the Sara Lee *Pierrot*, now in the Stedelijk Museum in Amsterdam (fig. 2), and, from this monumental *Pierrot*, one must wait until 1937 and 1938 for a flood of representations – small, medium, and large formats – to appear. Most of these were immediately purchased by Rouault's greatest dealer, Ambroise Vollard, who encouraged the artist to complete – or sign – as many canvases as he could. Yet, even after the 1937 Petit Palais exhibition, Rouault still held works of art back, and after Vollard's death in 1939 Rouault was forced to sue his heirs to retrieve unsigned, and hence unfinished, works that were in the dealer's possession at his death. Nearly four hundred works were returned to Rouault, who reportedly destroyed 315 canvases in 1948 by burning them. Among these were undoubtedly other Pierrots.

To be judged by a clown – that is what Rouault asks of his viewers. The Pierrot he creates to judge us is an oval-faced, sweet, genderless, and apparently guileless youth who receives our gaze with utter passivity. He does so in an array of colors that have, themselves, provoked a good deal too much purple prose in vain attempts to evoke them. The standard allusions to stained glass (Rouault had not yet visited Chartres, though he knew La Saint Chapelle), Limoges enamels, and Cézanne are inadequate. And we are left, after reading the scant prose about Rouault's "Pierrots," with a devotional object that transforms us from the judged into the worshipper, forcing us, in so doing, to worship a clown.

There is no better short evocation of the Rouault who created this wondrous and morally uplifting *Pierrot* than the first sentences from James Thrall Soby's essay on Rouault written in 1945 and published in 1947:

> Georges Rouault: a solitary figure in an era of group manifestos and shared directions; a devout Catholic and devotional painter in a period when artists have more often run the gamut of anti-religious feeling, from indifference to irreverence; a painter of sin and redemption in the face of prevailing estheticism and counter-estheticism; an artist with a limited vision of unlimited ferocity in contrast to many other painters who have scanned and pivoted but seldom stared fixedly for long; a man who opposed

Matisse's peaceful wish that art should evoke "the same sensation as a good armchair" by making his own painting resemble a seat of moral judgment.[2]

In this superb incantation, Soby was wrong only in the last phrase. For Rouault, painting was not a seat of moral judgment. Indeed, it was the reverse. By representing a simple pierrot in the glorious raiment of color, Rouault reversed the act of judgment, allowing the viewer to worship a man dressed as a clown and transformed by our gaze into a benign and calming God. There is ferocity in Rouault's lines and colors, in his relentlessly self-improving layers of paint, but, if he is the only modern painter to make important devotional images, he does so in a way that evokes the *bon dieu* of Chartres.

Rouault's *Pierrot* will join the permanent collection of the Museum of Fine Arts, Boston. This, one of the world's greatest art museums, is oddly weak in twentieth-century European modernism. The Sara Lee Rouault will be the first major painting by the Parisian artist to enter its permanent collection. The gift was made as part of the museum's own Millennium Campaign to attract one hundred major works from the twentieth century to its collection.

1. Pierre Courthion with Isabelle Rouault, *Rouault*, New York: Harry N. Abrams, 1961.
2. James Thrall Soby, *Rouault*, New York: Museum of Modern Art, 1947, p. 5.

45

Alfred Sisley (1839–1899)
Saint-Mammès – Morning (*Saint-Mammès – le matin*), 1880 or later

Oil on canvas, 65 × 92 cm. (25 × 34½ in.)
Signed lower right: Sisley
Daulte 369

Provenance: Durand-Ruel, Paris (bought from Sisley 31 July 1891); M. Boussod, Valadon et Cie., Paris; Colonel Henry B. Wilson, New York; Mrs. Winifred C. Bowman, New York; Parke-Bernet New York, sale of 8 April 1953; French and Co., New York; Nathan Cummings, Chicago; The Sara Lee Collection; Los Angeles County Museum of Art

Exhibitions: Paris, Galerie Georges Petit, *Exposition A. Sisley*, February 1897: no. 51; Washington, D.C., on loan to President Dwight D. Eisenhower, 1953; Montreal Museum of Fine Arts, November 1955; St. John, Canada, New Brunswick Museum, 24 April–31 May 1958; South Carolina, Columbia Museum of Art, *Impressionism: An Exhibition Commemorative of the Tenth Anniversary of the Columbia Museum of Art*, 3 April–8 May 1960: no. 28; New York, Paul Rosenberg and Company, *Loan Exhibition of Paintings by Alfred Sisley*, 30 October–25 November 1961: no. 15; Minneapolis 1965; New York, Wildenstein & Co., *Sisley*, 27 October –3 December 1966: no. 41; New London 1968; Art Institute of Chicago, *Masterpieces from Private Collections in Chicago*, 12 July–31 August 1969; Chicago 1973: no. 16 (as *St. Mannes* [*sic.*], *Morning*); Winston-Salem 1990: Memphis 1991; Laren 1997–8; Laurel, Mississippi, Lauren Rogers Museum of Art, *The French Legacy*, 1 May–6 September 1998.

Bibliography: François Daulte, *Alfred Sisley: catalogue raisonné de l'oeuvre peint*, Paris: Editions Durand-Ruel, 1959, no. 369. Raymond Cogniat, *Sisley*, trans. Alice Sachs, New York: Crown Publishers, 1978, p. 48. Brettell 1986, 1987, 1990, 1993, 1997, pp. 44–5, 169, repr.

Fig. 1 John Constable, *Boat Building near Flatford Mill*, 1815. Victoria and Albert Museum, London. Photo V&A Picture Library.

Impressionism is associated with the city of Paris and with the string of western and northwestern suburban towns where the Impressionists summered. Names such as Argenteuil, Bougival, Louveciennes, Marly-le-Roi, Reuil, Pontoise, and Auvers are associated completely with the movement during its heroic decade in the 1870s. Alfred Sisley, the Anglo-French master of Impressionism, remained faithful to this collective landscape until 1880, when he moved to the small village of Veneux-les-Sablons near the old walled town of Moret and the forest of Fontainebleau, and he remained in the same landscape until his death in 1899.[1] In this landscape he extended and refined Impressionism in a personal and lyrical manner, refusing to be drawn into the elaborate esthetic arguments of Paris and attending the Impressionist dinners less and less frequently in the city. By 1890 his health had deteriorated, and the last ten years of his life were spent in relative obscurity as he watched his friends Monet, Renoir, Cézanne, and Pissarro become independently wealthy and even famous.

Yet none of this depressing disintegration of a brilliant career is evident in *Saint-Mammès–Morning*, a large, confident and beautifully painted landscape that is among the principal works of Sisley's career in the first half of the 1880s. It was a short walk from Sisley's house in Veneux-les-Sablons to his motif in Saint-Mammès. He walked first through the fields, probably following the railroad tracks, crossed the railroad bridge, and continued up the Loing river until it met the larger Seine in the bustling town of Saint-Mammès. This town was well known for its boatbuilders and woodworkers, and Sisley set up his easel several times in 1880 at a respectful distance from this intensely traditional activity. In doing this, he was following his own instincts as a painter and

thus acting in a manner very different from his friends Monet and Renoir. These two painters were all but obsessed with the "modern" subject of suburban leisure, and almost completely ignored the "traditional" activities of the river – its dredgers, boat builders, lock maintainers, bargemen, and laundresses – so loved by Sisley. In this, we feel Sisley's "Englishness" and his familiarity with the boat builders and river workers of Constable (fig. 1), Old Crome, and Girtin. Yet, Sisley painted these traditional laborers in a style that was completely "modern" and, thus, completely urban.

Sisley seems to have experienced a form of liberation as a result of his self-imposed exile from the landscape of the other Impressionists. Once he arrived in what Gustave Geoffroy called "his own country," he worked with a ferocious energy, completing nearly three hundred paintings between 1880 and 1885. Of these, only about a quarter are dated, making it difficult to discuss his development clearly. In certain ways, it can be said that Sisley produced rather than developed in these five years, and, in this way, the period can be compared with Monet's first five years in Argenteuil or to Matisse's work in the Nice in the five years following the end of the First World War. In each case the artist felt able to paint easily, one might say naturally, without too much self-doubt and difficulty. It is, perhaps, for that reason that Sisley's painting from the early 1880s has not received the same probing analysis that has been lavished on his oeuvre from the previous two decades. Indeed, with the exception of Gustave Geoffroy and Richard Shone, most writers and exhibition curators underplay this period.

There is one kind of hierarchy in Sisley's production that seems to have eluded all his commentators – the varying sizes of his canvases. Although it would be a mistake to say that size is equivalent to quality, it is true to say that size is equivalent to ambition, and for Sisley the largest canvases he tackled in these – or any – years were either 65 × 92 cm. or 73 × 92 cm. Among the 282 works by Sisley from 1880 to 1885, only eleven are this size, and, of these, only four are dated. *Saint-Mammès–Morning* is one of these ambitious landscapes, and when it enters the permanent collection of the Los Angeles County Museum of Art it will add one to the list of only three of these eleven important works in public collections. When was this canvas painted? The literature is generally fairly consistent in accepting the date of 1880. This is the date adopted by François Daulte in his catalogue

raisonné, and, from the adjacent entries, it is possible to decode his reasoning. Another similar painting, of a smaller dimension, called *Footpath at Saint-Mammès* (private collection, Paris), is signed and dated 1880 and was purchased from Sisley by Durand-Ruel in September of that year. Given the fact that it is almost identical in point of view and also represents a foreground with strewn logs and a similarly positioned boat near the same tree, it seems likely that all five images of this scene (Daulte 368–72) were at the very least begun in the summer of 1880, Sisley's first in this landscape.

Interestingly, the Sara Lee Sisley has an identical composition to and is exactly the same size as yet another Sisley landscape of 1880, also called *Footpath at Saint-Mammès*. It is tempting to interpret these works as a pair, particularly since the Sara Lee painting is given the sub-title "morning," which could easily be paired with an "afternoon" effect. There is, however, no evidence that the two works were ever exhibited together, and there is no published color photograph of the second picture that would make it possible to speculate about the effects of light in each work. The Sara Lee work made its first recorded appearance in an 1897 exhibition devoted to Sisley's work at the Galerie Georges Petit in Paris, while its "pair" made its debut after the artist's death in the Sisley retrospective held at the rival Durand-Ruel Gallery in 1902. How we wish that the "pair"

were among the twenty-seven landscapes by Sisley sent by Durand-Ruel to the Impressionist Exhibition of 1882, but the dealer bought *Saint-Mammès–Morning* from Sisley in 1891, so this is also impossible. Neither of the landscapes was included in the large Sisley exhibitions held by Durand-Ruel in 1883 (seventy paintings) and 1889 (twenty-eight paintings) or at Boussod et Valadon in 1893. Why, if Sisley painted eleven exhibition-size paintings in the first half of the 1880s, did he fail to exhibit any but one of them in his lifetime?

Whatever its fate in Sisley's lifetime, *Saint-Mammès–Morning* is among the most beautifully painted and magisterial landscapes of Sisley's career. An unbiased modern assessment of his oeuvre of the early 1880s would put this work near the top, and, with *La Croix Blanche at Saint-Mammès* (fig. 2), it is the best of the eleven big pictures from those years.

1. For a summary discussion of this period, see Sylvie Patin's essay "Veneux-Nadon and Moret-sur-Loing, 1880–1899," in MaryAnne Stevens, et al., *Alfred Sisley*, New Haven and London: Yale University Press, 1992, pp. 182–7.

Fig. 2 Alfred Sisley, *La Croix Blanche at Saint-Mammès*, 1884. Museum of Fine Arts, Boston, Juliana Cheney Edwards Collection.

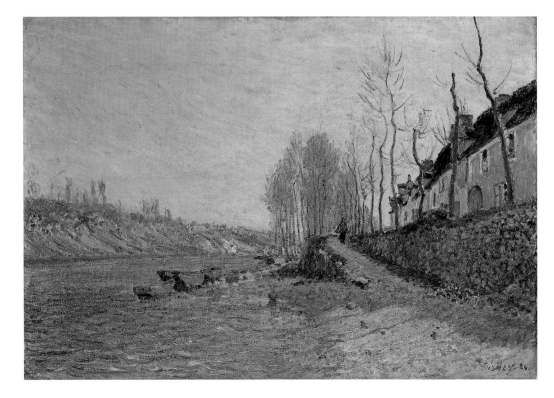

46

Alfred Sisley (1839–1899)
A Path at Les Sablons (*Un sentier aux Sablons*),
1883

Oil on canvas, 46 × 55 cm. (18¼ × 22 in.)
Signed lower right: Sisley
Daulte 492

Provenance: Lucienne Fribourg, New York
and Paris; Parke-Bernet, New York; Justin K.
Thannhauser, Munich and New York; Nathan
Cummings, New York; Christie's, New York,
sale of 15 May 1990; The Sara Lee Collection;
The National Gallery of Australia, Canberra

Exhibitions: New York Wildenstein & Co.,
Sisley, 27 October–3 December 1966: no. 49;
Winston-Salem 1990; Memphis 1991;
Lakeland 1995.

Bibliography: François Daulte: *Alfred Sisley:
catalogue raisonné de l'oeuvre peint*, Paris:
Editions Durand-Ruel, 1959, no. 492, repr.
Brettell 1990, 1993, pp. 112–13, 149–50, repr.

Fig. 1 Alfred Sisley, *Path at Les Sablons*. Louvre,
Paris. Photo © RMN.

This small canvas represents an utterly stable and traditional landscape of farms but is painted in a manner that can only be described as nervous and emotionally charged. Leaves are trembling in the wind, and clouds scud across its sky. Every corner of this canvas quivers with energy, and thus the painting has a scattered, unsettled quality that seems at odds with its traditionally pleasant subject. It is almost as if Millet had awakened from the grave, surveyed the situation in 1880s France, and painted his usual subject in the sway of the uncertainty and doubt that filled nearby Paris.

Sisley was painting so well and so easily in the early 1880s that his work can be read as a direct transcription of his emotions, and, if we can accept the date of 1883 given to this painting by François Daulte on the basis of a drawing in the Louvre notebook (fig. 1), we can do something about interpreting Sisley's state of mind. Sisley had been given the first large retrospective of his work at the Durand-Ruel Gallery in June of that year. Even Monet was worried about its timing and about the dealer's strategies for Sisley, fretting in a letter to Pissarro about the fact that the June weather in Paris was so good that no one was going to any exhibitions. Then, immediately following the exhibition, Sisley fell ill for more than a month, and was barely able to carry his canvases to Durand-Ruel unaided. It is also clear that the exhibition did not produce the desired sales and that Durand-Ruel sent Sisley only small amounts of money in the months following its closing on 25 June 1883. All of this seems to have forced Sisley from his small house in Moret-sur-Loing to a cheaper house in nearby Veneux-les-Sablons in the autumn of 1883, and there is little doubt that this painting – with its hint of autumn in the yellow-greens and with its wind – was painted shortly after Sisley's move.

A Path at Les Sablons is small enough and was quickly enough painted to be counted as an actual "impression." It is interesting, however, that Sisley tended to work out his compositions first in drawings, which he carefully numbered in a notebook now kept at the Louvre. It seems from this practice that Sisley wanted to know precisely how to organize his composition before even beginning to paint, thus freeing himself from making compositional decisions while he worked and enabling him to respond to the chromatic and gestural qualities of a motif with real immediacy. For that reason, many of the canvases from the early 1880s have almost the quality of "automatic paintings," paintings, that is, done with great rapidity while directly under the stimulating influence of the motif. It is perhaps no accident that the very best and most succinct account of the Impressionist manner of painting landscape was written by the Parisian poet Jules Laforges, in the same year that Sisley painted this landscape, and it bears quoting as one assesses the operations of the Anglo-French artist's sensibilities *en face du motif*.

This Sisley will be the first truly Impressionist landscape to enter the permanent collection of the National Gallery of Australia. Known for its superb collection of Australian painting and for its twentieth-century European and American paintings and sculpture, the museum has a very small group of easel paintings made before 1900. Together with a major late Monet, this vivacious painting by Sisley will represent the full range of Impressionist landscape practice in a succinct manner.

47

Chaim Soutine (1893–1943)
View of Céret (*Vue de Céret*), 1919–20

Oil on canvas, 54 × 73 cm. (20½ × 28¼ in.)
Signed, lower right: Soutine
Tuchman-Dunow-Perls, vol. I, 69

Provenance: Albert C. Barnes, Merion, Pennsylvania, from 1922 (?); Carstairs Gallery, New York; Kunstmuseum, Lucerne; Glenway Wescott, New York; Perls Galleries, New York; Jacob Rosenberg, New York; La Comtesse d'Escayrac, New York, Geneva; Parke-Bernet, New York, sale of 6 April 1967, lot 47; Nathan Cummings, Chicago; The Sara Lee Collection; The Cincinnati Art Museum

Exhibitions: New York, Museum of Modern Art, *Soutine*, 31 October 1950–7 January 1951; Cleveland Museum of Art, 30 January–18 March 1951; New York, The Perls Galleries, *The Perls Galleries Collection of Modern French Painting*, no. 7, 26 February–24 March 1951; no. 177; 26 March–21 April 1951; Los Angeles County Museum of Art, *Chaim Soutine, 1893–1943*, 20 February–14 April 1968: no. 12; Jerusalem, The Israel Museum, *Soutine*, organized in cooperation with the Los Angeles County Museum (50 works), Summer 1968; Washington, D.C. 1970: no. 58; New York 1971; Chicago 1973: no. 37; New York, The Jewish Museum, *Jewish Experience in the Art of the Twentieth Century*, 16 October 1975–25 January 1976: no. 231; Münster, Landesmuseum der Provinz Westfalen für Kunst und Kultergeschichte, *Chaim Soutine, 1893–1943*, 13 December 1981–28 February 1982; Kunsthalle Tübingen, 26 March–31 May 1982; London, Hayward Gallery, 17 July–22 August 1982; and Kunstmuseum Luzern, 31 August–31 October 1982; Winston-Salem 1990; Memphis 1991; Tokyo, Odakyu Grand Gallery, *Chaim Soutine Centenary Exhibition*, 18 November–7 December 1992; Nara Sogo Museum of Art, 27 January–28 February 1993; Ibaraki, Kasama Nichido Museum of Art, 5 March–4 April 1993; and Hokkaido Museum of Modern Art, 10 April–16 May 1993; Lakeland 1995; Laren 1997–8; New York, The Jewish Museum, *An Expressionist in Paris: The Paintings of Chaim Soutine*, 26 April–16 August 1998; Los Angeles County Museum of Art, 27 September 1998–3 January 1999; and Cincinnati Art Museum, 14 February–2 May 1999: no 10.

Bibliography: Paolo D'Ancona, *Some Aspects of Expressionism: Modigliani, Chagall, Soutine, Pascin*, Milan: Edizione del Milione, 1957, p. 60.
Marcellin Castaing and Jean Leymarie, *Soutine*, Paris: La Bibliothèque des Arts, 1963; New York: Harry N. Abrams, 1963, p. 22.
"Triumph of the Clumsiest," *Time* (New York), vol. XCI, no. 8, (23 February 1968), p. 65, repr.
Henry J. Seldis, "Chaim Soutine Exhibition at County Museum," *Los Angeles Times*, (3 March 1968), p. 42, repr.
Alfred Frankenstein, "The Phenomenon of Soutine," *San Francisco Sunday Examiner and Chronicle*, (10 March 1968), p. 26, repr.
Hilton Kramer, "Soutine and the Problem of Expressionism," *Artforum* (New York), vol. VI, no. 10 (Summer 1968), p. 25, repr.
M.C., "Chaim Soutine," *Israel Magazine* (Philadelphia), I, no. 6 (1968), p. 70, repr.
Pierre Courthion, *Soutine: peintre du déchirant* Lausanne: Edita, 1972, p. 187 (A), repr.
Raymond Cogniat, *Soutine*, Paris: Flammarion, 1973; New York: Crown Publishers, 1973, p. 14, repr.
Alfred Werner, *Chaim Soutine*, New York: Harry N. Abrams, p. 15, fig. 6.
Brettell 1986, 1987, 1990, 1993, 1997, pp. 88–9, 170, repr.
Maurice Tuchman, Esti Dunow, Klaus Perls, *Chaim Soutine (1893–1943): Catalogue Raisonné*, vol. I, Cologne: Benedikt Taschen Verlag, 1993, no. 69, pp. 184–5.

Fig. 1 Maurice Tuchman, photograph of Céret.

When the great American collector Albert Barnes was in Paris in 1922, he heard about a then unknown artist called Soutine from his friend the critic Paul Guillaume. Barnes visited Soutine's patron-dealer, the Polish émigré poet Leopold Zborowski, reputedly saw one small Soutine canvas in a corner, met the painter, and spent two days surrounded by Soutine's extraordinarily powerful painterly constructions, purchasing fifty-two works for his collection.[1] All of those works were from the group of about two hundred that Soutine had made in the Franco-Spanish mountain town of Céret, where he had lived between 1919 and 1921, far from the distractions of Paris.[2] Soutine himself seems to have later turned against these paintings and is said to have destroyed most of them, buying back works already sold and exchanging recent works with collectors who had already purchased Céret paintings (Soutine called them "Cérets"), before destroying as many as he could.[3] Fortunately for the history of modern art, most of the works purchased by Barnes escaped the destructive furor of their creator, largely because they were in the United States. Barnes himself seems to have lost his initial enthusiasm for his "discovery," becoming increasingly ambivalent about Soutine's works.[4] Although he kept a wonderful group of paintings that remain in the Barnes Foundation to this day, he found that Soutine's work did not continue to resonate as did the paintings of Renoir, Cézanne, Matisse, and Picasso, and he sold the majority of the works in 1924 and 1925. The Sara Lee *View of Céret* is perhaps one of those works.[5]

Because of its extraordinary provenance and its quality, this *View of Céret* has been included in every major American exhibition devoted to Soutine since the artist's death in 1943. The first, Monroe Wheeler's monographic exhibition at the Museum of Modern Art, opened in 1950, just as the young Abstract Expressionists were beginning to dominate American painting. America's greatest twentieth-century art historian, Meyer Shapiro, listed it among the most important exhibitions of the twentieth century in America, and he was surely correct.[6] Yet, if the Abstract Expressionists had begun to wane in the early 1960s, so too Soutine, who was next championed as a Jewish artist (rather than a modern artist) in Maurice Tuchman's retrospective of 1968 at the Los Angeles County Museum. This project propelled Tuchman to undertake an important catalogue raisonné project, which was published in 1993. If there were eighteen

years between the MoMA and the LACMA exhibitions, an even longer period was necessary for Soutine to become, once again, a "neglected" modernist, prompting the Jewish Museum in New York to mount the self-reflexive study of 1998 devoted less to Soutine's career than to his reputation.

Always an outsider, Chaim Soutine was born into the often violent, but closely knit shtetl culture in what is now Lithuania (the arguments over whether to call him a Lithuanian Jew or a Russian Jew are almost comic). Tuchman, the first critic to deal both fully and sympathetically with Soutine's "Jewishness," tells us that he came from the very bottom rungs of shtetl culture, a social ladder of almost baroque complexity.[7] Yet, after a life that included frequent beatings by family members and others, Soutine managed to rise quickly from this realm and to attend art school in Minsk and Vilna, before moving to Paris in July of 1913, never to leave France, where he died while on the run from the Nazis thirty years later. Soutine's reputation was slow to rise, and his oeuvre has never been canonized like that of Picasso, Braque, Gris, or Matisse. In some ways, he continues to occupy a place in the history of Jewish modernism — this, in spite of all Soutine's efforts to deal completely with the visual world and to include, whenever possible, images of Christian piety in his oeuvre.[8]

After living the life of an outsider in a city filled with other outsider artists (his friends were Polish, Spanish, Italian, Russian, and French), Soutine began to wander throughout France in search of paintable landscapes. His first search was undertaken in 1918 and resulted, the next year, in his discovery of Céret, a traditional mountain village in the Pyrenees. Although he returned with some regularity to Paris in 1919–21, Soutine spent the majority of those three years in this village, and his representations of it took his art to another level of expressive rage. As his first great patron, Albert Barnes, put it in 1925: "No contemporary painter has achieved an individual plastic form of more originality and power than Soutine." He based these assertions on the group of works he himself owned, all of which were painted in Céret.

Maurice Tuchman was the first of many writers about Soutine's work in Céret to attempt a chronological structure.[9] This proposal, while laudable, is based sheerly on pictorial evidence alone, because Soutine himself failed to date the works and brought them to Paris in 1922 together with a smaller group of works made in Cagnes. Tuchman is surely correct in treating the Sara Lee

painting as an almost classical work amidst the writhing contours and tortured surfaces of other works from Céret. He places it in the early-middle of Soutine's Céret period, proposing a progression away from grounded landscapes in which the viewer can "place" himself, to convulsive compositions that leave no space for the viewer and seem to expand outward from the pictorial surface into the viewer space, like relief sculpture.

Following a method begun by John Rewald and Leopold Reidemeister in their studies of Cézanne and Impressionism, Tuchman, in the catalogue of the 1968 exhibition, juxtaposes a black and white reproduction of the Sara Lee painting with a photograph made by him (Tuchman) of the actual motif painted by Soutine (fig. 1). He then analyses the differences between the two images in a way that is, like that of his predecessors, untenable. In order to photograph the buildings painted by Soutine, Tuchman was forced to cross a small valley so as to get them into the "field of vision" of his camera. He then supposes that Soutine had to be in the same position. It seems just as likely, from looking at the painting, that Soutine was actually positioned down hill from the houses and was translating onto his canvas the vertiginous feeling of looking up. Soutine did not work with a camera, so there is no necessity to imagine him in a position required by that equipment.

The Sara Lee painting, like several others in the Céret series, is closely tied to prototypes in the painting of van Gogh, with whose oeuvre that of Soutine has many parallels. And it is probably correct that, in painting this mountain village, Soutine unconsciously applied the pictorial strategies already used by another northerner working in France. In fact, many of the landscapes painted by van Gogh in both Saint-Rémy and the hillside hamlets near Auvers in the years 1889–90 can be clearly related to Soutine's 1919–20 views of Céret (fig. 2).[10] Like van Gogh, Soutine painted quickly, using paint as a plastic medium with a kind of visceral energy associated with pure emotion. Yet, it is difficult to suggest specific prototypes in the oeuvre of van Gogh for Soutine's work. The great Parisian exhibitions devoted to van Gogh had all been held before Soutine's arrival in Paris in 1913, and no monographs on the artist except those published in Dutch or German were available before 1922. These two facts suggest that Soutine's knowledge of van Gogh came from visits to dealers, discussions with others artists, and perhaps familiarity with works by that master in

Fig. 2 Vincent van Gogh, *Landscape with Three Trees and a House*, 1890. Kröller-Müller Museum, Otterlo, The Netherlands.

private collections. Yet, the absence of a specific prototype needs not deter us from making a clear assertion that van Gogh was the major source for Soutine's imagery, paint application, and working method in the Céret pictures.[11]

It is fascinating that the work of Soutine has been studied recently by a conservator of painting in ways remarkably similar to somewhat earlier studies of van Gogh's oeuvre.[12] All of this activity is directed toward the suggestion that these "master's" works are in fact not as emotional and direct as they appear, but were, rather, constructed quite deliberately in several sittings. In the face of the paintings themselves, this view is difficult to accept. At base, Pratt asserts that, because many of the touches of paint in the works were applied to the canvas when the under-layer was already either dry or tacky, Soutine must have worked in a deliberate and pre-determined manner. It is equally easy to suppose that Soutine, like van Gogh, did work in a kind of trance-like fury as he attempted to translate his sensations in front of a motif into a painted representation. That this process could be enriched by later alterations and painted additions does nothing to undercut the sheer emotional intensity of the original process, nor does it suggest that the later strokes were placed on the canvas in a more "deliberate" manner. It is more likely that Soutine looked long and often at his paintings and that they remained with him in his small space in Céret. He could return to a canvas with a fury equal to or even greater than the original emotional state in which he created the work, allowing the works to retain

the intensity that is at the core of Soutine's esthetic.

Interestingly, the Sara Lee Soutine is among the most legible and intelligible of the surviving landscapes painted in Céret. Thus, it is often included in exhibitions, but rarely discussed in their catalogues. It cannot, for example, be used to support the psychoanalytic reading of Soutine's Céret landscapes put forward in 1983 by Ernst-Gerhard Güse. For Güse, "Soutine's Céret landscapes must be understood as a high point of necrophiliac energy."[13] One pauses in attempting to apply this extreme view to the beautifully composed, almost dance-like *View of Céret*. How can the visceral reading of another Céret landscape (fig. 3) by Thomas Hess be connected with the Sara Lee painting? The "personal sensations of terror, violence" to which Hess refers do manifest themselves in other works from the series, but not in this work. It is, rather, an evocation of an intensely felt life that one confronts in this work. The paint is applied with a self-conscious crudity and the buildings do tilt and lean, but they do so in a way that seems visually to shout "life," not the death and destruction that seems so to have preoccupied scholars of Soutine. In fact, it is to the analytic Cubist works painted by Braque and Picasso in other villages in the South of France and Spain that one must turn for powerful analogues. As David Sylvester realized, "the mature Céret landscapes represent a development from Cézanne's art parallel to its development in analytic cubism . . . Both are forms of painting in which the physical reality of the picture as an object is as potent as that of an abstract painting, but

which is also a vehicle of sensations of particular external objects."[14] Few clearer and more important sentences about early twentieth-century landscape painting have ever been written.

The commitment of the Cincinnati Art Museum to adventurous exhibitions of modern European painting led them to work with the Jewish Museum on the most recent retrospective of Soutine's work, in which this painting was included. Yet the permanent collection of the Cincinnati Art Museum, although rich in late nineteenth- and early twentieth-century modernism, included no painting by Soutine. For that reason, no better home could be found for the *View of Céret*. The painting was scarcely dry when Albert Barnes bought it, but it graced the walls of the Barnes Foundation for less than three years before it was again sold. The painting was also owned briefly by the Kunsthalle in Lucerne (from whom it was borrowed for the 1950 MoMA exhibition). This institution, too, found it too strong to keep, and only at the very end of the twentieth century are we ready for it to enter a permanent museum collection for what it is hoped will be the final time.

Fig. 3 Chaim Soutine, *Hill at Céret*, c.1921. Los
Angeles County Museum of Art, California.
© ADAGP, Paris and DACS, London 1999.

1. There are many retellings of the famous encounter
between Barnes and Soutine, the most eloquent and
interesting is that by David Sylvester in *Chaim
Soutine, 1893–1943* (exh. cat.), London: Tate Gallery
and Arts Council of Great Britain, 1963, p. 6.
Although Sylvester seems to have gotten some of his
facts wrong, his "reading" of the meeting as the
turning point in Soutine's career is obviously true and
has never been bettered in the recent literature.
Fortunately, Barnes's own recollection of the meeting
in a letter to the Museum of Modern Art in 1950 has
recently been published in New York (1998), p. 198.
2. Even the dates of the Céret trip vary widely in the
published literature. In certain books, the dates are
given as 1920–23. I have opted for the dates in the
most critically sophisticated modern work by Maurice
Tuchman and his followers.
3. David Sylvester puts it most succinctly: "He
developed a mania for buying back work from the
Céret period in order to destroy them. His friend and
patron, Madeleine Castaing, says that whenever she
and her husband wanted to buy a picture that Soutine
had just completed, the artist would insist that before
the price could be discussed they must go out and find
a couple of Cérets. He himself was a heavy spender on
Cérets, and there are stories from several sources
about the violence with which he destroyed them and
the joy and relief he got from taking it out on them."
Sylvester, *Chaim Soutine, op. cit.*, p. 5.

4. Albert C. Barnes, *The Art in Painting*, 3rd rev. and
enlarged edn., New York: Barnes Foundation, 1937, p.
375. Although he went on to say, "But extreme
preoccupation with color, absence of the deep space
required for monumental effects, and his habitual
inability to organize plastic units, exclude all but a
few of his best pictures from the highest range of art.
The bulk of his work is very uneven – excess of
intensity presents synthesis of all the parts of the
picture into an organic whole, even when individual
units are effectively done."
5. This Barnes ownership is "traditional" in the small
Soutine bibliography, but is omitted – without an
explanation – from the definitive catalogue raisonné.
6. Norman Kleeblatt has written brilliantly about the
MoMA exhibition in New York (1998), pp. 53–6. He
follows up with a discussion of the opposing readings
of Soutine that resulted from the exhibition by
Clement Greenberg (negative) and Jack Tworkov
(positive), pp. 56–61.
7. It is interesting that the violence of shtetl culture is
most often portrayed in the larger literature as a
violence that comes from outside – from the Russians
and other eastern European anti-Semites. Yet the
Soutine literature is full of internal violence, as
Soutine is reported to have been beaten by his father,
his brothers, and a neighbor, whose beating was so
severe that Soutine's mother claimed – and received –
financial recompense sufficient to allow the young
artist to go to art school in Minsk, nearby his native
town (Smilovitchi).
8. Even in 1983, the great historian of modern
painting Sam Hunter declared that "Despite
systematic exploration by a new generation of
scholars and the recent revelations of a definitive
museum exhibition . . . the artist's stature and
reputation remain cloudy." ("Soutine's Expressionist
Legacy," *Soutine (1893–1943)*, New York: Galleri
Bellman, 1983, p. 15).
9. This was first proposed in Los Angeles (1968),
p. 22–7, and refined in Tuchman, Dunow and Perls
(1993).
10. See J.-B. de la Faille, *The Works of Vincent van
Gogh: His Paintings and Drawings*, New York:
Reynal, 1970, nos. 641, 661, 662, 673, 712, 744, 762,
780, 792, 805, 815. Plate 2 is 815, *Three Trees*,
Kröller-Müller Museum, Otterlo, inv. no. 317–13.
11. It is even possible that the very closeness of these
paintings to those of van Gogh was the single factor
that drove Soutine himself to disavow them.
12. See Ellen Pratt, "Soutine Beneath the Surface: A
Technical Study of His Painting," New York (1998),
pp. 119–35.
13. See *Soutine (1893–1943)*, New York: Gallerie
Bellman, 1983, *op. cit.* p. 22.
14. David Sylvester, *Chaim Soutine, op. cit.*, p. 9.

48

Chaim Soutine (1893–1943)
Valet (*Le Valet de chambre*), 1927–8

Oil on canvas, 65.1 × 49.8 cm. (25⅝ × 19⅝ in.)
Signed, upper right: Soutine
Tuchman, Dunow and Perls, vol. II, 103

Provenance: Perls, Galerie Charpentier, 15
June 1954, lot 87; Nathan Cummings, 15 June
1954–85; Robert B. Mayer Family Collection,
1985–91; Sara Lee Corporation; The Denver
Art Museum

Exhibitions: Paris, Galerie Katia Granoff,
Hommage à Chaim Soutine, June 1951;
Chicago Arts Club, *Paintings by Kokoschka
and Soutine*, October 1956: no. 58; St. John,
Canada, New Brunswick Museum, 24
April–31 May 1958; Los Angeles County
Museum of Art, *Chaim Soutine, 1893–1943*, 20
February–14 April 1968: no. 52; Washington,
D.C. 1970; New York 1971: no. 59; Chicago
1973: no. 38; Lakeland 1995; Laren 1997–8.

Bibliography: Jacques Lassaigne, *Soutine*,
Paris: Hazan, 1954, no. 14, repr.
Pierre Courthion, *Peintre du déchirant*,
Lausanne: Edita, 1972, p. 266E, repr.
Raymond Cogniat, *Soutine*, Paris:
Flammarion, 1973; English edn., New York:
Crown Publishers,1973, p. 48, repr.
Jacques Lassaigne, *Soutine*, Paris: Fernand
Hazan,1973, no. 10, repr.
Brettell 1993, 1997, pp. 86–7, 171, repr.
Maurice Tuchman, Esti Dunow, and Klaus
Perls, *Chaim Soutine (1893–1943): Catalogue
Raisonné*, Cologne: Benedikt Taschen Verlag,
1993, vol. II, pp. 662, 665, no. 103, repr.

Fig. 1 Chaim Soutine, *The Valet*, 1929. The
Armand Hammer Collection, UCLA at the
Armand Hammer Museum of Art and Cultural
Center, Los Angeles, CA. © ADAGP, Paris and
DACS, London 1999.

In contrast to its companion in the Sara Lee
Collection (Soutine's Céret landscape), *Valet*
has a relatively scant exhibition history and is
an example of a kind of painting from the
second half of the 1920s that is treated
collectively in the small Soutine bibliography.
However, its appearance in a public auction in
June of 1954 made it accessible to scholars,
and it has been regularly reproduced in books
on Soutine by Lassaigne, Courthion, and
Cogniat, all of which were published in
France. The works in this group represent
young men and boys who wear the uniform of
their trade or activity, which is identified in
the title of the painting. Among them are
pastry cooks, *valets de chambre*, waiters,
grooms, pageboys, musicians, choirboys, and,
on occasion, simply boys in blue. *Garçon*, the
French word for boy itself, has a pejorative
sense, as does its English equivalent, so that
the paintings called simply "boys" can also be
grouped with those from the serving trades.
These men and boys are always represented
alone against a background of fairly uniform
color that functions to isolate them from
others and from any specific place. Hence,
they are represented as "types" rather than
individuals.

It appears that these works have never
been studied in detail and are grouped only in
the 1993 catalogue raisonné. They are clearly
part of what might now be called a "project"
in Soutine's career that was intended to
contrast with other sequences of paintings
linked by subject, including landscapes,
portraits, female genre figures, portraits of
buildings, and various still-lifes. Interestingly,
they are as close as Soutine came in his career
to the type of painting called genre in both
French and English – works, that is, that
represent typical scenes populated by
nameless figures. Yet, it is their deliberate
avoidance of most aspects of genre painting
that defines them. In painting these
anonymous men and boys, Soutine annexes
the world of portraiture, generally reserved
for specific, named or namable individuals, to
the world of genre, in which anonymous
humans are represented as they work or
gather at leisure. Soutine's working men and
boys never work. Instead they stand,
confronting the painter – and his viewers –
with a stubborn defiance of their "proper"
role as workers, performers, or servers. The
musicians never play instruments; the
choirboys never sing, the valets never serve,
the pageboys never dash off, the pastry cooks
never make or even display pastries.
Collectively, these works might be called
"genre portraits," and they descend from a
type of serial representation common in
French popular printmaking and photography
from the eighteenth-century Cris de Paris to
Atget's genre-portraits of street musicians,
peddlers, and *clochards*. In modern art, they
find precedents in paintings of types by Corot,
Manet, Toulouse-Lautrec, Picasso, and Léger.

The subject of the Sara Lee canvas has
always been called a *valet de chambre*. The
painting is the smaller of two portraits of the
same model in the same uniform. Like other
sitters, this boy has never been identified, but
he is related to an entire series of portrait-like
representations of boys with similar, thin
faces, sharply pointed chins, long noses, and
protruding ears. A larger variant of this genre
portrait (fig. 1) was once in the collection of
Leigh and Mary Block of Chicago and was
well-known to their friend, Nathan
Cummings, who seems to have acquired his
work after seeing the larger version.
Interestingly, Chicago is an important city for
Soutine, because in 1935 the Arts Club of
Chicago gave him his first American
exhibition, after which a large group of works
by him entered public and private collections
in the city.

The entire group of thin-faced, pointed chinned figures is a reminder of Soutine's fascination with the painting of El Greco, which he knew from numerous photographs, from illustrated books, and from the three major works (two of which are portraits) in the Louvre. The very idea of El Greco – a Cretan, Greek Orthodox Christian who converted to Catholicism while living and working in Catholic Spain – must surely have appealed to the Jew from Lithuania who lived and worked in Catholic France. The emotional intensity of El Greco's portraits, together with the Spanish master's fascination with linear exaggeration of form and with paint itself as a carrier of pictorial meaning, clearly struck a chord with Soutine.

There is ample evidence to suggest that Soutine had intense difficulties with models and that working with him actually imperiled the model. One account of Soutine's method in painting from the model bears extensive quotation as we consider this modest portrait of a young boy depicted as a valet. David Sylvester says that, "for Soutine, the act of painting was so consuming that he reports blacking out while working on his portraits," and then goes on to quote from his most persuasive source, the Russian émigré called simply Marevna, whose book *Life with the Painters of La Ruche* was published in 1972. Marevna assumes the voice of Soutine himself in this quotation:

> To do a portrait, it's necessary to take one's time, but the model tires quickly and assumes a stupid expression. Then it is necessary to hurry up, and that irritates me. I become unnerved, I grind my teeth, and sometimes it gets to point where I scream. I slash the canvas, and everything goes to hell and I fall down on the floor. I always implore them to pose without saying a word and without stirring their arms and legs. Once the models understand that they are helping me work by sitting still and saying nothing, all goes well. But, you see, this is the way I am made. Sometimes the model is all right, but then something goes wrong – I suddenly see flames before me and feel them burning me. I begin to scream and throw myself on the floor. I admit that this is stupid, even horrible, and I am always terrified at this moment, but afterwards, like a woman in childbirth, I'm exhausted, but certain that the picture will go better.[1]

What we learn from this is that Soutine most valued models who were literally submissive to his aims and who would not move or speak while he engaged in an often violent encounter with them (and himself) through the act of representation. It is likely that working-class boys, perhaps even boys accustomed to forms of abuse from families and employers, were preferred by Soutine, who, as an abused child himself, could understand them as they understood him. In fact, Soutine seems actually to have re-experienced his own life of abuse by abusing others through representation, and his paintings of working-class boys in uniform can be interpreted as a form of suppressed self-loathing and, hence, self-portraiture.

This particular representation takes on added poignancy because of the vulnerability of the boy. He is small, thin, and completely enveloped in his red and black uniform. Soutine defined his face with thick, overlapping strokes of paint applied with a large brush, and the ruddiness of the hues chosen for the cheeks and ears make it seem almost as if the boy has been slapped. The contrast between the deep blue of the background and the deep, blood-red of the uniform can be found in many paintings by Soutine from the late 1920s, including the famous portrait of his patroness Madeleine Castaing in the Metropolitan Museum (fig. 2). In looking carefully at the features of Soutine's models, it is clear that he often used the same boy, dressed in various uniforms, for different portraits and that the boys may not actually have been valets, or choirboys or pageboys, but rather working-class models who posed in costume in Soutine's studio. In fact, the model for the two versions of the valet is very like the boy used for the various choirboys from the late twenties.

This painting will be the first work by Soutine to enter the permanent collection of the Denver Art Museum. After the museum acquired works of art from the Hanley Collection in 1969, it started work in earnest on its European modernist collection. The Soutine will join an important double portrait by Matisse to give visitors a sense of the range of concerns evident in European portraiture of the first three decades of the twentieth century.

Fig. 2 Chaim Soutine, *Madeleine Castaing*, 1928. The Metropolitan Museum of Art, New York, Bequest of Miss Adelaide Milton de Groot (1876–1967), 1967. © ADAGP, Paris and DACS, London 1999.

1.Marevna, *Life with the Painters of La Ruche*, London, 1972, pp. 158–9.

49

Henri de Toulouse-Lautrec (1864–1901)
Dancer Seated on Pink Divan (Danseuse assise sur un divan rose), 1884 (?)

Oil on canvas, 48.3 × 37 cm. (18¾ × 14¼ in.)
Unsigned
Inscription in pencil on the stretcher: "Donné par Henri de Toulouse-Lautrec, mon neveu, vers l'année 1886/j'habitais alors 205 bis. Boulevard Saint-Germain, Comte Odon de Toulouse-Lautrec."
Dortu P.248

Provenance: Count Odon de Toulouse-Lautrec, Paris; Count Robert de Toulouse-Lautrec, Paris; Palais Galliéra, Paris; Wildenstein & Co.; Nathan Cummings, Chicago and New York; The Sara Lee Collection; The Dixon Gallery and Gardens, Memphis, Tennessee

Exhibitions: Paris, Musée des Arts Décoratifs, *Exposition H. de Toulouse-Lautrec, trentenaire*, 9 April–17 May 1931: no. 38; Paris, Musée de l'Orangerie, *Toulouse-Lautrec: exposition en l'honneur du cinquantième anniversaire de sa mort*, 1951: no. 11; Musée d'Albi, *Toulouse-Lautrec, ses amis et ses maîtres*, 11 August–28 October 1951: no 35; Rennes, Musée des Beaux-Arts, *Toulouse-Lautrec et son milieu familial*, 5 February–17 March 1963: no. 48; Albi, Palais de la Berbie, *Centenaire de Toulouse-Lautrec*, June–September 1964; and Paris, Petit Palais, October–December 1964: no. 19; Chicago 1973: no. 19; Art Institute of Chicago, *Toulouse-Lautrec*, 4 October–2 December 1979: no. 23; Memphis, Tennessee, Dixon Gallery and Gardens, *The World of Toulouse-Lautrec*, 10 September–29 October 1989: no. 110; Winston-Salem 1990; Memphis 1991; Lakeland 1995; Laren 1997–8.

Bibliography: Maurice Joyant, *Henri de Toulouse-Lautrec, 1864–1901*, Paris: H. Floury, 1926 (rep. New York: Arno Press, 1968), p. 260.
M. G. Dortu, *Toulouse-Lautrec et son oeuvre*, vol. II, New York: Paul Brame and C. M. de Hauke, Collectors Editions, 1971, no. P.248, repr.
Brettell 1986, 1987, 1990, 1993, 1997, pp. 48–9, 171–2, repr.
Claire Frèches-Thory, Anne Roquebert, and Richard Thomson, *Toulouse-Lautrec*, New Haven and London: Yale University Press, 1991, p.184 and fn. 1.

This wonderful small painting has appeared many times in the extensive literature devoted to Toulouse-Lautrec. Its size and relatively tame subject matter must have appealed to Toulouse-Lautrec's politically conservative uncle, Count Odon de Toulouse-Lautrec, who was its first owner and from whom it descended until its sale at the Palais Galliéra, where it was purchased by Wildenstein & Co., who sold it to Nathan Cummings. Interestingly, it has always been dated 1886 and related to somewhat earlier paintings by Degas, Renoir, and Forain, all of whom were important to the developing modernism of Toulouse-Lautrec.[1] In fact, the young aristocrat was still an art student in 1886, remaining in the Atelier Cormon, where he had begun a formal course in painting after the closing of Bonnat's studio in 1882.[2] Yet his frankly bohemian lifestyle and his familiarity with vanguard art dealers lead him increasingly toward the art of the Impressionists (or "naturalists," as the figure painters among them were often called then) and their numerous followers.

If the Sara Lee painting is compared to others signed and dated 1886 or dateable by documents to that year, it seems oddly out of place. Indeed, in searching the Toulouse-Lautrec oeuvre for comparable work, one must turn to two somewhat larger though startling similar paintings, *Study of a Nude* (fig. 1) and *Gustave Lucien Dennery* (fig. 2). The nude representation features a similarly posed nude model on the identical divan with an identical covering and identical dark gray cushions and is painted in an absolutely similar style. This divan is also the support to Toulouse-Lautrec's wonderfully frank portrait of his friend Dennery, with whom he studied at Cormon's studio.[3] Curiously, none of these three paintings is dated, and Naomie Maurer, in the most extensive discussion in print on the Albi painting, simply asserts that it is from 1882. However, in a shorter but more informative discussion, Anne Roquebert dates it 1883, owing to the similarities between it and the Dennery portrait which is dateable through circumstantial evidence and a preparatory drawing dated November to late 1883 or early 1884. She opts for the 1883 date.[4] All writers about the Sara Lee canvas, including Charles Stuckey, simply repeat the traditional date of 1886.

Clearly, the three works were painted in the same room, probably at more or less the same time and project similar attitudes toward "modern" subject matter. The question is when. According to Frey, Toulouse-Lautrec rented his first studio in Montmartre in the spring of 1884, using it as a workplace for many years and spending the nights first with his mother, and, from the fall of 1884, with friends in Montmartre.[5] It seems likely that the paintings were made in that – or a subsequent – rented studio rather than in the Atelier Cormon, where Toulouse-Lautrec is known to have followed the procedure of drawing and painting from posed models and from plaster casts of antique sculpture. Although women did pose in the nude in Cormon's studio, they would have assumed standardized poses derived from high art and would not have worn black stockings and garters, as did Toulouse-Lautrec's nude model. Both the semi-nude model and the costumed one came from the class of available models that were common in Montmartre throughout the late nineteenth and early twentieth centuries. It is likely that Toulouse-Lautrec hired both models for his personal use and that he did so only after he had acquired his own studio in 1884.

The Sara Lee model was not a ballerina: she is too stocky and too well endowed. Rather, she was a professional model who was either asked by the painter or opted to wear a ballet costume and to sit on his divan. The vast majority of Toulouse-Lautrec's models in the years 1881–5 posed in a comfortable seated position – in what might be called "anti-poses" that allowed the artist ample time to study them without the strain of conventional poses.[6] The most "modern" aspect of the Sara Lee painting is the model's forthright gaze acknowledging a complicity in the act of representation. She attains the status of an "individual" rather than a "type," and we long to know her name as we do know those of many of Toulouse-Lautrec's early models.[7] Although the paintings represent different models in different poses, they each show an urgency to learn from the contemporary naturalist art of Manet, Degas, Forain, and others increasingly well known to Toulouse-Lautrec – and despised by his uncle, Odon.

Odon de Toulouse-Lautrec visited a small exhibition of paintings by his nephew in 1887 under the auspices of Theo van Gogh at the Boussoud et Valladon gallery in Paris. His letter to his mother, the painter's grandmother, makes it clear that the young artist had become a "naturalist" in a thorough-going way by 1887, and Odon pleaded for a little "beauty" in his nephew's art.[8] Clearly, there is – and was – enough beauty in this small painting to have appealed to its first owner, Odon de Toulouse-Lautrec who, like many upper-class clients, bought

Fig. 1 (*above left*) Henri de Toulouse-Lautrec, *Study of a Nude – Woman Sitting on a Divan*, *c.*1883. Musée Toulouse-Lautrec, Albi, Tarn, France.

Fig. 2 Henri de Toulouse-Lautrec, *Gustave Lucien Dennery*, 1883–4. Musée d'Orsay, Paris. Photo © RMN – Arnaudet.

Fig. 3 Edgar Degas, *Ballet Scene*, 1880. Collection of The Dixon Gallery and Gardens, Memphis; Gift of Sara Lee Corporation.

small-scale, expertly crafted representations of the demi-monde they knew but rarely acknowledged in public. As Odon himself put it in an undated letter, again to his mother, "Henri is rarely around, since he spends his life in the atelier in a neighborhood not often frequented by people from our world. Will a true talent be revealed by this?"[9]

The painting will enter the permanent collection of the Dixon Gallery and Gardens in 2000 and will follow a pattern of collecting practiced by that "house museum" since its founding more than twenty years ago. The Dixon opened with one of the great black chalk and pastel drawings of a ballet dancer by Degas. Using this as a "bud," the permanent collection has grown to include a mysterious later painting of a ballet dancer by the same artist (fig. 3), a gift to the museum by the Sara Lee Corporation, as well as a near-definitive collection of the early paintings and drawings by Toulouse-Lautrec's hero, Jules Forain. Nathan Cummings paid more for this exquisite small painting than for any other single work in his vast collection, and its acquisition from Wildenstein in 1972 for the sum of $300,000 set a financial level that this obsessive collector was never again to attain.

1. The longest and most interesting treatment of the paintings is by Charles Stuckey in Chicago (1979), pp. 100–01.

2 The biographical information in this entry is culled from Julia Frey's superb, but chronologically unwieldy biography of 1994, *Toulouse-Lautrec: A Life*, London: Phoenix, 1994. Because Frey's book is written with a linear narrative flow, but often without repetition of dates, it is difficult to "use" as a chronology.

3. Naomie Maurer wrote the entry for the painting of this nude in Chicago (1979), pp. 77–9. Anne Roquebert's superb entry on it can be found in Frèches-Thory, Roquebert, and Thomson (1991), pp. 116–17.

4. See ibid., pp. 112–15. Roquebert shrewdly admits that the date on the drawing may be either spurious or later and tends to use biographical evidence to suggest 1883. Yet, when one reads her text carefully, the same evidence could be marshaled to support 1884 or even 1885, but not 1886.

5. Frey (1994), pp. 157–8, 165.

6. Toulouse-Lautrec first used this pose (in which the model sits leaning forward with forearms on knees, hands joined, feet spread apart, and head turned toward the right shoulder) in an early (1881–3) academic drawing of a male nude (Dortu, 1971, vol. V, D.556, p. 413). He used it after the Sara Lee canvas in another *Seated Dancer*, of 1890 (Dortu, 1971, vol II, P.370, p. 199), reproduced by Richard Thomson as a comparative illustration in a catalogue entry in Frèches-Thory, Roquebert, and Thomson (1991), p. 184, fig. a.; Thomson mentions the Sara Lee work – giving it the 1885–6 date – but does not reproduce it; he suggests that it was the earliest in a series of single-figure ballet-dancer types represented by the artist from the mid-1880s. The 1890 figure is decidedly more ballerina-like in physiognomy and is seen from a more frontal view than is the Sara Lee "dancer." In his more mature period Toulouse-Lautrec repeated and exaggerated the pose in depictions of the clown/acrobat Cha-u-kao in *Cha-u-kao Seated* (Dortu, 1971, vol. III, P.580, p. 355) and in a lithograph from his album, *Elles*, *La Clownesse Assise* of 1896. Like the male model of 1881–3 and the 1890 *danseuse*, Cha-u-kao is seen from a frontal view and is much more "confrontational" as she sits on a lower "banquette" with her knees higher and her feet spread very widely apart.

7. Chicago (1979), pp. 92–3.

8. Frey (1994), p. 231.

9. Ibid., p. 132.

Maurice de Vlaminck (1876–1958)
Landscape – The Seine at Chatou (La Seine à Chatou), 1907-8 (?), conventionally dated 1912

Oil on canvas, 68 × 73.6 cm. (26½ × 28¾ in.)
Signed lower right: Vlaminck

Provenance: Ambroise Vollard, Paris; Christian de Gales, Paris; Nicole Bertagna, Paris; Nathan Cummings, Chicago; The Sara Lee Collection; Musées des Beaux-Arts, Brussels

Exhibitions: Paris, Nicole Bertagna, *Tableaux des maîtres XIVe–XXe siècle*, Unknown date; Winston-Salem 1990; Memphis 1991; Lakeland 1995; Laren 1997–8.

Bibliography: Consolidated Foods, *Consolidated Foods Corporation's Nathan Cummings Collection*, Chicago: Consolidated Foods Corporation, 1983, p. 27, fig. 23. Brettell 1986, 1987, 1990, 1993, 1997, pp. 90–91, 172, repr.

Fig. 1 Paul Cézanne, *Rooftops in a Village North of Paris*, probably 1898–9. Private Collection, Dallas.

Had Vlaminck died in 1907 at the age of forty-one, he would be rated today as one of the very greatest Fauve painters. Critics, historians, and the marketplace have all given pride of place to his Fauve landscapes, occasionally ranking them with those of Matisse as being "quintessential." And his "savage" reorientation of Impressionism into the realm of brilliant color and powerfully crude brushwork is seen as a major step in the progressive history of modern art.

But, instead, Vlaminck lived a long and productive life and died in 1958 at the age of eighty-two. If he had valued his reputation as an avant-garde modernist, he would have stopped painting after 1907, but, as we learn from the continued study of modernism, everything "important" is no longer everything "progressive," and it is time to reconsider Vlaminck's oeuvre after 1907.

Why 1907? The answer is simple. The great Cézanne had died in October of 1906, and it took the French artistic establishment until the spring of 1907 to organize a large-scale retrospective to honor – in fact, to present for the first time to the large Parisian public – his achievement as an artist.[1] Vlaminck saw that exhibition, and, after a four-year period of painting landscapes in which van Gogh and Gauguin are the dominating influences, he was stopped in his tracks by the analytical and constructivist methods of the Master of Aix and reoriented himself as an artist. His palette was reduced to blues, greens, reds, oranges, and the occasional purple. His "touch" was transformed from the viscous, almost slab-like lines of paint that seem to have been applied directly from the tube to thinned and deliberate patches, each of which was considered before its application.

Was it "mid-life-crisis?" Although this will never be known, it is highly likely that Vlaminck – a virtual alcoholic, who had "mastered" hard living – was in need of a slow-down after his fortieth birthday, and the fact that he received the impetus for this "recovery" from Cézanne, a former radical who had himself become an esthetic and political conservative in old age, is surely not accidental. And recover he did. In fact, Vlaminck and Vuillard were the only radical artists who became conservative before the First World War, and, for this, they deserve both recognition and study.

The large and masterfully composed landscape in the Sara Lee Collection is among the most important produced by Vlaminck between 1907 and 1914, when he seems to have assimilated Cézanne sufficiently and when the war interrupted his career, prompting another phase in his development. *Landscape-The Seine at Chatou* borrows most of the structural principals of Cézanne's mature landscapes and exaggerates them for expressive purposes. Yet, unlike Braque and Picasso, who had turned to the work of Cézanne as early as 1906, Vlaminck insisted on painting from nature directly – as did his master. The nature he chose was an ordinary suburban countryside, whose stucco houses and trees he sought to structure and, hence, render eternal. Yet, if he borrowed heavily from Cézanne, his paintings attempted an uneasy balance among competing compositional and chromatic forces that resolve the work to a considerably greater extent than comparable canvases by Cézanne.

What is most interesting for the scholar of modern painting is to try to pinpoint in any work made by Vlaminck between 1907 and 1914 the sources that lie in a particular painting or group of paintings by Cézanne. There are, in the end, no specific sources, and the reasons for this are twofold. First of all, Vlaminck "used" Cézanne in a general way, studying his works for hours and internalizing their complex lessons, making precise identification pointless. But there is another reason. Because Cézanne's landscape titles are so vague, and because Vollard owned so many works by Cézanne in the 1907 exhibition, it has been persistently difficult for scholars to identify the landscapes in the exhibition precisely. The painting then owned by Vollard closest to the Vlaminck in question is Cézanne's northern landscape from 1898 called *Rooftops* (fig. 1). Yet there is no proof that Vlaminck ever saw this work.[2]

The real difficulty with works by Vlaminck is their dating. The artist chose to sign

1. The most complete attempt at reconstruction can be found in John Rewald, *The Paintings of Paul Cézanne*, New York, 1996, vol. I, p. 563. The user of this partially identified list will note that the most difficult works to identify precisely are the landscapes and still-lifes, the former of which would have been the most important for Vlaminck.

² Vollard might well have already owned this painting by 1907, but it does not fit easily with any of the published titles in the exhibition's catalogue nor is it the kind of highly resolved picture that the organizers preferred for this exhibition. It is, however, likely that Vlaminck actually studied more works by Cézanne in Vollard's gallery, which he visited frequently. In fact, Vollard gave Vlaminck his first large one-man exhibition in 1907 and continued to represent Vlaminck for years.

3. See *Masters of World Painting: Maurice Vlaminck*, Leningrad: Aurora Publishers, 1987, pl. 1. The work, like the Sara Lee painting, is 73 × 92 cm.

Fig. 2 Maurice Vlaminck, *View of a Town on the Shore*, 1907. Pushkin Museum, Moscow. Photo The Bridgeman Art Library, London/New York. © ADAGP, Paris and DACS, London 1999.

virtually every canvas he sold to Vollard, but he dated remarkably few and, because the post-1907 Vlaminck has not been seriously studied, there is as yet no good identification of just which works by the artist were exhibited and sold in the years before the First World War. The Sara Lee painting is particularly close to a large – and famous – landscape by Vlaminck in the Hermitage called *View of a Town on the Shore*, that is persistently dated 1907 by the Hermitage itself (fig. 2).³ Yet, if this work was actually painted in 1907, it must have been done in the autumn or winter. Many of the published works by Vlaminck from 1909–12 are tighter in execution and use repeated diagonal strokes to compose the landscape, suggesting that the Sara Lee painting might well date from 1907–8.

The Vlaminck will enter the national collection of Belgium, the country of Vlaminck's name and family. It will join three other works by that great "northern" painter of France, who attempted to apply the lessons of Cézanne's "south" to the northern landscape of France.

Fig. 3 Maurice Vlaminck, *The Compote Dish*. Musées royaux des beaux-arts, Brussels. © ADAGP, Paris and DACS, London 1999.

Edouard Vuillard (1868–1940)
Facing the Door (*Devant la porte*) [formerly
The Bay Window at Pouliguen], 1908
(Summer)

Distemper on paper, laid down on canvas,
89 × 166 cm. (35 × 65 in.)
Signed lower right

Provenance: Galerie Bernheim-Jeune, Paris;
M. L. Rothschild, Brussels; Antoine Salomon,
Paris *c.*1977; Thomas Gibson Ltd., London;
Nathan Cummings, New York; Michael Owen
Inc., New York; The Sara Lee Collection; The
Portland Art Museum, Oregon

Exhibitions: Paris, Galerie Bernheim-Jeune,
1908: no. 12; Brussels, Palais des Beaux-Arts,
Exhibition Vuillard, 1946: no. 39; Brussels,
Galerie Georges Giroux, *Exposition
anniversaire, 1911–1946: 35 ans d'activité*,
September–October 1946: no. 168; Brussels,
Galerie Georges Giroux, *Exposition de l'art
vivant dans les collections privées belges*,
June–August 1947: no. 84; Antwerp,
Guillaume Campo Gallery, *Edouard Vuillard*,
1977: no. 342c; Winston-Salem 1991;
Memphis 1991; Laren 1997–8.

Bibliography: Brettell 1990, 1993, 1997,
pp. 66–7, 172–3, repr.

Fig. 1 Edouard Vuillard, *Place Vintimille*, 1909.
Private Collection, Portland. © ADAGP, Paris and
DACS, London 1999.

The year 1908 was tremendously productive
and important for Vuillard. While Picasso and
Braque worked furtively together to
reinvigorate figure painting, particularly the
nude, Vuillard extended and refined the "field
of vision" of the Impressionists. He started the
year by exhibiting in February, at the Galerie
Bernheim-Jeune, three large decorative
paintings made on commission for two
wealthy and socially connected Romanian
princes, Antoine and Emmanuel Bibesco.
These three decorative paintings were joined
at Bernheim-Jeune that February by thirty-
three other works by Vuillard in oil, gouache,
and pastel, which were eagerly snapped up by
members of the social set that surrounded the
shy artist.[1] This group included Frenchmen as
well as foreigners of Romanian and Polish
descent, Jews and Catholics, aristocrats and
bourgeois, and these men and women served
both as Vuillard's models and his clients. No
society painter in European history has ever
had a more diverse and cosmopolitan clientele
or painted it in a more complex – one might
say, Proustian way.[2] In fact, the three great
decorations in the February 1908 exhibition
were all painted for the Bibescos, yet they
represent Vuillard's Jewish friends, the
Hessels, the Natansons, and the Arons, none of
whom would have socialized with the
Bibescos.

Among the key "players" in Vuillard's
world were Jos and Lucie Hessel. Jos Hessel
was a wealthy art dealer – in fact, the office
manager in the firm of Bernheim-Jeune,
Vuillard's dealer at the time. He was also a
first cousin-once-removed of Josse and Gaston
Bernheim, the brothers who owned the
gallery (his first cousin had been the brothers'
father Alexandre Bernheim, the founder of
the gallery). Jos's wife Lucie was a larger-
than-life figure in Parisian right-bank society,
who came to play a major role in Vuillard's
life, succeeding the famous Misia Natanson as
the painter's muse/friend/mentor, and
possibly, lover.[3] While Jos maintained an
active friendship with Bonnard, Lucie
concentrated her attentions – and affections –
on Vuillard and invited him often to stay with
them at various properties in the country.[4]
Summers were spent between the Hessel's
Normandy house, the Château Rouge, at
Amfreville, and rented properties at such
places as the fashionable Brittany resort of
Pouliguen (near La Baule), where the couple
took a seaside villa in the summer of 1908. In
all these places, Vuillard made his habitual
croquis or rapid pencil sketches done without
looking down at the sketch itself. He also took
Kodak photographs in each of these locations
and used both kinds of *aides-memoires* in the
construction of larger paintings in Paris. In
painting the large and fragile work on paper
Facing the Door, Vuillard surely turned to a
drawing or two and perhaps a photograph of
the house at Pouliguen for prompting.

In 1907–8 Vuillard produced an important
group of large-scale distemper paintings on
paper, many of which he was to include in
another 1908 exhibition at Bernheim-Jeune,
held in November to coincide with the
painter's fortieth birthday. This was the
biggest and most important exhibition of his
career, with seventy-five works, many of them
large-scale drawings on paper.[5] In fact,
Vuillard seemed to prefer to make works that
have the look of vast painted drawings. He
used brownish paper, probably purchased in
rolls and cut by the artist to the desired
length. The formats of these works suggest
Asian scrolls and even folding screen
paintings. As if in mimicry of this joint source,
Vuillard worked in very long formats
presented both vertically and horizontally
(figs. 1 and 2). These paintings are almost
aggressively complex, yet casual and
spontaneous, combining many disparate
observations onto a single sheet that seems to
have been painted very quickly. Because
Vuillard allowed the paper itself to show
through, throughout the large sheets, and
because he used gouache and glue-based
distemper to produce a thoroughly "dry"
surface, they look provisional and
intentionally incomplete in ways that became
increasingly acceptable in French art as the
seemingly unfinished canvases and sheets by
Cézanne and Degas began to be published and
exhibited.[6]

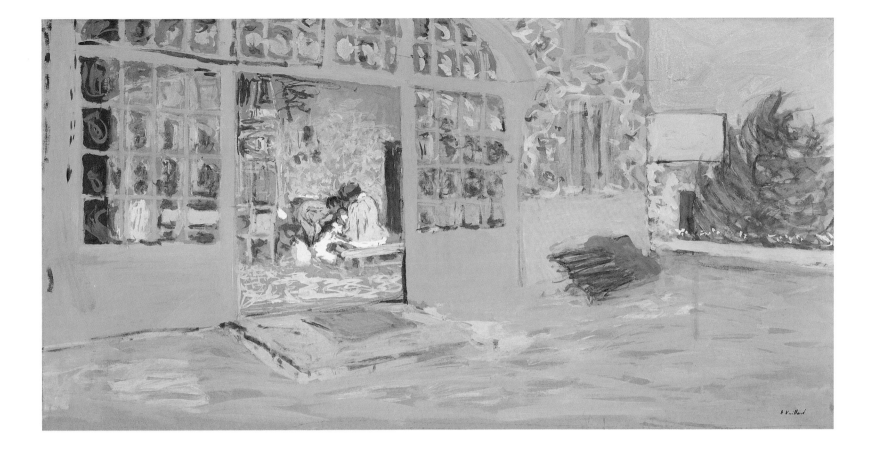

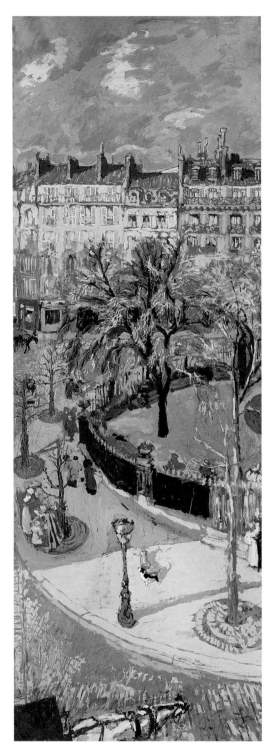
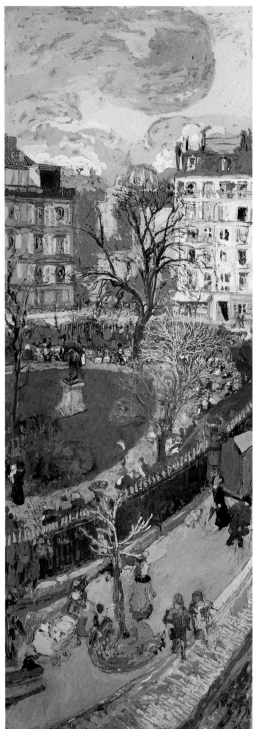

Fig. 2 Edouard Vuillard, Place *Vintimille*, 1908–10.
Solomon R. Guggenheim Museum, New York.
Thannhauser Collection, Gift, Justin K. Thannhauser, 1978.
Photograph by David Heald © The Solomon R. Guggenheim Foundation, New York.
© ADAGP, Paris and DACS, London 1999.

Facing the Door is a horizontal transcription of a warm, windy afternoon on the Brittany coast, a little too overcast to encourage outdoor activity. Vuillard situated the viewer on the terrace of the flint-built house, outside a vast doorway glazed with bottle-glass windows that sparkle in the light. Rather than direct his (the viewer's) gaze out to the sea, which was churning away just to the right of the pictorial format, Vuillard turned his attentions inward, revealing a comfortable room where his friend Lucie Hessel is playing with children. Although impossible to identify from the work of art itself, these children have been conclusively identified as those of Alfred Natanson and his wife, the actress Marthe Melot, all of whom were part of Lucie's extended house party. This information helps in certain ways to explain the oddly disconcerting distance between the painter/viewer and the presumed subject of this large painting – the women and children in an interior. Both Vuillard (a lifelong bachelor who lived with his mother) and Lucie Hessel were childless (Lucie was later to adopt a little girl and to ask Vuillard to be her godfather), and these "borrowed" children must have meant a good deal to her. The painter himself maintained a discreet distance from this intimate scene and managed to combine in one composition a tiny "interior" and a thoroughly modern landscape. We, like him, are not privy to their conversations or activities, but, in peeping in at them, we yearn to enter and to join this small familial party.

This painting will be the first major work by Vuillard to join the small collection of French paintings in the Portland Art Museum in Oregon, which includes major works by Courbet, Degas, Monet, Renoir, Morisot, and Pissarro. Yet, perhaps the most sympathetic context for the Vuillard in Portland will be the superb collection of Asian art, including Japanese and Chinese screen and scroll paintings to which Vuillard alluded both through his choice of a paper support and by the horizontal "scroll" format he adopted.

1. This exhibition is thoroughly discussed in Gloria Groom's *Edouard Vuillard, Painter-Decorator: Patrons and Projects, 1892–1912*, New Haven and London: Yale University Press, 1993, pp. 159–61. She also reproduces the one-page catalogue. Although her discussion focuses on the large decorative panels and the fourth large painting, her inclusion of the entire catalogue encourages speculation that the Sara Lee painting might well be no. 9, *Devant la Porte*.

2. Groom's entire book (*op. cit.*) is a thorough study of Vuillard's clientele. Her focus on the commissioned decorative paintings means that her analysis of the portable works – paintings and works on paper – limits her analysis to a small group of Vuillard's actual purchasers. However, her discussion of the social, national, and religious character of Vuillard's clientele is unsurpassed.

3. Their relationship – as well as that between her husband and Bonnard – are discussed discreetly in Groom, *Vuillard, op. cit.*, pp. 147–8.

4. Vuillard's portrait of Lucie Hessel is a collective analysis of this single woman in every possible position, attitude, and costume. She is represented indoors and out, by natural and artificial light, alone and with others, contemplative and active, near and far. Groom, *Vuillard, op. cit.*, reproduces a delightful "portrait," *Lucie Hessel in the Small Salon, rue de Rivoli*, 1903–4, (p. 149, pl. 232).

5 I have not seen a catalogue of this exhibition, but there is a very unflattering anonymous review – a review that chastises Vuillard for the unformed and sketch-like nature of his works – in *La Chronique des arts* for 21 November 1908, p. 370.

6. The knowledge of Cézanne's unfinished works was widespread after his death in 1906. Degas's pastels on paper, in various states of "finish" had been exhibited widely since the mid-1880s.

Edouard Vuillard (1868–1940)
Foliage – Oak Tree and Fruit Seller (*Verdure – chêne et fruitière*), 1918

Distemper on canvas, 193.2 × 284.8 cm.
(76 × 111½ in.)
Signed and dated lower left: E. Vuillard/1918

Provenance: George Bernheim, Paris; Mr. and Mrs. Roger Darnetal; Daniel Varenne, Geneva Nathan Cummings. Chicago; The Sara Lee Collection; The Art Institute of Chicago

Exhibitions: Paris, Musée des Arts Décoratifs, *Exposition E. Vuillard*, May–July 1938: no. 163; New York, Metropolitan Museum of Art, March 1968; Paris, American Embassy, on loan December 1969–May 1970; Washington, D.C. 1970: no. 25 (as *Public Garden*); New York 1971: no. 25; Washington, D.C., Federal Reserve Board, on loan 11 May 1972–12 August 1981; Laren 1997–8.

Bibliography: Consolidated Foods Corporation, *Consolidated Foods Corporation's Nathan Cummings Collection*, Chicago: Consolidated Foods Corporation, 1983, p. 10, fig. 4. Brettell 1986, 1987, 1990, 1993, 1997, pp. 70–73, 173, repr.

Fig. 1 Edouard Vuillard, *Landscape: Window overlooking the Woods*, 1899. The Art Institute of Chicago. L.L. and A.S. Coburn, Martha E. Leverone and Charles Norton Owen funds; restricted gift of an anonymous donor. © ADAGP, Paris and DACS, London 1999.

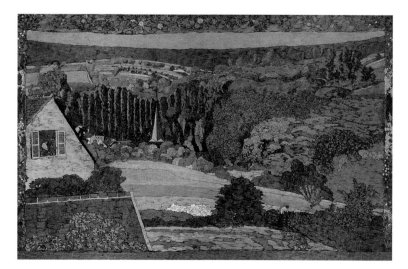

There is no doubt that Edouard Vuillard was the greatest "decorative" painter of the late nineteenth and early twentieth centuries. His achievement in both public, private, and what might be called semi-private decorations has been much discussed in the extensive literature devoted to his career, and a surprising number of these large and often fragile works have been included in various exhibitions devoted both to Vuillard's oeuvre itself and to that of his Nabis circle. The most systematic study of Vuillard's decorative painting was a dissertation for the University of Texas by Gloria Groom that resulted in a major monograph published in 1993.[1] This superb book pushes the reader headlong into the giddy and gossipy world of fin-de-siecle Paris and into the extended milieu of the rather diffident painter, who surrounded himself with larger-than-life friends of a very diverse sort. Unfortunately for our understanding of the great Sara Lee decoration *Foliage*, Groom's book goes only to 1912, just as Vuillard's decorative career stepped from the private into the public realm as he was selected to paint fixed decorations for the foyer of Auguste Perret's Théâtre des Champs Elysées in Paris. Unfortunately, the "late" Vuillard has often suffered this slight, and the bibliography devoted to the first ten to fifteen years of his career dwarfs that which describes the last forty.[2]

Foliage was signed and dated in 1918 and installed in the home of the great art dealer Georges Bernheim in that year. The painting has long been in the Vuillard "canon." It was first selected for exhibition by Vuillard himself and appeared in the great retrospective of 1938, held (not accidentally) at the Musée des Arts Décoratifs in Paris. Since then, it has appeared at major American museums and was loaned for nearly a decade to the Federal Reserve Board headquarters in Washington. The work represents a view of the closerie (now allée) des Genêts in the western Parisian suburb called Vaucresson. Vuillard and his mother rented the closerie apartment in 1918 as a retreat from Paris in the last year of the Great War and returned to it regularly for the next seven years. Vuillard's friends Jos and Lucie Hessel rented the Villa Anna in Vaucresson in 1917 and bought the Clos Cézanne there in 1920.[3]

With its dominant greens and patterned use of foliage as a surface unifier, this painting can be easily related to the "verdure" tapestries of the sixteenth and seventeenth centuries that Vuillard is known to have admired. In fact, Vuillard had created a pair of verdure decorations in 1899 for Adam Natanson, and *Foliage* is, in many ways, a response to those dour decorations.[4] It is, in this way, infinitely richer, livelier, and more confident in its spatial and chromatic structures than *Window overlooking the Woods* of 1899 (fig. 1), which it will join in the permanent collection of the Art Institute of Chicago. Its first owner, Georges Bernheim, had represented Vuillard for many years and was completely familiar with the earlier scheme. It is interesting, in speculating about the work, that Vuillard chose to represent a Vaucresson view associated not with the Bernheims themselves, but with their cousin and Vuillard's friend Hessel, and with Vuillard himself. Yet, in this, Vuillard seems to have followed his utterly Proustian pattern of painting a kind of esthetic autobiography for others.

The closerie des Genêts is a tiny, L-shaped dead-end street in the oldest section of the village of Vaucresson. In conceiving the painting, Vuillard situated himself in a second-floor room (his bedroom?) of the house on the corner of the closerie des Genêts and the avenue du Louis Coteaux.[5] The window faced east, and Vuillard oriented both himself and the viewer on axis with a tall and straight oak tree that rose from the center of the small garden in front of the house. To the left and the right of the tree, the street moves parallel to the picture plane, with its L-extension moving off on the left side, animated by a small cart from which an itinerant merchant farmer, as was common during the war, sold fruits and vegetables. It is full summer, and the angle of the sun suggests that the time is midday. This is a world of retreat – both from the city and from the war – a realm of women, children, and foliage, whose time is cyclical and natural rather than cataclysmic,

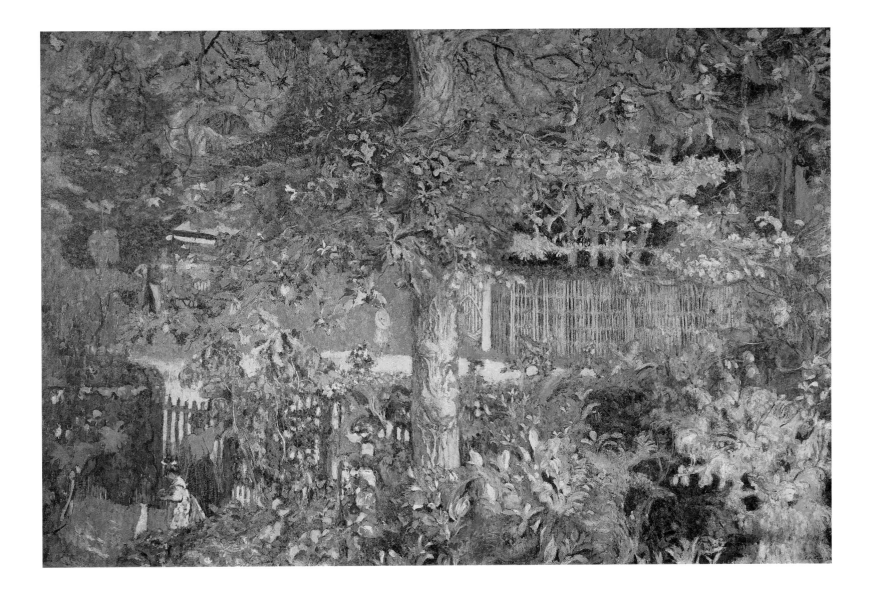

1. Gloria Groom, *Edouard Vuillard, Painter-Decorator: Patrons and Projects, 1892–1912*, New Haven and London: Yale University Press, 1993. Groom explains and justifies the perimeters of her study in an intelligent introduction, pp. 1–3. She is currently preparing a major exhibition and scholarly book devoted to the decorative paintings of Vuillard, Bonnard, and Roussell, which will be held at the Art Institute of Chicago and the Metropolitan Museum in 2001.
2. There is simply no good book on the "late" Vuillard. The best work was produced by Jacques Salomon, the painter's "nephew-in-law" in the forties and fifties. This culminates in his monograph, *Vuillard*, Paris, Gallimard, 1968. For a full investigation, we await the research of his son Antoine Salomon and his collaborators, most recently Guy Cogeval, who is preparing both a scholarly catalogue raisonné and a major exhibition.
3. For a discussion of this portion of Vuillard's career, see Belinda Thomson, *Vuillard*, New York: Abbeville, 1988, p. 122.
4. The most intelligent discussion of verdure tapestry and Vuillard can be found in Groom, *Vuillard, op. cit.*, pp. 121–34.
5. There are many maps of the Vaucresson, for example in André Leconte, *Guide de la Banlieue de Paris, Indicateur des rues de 240 communes de la région parisienne*, Paris, n.d., p. 939.
6. See Thomson, *Vuillard, op. cit.*, p. 119.

and, were it the only work to survive in Vuillard's oeuvre from the war years, it would appear that the painter fled the grim realities of war with real determination.

Yet, this is not the case. Belinda Thomson was the first to publish in easily accessible form a series of works produced by Vuillard during the war, and her treatment of these years is fascinating. We learn that although the painter was too old (forty-six) for active service, he was nevertheless mobilized and worked early in the war as a *garde-voie*, watching the railroad lines going into the Gare de Lyon for suspicious activity. Later in the war, he visited his friend Thadée Natanson, who was stationed in Lyon as administrator to a munitions factory owned by a man named Lazare-Levy. Lazare-Levy commissioned Vuillard to paint a series of four "decorations" unlike any others he had done before. They record the activities of the munitions factory as it worked both by day and by night (fig. 2). In many ways these are "anti-decorative" in their subject, and Vuillard himself referred to these subjects in his journal as a "flux of sensations—terribly interesting—discordant—feverish," and to a world of "engineers, of active and ambitious people and raging conflicts."[6] These works consumed Vuillard, who became the first great artist since Adolph von Menzel to bring factory life directly into the realm of high art. These were not his only "tough" subjects, however, for he also painted an interesting and unprecedented painting on paper mounted on canvas called *Interrogation* in 1917 (fig. 3). These works — and others — demonstrate beyond question that Vuillard confronted war on both the social and the personal levels as directly as any great artist of the early twentieth century. It is surely in this

context that one must place the later — and hopeful — decoration for the Bernheims, completed in 1918, most probably in the months before the armistice, 11 November 1918. The tide had turned against the Germans by the summer of 1918, and the world that Vuillard observed from his balcony in Vaucresson was the world of France's future. It is perhaps worth noting that, while Vuillard labored to finish his great *Foliage*, the elderly Monet, whom Vuillard had already visited at Giverny, signed and dated a great landscape on Armistice day, a work he offered through his friend Georges Clemenceau to the French nation, but which now resides in the Kimbell Art Museum in Fort Worth, Texas. Oddly, both Vuillard and Monet embodied their response to war in a tree. While Monet's writhes in eloquent agony, Vuillard's rises straight and tall.

Fig. 2 (*above*) Edouard Vuillard, *The Forge*, 1917. Musée d'Art Moderne, Troyes. Donation Pierre et Denise Levy. © ADAGP, Paris and DACS, London 1999.

Fig. 3 Edouard Vuillard, *Interrogation*, 1917. Musée d'Histoire Contemporaine – BDIC, Paris. Photo Archipel. © ADAGP, Paris and DACS, London 1999.

Abbreviations

San Francisco 1953

The Nathan Cummings Collection, San Francisco, M. H. de Young Memorial Museum, 1953.

Toronto 1955

Collection Nathan Cummings d'art ancien du Perou et peinture françaises XIXe et XXe siècle, Art Gallery of Toronto, 10 September–16 October 1955.

Paris 1956

Collection Nathan Cummings d'art ancien du Perou et peinture françaises XIXe et XXe siècle, Paris, Musée des Arts Décoratifs, March–May 1956.

Rome 1956

Collezione Cummings, Rome, Palazzo Venezia, 1956.

Chicago 1963

Paintings from the Nathan Cummings Collection, Art Institute of Chicago, 20 September–22 October 1963.

Minneapolis 1965

Paintings from the Cummings Collection, Minneapolis Institute of Arts, 14 January–7 March 1965.

Davenport 1965

Collection of Masterpieces – Courtesy of Mr. and Mrs. Nathan Cummings, Iowa, Davenport Municipal Art Gallery, 21 March–11 April 1965.

New London 1968

Paintings and Sculpture from the Collection of Mr. and Mrs. Nathan Cummings, New London, Connecticut, Lyman Allen Museum, 19 January–18 February 1968.

Washington, D.C., 1970

Selections from the Nathan Cummings Collection, National Gallery of Art, Washington, 29 June–11 September 1970.

New York 1971

Selections from the Nathan Cummings Collection, New York, Metropolitan Museum of Art, 1 July–7 September 1971.

Chicago 1973

Major Works from the Collection of Nathan Cummings, Art Institute of Chicago, 20 October–9 December 1973.

Winston-Salem 1990

An Impressionist Legacy: The Collection of Sara Lee Corporation, Winston-Salem, North Carolina, Reynolda House Museum of American Art, 9 September–25 December 1990.

Memphis 1991

Memphis, Tennessee, Dixon Gallery and Gardens, *An Impressionist Legacy: The Collection of Sara Lee Corporation*, 20 January–17 March, 1991.

Lakeland 1995

Modern Masters: The Collection of Sara Lee Corporation, Lakeland, Florida, Polk Museum of Art, 14 January–12 March 1995.

Laren 1997–8

The Sara Lee Collection: An Impressionist Legacy, Laren, The Netherlands, Singer Museum, 18 October–15 February 1997–8.

Brettell 1986, 1987, 1990, 1993, 1997

An Impressionist Legacy: The Collection of Sara Lee Corporation, New York: Abbeville Press, 1986, 1987, 1990, 1993, 1997.

Appendix:
Introduction
by Douglas Cooper
to the 1970 Washington
Exhibition Catalogue

Nathan Cummings began to buy paintings by chance and on his own initiative. He had never studied painting, nor indeed had he begun to discover what it is all about through reading books. However, one day in 1945, when Cummings was in Paris, he happened to see a painting in a dealer's window which he instinctively liked. The name of the artist meant nothing to him at the time, but Nathan Cummings had in fact purchased a harvesting scene of 1893 by Camille Pissarro.

There are many kinds of art-collectors and each has a variety of motives for collecting. Some are driven by an insatiable desire to possess, irrespective of the value or artistic merit of the object. Others see in the possession of works of art a way of asserting their power, of displaying their wealth or of improving their social standing. Some look for sensual gratification through the voluptuousness of the subject depicted or through the opulence or unexcelled "quality" of the art-objects which they can assemble around them. While others find in collecting works of art an activity which enables them to project or extend their personality. These collections, whether they be vast or small, limited or diverse, are inevitably endowed with some general characteristic, or are unified by an inherent logic. It may be that of famous works by famous names, or the best that money can buy, or a concentration on works of a particular kind or period, or by some specific artist, just as it may be the distinctive taste of the collector.

There is, however, yet another type of collector – and Nathan Cummings is one of them – who has no specialized interest which his collection is intended to serve, but who buys a work of art because something about it appeals to him. He gives no thought to what he bought last or is likely to buy in the future. This kind of collector cares nothing about either the fashionable taste of the day or historical considerations, nor does he worry about building up a balanced ensemble or conceive of his collection as providing him with a decorative setting. His acquisitions are simply an expression of his temperament, with all its fluctuations, so that his collection becomes diffuse but fascinating in its variety. An outsider is unlikely to enter into the spirit of such a collection as a whole because it is so intensely personal, and inspired by feelings and factors of which not only is he ignorant but also which he cannot share. He can and will, however, react to its inherent surprises, because he is sure to find himself faced with incongruous confrontations, which, from the point of view of taste might seem hard to reconcile, for he cannot guess what sort of great or unknown work he is about to encounter on the next wall.

This is precisely the way it is with the art collection of Nathan Cummings. Not only is the number of works that he owns too large to allow the collection to be exhibited in its entirety, but also the range and diversity of styles that it represents is a factor which can only be reconciled within himself. Therefore it was decided that the most effective way to present Nathan Cummings's collection to the public would be through a small number of particularly choice works representing, in a condensed form, Cummings's own artistic preferences. Nathan Cummings wants very much for others to share with him the stimulation and enjoyment inherent in the works of art he has collected. That to him constitutes one of the great pleasures of ownership. So he has given a completely free hand to those of us involved in organizing the present exhibition to make our own "discoveries" among all that he owns. That is why it is simply entitled "Selections from the Nathan Cummings Collection."

The paintings and sculptures selected merely reinforce what I have already said about the eclecticism of Nathan Cummings's taste and the fact that his choice is not determined by any aesthetic ideal, scientific purpose or preconceived plan. In terms of time the works he has acquired range from the splendid drawing and painting by Daumier, both executed around 1860, to paintings and sculpture by Dubuffet, Giacometti, Manzù, and Moore executed one hundred years later. That is to say, this selection embraces works of both the nineteenth and twentieth centuries, and represents the creative effort of thirty-five different artists. Although the number of twentieth-century artists is virtually double that of the nineteenth century, the Cummings collection centers in spirit more around the art of the late nineteenth and early twentieth century than it inclines to modernism.

The best way to gain an insight into Nathan Cummings's spontaneous way of collecting is to look into the purchases he has made in different years. One might expect that, having begun with a Pissarro, he would have continued to buy nineteenth-century works, at least for a while. But not at all. In 1950, Cummings bought his first and only Chagall. In 1951, he bought not only his first Picasso, the *Torso of a Young Girl* of 1908, but also Monet's enchanting 1872 portrait of his son on a mechanical horse. In 1952 Degas's *Russian Dancer* was added to the collection because, as Nathan Cummings has told me, he loved its vigorous movement. But in the same year he also bought the calm, sensuous, linear, recumbent *Nude* of Modigliani. Then he forgot about Degas for ten years and did not buy another until 1962 when he acquired *Woman Resting on Her Arm*, after which he rapidly added four more in 1964 and 1968, and now Degas is one of Cummings's preferred artists. Similarly with Rouault, another artist who is currently one of Cummings's favorites: the *Pierrot* was acquired in 1954, but it was 1967 before he acquired the other three.

During the 1950s Nathan Cummings seems to have been looking around and feeling his way. In this decade he bought more nineteenth than twentieth-century works, though he nonetheless acquired his first examples of Braque, Léger, Picasso, Rouault, and Soutine. At the same time, he also acquired in 1954 a large and very important collection of ancient Peruvian art objects – of pottery, gold, silver, copper and stone – which a few years later he graciously gave away, a large share going to The Metropolitan Museum of Art and some to The Art Institute of Chicago. Since then Nathan Cummings has shown no more interest in the art of so-called "primitive" cultures. During the 1960s, however, Cummings has acquired many more works than in the previous decade, but far fewer of them are nineteenth-century works – principally the group by Degas, Gauguin's *Boys Wrestling* in 1962, and Pissarro's *Pont-Neuf* in 1968 – because he has largely moved into the field of the twentieth century. There he has made a number of memorable acquisitions: two major canvases of 1929 and 1932 by Picasso, a fine *Fauve* painting by Braque, a group of five Kandinsky oils of the Bauhaus years from the collection of the Guggenheim Museum, a fine still life of 1927 by Matisse, a group of works by Soutine, two paintings by Dubuffet, and an excellent group of works by Léger.

Léger is another artist whose work appeals particularly to Nathan Cummings, and this aspect of his taste has been encouraged greatly by his wife who studied at Léger's academy in Paris in the early 1950s. What is more, Joanne Cummings has used her influence to persuade her husband to take an interest in sculpture, with the result that between 1961 and 1964 he put together the impressive group of works by Giacometti and has been buying sculptures by different artists ever since.

Quite apart from the inherent quality of excellence which has determined the choice of each work individually, this "selection" from the Cummings collection, considered as an entity, seems to me fascinating because it is also surprising. And I mean this in more senses than one. I can think of no other private American collection today to which it can be compared. For the make-up of the Cummings collection is exceptional in that it covers an unusual span of time (1860–1970) as well as artists with many different kinds of style. It has no polarity. Signac is there but not Seurat; Degas but not Toulouse-Lautrec; Pissarro but not Cézanne; Monet, Matisse and Braque but not de Staël. Some of the sculptures have been executed quite recently, yet the latest tendencies in painting and sculpture are not represented in the Cummings collection. The only non-figurative works included were done forty years ago by Kandinsky. There is no Mondrian, no Pollock and no Pop Art, nor is there any "fantastic" art, such as works by Redon and Klee. Equally, Nathan Cummings has passed over Cubism, Futurism, and Surrealism: there are no paintings by Gris, Delaunay, Feininger, Boccioni, Ernst, Miró, or Dali, nor any sculptures by Lipchitz. In short, one is as much surprised to discover what *has* appealed to Nathan Cummings as to find out what has *not*.

I do not mean this as a criticism of Nathan Cummings's taste or judgement. On the contrary, this sort of analytical approach is the best way to gain a significant insight into what makes a particular collector tick. Personally, I find it refreshing, in this age of standardization, to look at and think about an art collection which is puzzling in its complexity, rich in outstanding and exciting works, and yet so completely different in spirit and substance from any other that one knows. And I have been fascinated to discover that by day Nathan Cummings is surrounded in his office by two great Picasso oils and by three strong compositions by Léger, whereas when he goes back to his apartment he loves to wander round the living room (as he told me) looking at his Gauguins, the Mary Cassatt, the Berthe Morisot, and the early Monet before sitting down to his desk, where he is confronted by the Fauve Braque.

When I asked Nathan Cummings which artists were his favorites out of all those whose works he has acquired, he replied immediately: "Degas, Monet, Rouault, Braque, Léger, Giacometti, and Renoir." Renoir, whose paintings do not appeal to Joanne Cummings, is represented in this selection on exhibit only by two small bronzes. Each of the other six artists that Cummings mentioned is, however, featured in a group of memorable works. Yet I am sure that Nathan Cummings wants us to look at and enjoy each work individually, as he certainly does himself. For he does not think of his collection in terms of personalities, tendencies, or groups. Nathan Cummings's list of favorite artists, even of his favorite paintings, surely fluctuates as he discovers something new or gets tired of something he thinks he has looked at for too long. It is an unusual attitude in a collector. Yet it is only because Nathan Cummings feels this way that he is happy to take down from his walls a selection of the finest things he owns and let the public, too, enjoy them. I even believe that he hopes to learn something by the experience of seeing them in unfamiliar surroundings and listening to the comments of other people.